ISAAC SOYER

Facing Beauty

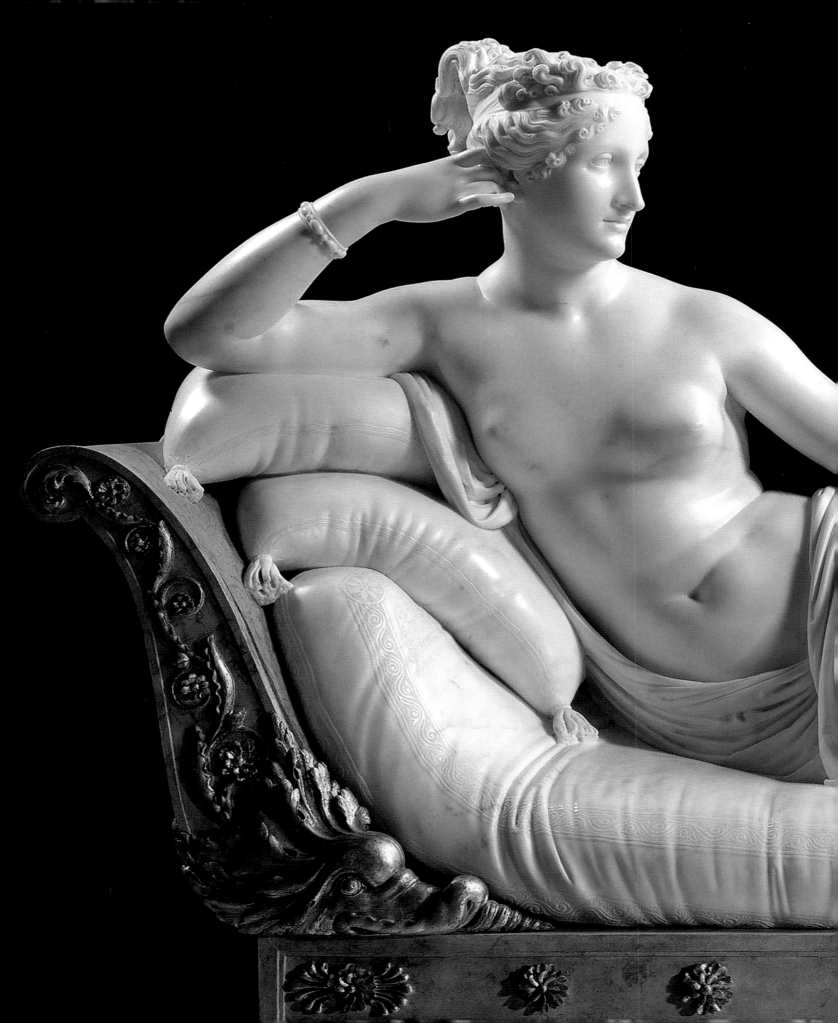

Facing Beauty

PAINTED WOMEN & COSMETIC ART

Aileen Ribeiro

Yale University Press ❧ New Haven & London

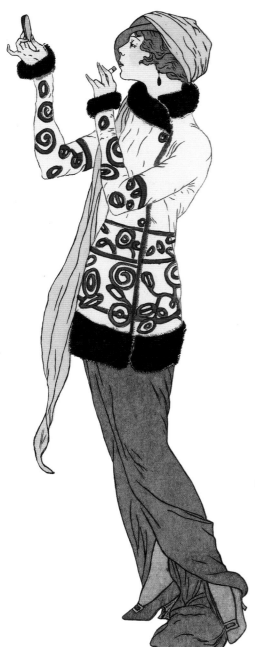

Designed by *Gillian Malpass*

Printed in Singapore

Library of Congress Cataloging-in-Publication Data

Ribeiro, Aileen, 1944–
Facing beauty / Aileen Ribeiro.
p. cm.
Includes bibliographical references and index.
ISBN 978-0-300-12486-6 (cloth : alk. paper)
1. Feminine beauty (Aesthetics) 2. Women in art.
3. Feminine beauty (Aesthetics) in literature. I. Title.
NX650.F45R53 2011
306.4'613–dc23

2011021878

A catalogue record for this book is available from the British Library

Page i Illustration from the *Gazette du Bon Ton*, April 1920 (see fig. 206)
Pages ii–iii Antonio Canova, *Pauline Borghese* (detail of fig. 6)
This page Illustration from the *Journal des Dames et des Modes*, 1913
(see fig. 199)
Facing page 'The Enchanting Mirror', from *The Toilet*, 1823
(see fig. 151)
Pages vi–vii Isaac Soyer, *Art Beauty Shoppe* (detail of fig. 218)
Pages viii–ix Jean Raoux, *A Lady at her Mirror* (detail), 1720s.
Wallace Collection, London
Pages x–xi Jean-Etienne Liotard, *Maria Gunning, Countess of Coventry*
(detail of fig. 98)

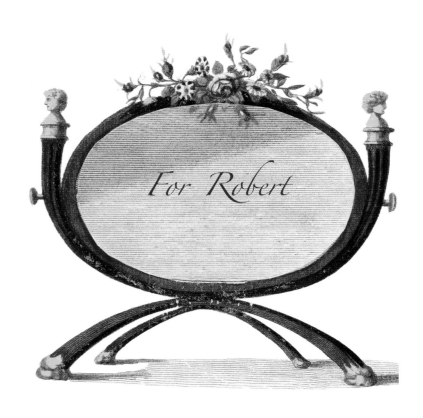

For Robert

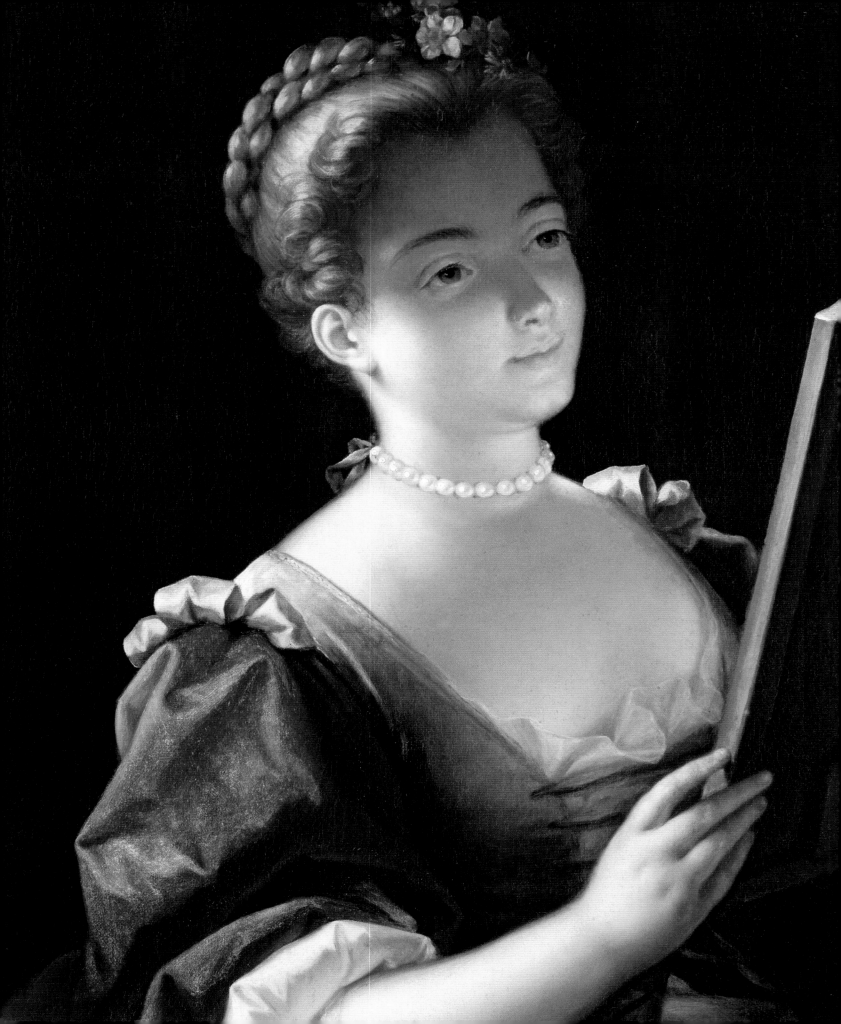

Contents

*T*HIS BOOK HAS BEEN A LONG TIME IN GESTATION. I FIRST BECAME INTERESTED IN THE SUBJECT IN 1986 WHEN I WAS asked by the Tate Gallery Education Department to select twelve paintings of women from the Tate's collection and to write about their faces and the cosmetics they might have worn. The resulting small publication, *The Female Face in the Tate's British Collection 1569–1876*, appeared in 1987. From that time onwards my ideas on female beauty and how it might be linked with the cosmetic arts remained an interest, usually lodged at the back of my mind when pushed out by more pressing projects and other books. But in recent years those ideas have elbowed their way to the forefront; this book is the result.

What seemed at first to be a fairly limited topic gradually developed into something more complex and infinitely wide-ranging. Over the years I have had innumerable conversations, with historians of all kinds, as well as students, friends and acquaintances, about what constitutes beauty and how it could be enhanced; a bewildering variety of views and opinions resulted. This is, therefore, an appropriate place to thank everyone with whom I talked, especially the librarians and researchers who suggested various sources, the curators who showed me cosmetic artefacts, and those interested in cosmetic science who discussed current trends in make-up with me. They are too many to list, so rather than mention individuals, I am grateful to them all collectively.

I should like to thank all the institutions, art dealers and private individuals who gave me permission to reproduce objects in their collections, and who, in some cases, supplied images that were free or provided them for considerably reduced fees. Academics rely so much on this kind of generosity, and I am truly grateful to those who offered such help.

There *are* a few exceptions to my 'no-names' diktat. I am enormously indebted to Elizabeth Prettejohn who read the draft manu-script and made a number of very helpful suggestions. At Yale University Press my thanks go to Katharine Ridler for her thorough and efficient copy-editing, and to Sophie Sheldrake for her hard work in obtaining most of the images. As for my editor, Gillian Malpass, once again I should like to salute her dedication and commitment to this book, as to all the others of mine she has worked on.

And (although Katharine tells me I am too prone to begin sentences this way), finally, I want to acknowledge my husband's constant help and support over the years with regard to my work, which is why this book is dedicated to him, with all my love.

Acknowledgements

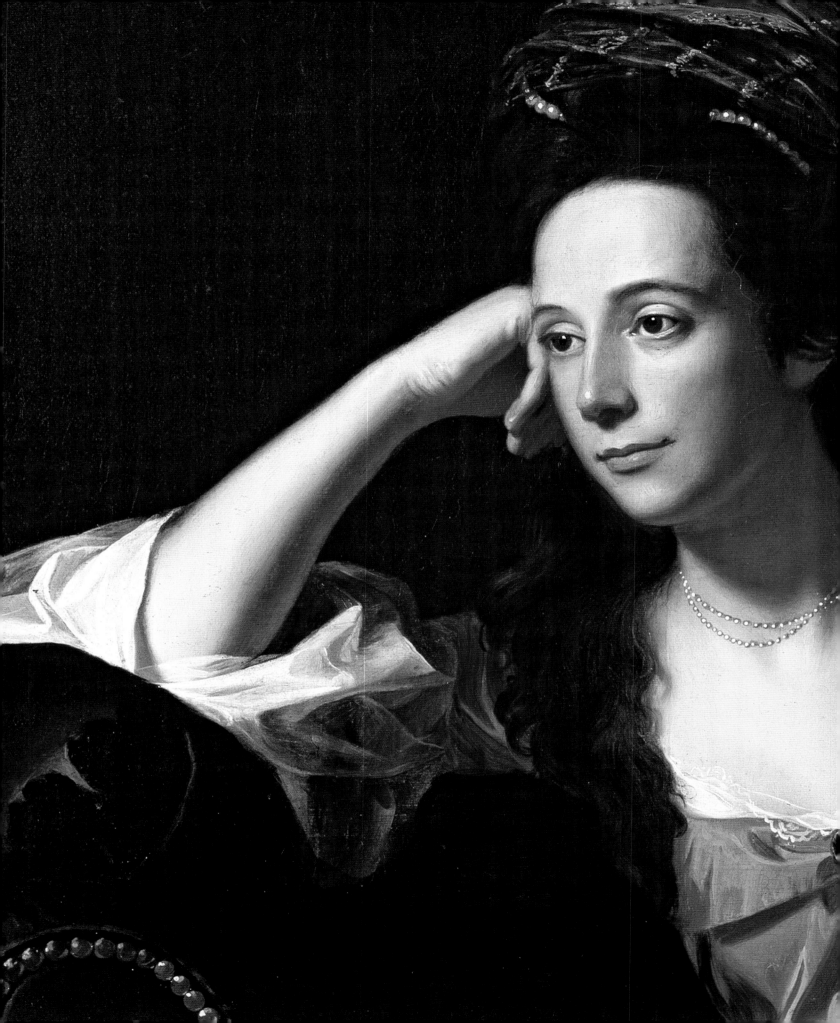

Introduction

I cannot say often enough how highly I rate
beauty, a powerful and most beneficial quality.
We have no other qualities which surpass it in
repute. It holds the highest rank in human
intercourse; it runs ahead of the others, carries
off our judgement . . . with its great authority
and its wonderful impact.

Montaigne 'On Physiognomy'[1]

*B*EAUTY, ALTHOUGH IN SOME PERIODS OF TIME A LESS IMPORTANT ASPECT THAN OTHER ELEMENTS OF THE INTELLECTUAL AGENDA, HAS always played a meaningful part in human life and culture. This book aims firstly to discuss beauty in terms of the female face, both as an abstraction – the ideal and the mythological – and as reality – women who have been celebrated for their beauty, and have at times enhanced it with cosmetics. With regard to both types of beauty, conventional wisdom saw it as the perfection of proportion, symmetry, harmony and colour in face and body; in addition, some philosophers and critics insisted on inner spiritual qualities such as virtue and morality. Beauty in reality, in the flesh, is a more complex phenomenon, often incorporating slight flaws; as Francis Bacon declared in his essay *On Beauty* (1597): 'There is no Excellent Beauty that hath not some Strangenesse in the Proportion'. Interweaving the idea of beauty for beauty's sake alone and the Platonic notion of beauty as virtue lies at the heart of any discussion of this highly complex subject.

In what follows, I argue that beauty is largely mediated through the visual; the face is a creation of art, both in the sense of the Aristotelian notion of the enhanced power of the represented image, and the use of cosmetics to 'gild the lily'. Thus, I will be concerned with beauty in the traditional sense of *ideals* (which respond to changing aesthetic attitudes) and with the *idea* of beauty as make-up, as adornment of women's faces. It might be claimed that beauty as cosmetic is a debased version of the ideal – Venus reduced to the beauty counter of a department store – but for hundreds of years the link has been made between art and artifice; the latter is a crucial part of the story of women, as well as of beauty. Baudelaire knew this, declaring beauty both specific and transient, and yet eternal, especially when subject to the imagination of poet and artist. His contemporary Théophile Thoré remarked on the fugitive nature of beauty, constantly in flux, like life, and to be seen merely in an accident of gesture and movement, as a flash of light: 'Elle est souvent fugitive, et n'a qu'un moment rapide, un hasard de geste et d'attitude, d'illumination et de rayonnement. Car la Beauté c'est la vie, dont la condition est un changement continuel'; it can be fixed only by means of art ('le propre de l'art est d'attraper cette expression passagère et de la fixer dans une forme qui demeure').[2]

This book sets out to examine concepts of female beauty in terms of the ideal and the real; how abstract and real ideas of beauty are represented in art and discussed in a range of texts, and the ways in which beauty is enhanced, possibly even created, by cosmetics. There are inherent tensions in any discussion of ideals and how far they are reflected in reality; how far abstract theories of beauty can be comfortably set beside applied beauty, that is, make-up, has never been considered before.

I have in front of me an image by Philip Wilson Steer entitled *The Toilet of Venus* (fig. 3); painted in the late 1890s and clearly inspired by Boucher, it depicts

1 (*previous page*) John Singleton Copley, *Margaret Kemble Gage* (detail of fig. 21)

2 (*facing page*) Rogier van der Weyden, *Unknown Woman* (detail of fig. 29)

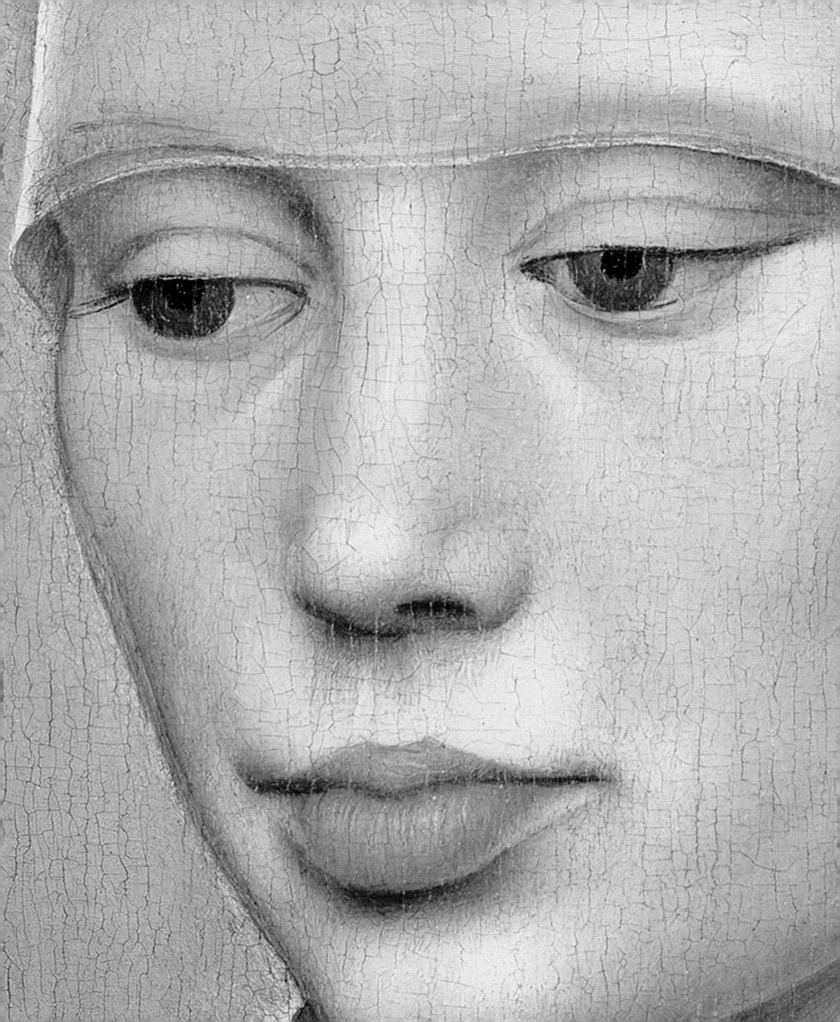

the goddess in a luxurious interior surrounded by *putti* and with a small black servant in a feathered turban (taken from Hogarth's *Marriage A-la-Mode* IV: *The Toilette*), but her face is blurred, her hair indistinct. The painting, a theatrical *mise-en-scène* in hazy blues and greens, may be unfinished but Venus's body, a slender high-breasted Rococo ideal, is clearly painted, whereas her face is indistinct, suggesting perhaps a deliberate choice; we, the viewers, have to create her face with regard to *our* notions of beauty.

The question here might be: does the paradigm or ideal of beauty derive from our thinking, or does it exist outside ourselves? Plato would have said the latter but later commentators, especially writers and artists, preferred the former. If the word 'beautiful' enters any conversation, how can we tell if it means the same to each of those taking part? For definitions of beauty, whether in art or literature, are notoriously difficult to pin down, as will be seen in the course of this book. The limits on some verbal descriptions of beauty are stated by Mr Glanville in Charlotte Lennox's novel *The Female Quixote; or, The Adventures of Arabella* (1752):

> all who have eyes, and behold true beauty, will be ready to confess it is a very pleasing object; and all that can be said of it may be said in a very few words: for when we run over the catalogue of charms, and mention fine eyes, fine hair, delicate complexions, regular features, and an elegant shape, we can only add a few epithets more, such as lovely, dangerous, inchanting, irresistible, and the like; and everything that can be said of beauty is exhausted . . .[3]

Beauty, it might be argued, is to be distinguished from such qualities represented by words such as 'lovely'; as the quotation from Lennox suggests, there are other more complex aspects such as 'dangerous, inchanting, irresistible'. The critic Susan Sontag preferred to use the word 'handsome', suggesting it had more *gravitas* than 'beauty', and was free from too overt an association with the feminine; for Sontag beauty was too much about looking and admiring, the very word suggesting the beauty industry, 'the theatre of feminine frivolity'.[4] Her preferred word 'handsome', however, suggests to me someone who – while attractive – is not truly beautiful; it lacks the sense of mystery and the quasi-divine which beauty may manifest. As for 'glamour' – described enthusiastically in a recent book as 'an imaginative synthesis of wealth, beauty and notoriety'[5] – it has been seen as merely 'manufactured radiance', the 'empty achievement' of the flawless, a marketing image created by the beauty (cosmetics) industry and promoted by the movies; in its absence of character it can be seen as akin to kitsch.[6]

Walt Whitman remarked of beauty that it is 'a result, not an abstraction', and this is how it can often be seen – as a reaction to its manifestation. 'Amongst all the things which administer delight and wonder, it seemeth Beauty holdeth the the chiefest place'; the author of *The Courtier's Academie* (1598), Annibale Romei,

3 (*facing page*) Philip Wilson Steer, *The Toilet of Venus*, 1898. Tate Britain, London

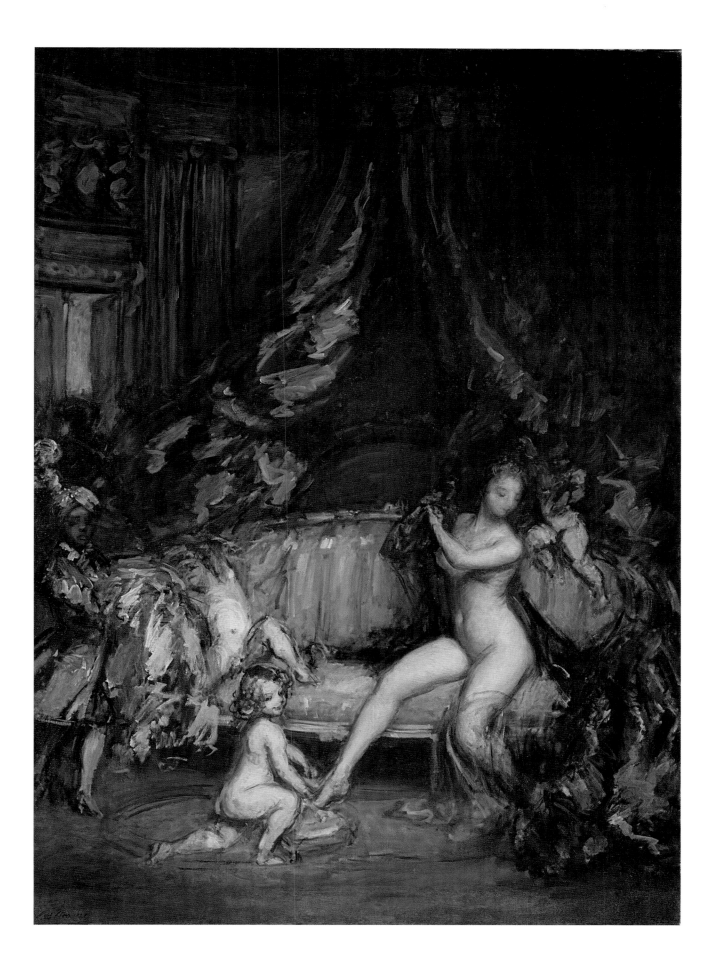

found it difficult to describe beauty but was aware when in the presence of it.[7] This reactive and generalised concept of beauty, rather than the descriptive, is seen in much poetry and sometimes in strikingly similar words, as in the personified figure of Beauty (*Biauté*) in the twelfth-century *Roman de la Rose*:

> Ne she was derke ne browne, but bright
> And clere as the moone lyght,
> Agayne who al the starres semen
> But smale candels, as we demen

(ll. 1009–12, *The Romaunt of the Rose*, translation attributed to Chaucer) and as in Byron's famous poem *She Walks in Beauty*, written in June 1814 after he saw his cousin Anne Wilmot for the first time:

> She walks in beauty, like the night
> Of cloudless climes and starry skies;
> And all that's best of dark and bright
> Meet in her aspect and her eyes (ll. 1–4)

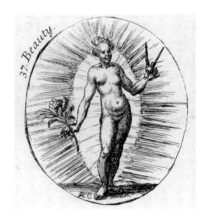

4 Cesare Ripa, 'Beauty', from *Iconologia*, 1709. Wellcome Library, London

5 (*facing page*) William Etty, *Mlle Rachel*, 1840. York Art Gallery

In contrast, when beauty was personified in works of theory, it became subject to a discussion of proportions (as, for example, in some Renaissance manuals), or in flights of allegorical fancy, such as in Cesare Ripa's *Iconologia*. The first English edition (1709) of this famous emblem book, depicts the personification of beauty (fig. 4) as a figure with lopsided breast and – to our eyes – a somewhat unbeautiful face. The accompanying text describes a woman surrounded by 'Splendour' and with her 'Head in the Clouds' as a 'Ray of Divinity'; the ball and compass 'denote that Beauty consists in Measure and Proportion', and the lily symbolises the senses.[8] The impossibility of incorporating such an ideology of beauty in visual terms cannot be more evident.

In order to capture what beauty is, in the visual sense, art historians in the past saw two main categories. For 'The Masque of Beauty' exhibition held at the National Portrait Gallery in 1972, Roy Strong defined the 'classic' and the 'romantic' types: the first is classical in its 'perfection of feature and form', and the second is 'less demanding, soft, transparent and fluttering';[9] one might add to these ultra-feminine attributes the words 'striking' and 'unusual', for beauty, even of the 'romantic' kind (especially of the 'Romantic' type) is more than mere prettiness – a word, indeed that writers like D. H. Lawrence found 'repellent'. For an example of the striking and unusual beauty, I suggest William Etty's portrait of the great tragedienne *Rachel* (Elisa Félix), 1840 (fig. 5), painted in one sitting when she came to London. Her huge expressive eyes, long 'Greek' nose, mobile lips and slightly dishevelled hair give her what one writer called 'an unquiet, bold and imperious air';[10] it is a supremely dramatic Romantic portrait.

Kenneth Clark, a few years after Strong, defined his own two types as 'classic and characteristic', the former reliant on symmetry, proportion and regular fea-

Facing Beauty

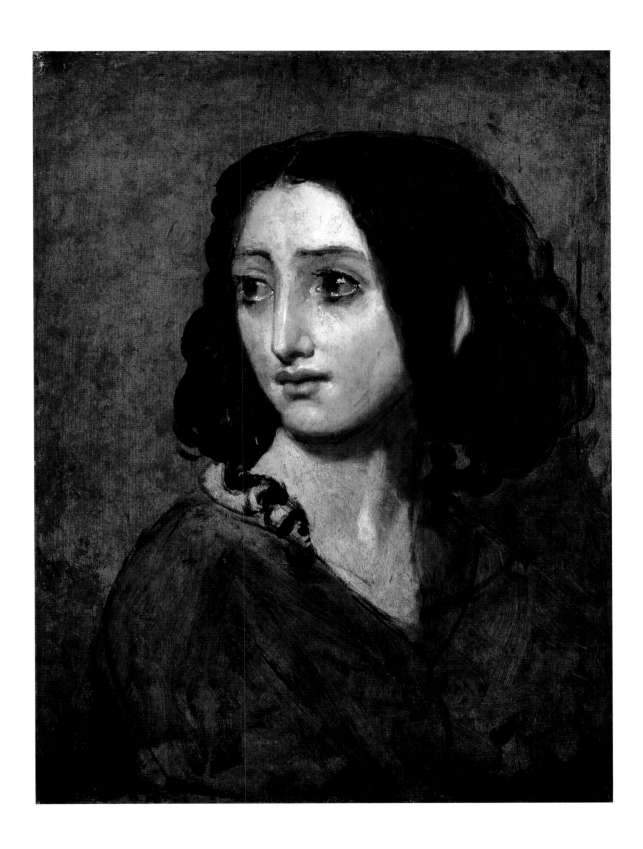

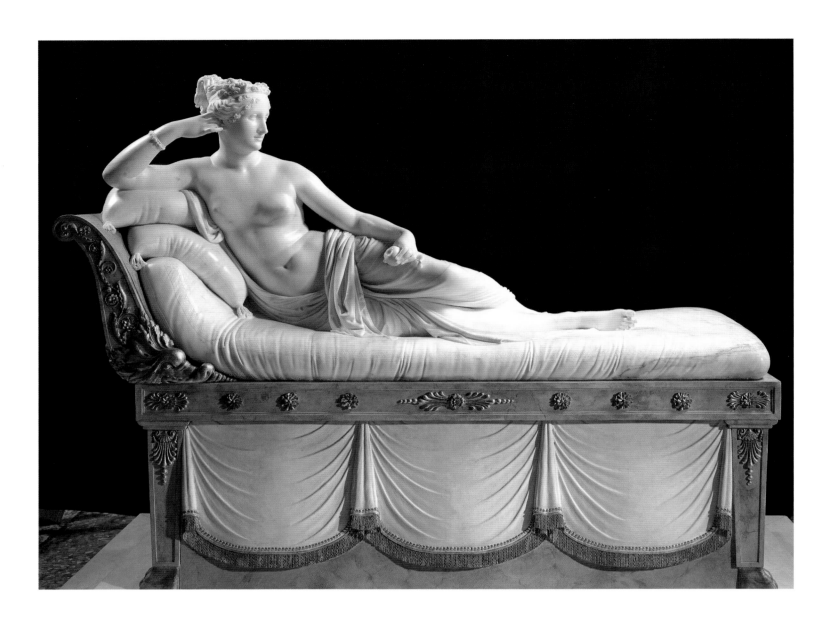

6 Antonio Canova, *Pauline Borghese*, 1804–8. Galleria Borghese, Rome

tures, the latter allowed to present 'greater freedom' in the features.[11] The classic beauty can be seen, for example, in Antonio Canova's *Pauline Borghese*, 1804–8 (fig. 6), indebted obviously to antique art in its simplicity, regularity and smoothness, the face a perfect oval, the nose long and the hair-style inspired by ancient Rome: 'Faultily faultless, icily regular, splendidly null,/Dead perfection, no more';[12] it has the deathliness of some Neo-classical sculpted beauty. The 'classic' beauty can be seen both in ideal beauty and in reality, but the 'romantic'/'characteristic' beauty can be seen only in images of real women. Henry James

Facing Beauty

remarked in his novel *The American* (1877): 'A beauty has no faults in her face; the face of a beautiful woman may have faults that only deepen its charm'; it is clear that James preferred the latter, for to him a 'beauty' was unnaturally flawless, like the 'professional beauties' then coming into vogue, glossy and without much individuality.

An essential concern with any discourse on beauty is the link (if it exists) between the physical and the spiritual. Plato's philosophy of idealism bound beauty to virtue; physical beauty had to be transcended so as to contemplate absolute spiritual beauty, but it proved difficult to move from beauty in the flesh to the idea of beauty as spirit and divine love. Abstract ideas of beauty cannot be thought of without some sense of the real; what we think of as 'beauty' must be grounded in the particular. Thus, the philosophers who followed Plato, while in some cases accepting the equation of beauty with virtue, attempted more concrete definitions. Aristotle, for example, proposed that individual beauty is more appealing than beauty in the abstract; Plotinus (a prominent Neo-Platonist of the Hellenistic period), while agreeing with classical ideas of proportion and regularity of features, concluded that 'beauty is something more than symmetry'.[13]

Although many of the views on women's appearance discussed in this book resonate throughout recorded history, I begin with the Renaissance, for it is my contention that then there was for the first time a serious and sustained discussion of beauty, both physical and spiritual. The first treatise on aesthetics (although the word was not coined until the eighteenth century), *De Pulchro et Amore* (1549) by the philosopher at the papal court Augustinus Niphus, rejecting the Platonic ideal, declared that beauty existed in all the senses and especially in the materiality of women's faces and bodies.[14] Compared to the pale and demure beauty admired in the Middle Ages, with the Renaissance came a more vivid beauty, with a greater sense of self, of individuality, which served to focus more attention on the face, aided by the growth in the use of cosmetics, especially in sixteenth-century Venice. A new culture developed, that of women on display, markedly more subject to current ideals of beauty, which is the main reason why this book begins with the Renaissance. Nuanced discourses of beauty, both visual and textual, appeared, alongside a wider use of make-up fostered by the notion of public display and helped by the greater availability of the exotic cosmetic substances brought to Europe by the growth in trade from the late fifteenth century onwards. Although Platonic and Renaissance discourses of beauty continued to inspire artists, critics and philosophers, from the eighteenth century new concepts emerged, to some extent disentangling beauty from truth and virtue, and promoting notions of taste, reason and the imagination. Alexander Baumgarten introduced the idea of aesthetics, prioritising the senses over the intellect, a theme which had a profound effect on visual depictions of beauty; Edmund Burke and Immanuel Kant disposed of the traditional and well-estab-

lished Platonic universals of reliance on symmetry and proportions, with regard to beauty. In their place, Burke in 1757 suggested new ideas of fragility and delicacy, variety and gracefulness – ideas much in line with current fashion and female appearance; beauty was 'a composure of the parts, in such a manner, as not to incumber each other, nor to appear divided by sharp and sudden angles', and must include 'ease . . . roundness, and delicacy of attitude and motion'.[15]

Kant, for his part, in 1790 suggested that as neither beauty nor goodness can be in an object, any assessment of beauty is a process of communication between observer and observed, a judgement of taste. However, if beauty is to be seen, as Kant believed, in the eye of the beholder, what is the role of taste? Can someone else's taste in beauty – which you or I might consider vulgar and trite – be considered as acceptable? Furthermore, Kant asked us to make a distinction between what he thought was 'true' beauty – when one views an object (such as music, or flowers) in a purely disinterested way without any personal emotions such as greed – and 'conditioned' or 'adherent' beauty (such as that of a woman), where baser instincts may prevail and purely aesthetic considerations are pushed to one side. He thus overturned the Renaissance ideal 'that the human figure demonstrates the highest beauty of which we can have experience'.[16] Kant's concepts are perplexing, and sometimes troubling, especially when demanding that we exclude cultural and social context, that is, the human condition, in the contemplation of beauty in face and body.

From the nineteenth century and onwards, notions of beauty became irredeemably fragmented, and while some writers still held to the Platonic belief in the link between beauty and virtue, others dismissed the very idea of universally accepted canons of beauty, either in art or in the reality of women's appearance. Théophile Thoré, in an essay 'De la beauté dans les arts' (1856), claimed that there was no such thing as beauty, no longer any formulae for identifying and describing it.[17] As for the twentieth century, too many ideas as to what beauty is, or could be, collided with the downgrading of the idea that it exists at all, as much art became increasingly removed from aesthetic considerations and the representation of the figurative. Avant-garde art forms – like new ideas of female dress and appearance – represent what Umberto Eco calls the 'beauty of provocation'.[18] Modernism argues in support of the Kantian idea of the subjectivity of beauty, shifting what is thought of as beautiful to the spectator; it teaches us to prize 'the difficult, the discomforting, and the edifying, instead of the lovely or attractive'.[19] By the middle of the twentieth century, beauty had become increasingly a commodity which could be purchased – a new face could be created with the help of the cosmetic counter or via aesthetic surgery. That is a separate story in its own right, beyond the remit of this book.

Also beyond the concerns of this book – for reasons partly of space and also because a beautiful appearance is usually more valued in women than in men –

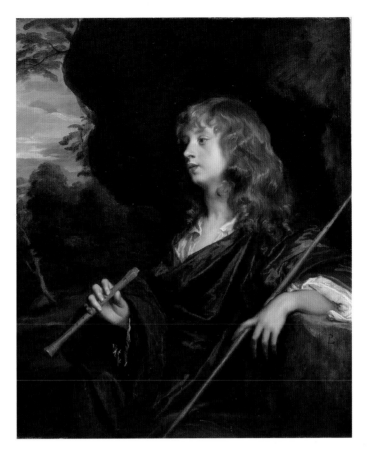

7 Peter Lely, *Young Man as a Shepherd*, c.1660. Dulwich Picture Gallery, London

is a discussion of male beauty. Although generally far less mentioned in literary and documentary texts, at some periods – such as in classical Greece and during the Renaissance – male beauty was a fact of life and evoked discussion akin to the concerns of female beauty. The artist Albrecht Dürer – whose drawings of handsome young men are also beautiful works of art – remarked on how uncertain were our ideals of beauty, 'that we may perhaps find two young men both beautiful and fair to look upon, and yet neither resemble the other'.[20] The Renaissance, of course, revisited classical ideas of beauty as a complex of body and spirit; while men as well as women could be beautiful, children could not, as their beauty was thought incomplete, only on the surface.[21] This may be borne in mind when looking at, for example, Lely's *Young Man as a Shepherd* (fig. 7), an image of a beautiful androgynous teenager with long curly hair, creamy complexion, delicate features and very red lips. Although a few men at this period sometimes wore cosmetics (what John Bulwer in *The Artificial Changeling* of 1650 described as 'sluttish and beastly confections'), in Lely's portrait, one assumes that the complexion is natural, although it has the appearance (aided by the fact that

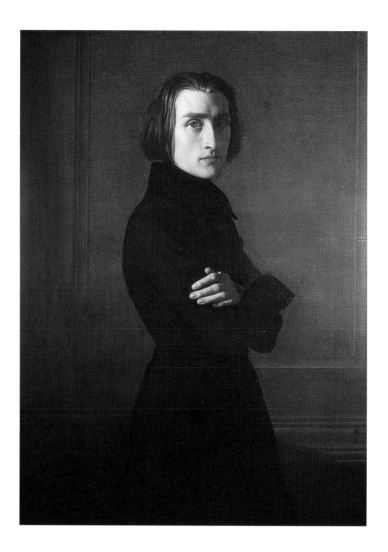

the sitter is too young to shave) of being 'finished' by lightly applied cosmetics;
when, therefore, we assess beauty in men, we might relate this – consciously or
unconsciously – to what we perceive as 'feminine' traits. I think we are to read
this into Oscar Wilde's description of Dorian Gray, who was 'wonderfully hand-
some, with his finely curved scarlet lips, his frank blue eyes, his crisp gold hair
. . . All the candour of youth was there, as well as all youth's passionate purity';
as with women's beauty, there is a tendency to emphasise youth when apprais-
ing the beautiful in men. Youth and beauty, especially when allied to power, arro-
gance perhaps, and physical presence, can create an overwhelming impression, as
in the appearance of the young Franz Liszt in Henri Lehmann's famous portrait
of 1839 (fig. 8); his black coat with velvet collar is the perfect foil to the dra-
matic beauty of his face, with its large eyes, long nose, firm lips and Romantic

Facing Beauty

pallor. Although we know who he is and what he achieved in life – facts which colour our attitude towards this portrait – it is, none the less, a striking image of a beautiful man and redolent with sexual magnetism.

Ideas of Beauty

Who can think, or talk, temperately when Beauty is the Subject?

Anon. *The Challenge*, 1697[22]

Everyone, it seems, has a view about beauty, even if there is no consensus as to what it is and where it should be placed in the universe of human culture. The authors of *Face Value: The Politics of Beauty* (1984) confessed themselves baffled by beauty's 'very imprecision – how it changes even as we look at it, how it defies being pinned down for all time, or even for any time'; they concluded that it 'remains in the realm of the poets and painters where it probably belongs'.[23] For beauty is an evanescent quality, always changing, and often impossible to define.

A sense of mystery is often invoked in a discussion of beauty both visual and literary. Giovanni Bellini's first female nude, painted when he was in his mid-eighties, *Young Woman at her Toilette* of 1515 (fig. 9), has this mysterious kind of beauty, serene, restrained and delicate; her red hair centrally parted and tied back in a silk *scuffia* (snood) edged with pearls, and with only the lightest touch of make-up, she holds up a hand mirror to examine her face with a kind of dispassionate interest.

Virtue, morality and desire

Female beauty in itself cannot be moral or immoral; it exists to a large extent in the sensations it arouses, such as the 'delight and wonder' which Annibale Romei noted (p. 4). Beauty can also provoke passions such as lust in men and envy in women; so, a beautiful woman often had to tread carefully in order to avoid such perils, and yet to cultivate her beauty both for financial support from a man (and presumably for love also) and to justify her place in wider society.

Renaissance writers followed Plato in equating beauty with virtue and nobility of mind; they admitted that beauty without virtue could exist, but it was the beauty of those women who prostituted their virtue. 'As in all naturall thinges, neither goodnesse can stande without beauty, nor beauty without goodnesse', claimed Giovanni Lomazzo in the late sixteenth century.[24] This view was qualified by Kant as he suggested that although beauty can symbolise goodness, it was really distinct from morality, a view abhorrent to many later writers such as John Ruskin, who thought beauty excluded the 'lower sensual pleasures',

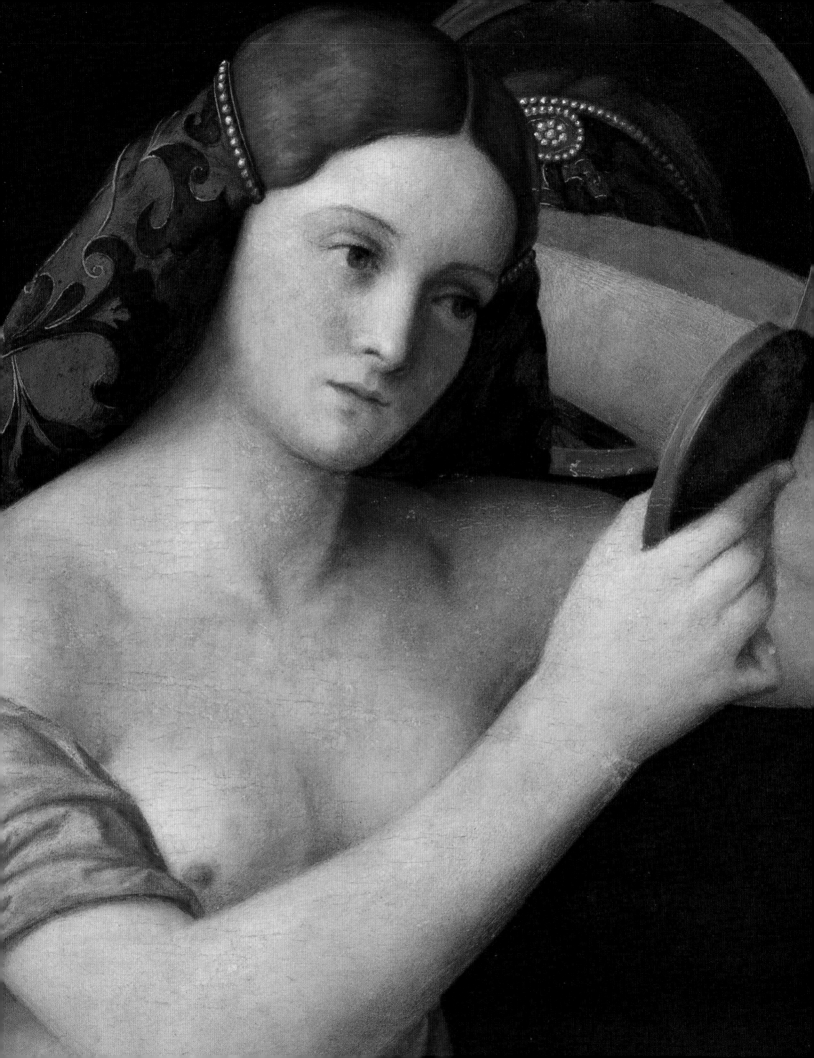

although he made an exception with regard to the Venetian artists of the Renaissance. Ruskin claimed that the face was the most important part of a woman's beauty, because it was the least animal. Apropos images of women, he felt the best expressed what he called 'soul-culture', defined as intellectuality and 'individual humanity' – features quite different from the 'unhappy prettiness and sameness' of much fashionable portraiture. For Ruskin, 'the sensation of beauty . . . is dependent on a pure, right, and open state of the heart'.[25]

According to Burke, pleasure in beauty is not to be confused with sex, and Umberto Eco thought: 'we talk of Beauty when we enjoy something for what it is, irrespective of whether we possess it or not'.[26] Yet beauty in a woman often cannot be divorced from desire and specifically from sex; for Stendhal, in *On Love* (1822), beauty was *only* the promise of happiness ('La beauté n'est que la promesse du bonheur'[27]) and served to suggest sexual possibilities about a woman. Pursuing this argument, Stendhal suggested that an ugly woman could become beautiful by exciting desire – an aspect of the dualist philosophy which links opposites; for if there is beauty, there must also be ugliness, otherwise we would have no means of comparison; ugliness, therefore, serves to heighten beauty, to make it more desirable. In *De Pulchro et Amore* Augustinus Niphus stated that while it was possible for an ugly women to provoke sexual interest, it was unlikely, for nature had decreed that beauty would always be more loved than ugliness ('la beauté serait plus aimée que la laideur').[28]

In periods when canons of beauty were less important, like the twentieth century and today, 'ugliness' is a word rarely used about women, and almost as difficult to define as beauty. For the novelist D. H. Lawrence, 'the fire of sex' could transform the plainest woman; sex-appeal (a word beginning to come to public attention in the 1920s) he declared was 'the communicating of a sense of beauty'.[29] Freud in his *Civilization and its Discontents* (1930), rarely mentioned beauty and when he did, he usually linked it to sex and the sexual object. Scientists say that beauty is necessary for the propagation of the species; it 'impels actions that help ensure the survival of our genes', because 'we find beautiful those physical characteristics that suggest nubility, fecundity, health'.[30] These features include firm and rounded facial contours, a glowing complexion, and glossy hair – the kind of women we see in definitely corporeal images, such as Rubens's *Venus looking at Herself in a Mirror*, 1614–15 (fig. 10), or in *vanitas* portraits which offset a pride in sensual gratification against the inevitability of death. Molenaer's *Allegory of Vanity*, 1633 (fig. 11), depicts the luxury and idleness of a young wealthy beauty, holding a mirror while her fine long blonde hair is combed by an attendant, whose deliberately archaic clothing is there to remind us that – as in much Dutch genre painting – we see both the specific reference to contemporary beauty and her privileged existence, *and* the moral tale that this scene is timeless; vanity and beauty are closely linked and appear in every culture.

9 (*facing page*) Giovanni Bellini, *Young Woman at her Toilette* (detail), 1515. Kunsthistorischesmuseum, Vienna

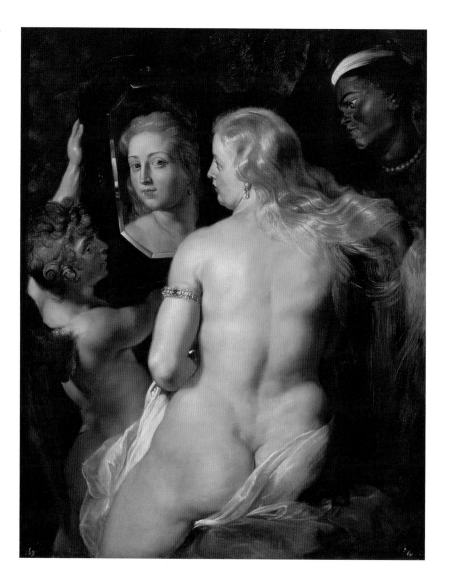

According to the historian Roy Porter, from the second half of the seventeenth century there was a 'parade of the eroticized female form . . . sanctioned in the names of beauty, charm and aesthetics'.[31] This bodily display, I argue, is most of all to be seen in the greater use of cosmetics, a form of artifice both praised and dispraised (as this book will show), and which in itself had and has sexual implications. For example, the made-up face mimics the physiological changes which occur during sex – the moist glow on the skin, flushed cheeks and brilliant eyes. Cosmetic utensils themselves can be erotic, most obviously the phallic shape of lipstick; the Freudian psychologist John Carl Flügel equated 'manipulation' of the face, such as powdering the nose or using lipstick, with

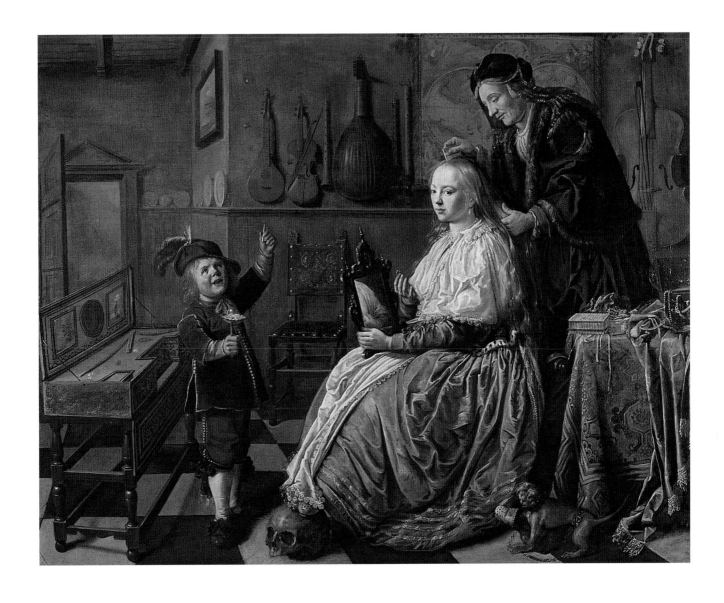

masturbation.[32] Further, the act of making up, whether formalised in the lengthy *toilette* at the dressing table or a brief session before a bathroom mirror, could be seen as preparation for a sexual encounter.

Representations of Eve, for example, need to demonstrate the idea of beauty as sexual temptation, even as satanic temptation; in medieval mystery plays the Devil appears as Eve in the character of a beautiful woman. In art – especially in northern Europe – Eve appears as beauty enhanced by cosmetics; in van Eyck's *Ghent Altarpiece* she has plucked eyebrows, a thin line at the edge of her upper eyelid which serves to elongate the eye slightly, a polished oval face and reddened lips. As for Cranach's *Adam and Eve*, 1526 (fig. 12), Eve's beauty (also aided

11 Jan Miense Molenaer, *Allegory of Vanity*, 1633. Toledo Museum of Art, Ohio

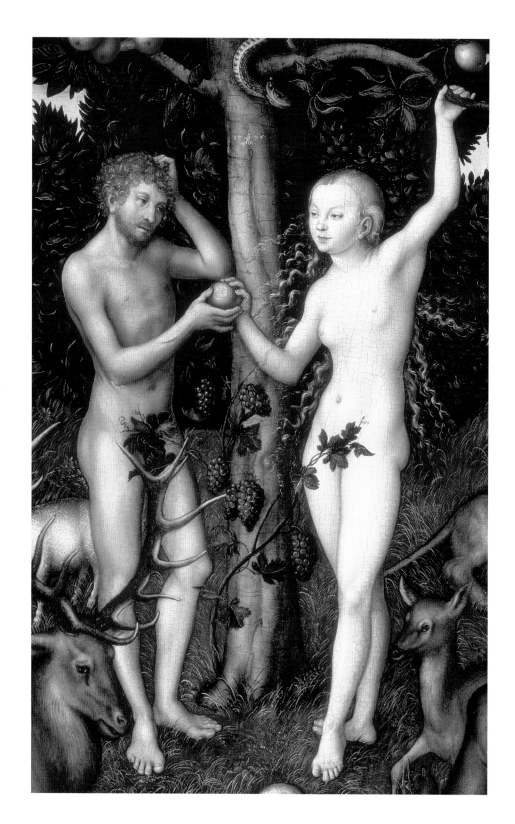

12 Lucas Cranach, *Adam and Eve*
(detail), 1526. Courtauld Gallery,
London

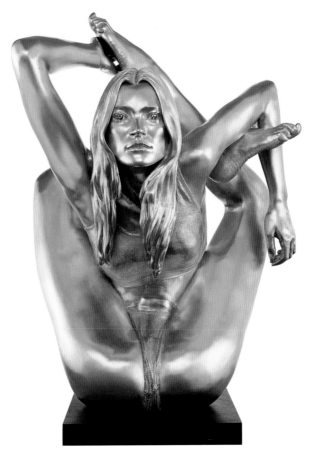

13 Marc Quinn, *Siren*, 2008.
Private collection, © Marc Quinn

by cosmetics) has a quirky Gothic quality, a round face, slanting eyes and a short nose; her 'long curls, which radiate unnaturally behind her, framing her temptingly beautiful body like a halo', serve to draw attention to the painting's 'artful stylization that prevails over the need for anatomical correctness'.[33]

Beauty is complex and can encompass both the sensual and the spiritual, notably with regard to these two aspects of Venus, a frequent theme in Renaissance thought. The idea is articulated in Plato's *Symposium* – the famous dinner party for several literary celebrities of Athenian society, during which Socrates made his famous contribution on the idea of divine beauty – when one of the guests refers to the sacred (*coelestis*) and profane (*naturalis*) sides of Venus. Venus, and especially the sensual Venus, was represented innumerable times in art, so much did she capture the artistic imagination; she was the ultimate symbol of beauty and an acceptable reason for depicting various states of nudity. Moreover, she could be identified with contemporary ideas of the beautiful, an idea still present in art today, as witness Marc Quinn's *Siren* (fig. 13), created in 2008, a life-size gold figure of the model Kate Moss, modelled in an athletic yoga pose;

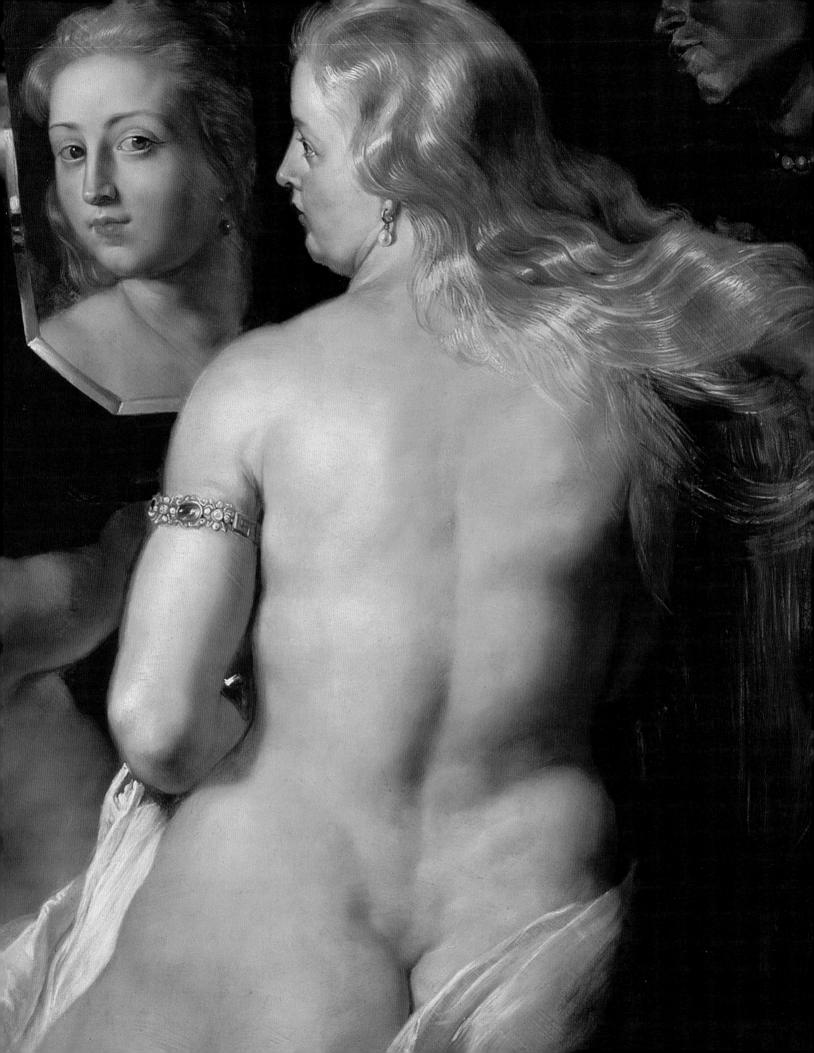

her face has wide cheekbones, small nose and wide mouth – features which first appeared in fashionable notions of beauty in the 1960s. Quinn claims to see in her 'a modern day Aphrodite [Venus] . . . the ideal beauty of the moment'. The 'beauty of the moment' may vary according to the aesthetic ideals of any given period. In terms of early seventeenth-century Flanders, the ideal beauty was large and voluptuous, such as Rubens's nude *Venus looking at Herself in a Mirror* (fig. 13), and combing her naturally blonde hair: 'This clarity of tone, this wonderful dazzling freshness, this flesh coursing with so much lifeblood, these beautiful tresses tumbling down like a golden cloak . . . these amorous dimples, this suppleness, these satiny sheens, these well-rounded curves, these plump arms, these smooth and fleshy backs, all this wonderful robustness belongs to Rubens'.[34] This lyrical description by Théophile Gautier – a man who loved women and celebrated their beauty – comes from his novel *Mademoiselle de Maupin* (1835–6), most famous for its preface, in which he elaborated on art for art's sake ('the only things that are really beautiful are those which have no use').

In the novel, Gautier declared his desire to have seen Pauline Borghese posing for Canova (see fig. 6); another image of the sensual Venus, she reclines on a classical day-bed with an apple in her hand given to her by Paris, who judged her more beautiful than her rivals Juno and Minerva. One of Pauline Borghese's contemporaries, Laure Junot, Duchesse d'Abrantès, thought the sculpture was the 'chef-d'oeuvre de Canova' and, just like the sitter, with a perfect representation of the softness of her skin (a thin layer of wax gives the marble a pale flesh colour); but in the end she found it too cold and deathly, 'une froide imitation de la mort'.[35] Begun shortly after Pauline's 1803 marriage to Prince Camillo Borghese (the Borghese family claimed descent from Aeneas whose mother was Venus), the sculptor depicts a woman famous for her perfect figure, her beauty and her lovers. Appropriately, Boccaccio classed Venus in his list of famous women (*De mulieribus claris*, 1361–2) for her 'outstanding beauty' but also for her 'wanton urges' and 'incessant acts of fornication'.[36]

Like Venus *naturalis*, Helen, the wife of King Menelaus of Sparta, figures in Boccaccio as a famous beauty, driving men to distraction; it was, after all, Venus's promise of Helen to the Trojan prince Paris that led to the wars which lasted ten years. Paris fell in love with her 'as soon as he saw her, resplendent in celestial beauty, wanton in royal elegance'.[37] In an emblem book of 1684, the image entitled 'Ubi Helena, ibi Troia' (fig. 15), shows a fashionably décolletée Helen leaning from a balcony watching two men fighting over her. The caption is explained as: 'Where Helen is, there will be war/ For Death and Lust Companions are'. In *The Honour of Ladies* (1612), Abraham Darcie noted how beauty was 'a mortall poyson', depriving men of sense and reason; it 'hath caused many troubles, murthers, warre and mischiefes', and resulted in 'the destruction of Troy'.[38]

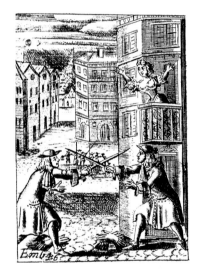

15 'Ubi Helena, ibi Troia', illustration to Emblem XLVI from Nathaniel Crouch, *Delights for the Ingenious: Emblems Divine and Moral, Ancient and Modern*, 1684. British Library, London

14 (*facing page*) Peter Paul Rubens, *Venus looking at herself in a Mirror* (detail of fig. 10)

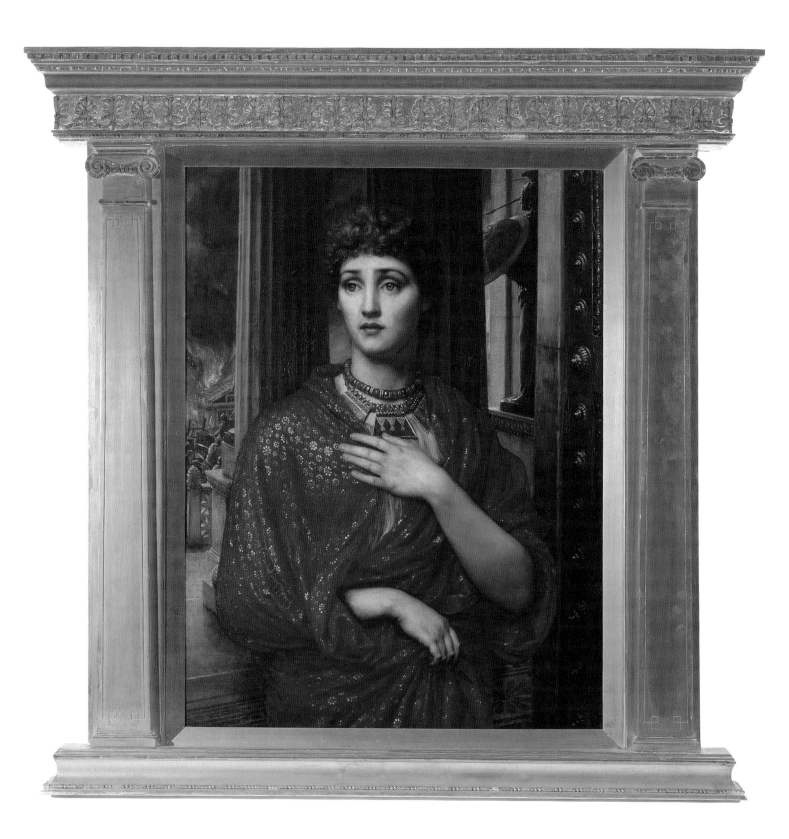

Homer does not actually describe Helen, except in terms of words such as 'matchless' or a reference to her 'celestial charms'; perhaps for this reason there are surprisingly few visual images of her – how could artists rise to the challenge of portraying the most famous beauty in the world? It was easier to depict her in terms of contemporary paradigms of beauty, especially as she acted like a mortal. Thus Edward Poynter's *Helen* of 1881 (fig. 16) shows a woman in loose red silk drapery with jewellery modelled on that of ancient Greece, with strong features, large and widely spaced eyes and with the fashionable hair-style of the early 1880s. The portrait created a sensation when it was exhibited at the Royal Academy, for Helen's face was that of the famous beauty Lillie Langtry, the mistress of Edward Prince of Wales, suggesting that the painting was not only a depiction of classical myth but had topical relevance as well, pointing at royal adultery.

Outside the realms of myth, the biblical figure most akin to beauty and sexuality was Mary Magdalene, one of Christ's female followers and present at the crucifixion, often depicted in art as a penitent with long hair, weeping for her sins, signs of her vanity and worldliness (jewellery and cosmetics) pushed to one side and replaced by the symbols of a jar (she anointed the Lord's feet with ointment and wiped them with her hair), and a skull which signifies the contemplation of death. Associated in her abandoned life with luxury, the image of Mary Magdalene became in the early sixteenth century a Venus-like figure, more a barely dressed courtesan than a saint. She features in the story of make-up due to her association with the jar of ointment, being 'particularly attractive to ointment-mixers, scent-makers and apothecaries'; as the figure of Everywoman in early liturgical drama, she appeared before her conversion in the latest fashions, buying cosmetics to make herself attractive to men.[39]

Given her association with the worldly joys of life, it was natural for Mary Magdalene to be depicted in a secular way, a style considered inappropriate for more saintly saints, who appear in art simply dressed and with a more spiritual kind of beauty. A painting attributed to Alonso Cano of the mid-seventeenth century, *A Woman, possibly as a Saint* (fig. 17), shows a figure holding a cross and the palm of martyrdom who is both specific (a real woman in working-class costume) and yet a timeless beauty – her face a perfect oval and her dark hair simply styled and drawn back off the face.[40]

❧ ❧ ❧

16 (*facing page*) Edward Poynter, *Helen*, 1881. Art Gallery of New South Wales, Sydney

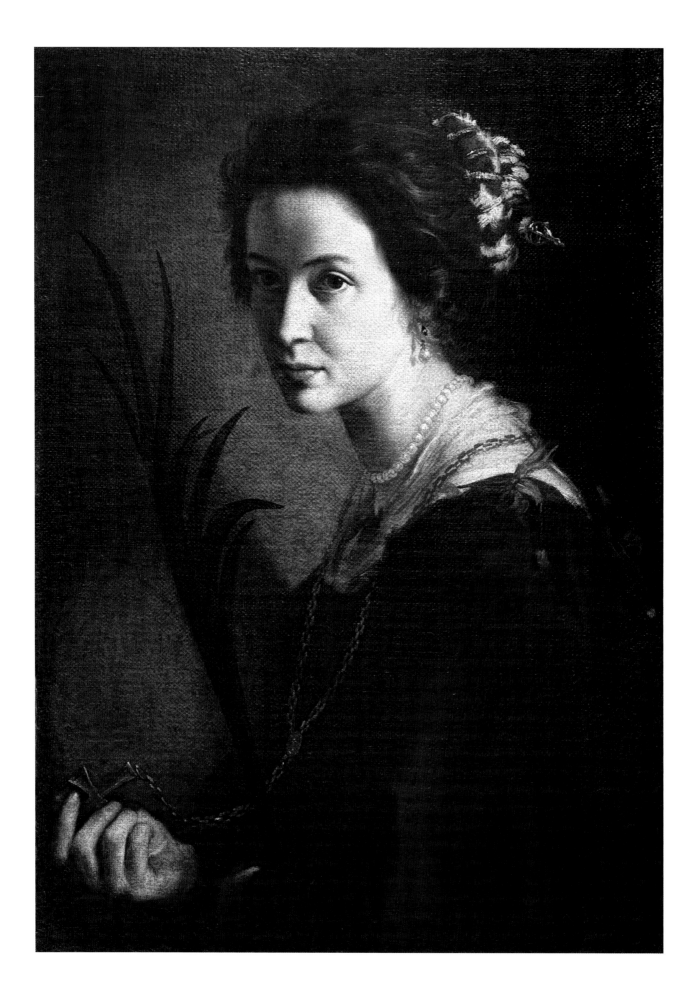

Beauty, universality and art

One of the main debates about beauty is whether it is universal or specific. How far are there inalienable and constant canons of beauty manifest across time and different cultures? Or is beauty produced by the particular aesthetic of a given period; otherwise, how can one reconcile such extreme variations in beauty as the ascetic ideals of the Middle Ages and the opulence of northern European Baroque? The general consensus, especially with regard to feminist writers holding the view that every aspect of intellect can be culturally shaped, may be summarised by Francette Pacteau in *The Symptom of Beauty* (1994): 'what is considered beautiful in a woman varies between historical periods and between cultures'.[41] Pacteau was writing largely in response to Arthur Marwick's *Beauty in History* (1988),[42] in which he declared beauty to be universal and not socially constructed. Most writers discount this, believing ideas of beauty to be created out of a specific culture, and linked to contemporary society, part of fashion, and the look of the moment; this is what Wilde referred to as 'the absolute modernity of beauty' (*The Picture of Dorian Gray*). D. H. Lawrence in 1928 decried the very idea of rules for beauty, which was not 'a fixed arrangement: straight nose, large eyes etc'; typically Lawrentian is the concept of beauty as an emotional response: 'an experience . . . not an arrangement of features. It is something felt, a glow or a communicated sense of fineness'.[43] Pressed to define his essentialist view of beauty, Marwick proposed 'a certain harmony of proportions' and a 'notion of what a human being ought to look like'.[44] As for 'what a human being ought to look like' whether in an ideal or a real world, it is a truth universally acknowledged that the painted limestone bust of *Nefertiti* (fig. 18) of about 1340 BCE is the paradigm of beauty, with her finely chiselled features, large and well-shaped eyes (the missing left eye possibly indicates that the bust was 'intended as an artist's model and teaching aid, the eye socket being deliberately left empty to allow pupils to study inlay techniques') and reddish–gold skin. She appears 'an aloof, remote being, seemingly attractive to every race, every generation, and every gender of every age. It is a powerful, compelling, and curiously modern image'.[45] Beautiful and painted (in both senses of the word), Nefertiti is the ultimate gilded lily. Dug out of the desert south of Cairo in 1912 and put on display in 1924, the bust was certainly in tune with the 1920s taste for sharply defined and brightly painted features, fitting well into the westernised ideal of beauty. As a result of her enduring appeal, she is often quoted to support the universalist argument regarding beauty.

Alexander Nehemas has noted that 'much psychological research supports the idea that standards of beauty are remarkably consistent regardless of culture, race, age, income or sex'.[46] Experiments have shown a preference for certain elements in women's faces such as regularity of the features, plump skin, large eyes, full

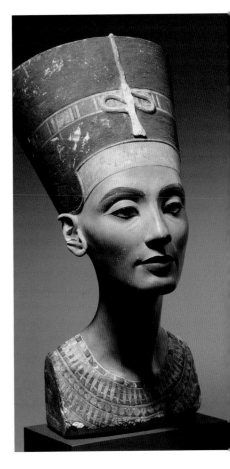

18 *Nefertiti*, *c.*1340 BCE. Egyptian Museum, Berlin

17 (*facing page*) Alonso Cano (attr.), *Unknown Woman, Possibly as a Saint*, late 1640s. York Art Gallery

lips and the lower part of the face smaller than the upper. As the clinical psy-
chologist and cognitive neuroscientist Nancy Etcoff cautiously says: 'Judgements
of human beauty may be influenced by culture and individual history, but the
general geometric features of a face that gave rise to perceptions of beauty may
be universal'.[47] So there may be a compromise between two often uncompro-
mising viewpoints, those of the universalist and those of the relativist, for in most
periods in western culture certain key features of beauty are constantly men-
tioned and represented in art – a good bone structure, a prevailing harmony of
features, a perfect complexion, large eyes, a straight nose and a long neck; some
repetition will, therefore, be unavoidable in the chapters of this book. These
attributes, I argue, are retained in images of female beauty but set within the
prevailing fashions (such as clothes and body shapes) of the period covered by
this book, and heightened by the use of cosmetics. John Donne suggested in his
Paradoxes that as the lover likes to see his beloved in a painting, so he appreci-
ates her face also painted: 'Are we not more delighted with seeing Birds, Fruites,
and Beasts painted than we are with Naturalls?'[48] This is the Aristotelian idea
that art completes what nature cannot finish, and suggests that we must distin-
guish between the woman herself (as 'Naturall') and her representation in art;
we do not know enough, for example, about the reception of portraits to know
always what contemporary thought regarded as beautiful. So we are largely left
with beauty as represented in art, problems and all. For the words 'beauty' and
'beautiful' with regard to figurative art in particular can be difficult to discuss;
a beautiful painting or sculpture can depict an unpleasing person, while an ugly
work of art can show beautiful people.

Art, like philosophy, tries to define ideals of beauty, as well as to depict reality,
although it rarely succeeds with the former, for the visual, of necessity, is
grounded in the here and now and has to be utilised in order to attempt abstract
ideas. The Greek painter Zeuxis in the fifth century BCE had to see a number
of beautiful virgins in the flesh (literally so), to combine their best features
in order to produce a portrait of the ideal woman, Helen of Troy, for, says
Boccaccio, he had only 'Homer's poetry and Helen's own universal fame' to help
him. Yet he could produce only a 'simulacrum of her celestial grace' because he
could not capture the happiness in her eyes, her laugh 'and the charming changes
of expression reflecting what she heard and saw – who could represent these with
a painter's brush or an artist's chisel? That is the prerogative of Nature alone'.[49]
This subject, frequently represented in art from the Middle Ages to the late
eighteenth century, needed contemporary models to create a collective beauty
suitable for Helen. A late fifteenth-century miniature from the *Roman de la Rose*
(fig. 19) shows Zeuxis painting his nude models, who are naked apart from their
headdresses. The ideal beauty here is white and slender with small high breasts
and gently swelling belly, long blonde hair, high forehead and delicate features –
the fashionable woman of the period.

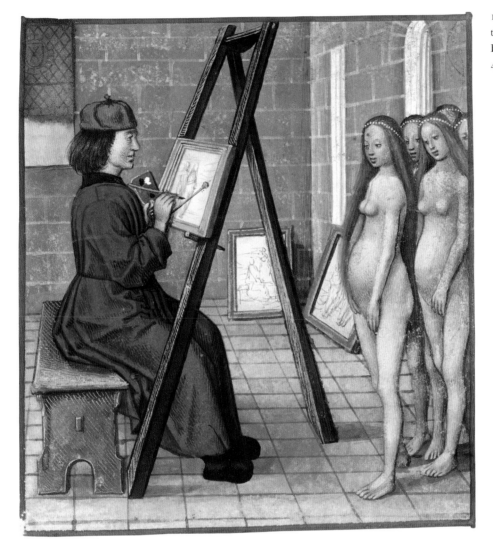

How much is beauty dependent on the creator of art? Artists select what they paint and the results sometimes reflect their own ideas rather than objective reality. According to the artist and engraver Thomas Woolnoth in *Facts and Faces* (1852), the viewer of a portrait often sees 'a certain order of Beauty which has never been seen in Nature'.[50] This is particularly true of society portraiture, especially where women are concerned; subservience to current ideals of beauty may create a fashionable mask, preventing us from actually seeing the face beneath. As for likeness, this often appeared less important to the artist than to the sitter, whose ideas – claimed the eighteenth-century French critic Charles-Nicolas Cochin – were sometimes ignored; artists, he maintained, wish above all for their work to be esteemed by posterity, so that if we look at a portrait by Titian or van Dyck, we can no longer tell if it is a likeness or not.[51] Is the

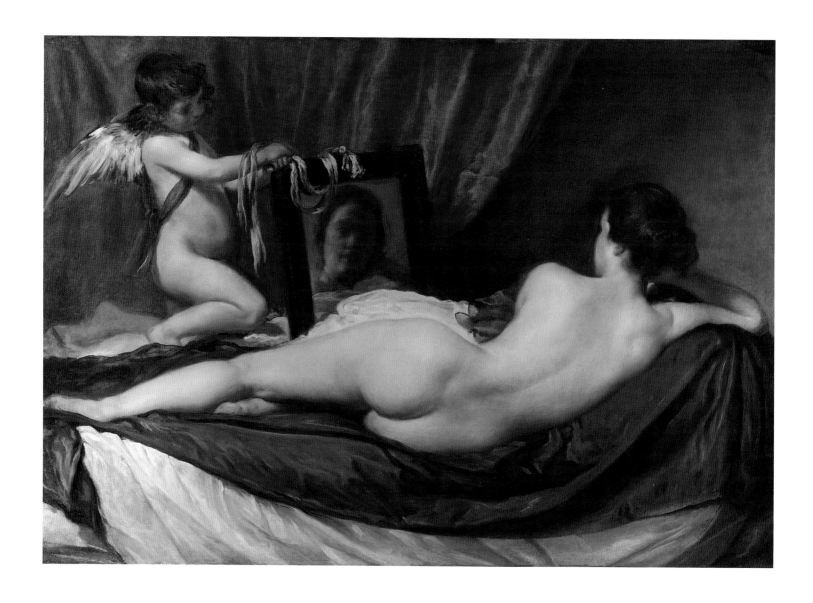

20 Diego Velázquez, *The Toilet of Venus ('The Rokeby Venus')*, *c*.1647–51. National Gallery, London

21 *(facing page)* John Singleton Copley, *Margaret Kemble Gage*, 1771. Timken Museum of Art, San Diego

famous *Rokeby Venus* by Velázquez (fig. 20) a faithful representation, perhaps of the artist's mistress? It is certainly, in the Spanish tradition, an image of a real woman, painted from life, beautiful in her body (the most eloquent back in the history of art) and as much of the face as we can see; but the mirror draped with pink ribbons, which Cupid holds up, reflects a different face, plain and with blurred features. Does the mirror suggest the future eclipse of beauty, due to age and, perhaps, the ravages caused by dangerous beauty preparations? Are we to read in this that there are two sides to beauty, the ideal/universal and the less beautiful reality? As for portraits of identified sitters, truth was not necessarily a priority. John Singleton Copley's 1771 portrait *Margaret Kemble Gage* (fig. 21) – 'the best Lady's portrait I ever drew' – shows the wife of Thomas Gage (the Commander-in-Chief of the British forces in North America) in an imaginary quasi-Turkish costume of coral silk, gazing into the middle distance. 'She is

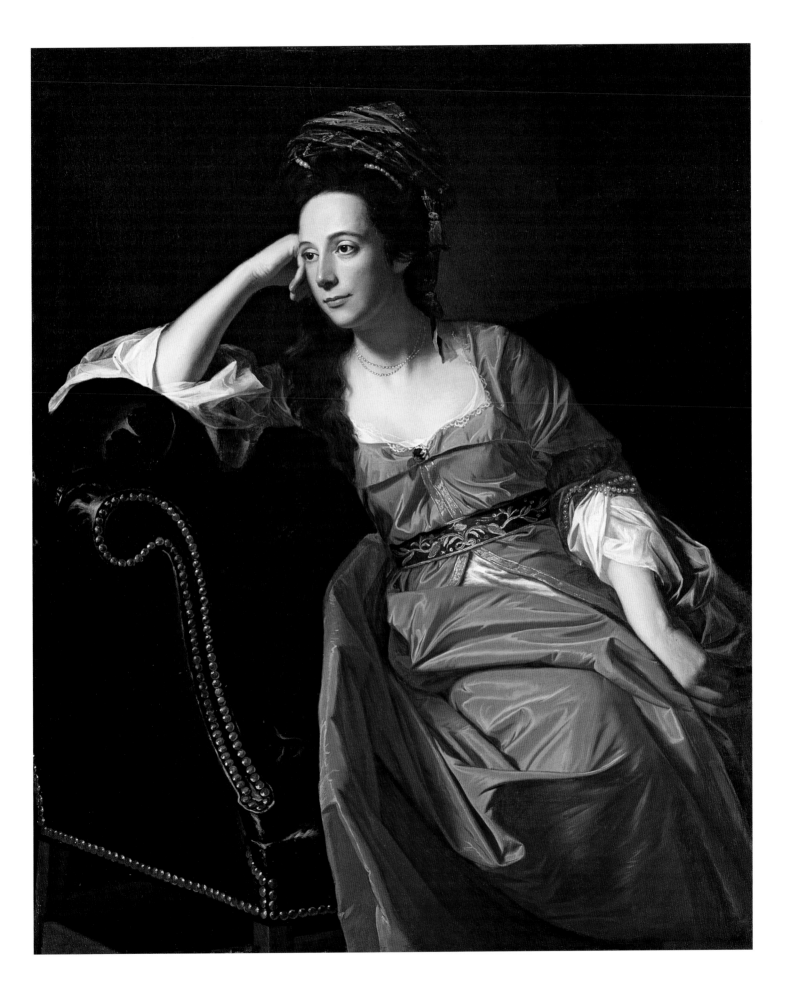

22 Franz Xaver Winterhalter,
Pauline Metternich, 1860.
Private collection

striking by almost any standard of beauty, with deep-set brown eyes, heavy eye-brows, long nose, and small mouth',[52] but she was not thought especially attrac-tive by contemporaries; indeed, another portrait possibly of her by Copley shows a more humdrum reality.[53]

Another example of a woman who was not renowned at the time as a beauty but appears so in art, is Pauline Sandor, Princess Metternich, the wife of the Austrian ambassador to France during the Second Empire. Her portrait by Winterhalter, of 1860 (fig. 22), is akin to a society photograph – flatteringly lit,

in rows of pearls, and a tulle ball-gown by Worth, who coined the word 'chic' with her in mind, as she had such style and elegance. She was not a conventional beauty, with her piquant features and wide mouth (she called herself a 'singe à la mode') but Winterhalter made her singularly attractive, especially to our eyes. As a commissioned work, a society artist had to create an image that presented a likeness without being too obsequiously flattering, but no such caveats hindered Degas's portrait of the same sitter (fig. 23); this was copied from an 1860 *carte de visite* by Disderi of Prince and Princess Metternich, and cleverly creates the blurred effect of an early daguerreotype. With her severe hairstyle and bruised eyes, she looks not unlike Wallis Simpson; both women were leaders of fashion, both *singes à la mode*.

So, beauty as represented in art has its problems and consequently its detractors. As the critic Jacqueline Lichtenstein notes in an essay 'On Platonic Cosmetics', Plato downplayed art as a kind of 'mimetic duplication', equating it to cosmetics, both being 'artifices of seduction'; make-up not only corrects the faults of a face but 'invents its features and gives it a form, a garment that cannot be taken off without pulling off the skin'. Thus, art and cosmetics, paint and paint, can be both deceitful and deceptive, like a mask with nothing beneath it; in Plato's *Gorgias*, *kosmetiké* is defined as 'all activities that resort to artifice to feign the truth . . . all techniques of make-up, dyeing and painting, that is, all the ornamental, pleasurable arts – for the human form as for its surroundings, for the face as for the body'. Lichtenstein concludes:

Painting is the cosmetic art par excellence and by definition, in which artifice exercises its seduction in the greatest autonomy with regard to reality and nature. Pictorial activity does not merely modify, embellish, or make up an already present reality whose insufficiency could be revealed if its ornaments were removed, like a woman without her make-up. Behind the layers of paint used by the painter to represent forms in a picture, nothing remains, just the stark whiteness of a canvas. No reality hides beneath the colors. . . . painting hides or covers nothing. It does not present us with an illusory appearance, but with the illusion of an appearance whose very substance is cosmetic.[54]

Many of the images in this book are of paintings and the reader may wonder if it is possible to tell truth from fiction; how can we tell if artists depict the natural face or if they depict cosmetics? It is not always easy to give a precise answer to this question. The artist may consciously or unconsciously paint a woman's face in conformity with the prevailing standards of beauty. If the sitter's face was overly made up, then the artist could decide to give it a more 'natural' look; sometimes an artist might choose to 'enhance' the bare face of a sitter by giving her a more appealing appearance through the 'cosmetic' use of paint. Links between artists' use of paint and the paint women wore on their faces are close, and are discussed in some detail at the end of the Renaissance chapter. Techniques employed in painting the face either by colours on the artist's palette, or by a woman in front of her mirror, were similar; both use paint to create an image that is at the same time truthful and flattering, according to the fashionable taste of the moment. At times in the history of cosmetics, women's faces looked artificial in their use of stark contrasts between white and red; this combination of colours is easy for us to decipher as make-up. At other times it is more difficult to detect a face which is definitely assisted by art, for red and white might be blended into skin colour to create various shades of fleshy pink, which look natural but are not; a bare face will often have irregular patches of red on the cheeks which might give a look too hectic, too rustic for a stylish appearance.

24 (*facing page*) Peter Paul Rubens, *Helena Fourment* (detail of fig. 65)

When we look at portraits, then, the physical ways in which paint is used, the marks on the canvas *per se* cannot inform us about the presence (or otherwise) of cosmetics; the context in which the image is produced is a more effective guide. It is rare in the period covered by this book that a woman would sit to an artist without having had her face made up, either obviously or discreetly. Whether wearing formal or less elaborate dress, she would wish to look her best – to make her eyes larger and more prominent, to even out her skin colour when appropriate, to redden her lips and so on. The finished work of art, the portrait, is therefore a collaborative enterprise between sitter and artist, in which cosmetics play their part.

Beauty, ideal faces and the cosmetic arts

It has been remarked: 'We long to be not only works of nature but works of art',[55] we may wish to appear natural but to use some artifice when our facial imperfections require it. In art the female face rarely appears truly naked, although many (usually male) critics of cosmetics thought unadorned Nature best. Castiglione in *The Courtier* preferred to see a woman's naked face 'that is manifestly seene she hath nothing upon her face, though shee bee not white nor so redde, but with her naturall colour somewhat wan, sometime with blushing, or through other chaunce dyed with a pure rednesse'.[56] Richard Crashaw's poem *Wishes to his Supposed Mistress* urged 'A face that's best/ By its own beauty drest . . . A face made up/ Out of no other shop/ Than what Nature's white hand sets ope' (1648; ll. 25–6, 27–30).

In art particularly, a woman's face is most likely to appear made up to a greater or lesser degree, but with a semblance of Nature; cosmetics, after all, merely heighten the natural white and red of the complexion, just as the naked body turns into the nude by being polished and enhanced with carefully placed draperies, accessories and jewellery. As dress is decorated, so the face requires some parallel ornamentation. Unlike in some non-western societies where face and body decoration relate to group allegiance, rites of passage, ritual and role-playing, make-up in the west is closely linked to what the anthropologist Robert Brain refers to as imprisonment by fashion: 'Paint and pattern do not celebrate in symbol the physical and social body; they celebrate the conformity of fashion'.[57] Yet, as fashion itself has not always been limited to the slavish imitation of the human body, there is no reason why cosmetics cannot be released from merely mimicking the contours and the natural colours of the human face. Why not make the face more 'ornamental', asked the philosopher Curt Ducasse. Why not 'green or blue or golden lips, eyebrows, cheeks and ears?' Why not double eyebrows 'or forked or serpentine eyebrows?' It is not clear if this is a rhetorical question to which the unspoken answer might be that such a face

25 (*facing page*) British School, *Young Woman* (detail of fig. 55)

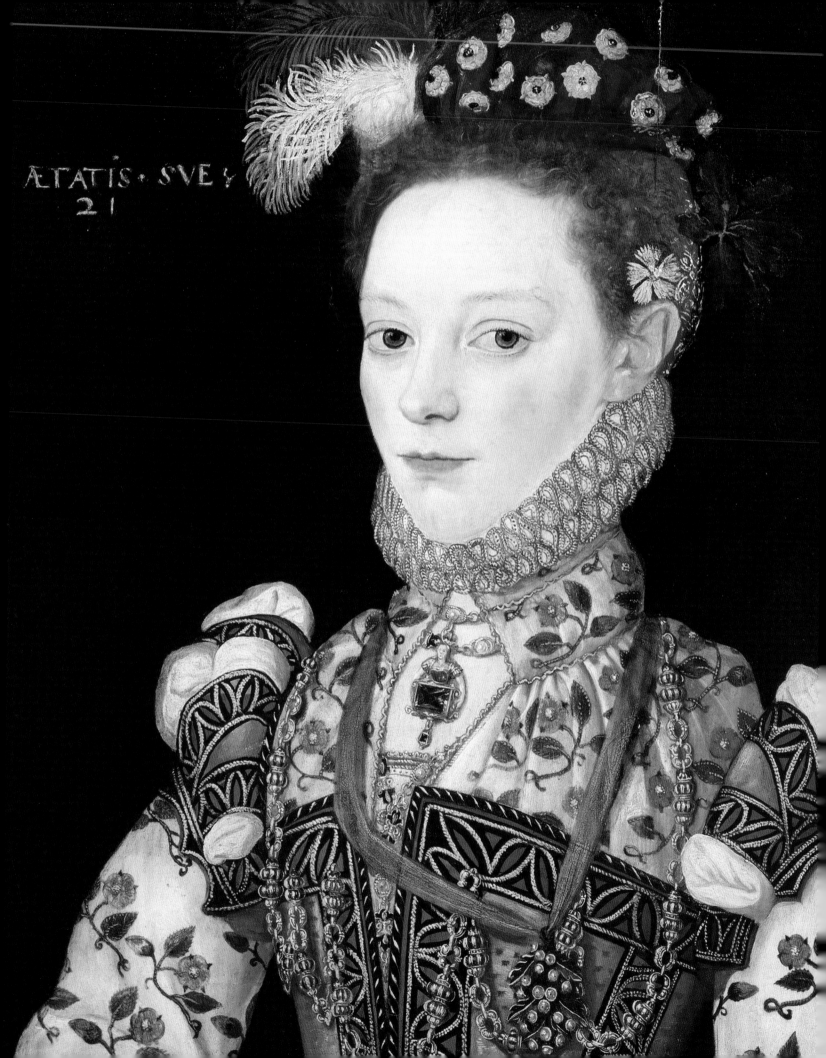

might look clownish. It would certainly not conform to conventional standards of beauty and it would take some time for us to see this kind of face decoration as beautiful rather than bizarre, so wedded are we to the idea that painting the face should mimic and enhance the colours that we already have. Cosmetic arts must be used with skill, if we agree that 'Kant's assertion that to be good, art must look like nature, is completely true'.[58]

During the period discussed in this book, beautiful faces were intended to be part of the body beautiful, and the body shape was mainly created by clothing, by fashion, which, stated Christian Garve in an essay of 1792 was 'the dominant opinion of the beautiful and proper at any time'.[59] However, fashion and beauty sometimes exist in an uneasy cohabitation, as a contest between nature and artifice. A poem in the *London Magazine* (1762) took the form of a dialogue between Lady Beauty and Miss Fashion. Beauty complains that she is so 'metamorphos'd' by Fashions's 'fiddling and fangling' that she hardly recognises herself; in reply, Fashion contends that Beauty is too mean with her favours: 'Here your nose is too red, there your lily's too pale;/ Or some feature or other is always amiss', and concludes: 'a woman is nothing unless à-la-mode;/ Neglected she lives, and no beauty avails,/ For what is a ship without rigging or sails?'[60]

The constant scrutiny of the female face is a fact of western culture; it is the most naked (in the sense of vulnerable) part of the body and the signifier of identity; 'our Faces . . . carry in them the Mottos of our Souls, whereby our very Natures are made legible'.[61] That the face is also 'the chief Seat of Beauty' is the theme of the most famous beauty treatise of the eighteenth century, Antoine Le Camus's *Abdeker* (1754), to be discussed later in this book. Writers on beauty not only see the face as a whole but may devote equal attention to the individual parts of the face, just as 'the Famous Limner [Zeuxis] when he drew the *Picture of an Exact Beauty*, made use of an Eye from one, of a Mouth from another, and so cul'd what was rare in all others, that he might present them all on one Entire Piece of Workmanship'.[62] The beauty of displaced parts of the face, such as the lips and eyes, was one of the themes of Surrealist art, as in Dalí's *Lips* (fig. 26). Alexander Pope, in a letter to John Gay in 1713, found himself obsessed by the fleeting glimpses of female beauty he saw in the London streets, never the face as a whole, but certain features: 'Every corner of an eye, or turn of a nose or ear, the smallest degree of light or shade on a cheek or in a dimple have charms to distract me'.[63] Pope does not specify the appeal of such beautiful features but many less able writers (including poets, critics and the authors of beauty manuals) resorted to conventional and often banal descriptions of parts of the face – eyes being like stars, with diamond tears, or windows into the soul, and complexions akin to lilies and cherries. Beauty was often equated with precious materials – a skin like ivory, lips of rubies, teeth like pearls, and so on (figs 26 and 27). These clichés of beauty are interleaved with more refreshing (even satirical) attitudes

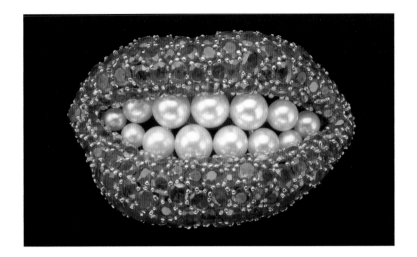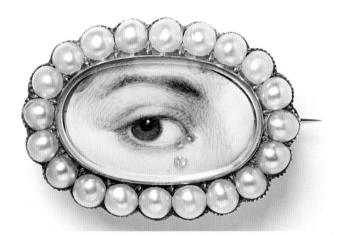

to the features of the face, such as in Shakespeare's *Twelfth Night* when Olivia says to Viola/Cesario: 'I will give out divers schedules of my beauty: it shall be inventoried, and every particle and utensil labelled to my will: as *Item*, Two lips, indifferent red; *Item*, Two grey eyes, with lids to them; *Item*, One neck, one chin, and so forth' (I: v).

The face is a canvas on which to paint the fashionable being but it also depicts the social being, for it is a kind of adornment which may indicate rank and status; cosmetics removed sweat from the face and gave the skin a pallor to underline a woman's elite status. According to the sociologist and social philosopher Georg Simmel's *Exkurs über den Schmuck* (1908), adornment can be both egotistical (as it provokes attention and intensifies personality) and altruistic for 'the visual delight it offers to others'.[64] Rudi Laermans also focuses on the social aspect of make-up, and touches on its psychological implications:

> The cosmos that is produced and/or reproduced by cosmetics is, in the first place, of a social nature. Powdering one's nose, applying rouge or lipstick, blackening the eyebrows . . . all these practices undoubtedly also have a psychological motive . . . the final result betrays a desired identity, a phantasmal self-image, an imaginary striving for sexual recognition and social success . . . [65]

As well as cosmetics representing what Bourdieu referred to as 'one's position in social space',[66] make-up could also be seen as protective, a liberating force – to negate insignificance and give women the self-confidence they might lack in a masculine world. It also offered women the chance to play with a borrowed identity – 'la délicieuse expérience d'une identité d'emprunt', as Philippe Perrot rightly remarked.[67] Cosmetics, like the expansion of fashion concepts from the

26 (*above left*) Salvador Dalí, *Ruby Lips*, 1949. Primavera Gallery, New York

27 (*above right*) British School, miniature of an eye, *c.*1800. Victoria and Albert Museum, London

Renaissance onwards, opened wider possibilities to women and enlarged their horizons, helping to create a culture of feminine display, the pleasure of seeing and being seen in society: 'Beauty is Nature's brag, and must be shown/In courts, at feasts, and high solemnities,/Where most may wonder at the workmanship' (Milton's *Comus*, 1634, I ll. 745–7). What is not clear is how far make-up reflects the ideal face or creates it; the answer is probably a mixture of both, a complex process of transformation which varies from one to the other at different periods in time. The use of cosmetics goes back to the very earliest civilisations and, as this book really begins with the Renaissance, a brief narrative of the history of make-up and notions of ideal beauty before the sixteenth century is a necessary preliminary at this point.

As with clothing, cosmetics soon evolved from the aim of protection (in the sense here of camouflage, magic, ceremony and group allegiance) into decoration. Physical beauty became an ideal, not just of the face but the body as well; according to Pliny, the ancient Britons tattooed themselves, and the word 'Briton' may even derive from a Breton word meaning 'painted in various colours'.[68] The word *kosmetiké* comes from the Greek word for adornment, mainly relating to feminine custom and which encompassed the care of the skin (face and body) as well as the painting of the face and the arrangement of the hair. This definition has remained more or less the same as today; the US Food and Drug Administration defines cosmetics as whatever is 'rubbed, poured, sprinkled or sprayed on, introduced into, or otherwise applied to the human body for cleansing, beautifying, promoting attractiveness or altering the appearance *without affecting the body's structure or function*'[69] (my italics; this refers to invasive beauty treatments closer to surgery than to make-up, which is largely on the surface).

By the fourth century BCE, the application of cosmetics was a well-established part of the life of the fashionable woman. The body was smoothed by pumice stone and scented oils, the complexion softened by moisturising creams and ointments; the face was painted (with white lead powder or wheat flour), the cheeks and lips reddened (either with wine lees, red ochre or vermilion – red mercuric sulphide), and the eyes outlined with kohl (powdered antimony), ivory black (from charred ivory or bone), lampblack (the burnt residue from oil-burning lamps); hair was dyed and arranged in complicated styles, as were the wigs which were widely available. As in any period until the twentieth century, there is little information on the consumption of cosmetics; it is not clear which classes of women wore cosmetics (other than the upper classes and courtesans), nor is it known for certainty on what occasions they were used. It is a paradox that, until late in the nineteenth century, cosmetics were often harmful, although they were used not just to create the perfect complexion but also to hide the effects of age, illness and disease. When we look at beauties in art, it is necessary to remember the reality for the majority of women – the impact on the appearance of a

defective diet, loss of teeth, badly fitting false teeth, poor skin, eye infections, hair suffering from erratic dyeing and the torture of extravagant styles, and so on. Women's appearance was usually crucial to their happiness (and sometimes to their livelihood); therefore it is not surprising that they resorted to making the most of themselves by using cosmetics. Unfortunately, women's views about cosmetics are unknown; their voices are silent, so most of our information derives from largely hostile comment, from Plato onwards. The 'only writer in antiquity to avoid a negative attitude to facial make-up' was Ovid and even he was careful to emphasise that 'the goal of the cosmetic art is not artificiality *per se*, but the imitation of nature'.[70] His *Ars Amatoria*, written in the first century CE, contained frank advice on how women could embellish their beauty, which kinds of hairstyles to wear (eight are mentioned, some copied from statues which possibly acted as fashion models[71]), how to give a dazzling whiteness to the skin (lead unguents and chalk were recommended), how to brighten the eyes (with saffron or 'finely powdered ash'), and the use of beauty patches of soft leather which could cover blemishes on the face. His comments are somewhat ambivalent at times, not always a defence of women's rights to improve their appearance, more about the revealing of female secrets and the rites of beauty to a male audience.

Compared to the acceptance of the cosmetic arts in Ovid, the writings of the Early Christian Fathers are full of condemnation: make-up was denounced as sinful in itself, against both nature and the explicit wishes of God. In the second century, Clement of Alexandria (originally Titus Flavius Clemens, a pagan philosopher) referred to women as apes painted white who 'smeare their faces with the ensnaring devices of wily cunning'.[72] In the following century, St Cyprian in his *De Habitu Virginum* – demonstrating some familiarity with cosmetic techniques – insisted that it was 'the sinful and apostate angels . . . [who] taught how to paint the eyes by spreading a black substance around them, and to tinge the cheeks with a counterfeit blush, and to change the hair by false colors'.[73] This notion of a beautiful woman as satanic temptation (even more so when her appearance was heightened by art) was a commonplace of medieval religious discourse; in the late fourteenth-century *Summa Praedicantium*, an anthology of texts for Dominican preachers, they were told not to look at attractive women: 'A beautiful woman is a temple built over a sewer'.[74] The contemporary idea of such a woman might be the figure of Vanity from the tapestry of the *Apocalypse* at Angers (fig. 28), combing her long blonde hair as she holds a mirror, a luxury item as precious as jewellery; her fashionably skin-tight dress would normally have been covered by a voluminous overgown, the *houppelande*, omitted here so that her body shape could be revealed.

In the Middle Ages beauty was as much discerned in the body type as in the face, with no dramatic changes in this ideal over a long period. The ideal woman was slender – 'graceful and slim as a weasel' is Chaucer's description of the lech-

28 'Vanity', from the *Apocalypse* tapestry, *c.*1380. Musée de la Tapisserie, Angers

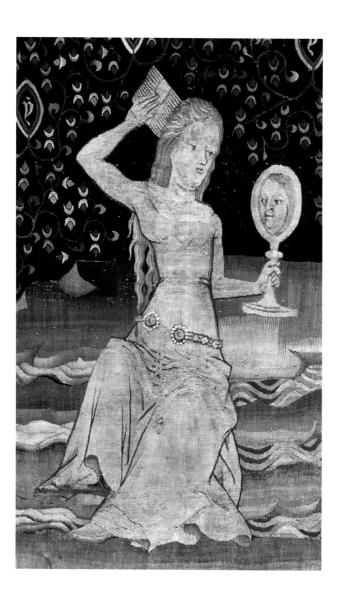

29 *(facing page)* Rogier van der Weyden, *Unknown Woman, c.*1460. National Gallery of Art, Washington, Andrew W. Mellon Collection

erous Alisoun in the *Miller's Tale* – and the perfect face had pale skin and downcast eyes. Rogier van der Weyden's portrait of an *Unknown Woman* of about 1460 (fig. 29) is a paradigm of late medieval beauty, with her blonde hair, white, perfectly oval face and heavy-lidded eyes and the lower lip fuller than the upper. She appears the epitome of pure 'natural' beauty, but the pallor of her face may be enhanced by white make-up, her eyebrows are plucked, and possibly her front hair so as to create the high, rounded forehead in vogue at the time; in order to prevent her headdress (and her false hair) falling back too far, she pulls it forward with the aid of a black silk loop attached to the black band (frontlet) on the crown of her head.

Facing Beauty

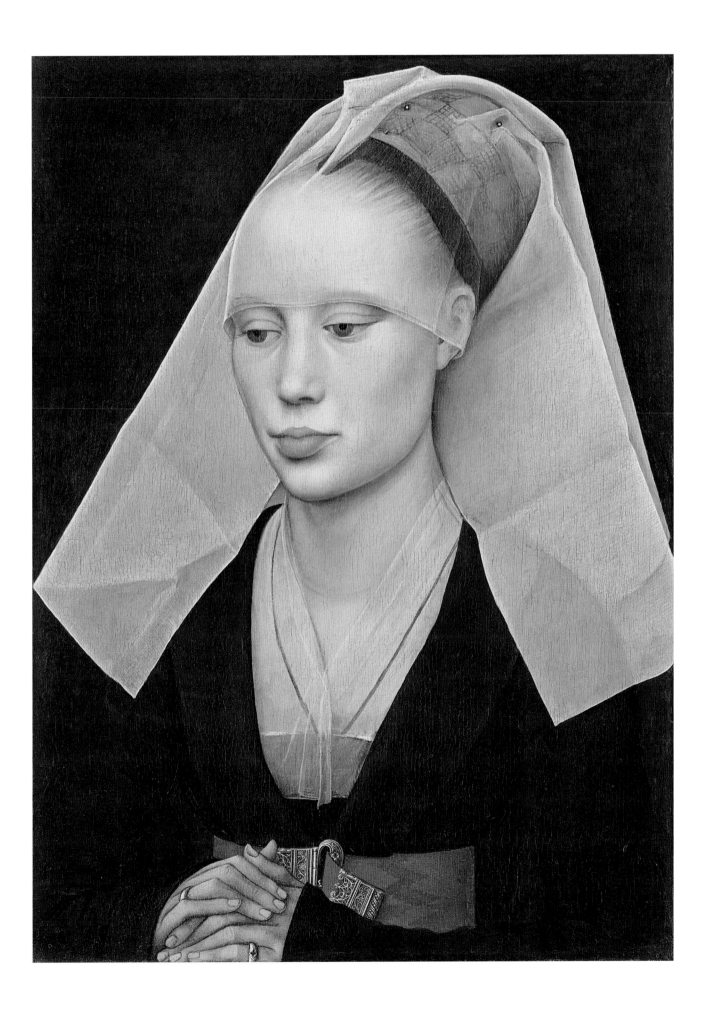

Although the use of cosmetics in the medieval period was not as overt as in the Renaissance, and far less celebrated in art, it is clear from contemporary texts that aids to beauty were available. Jean de Meun's immensely discursive continuation of the *Roman de la Rose* late in the thirteenth century (in which he rejects the original theme of courtly love, the *amour courtois* admired by earlier troubadour poets, in favour of love as merely a device for the propagation of the species), contains advice to women on how they can attract men by making themselves beautiful and dressing in a seductive way; their dress can be cut low to show off the neck and bosom (as in the *Apocalypse* tapestry; see fig. 28), their skin can be kept fair with creams and their hair eked out with the locks of dead women or with pads of blonde silk – 'cheveus de quelque fame morte,/ Ou de soie blonde bourreaus'.[75]

'Problemes of Beautie'

The titles of recent books by women on beauty resound with their fears: *The Beauty Trap: How every woman can free herself from it* (1986), *The Beauty Myth* (1990), *The Symptom of Beauty* (1994), *The Trouble with Beauty* (2001), *Beauty and Misogyny* (2005), to name just a few. Beauty is thought of as vanity manipulated by the beauty industry, as irrelevant to women's serious concerns with its emphasis on femininity. It has also been described as divisive, and as elitist, an argument proposed by Sontag, contemplating what she saw as the decline of the importance of beauty: 'Beauty belonged to the family of notions that established rank, and accorded well with social order unapologetic about station, class, hierarchy, and the right to exclude'.[76] Writing on beauty with regard to women consists mainly of two categories, men writing on the aesthetics of beauty through images in art, and women who write about the political and social contexts in which beauty operates. The majority of feminist writers move the argument away from theories of ideal beauty, to beauty as artifice, to a denunciation of the beauty industry. Naomi Wolf's book *The Beauty Myth* (1990) is a rather overwrought discussion of the different ways in which women are not free as a result of their obsession about beauty; images of beauty, in particular, the author suggests, are a kind of 'glamorized degradation', and 'a political weapon against women's advancement'.[77] Critics of Wolf's book, including Nancy Etcoff, have queried the idea of beauty as a myth propagated by the beauty industry, manipulated by men to 'stir up envy and desire' and thus disempower women – 'the idea that beauty is unimportant or a cultural construct is the real beauty myth'. 'In the real world the beauty myth collides with reality', for women, she states, are able to make their own choices about their appearance. The beauty industry is a multi-billion-dollar business, largely controlled by men, but while it may to some extent exploit women, it cannot be responsible for creating the idea of beauty.[78]

Sheila Jefferys's *Beauty and Misogyny: Harmful Cultural Practices in the West* claims that beauty practices are dangerous – 'a highly effective way of transmitting chemicals into the body' – and damage women's self-esteem; to the argument that women are not coerced to make themselves beautiful, she replies that women do not have a choice, for society is founded on the notion of sexual difference.[79] The false implication here is that gender differentiation denies women choice.

One of the 'problems' which some critics of beauty see is its unavoidable link with femininity – defined by Wendy Steiner in *The Trouble with Beauty* (2001) as 'ornament, charm and gratification'[80] – passive subservience to masculine criteria regarding women's appearance and behaviour. Historically, the creation of femininity has been a prominent cultural theme in western thought and has largely been constructed by ideals of appearance, in body, fashion and in make-up. Simone de Beauvoir's often quoted dictum in *The Second Sex* (1949) – that a woman 'is not born, but rather becomes, a woman' through the cultivation of 'feminine' skills such as clothes, deportment and make-up[81] – was true to a great extent in the past if no longer so today.

As for the body, according to Simmel's *On Women, Sexuality, and Love* (1911), women's beauty is related to their passivity, to physiology, to rounded forms:

> The smooth face, the lack of the paltry sexual organs that interrupt the flow of the lines of the [male] body, the symmetrically molded cushions of fat – all this orients the female body much more to the stylistic ideal of beauty than to the active ideal of significance . . . beauty is more closely related to the female phenomenon than to the male, even if only in the sense that the woman possesses a greater natural disposition to beauty . . .[82]

Women, he implied, are – due to their position in society – more conformist, more desirous of social approval and therefore more reliant on fashion both in dress and in beauty. That women were (and are) passive subjects of the male gaze – a theory outlined by the critic John Berger in his famous essay *Ways of Seeing*, first published in 1972 – is a given in any discussion of gender: 'Men look at women. Women watch themselves being looked at'.[83] Yet this does not necessarily make women into objects, either decorative or sexual; they can appreciate and enjoy their own beauty (and the clothes they wear) without reference to male (or female) judgements, and without any suggestion that their worth is bound up only in appearance. Denunciation by some feminists of cosmetics as merely skin-deep beauty is no different from the fundamentalist views held on women's appearance by moralists through the ages, and could be seen as inherently anti-democratic, censoring and limiting freedom of choice.

For many women, the whole process of beauty in the sense of cosmetic routines was an enjoyable albeit time-consuming business. For the elite, it was an

important part of the elaborate *toilette* during which dress and appearance was carefully considered. For those lower down the social scale, it gave an opportunity for what today one might call 'me-time', respite from the cares and duties of a household. From the Renaissance onwards, luxury goods increasingly included the paraphernalia of beauty, not just cosmetics themselves but expensive containers and utensils, elaborate and costly make-up boxes and dressing tables and, most of all, mirrors, literally looking-glasses. Venice, famous for cosmetics, also produced high-quality glass, which could be used for scent bottles and for mirrors; by the seventeenth century, glass factories were established in France and England, and mirrors became essential household items. It became *de rigueur* for royal palaces all over Europe to create mirrored halls like the Galerie des Glaces at Versailles or the Great Gallery at Schönbrunn in Vienna; on great formal occasions, courtiers would see themselves in all their finery, their appearance constantly replicated.

Mirrors have a complex iconography and are closely linked with beauty; they have been seen as magical, seductive and dangerous. The mirror 'stands for good and evil; for sacred and for profane; for the spiritual and the worldly'; it is the symbol of the Virgin Mary and of Mary Magdalene but also an attribute of the deadly sins Pride (*Superbia*) and Lust (*Luxuria*) – Pride, as well as Vanity, is often shown as a fashionably dressed figure looking into a mirror.[84] As Jonathan Miller notes: 'human beings deliberately exploit mirrors with the express purpose of improving their own appearance. Each individual has an idealised version of the self which they would prefer to offer to the world at large, and with the aid of a mirror, this publicly visible façade can be carefully constructed'.[85]

Women, inevitably, had a close link with mirrors, firstly to help in making up the face and as an aid in dressing. The mirror is a kind of self-interrogation, a self-portrait which comes alive when one looks into it. Its real function, Berger claimed, was 'to make the woman connive in treating herself as, first and foremost, a sight';[86] the suggestion here, in a play on words, is literally so she can 'see' herself in the mirror and perhaps that her appearance is a 'sight' in the sense of being ridiculous. For the mirror was, as noted, a *vanitas* symbol, often used in satirical images of older women being decked out in inappropriate finery and cosmetics. An engraving of 1745 after Charles-Antoine Coypel's *La Folie pare la Décrépitude des ajustemens de la Jeunesse* (fig. 30) shows an old woman about to place a patch on her face, as she attempts to achieve a youthful appearance with the aid of make-up, in order to gain a lover; although the laughing Cupid, complicit with the maid dressing her mistress's head, flies away with his arrow, it is unlikely to pierce a man's heart. The anonymous author of *The Art of Making Love* (1676) remarked that men 'cannot love a woman when her beauty fades', and 'there is nothing so frail and changeable as Beauty'.[87] The magical ingredient of beauty is youth; Ducasse's essay *The Art of Personal Beauty*, published in

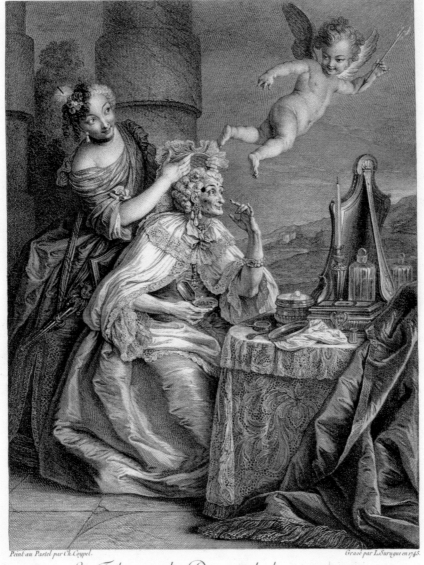

Peint au Pastel par Ch. Coypel. Gravé par L. Surugue en 1745.

La Folie pare la Décrépitude des ajustemens
de la Jeunesse.

a Paris chez L. Surugue Graveur du Roy rue des Noyers, attenant le Magazin de Papier vis-a-vis St. Yves. A.P.D.R.

30 Louis Surugue after Charles-
Antoine Coypel, *La Folie pare la
Décrépitude des ajustemens de la
Jeunesse*, 1745. British Museum,
London

1944, is still valid: 'the beauty characteristic of the years of youthful bloom is traceable to such familiar factors as a clear smooth skin, bright eyes, abundant and glossy hair, sound teeth, rosy color of lips and cheeks',[88] the kind of youthful glow seen in Sebastiano Ricci's *Head of a Girl wearing a Ruff*, of 1716–20 (fig. 31). Her hair is loosely knotted on top of her head, her face a perfect oval with

refined features – large, well-set eyes, a long slim nose and small pink lips. A problem with beauty is that it rarely outlasts youth and we are conditioned to see time as a flaw on the faces of women. Pompeo Batoni's *Time orders Old Age to destroy Beauty* (fig. 32) shows the winged figure of Time holding his scythe and hourglass, as an aged, wrinkled crone attacks a young woman, whose generalised 'timeless' costume, silk turban, and natural, unpainted complexion is intended to symbolise ideal, true beauty.

Women who have been beauties can never forget it, especially when immortalised in art and literature – 'Ronsard me celebroit du tems que j'étois belle' (Number 46 of Pierre Ronsard's *Sonnets to Helen*, 1578). In everyday life, too, the consciousness of beauty past and present is always present; Mrs Ramsay in Virginia Woolf's novel *To the Lighthouse* (1927) 'bore about with her, she could not help knowing it, the torch of her beauty; she carried it erect into any room that she entered; and after all, veil it as she might, and shrink from the monotony of

bearing that it imposed on her, her beauty was apparent. She had been admired. She had been loved'. Dickens's tragic but 'perfectly well bred' Lady Dedlock in *Bleak House* (1853) has 'a fine face . . . improved into classicality by the acquired expression of her fashionable state'; she 'has beauty still, and if it be not in its heydey, it is not yet in its autumn'. The reader knows, however, that autumn will sooner or later become winter, when 'round and round the Ghosts of Beauty glide', as Pope commented in his poem *Of the Characters of Women* (1735; l. 241). It is the most beautiful women who try to defy time, if they cannot endure the fading of their beauty. Federigo Luigini in his *Book of Fair Ladies* (1554) stated that the main reason why women paint themselves is 'in vain endeavour to put back the hand of Time, that never will restore the years gone by and fled'.[89]

For this reason, cosmetics then and now invoke youth and suggest they have magical properties to hold back the ravages of time. Typical of supposedly age-defying advertisements is one from *Beauties Treasury* (1705), described as 'A Beautifying Tincture to preserve the Face from the Ruins of Old Age'. The ingredients – ceruse (a cosmetic made from white lead), mastic (resin), sulphur, egg whites, blanched almonds, camomile flowers and others – 'will cause a curious Lustre to appear on the Skin . . . keeping it plump and beautiful even to Old Age';[90] the 'Tincture' would have enamelled the skin and set it hard. As well as shops selling cosmetics, other businesses also used the possibility that youth could be restored

33 Trade card of Legris, Hairdresser, *A la Fontaine de Jouvence, c.*1805. Waddesdon Manor, Aylesbury, The Rothschild Collection (The National Trust)

Facing Beauty

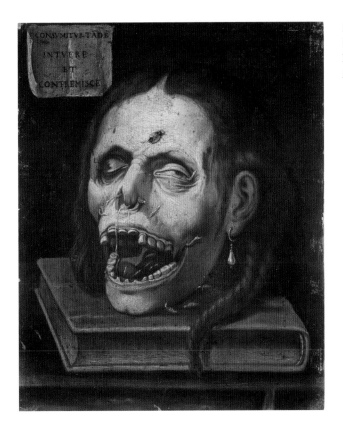

to their clients: a popular name in France in the selling of 'beauty' was *A la Fontaine de Jouvence*, from the classical myth of a nymph metamorphosed by Jupiter into a fountain and given rejuvenating powers. This, according to a trade card of about 1805 (fig. 33) was the name of a hairdressing establishment owned by a M. Legris in Paris; the illustration depicts elderly women bathing in the fountain, from which they emerge on the right with their youthful looks restored. The fountain is also linked with fashion, for on the left are two old women in the costume of the 1780s (symbolising old age), looking towards the young women on the right in their modish Empire-line gowns and Neo-classical hair-styles.

Another 'problem' with beauty is its awareness of death, for beauty at its height – whether vainglorious or unaffectedly natural – can be so speculative as to suggest, perversely, its opposite, a gruesome corpse, the finality of bodily extinction, just as the skeletons in the medieval Dance of Death remind the fashionable that in the end they too will die. 'Hélas! Pensez, se vous estes bien belles/ Comment la mort toute beauté efface' (*Le Miroir des Dames*, of about 1450). Death has effaced all signs of beauty in an *Allegory of Time* of the mid-seventeenth century (fig. 34); what might once have been a beautiful woman

with a pearl earring is now a sight of horror. Time and death have ruined her face, just as when she was alive, syphilis and/or cosmetics might have ravaged her appearance.

Self-absorption in one's own physical appearance can be dangerous, as Narcissus found out when he drowned in beauty or when Wilde's Dorian Gray died as a result of his obsession with retaining for ever his youth and beauty. The beautiful deadly woman is known as a *femme fatale*; she is a variant of the *vanitas* figure but with the difference that she deliberately lures men to their destruction. Walter Benjamin remarked that, apropos the 'detailing of feminine beauties . . . in which each single part is exalted through a trope, secretly links up with the image of the corpse. This parcelling out of feminine beauty into its noteworthy components resembles a dissection'.[91] Referring to Freud's essay *On Transience*, of 1916, that beauty and death are linked, Efrat Tseëlon agrees that as 'woman is equivalent to death, beauty is equivalent to some death rituals'; make-up lends the face 'an idealized timeless mask of beauty. This procedure captures the spirit of the making of death masks'.[92] Funereal practices such as death-masks or embalming might also suggest the idea of what was once called plastic surgery and now is often referred to as cosmetic or aesthetic surgery; the word 'aesthetic' in particular makes it clear that the search for beauty is involved. For the performance artist Orlan aesthetic surgery (in a series of operations from 1990, which take place in public and are filmed) gives her the opportunity to re-engineer her face in a project she calls the 'Reincarnation of St Orlan', a critique of western ideals of beauty. There is nothing religious about this work, except perhaps the notion of pain as purification, and mystical fervour – 'a moment of intensity for oneself and for others'.[93] Orlan uses surgery to create 'standards of beauty codified in the art of the great masters of Western Europe, beginning with the Renaissance'. Her face has been altered 'to resemble a composite computer-generated image combining the chin of Sandro Botticelli's *Birth of Venus*, the forehead of da Vinci's *Mona Lisa*, the lips of Gustave Moreau's *Abduction of Europa*, the eyes of a Fontainebleau School *Diane Chasseureuse*, and the nose of Gérard's *First Kiss of Eros and Psyche*'. The reasons why these particular faces were chosen are somewhat vague but the idea, apparently, is to underline how the artist is against 'any one standard of beauty or any notion of a timeless or universal ideal of beauty'.[94] She must, however, have had some kind of ideal in her mind, for this description does more than hint at the way the painter Zeuxis sought to achieve his ideal beauty in art. Orlan's face, though striking, is not beautiful by normal standards, but her 'reincarnation' serves to make one think about beauty and suffering ('Il faut souffrir pour être belle') and perhaps hints at a long tradition of dangerous cosmetics in the past.

❧ ❧ ❧

The book you are reading, then, deals with aspects of female appearance which are abstract and theoretical, as well as grounded in the reality of the physical and in the use of cosmetics. Many works have been written on female beauty but nothing of substance on the history of cosmetics which is closely allied to the creation of this beauty. Think, for example, of Lady Diana Spencer when she stepped on the world stage by marrying the Prince of Wales in 1981; a shy and not spectacularly good-looking upper-class girl (I use the word 'girl' deliberately here), her face, while attractive, had a large nose and a mouth which sometimes turned rather awkwardly up at one side. Yet over the years, through experience, deportment, a sense of fashion, a love affair with the camera and most of all – I argue – the cultivation of the cosmetic arts (and skilled hairdressing), she became a beauty. Via the sexual appeal which is intrinsic to most forms of female beauty, the support of public adulation and the clever but subtle enhancing of face and body, Diana thought herself into beauty. Her beauty was, of course, the archetype admired and sanctioned by white western culture, and here it is as well to state my consciousness of how Eurocentric this book is. This is an approach I can justify only by suggesting that ideas of beauty and make-up were historically part of the culture of the western world, until at least the middle of the twentieth century. Now we live in a multi-cultural society where different, sometimes overlapping, standards of beauty co-exist; the story of contemporary ideals of beauty and the variety of cosmetics linked to non-western ideals of beauty has yet to be written.

Reviewing a time-frame as long and complex as that from the Renaissance to the mid-twentieth century means that I cannot deal comprehensively or in a sustained way in every period with the themes I set out above, so make no claim to write a sustained history of beauty; nor is this book intended to be read as a history of cosmetics. So I have chosen to be selective and to concentrate within each century on a few topics – enough to give an idea of the multi-faceted subject of beauty and how it has been defined and enhanced through the ages.

Renaissance

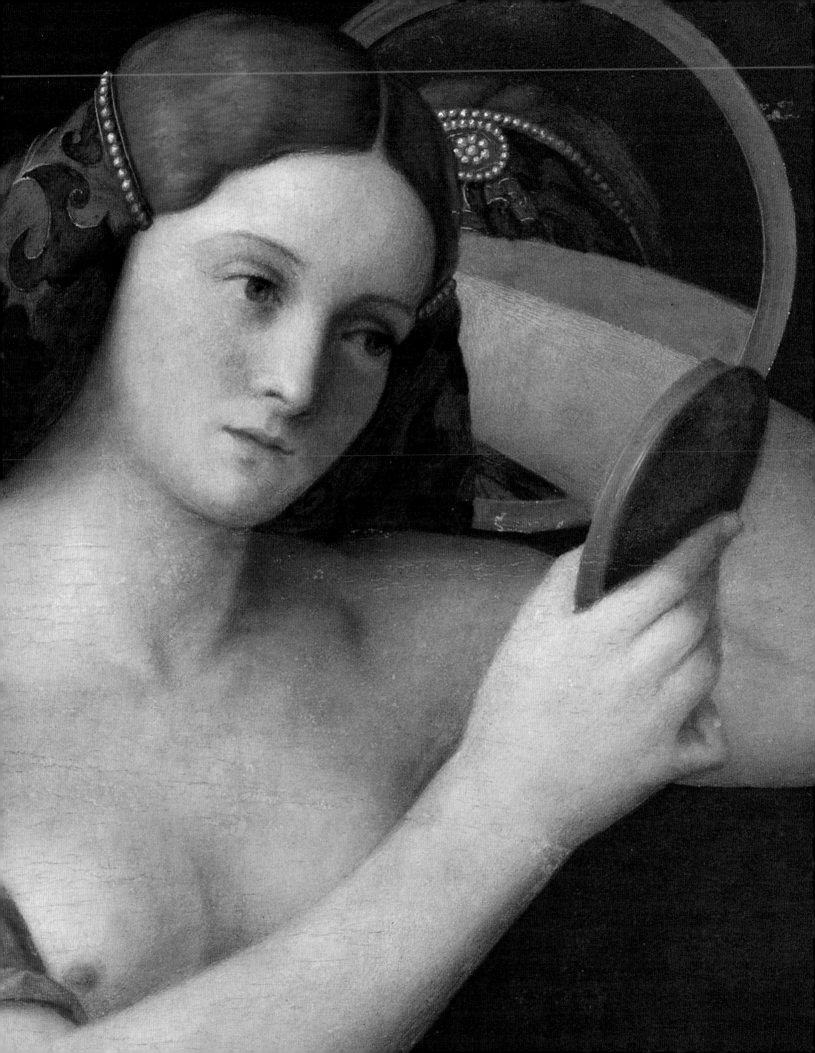

*T*HIS CHAPTER, DIVIDED INTO THREE SECTIONS, COVERS THE PERIOD FROM THE EARLY SIXTEENTH CENTURY TO THE END OF THE SEVENteenth. The word 'Renaissance' of course refers to the rebirth/reinterpretation of classical knowledge, which was at its peak in sixteenth-century Italy; a later flowering took place in Northern Europe in the following century. However, I mean 'renaissance' also in the wider sense, a re-examination of the position of women in society, a new emphasis on female self-presentation through fashion and cosmetics and the beginning of a sustained discourse of beauty in image and text.

The first section is a discussion of ideal beauty in painting, especially in Venice, the city of Venus and of the rebirth of cosmetics; beauty also played a crucial part in the philosophy of humanism and the standards of behaviour codified in the courtesy manuals published in the cities of northern Italy. 'Next to the subject of Love, the most common topic of discussion in the sixteenth century was Beauty'.[1] Beauty became part of a sophisticated and cultivated way of life, both in theory and practice; philosophical works discussed ideals of beauty in a perfect society and manuals provided factual information on how women could achieve beauty in the real world. The practical application of beauty, however, became the serpent in the Garden of Eden, and the second section revolves mainly round cosmetics and their discontents, mostly in England from the late sixteenth century, exacerbated by the spread of Protestantism which laid more emphasis on inner spirituality than on outward show. The final section looks at the creation of an Anglo-French court culture from the second half of the seventeenth century, in which beauty became enshrined in the formal *toilette* and celebrated in literature and in the development of the first fashion plates. What critics referred to as 'auxiliary beauty' (make-up) became an accepted part of elite life and this section also suggests a close link between paint (cosmetics) and paint (art).

Dialogues on the Beauties of Women

Beautiful women and beauty are worthy of praise and everyone's esteem. For a beautiful woman is the most beautiful object one can admire, and beauty is the greatest gift God bestowed on his human creatures . . . For this reason beautiful women have been sent among us as a sample and a foretaste of heavenly things . . .

Agnolo Firenzuola *Delle bellesse delle Donne*, 1548[2]

Although the male nude was highly admired in western art from at least the sixth century BCE (some considerable time before the appearance of the female

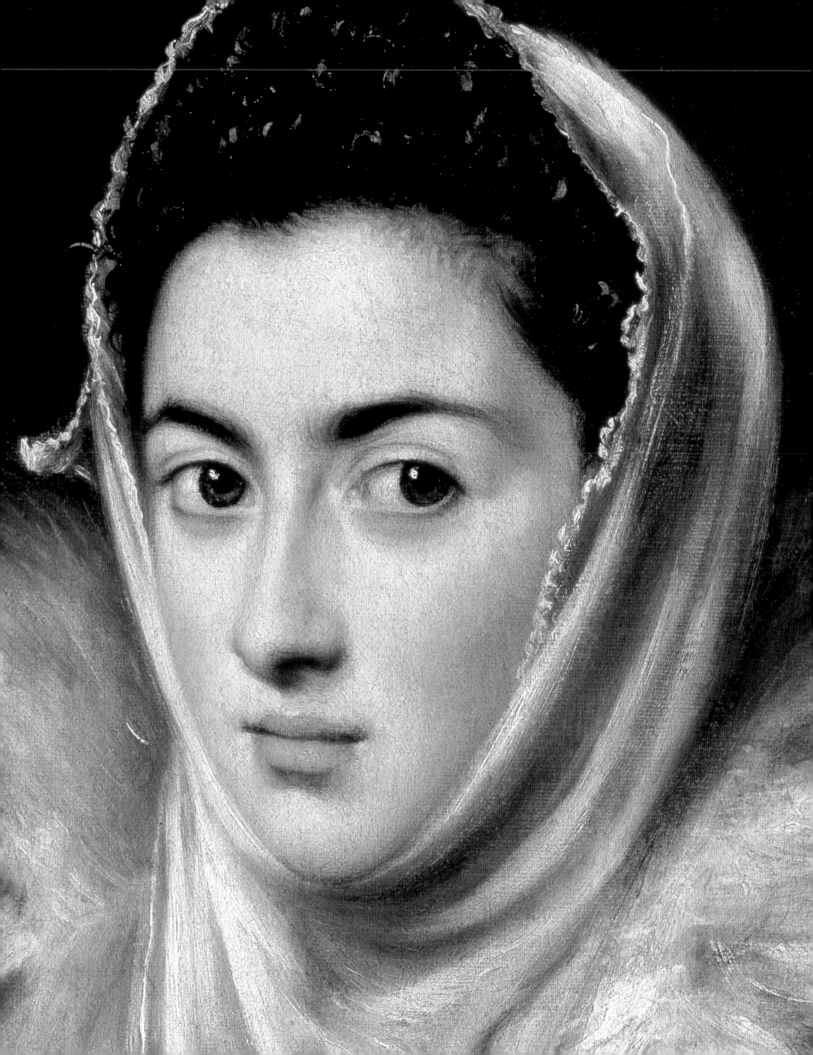

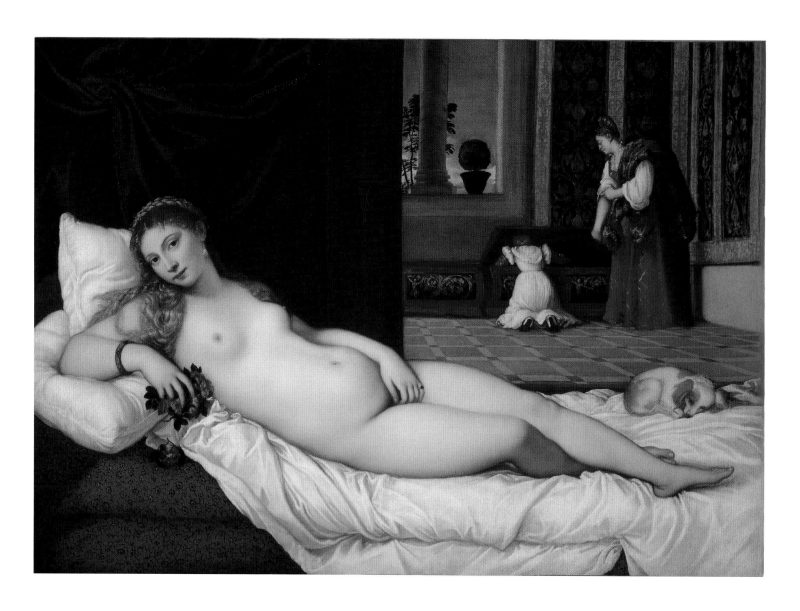

37 Titian, *Venus of Urbino*, 1538.
Uffizi, Florence

equivalent in about the fourth century BCE), among the rediscoveries of classi-
cal art during the Renaissance was an awakened sense of the beauty of the nude
female figure. By the early sixteenth century in Italy, the female nude was a
popular and celebrated form of beauty both in face and body. Kenneth Clark in
his well-known study of the nude (1976), compared it favourably to the naked
body (which embodies a sense of shame, as when we are 'deprived of our
clothes'); Clark saw the nude as 'a balanced, prosperous and confident body',[3] a
reference surely to the sensual amplitude created by clothes as well as to the full
body underneath. For the nude is more than merely a sleek and 'finished' figure
of a naked woman; it relies for effect on a sense of eroticism created by care-

fully disposed draperies, jewellery and make-up. It is, as Niphus suggested in his *De Pulchro et Amore* (1549), a harmonious assemblage of the senses – sight, obviously, but touch (softness of skin), taste (the lips), sound (the voice) and smell (flesh, hair, breath) – which serve to provoke desire.[4] This is the kind of nude made flesh in the form of Venus, not the celestial and chaste Venus, but Venus *naturalis*, described by Firenzuola as 'daughter of the Earth . . . earthly and sensual'.[5] 'Why doe they make Venus the mother of beauty?' asked Tommaso Buoni in 1605; the answer was that she was 'the mother of Love', and 'sayd to have been the fairest woman that ever was', and thus it follows that beauty is 'the proper ornament of Women'.[6] Clark suggested that the concept of Venus *naturalis* is essentially Venetian and cited as an example Titian's *Venus of Urbino* (fig. 37), a reclining nude – bride or courtesan, probably the latter. This is a Venus enjoying her beauty, while giving pleasure to both male and female viewer; such a woman, according to Giovanni Lomazzo's 1584 treatise on art, 'is found in every man's sense and minde . . . her motions are pleasant and mirthfull, being given to sportes, dalliances, dauncings and embracings'.[7] The contrast is made between the nudity of Venus, a sensuality heightened by the jewellery she wears, her unravelled and lightened hair and her made-up face, and the clothing worn by the servants who search through *cassoni* for their mistress's clothes.

Whether women appeared most beautiful when nude or when clothed was a subject for debate; perhaps Titian was referring to this in his painting *Sacred and Profane* (fig. 38), a work with a multitude of theories as to its meaning and who or what it represents. It was probably commissioned by Nicolò Aurelio for his wedding in 1514 to Laura Bagarotto of Padua, but it is not necessarily a portrait of the bride, naked or clothed; I think it is a visual discussion of beauty within a contrast between the sacred (Venus *coelestis*) and the profane (Venus *naturalis*). One is not meant to make a choice as to which Venus is *coelestis*, which *naturalis*, but to see both these figures as ideal women half sacred, half profane; it is the same woman with identical made-up face and long hair, frizzed and dyed according to Venetian custom. The glowing full-bodied nude is what one sees under the clothed Venus, whose soft ample dress in its turn reflects the curves of the body beneath. Firenzuola's book on the beauty of women declared that they were most beautiful when clothed in a way which drew attention to the swelling curves of the body; dress acts as a foil to the perfect features of the face, neck and bosom. Freud stated the obvious when he declared (in *Three Essays on Sexuality*, 1905) that clothes excite sexual curiosity, and this is especially so in Titian's painting when clothing is obviously seen as a second skin, drawing attention to what it envelops, just as the nude Venus's draperies highlight her flesh. Titian underlined the metaphorical nature of the two Venuses by what they wear, one in drapery and the other not (as Rona Goffen suggests in her book on *Titian's Women*[8]) in a specific bridal dress but a generalised version of fashionable

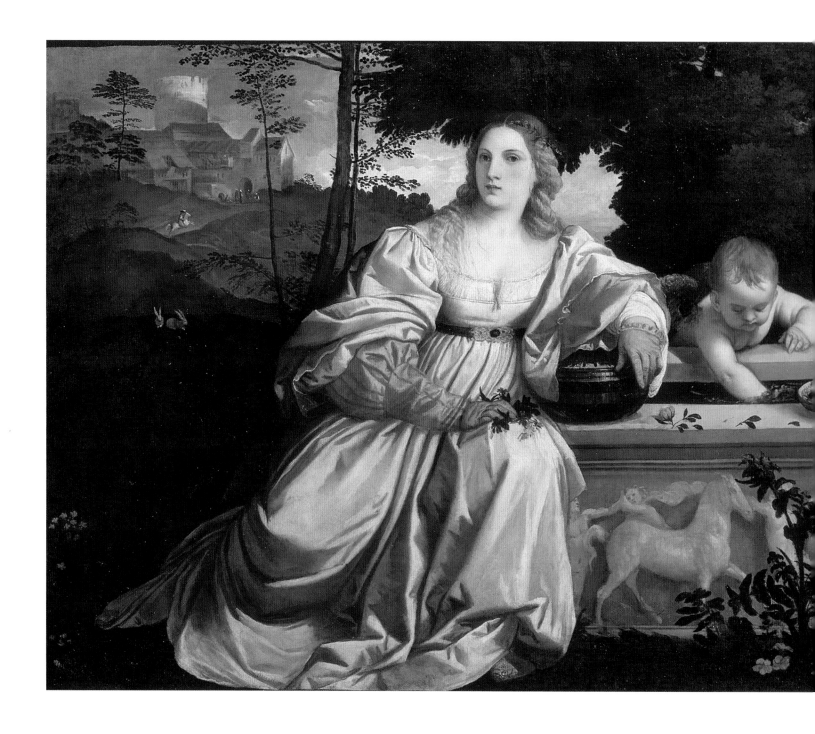

dress, with one red sleeve – the other is absent and not pushed up her arm. Both figures complement each other in red and white, the colours of love for the early Renaissance humanist and poet Petrarch; red signified beauty and passion, and white modesty and virtue. Moreover, red and white were the colours mingled perfectly together in the beautiful face, and of the cosmetics which mimicked and enhanced such beauty. So there is no opposition in Titian's paint-

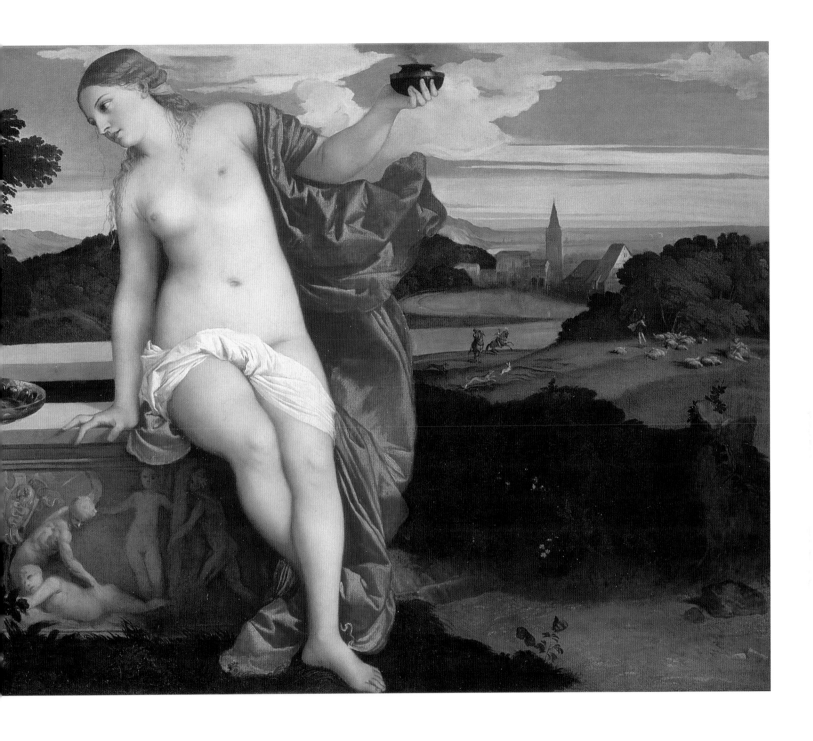

ing between clothes and nakedness, but a nuanced discourse about sensuality and beauty, about nature and artifice.

The format for many images of beautiful women in early sixteenth-century Italy was the half-length or the three-quarter length; full-length portraits – unless in the hands of a great master like Titian – could easily be overwhelmed by the elaborate costume of the period. Such 'portraits', whether of real women or

38 Titian, *Sacred and Profane Love*, c.1514. Galleria Borghese, Rome

generic beauties, were often given the title 'La Bella'; they were ideal and poetic. A 'portrait' by Palma Vecchio (an artist from Bergamo who worked in Venice), entitled *La Bella* of about 1520 (fig. 39), is possibly an ideal beauty, her silk gown, with its vast upper sleeves of red silk lined with blue, pushed to one side so one can see her pleated white linen shift; she has a perfect creamy skin, dark eyes, a long 'classical' nose and small red lips, and her dark brown hair is partly lightened to a tawny colour.

In 1509 the 'Renaissance' man (physician, soldier, lawyer, historian, theologian) Henricus Cornelius Agrippa, delivered a lecture on the pre-eminence of women at the university of Dôle; in 1529 it was published as *De nobilitate et praecellentia feminei* (On the nobility and pre-eminence of the female sex), and immediately translated into the major European languages. According to Agrippa, woman's superiority consists of:

> the wonderful softness of the female body to sight and touch, her tender flesh, her fair and clear complexion, her shiny skin, the beauty of her head decked with long silky hair shining and supple . . . her face the most fair of all creatures, her neck of a milky whiteness, her forehead large, high, noble. She has penetrating and sparkling eyes, which unite grace and an amiable gaiety; the slender arch of her eyebrows rises above them, between them a beautiful open space, descending from which is a nose straight and properly proportioned. Under her nose is a red mouth, which owes its beauty to the symmetrical disposition of her tender lips; when she smiles we see her dainty teeth, well placed, as white as ivory, less numerous however than those of men for woman is neither a glutton nor as aggressive as man. The cheeks and jaws impart to her a tender softness, a tinted rosy glow and modest demeanor; she has a delightful chin, round and with a charming dimple. Under this she has a slender neck, long enough, elevated above round shoulders. Her throat is delicate and white . . .[9]

This description, both general and specific, applies to many images of ideal beauty, both real and imaginary; Palma Vecchio's *La Bella* could be either. If a real woman, she could be a courtesan, for such women at the highest level of their profession were famous not only for their beauty but also their dress sense and their intelligence; it is not always easy to define the status of unidentified beauties in portraits at this period. Parmigianino's *Antea* of about 1531–4 (fig. 40) is a case in point, being variously described as a 'professional Roman courtesan',[10] an aristocrat, a bride, the artist's mistress and an ideal beauty. A recent exhibition catalogue explores these various identities, rejecting the notions of the sitter as mistress or courtesan, and concluding: 'In Parmigianino's *Antea*, the artist created a woman with whom the viewer could fall in love'.[11] Parmigianino depicted a beautiful woman with an oval, slightly pointed face, a long nose and

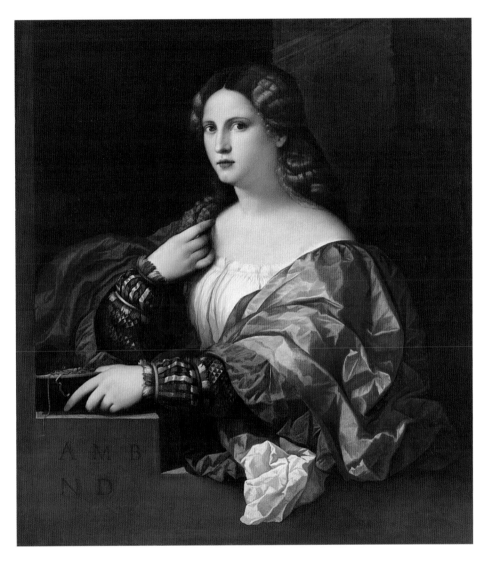

small pink lips – early sixteenth-century ideals of beauty, as Agrippa suggested; the jewelled ornament attached to her braided hair, her pearl earrings, her sumptuous costume and sable flea-fur over the shoulder indicate wealth, fashionability and refinement. The painting is typical of its kind in being a compromise between the ideal beauty and that of a real woman, verging more towards the latter in specificity of dress and ornament. It suggests desire but desire not necessarily limited to a sanctified relationship; Antea could as well be a courtesan as a bride.

Some courtesans, especially in Venice, were celebrated beauties, renowned all over Europe for their accomplishments; the word itself, *cortigiana*, is a feminine

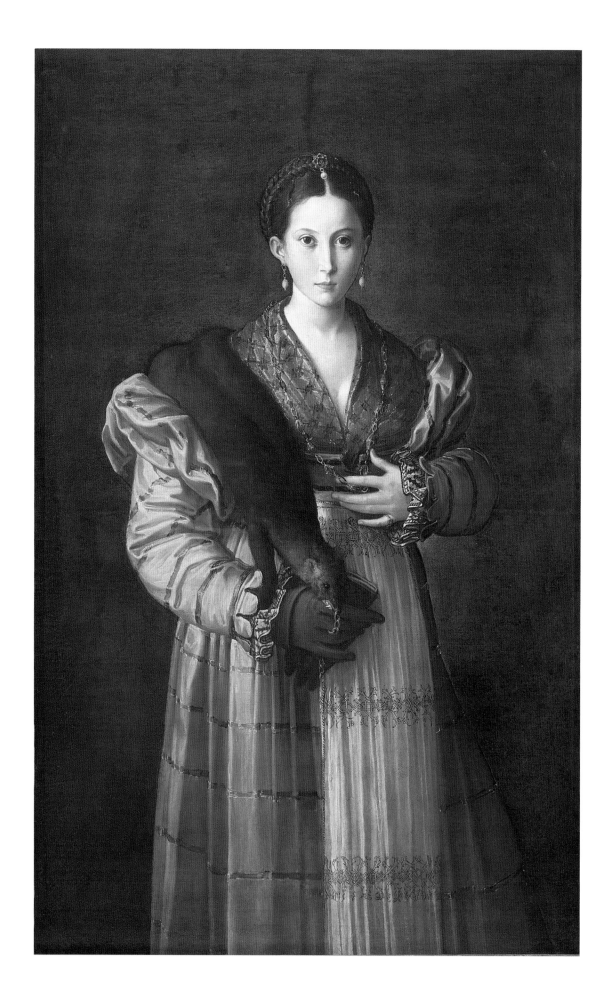

41 Follower of Jacopo Tintoretto, *A Woman, possibly Veronica Franco*, *c*.1575. Worcester Art Museum, Worcester, Mass., Austin S. Garver Fund and Sarah C. Garver Fund

version of *cortigiano* (courtier), a woman at home in the highest society. The Venetian courtesan Veronica Franco, who was also famous for her learning, declared: 'To succeed as a courtesan, a woman needed to be beautiful, sophisticated in her dress and manners, and an elegant, cultivated conversationalist'.[12] Her published letters include one to the artist Tintoretto in 1574 in which she wonders if his portrait of her was a trick to make her fall in love with herself;[13] this is perhaps the painting *A Woman, possibly Veronica Franco* (fig. 41) – the date certainly fits. Fashionably bejewelled and dressed in the Venetian style with a low-cut neckline – the English traveller Thomas Coryat noted how women 'do walke abroad with their breastes all naked . . . a fashion me thinkes very uncivill and unseemely'[14] – Franco's face is expertly made up, with reddened cheeks and lips

40 (*facing page*) Parmigianino, *Antea*, *c*.1531–4. Museo di Capodimonte, Naples

42 Thomas Coryat greeted by the courtesan Margarita Emiliana. Engraving from *Coryat's Crudities*, 1611. By permission of the Folger Shakespeare Library, Washington, DC.

43 (*facing page*) Palma Vecchio, *Blonde Woman*, c.1520. National Gallery, London

and possibly her nipple, her hair tightly curled and swept up off the face. Coryat, setting off in 1608 for a five-month tour of Europe, was intrigued by the 'noble & famous Cortezans' he saw in Venice, and visited one, not – he claims – out of 'wantonnesse' but just for knowledge. In the account of his travels, *Crudities*, published in 1611, 'Coryat greets the courtesan Margarita Emiliana' (fig. 42) and he informed his readers: 'her face is adorned with the quintessence of beauty. In her cheekes thou shalt see the Lilly and the Rose strive for the supremacy'; her hair had 'two frisled peakes standing up like pretty Pyramides'; after this initial enthusiasm, however, he deplored the fact that Emiliana's face was 'varnished' with 'paint'.[15]

One of the many facets of Venetian life that intrigued Coryat was the way in which fashionable women dyed their hair in order to become blonde, in a range of colours much admired. Firenzuola stated firmly that a beautiful woman should have hair 'sometimes similar to gold, sometimes to honey, sometimes like the bright rays of a clear sun'.[16] Federigo Luigini in his *Libro della bella Donna*, published in Venice in 1554, agreed that hair of 'clear shining gold' was 'the glory of women'; it should be 'long, thick, golden and softly curling . . . not hidden away in any net of gold or silk, but open to the gaze, so that each favoured mortal may behold it'.[17] Both ideal and real beauties were often depicted with blonde hair, as in Palma Vecchio's *Blonde Woman* of about 1520 (fig. 43); her linen *camicia* (shift) reveals the white skin praised by writers on beauty; Firenzuola thought that while the face should be 'fair', a colour he describes as white but with an ivory lustre, the bosom should be pure white.[18] As for her hair, it is clearly dyed, with the roots showing; artifice seems to have been deliberately cultivated by Venetian women, whether courtesans or not. To achieve this effect, Coryat reported how women 'doe use to anoint their haire with oyle, or some other drugs, to the end to make it looke faire, that is whitish. For that colour is most affected of the Venetian Dames and Lasses'; he then explained how they sat with a straw hat 'without any crowne at all', spreading their hair over the brims so they could 'sophisticate and dye' it.[19] Exposure to the sun as well as the various unguents used on the hair aided the transformation to the 'clear, shining gold' praised by Luigini. Venice in the sixteenth century appeared as 'un vaste paradis des Blondes'; contemporary beauty books and herbals had many recipes for dyeing the hair, including twenty-six in Giovanni Marinello's *Gli Ornamenti delle Donne* (1562), with such ingredients as vine ashes, lemons, white wine, alum and myrrh.[20] Other potions which created various yellow colours include – according to *The Secretes of the Reverende Maister Alexis of Piemont* (1555), attributed to the humanist Girolamo Ruscelli – rhubarb in white wine, and various lyes (solutions of potassium salts made by percolating rainwater through wood ashes), which could be scented with citrus fruits and flowers, and 'maketh the haire long, faire and yellow, like golde'.[21]

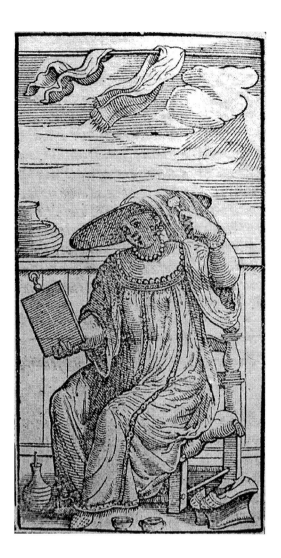

The most famous description, and depiction, of this custom is in Cesare Vecellio's costume book *Habiti Antichi et Moderni di tutto il mondo* (fig. 44). The women of Venice, he said, sit on their roof, mirror in hand and wearing a lightweight gown of silk (*habito di seta*), or of a very fine linen called *schiavanetto*, and on their head the crownless straw hat (*solana*); they apply to their hair various liquids (*diverse sorti di acqua*), with a little sponge (*sponzetta*). Such images appeared in a number of costume books[22] and caught the imagination of travellers to Venice as typical of the unique nature and curious customs of the Republic. They were recorded in travel books and journals, such as the *album amicorum* (a student scrapbook which contained autographs, emblems, mottoes, portraits, costume plates and topographical scenes of places visited). That created by the Scottish traveller Richard Balfour at the turn of the sixteenth century shows an illustration of a 'Venetian woman bleaching her hair' (fig. 45). It is inspired by Vecellio's well-

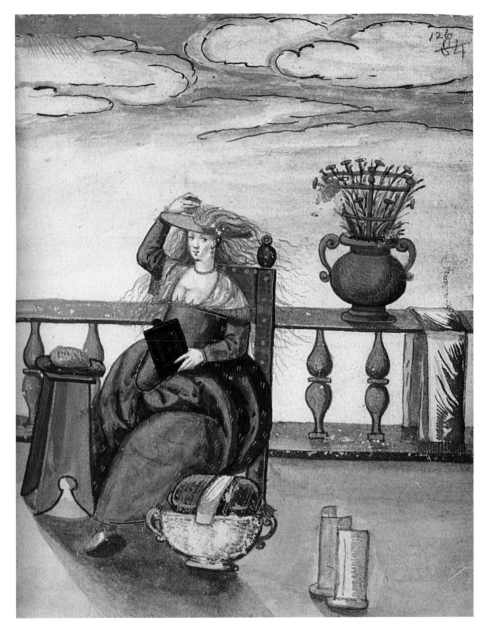

45 'Venetian Woman bleaching her Hair', from Richard Balfour, *Album Amicorum*, *c.*1598–*c.*1610. National Library of Scotland, Edinburgh

known image but informed by northern European perceptions of Venetian women and the features of their appearance – the 'breastes all naked' (in Coryat's phrase) above a low-necked dress with curved and stiffened stomacher, and the *chopines* (tall columns of cork attached to the shoes). Nice domestic touches here are the sewing basket and the vase of pinks or gillyflowers whose clove-scented flowers were widely used all over Europe in cosmetics and to scent linen and accessories such as gloves and handkerchiefs.

The mirror in such images is an essential aid to the creation of beauty and Venice manufactured the highest quality clear glass known as crystal; 'the secrets of Venetian glass and mirror making were carefully guarded because of their highly profitable revenues'.[23] Even in Bellini's image of ideal beauty, the *Young Woman at her Toilette*, there figures a cosmetic dish (*sponzarol* in Venetian dialect) (fig. 46), which might contain ceruse, a lead-based cosmetic for which Venice was famous.[24] The looking glass can sometimes refer to spirituality, 'the remembrance of the past, the ordering of the present, and the contemplation of the future'.[25] 'Reflection upon what we are and the attempt to transform that into what we should like to be, is . . . a process analogous to that of sitting in front of a mirror, and applying to our lips and cheeks the lustrous glow that nature forgot, begrudged, or eventually took away'.[26] Yet, looking into a mirror always implies self-esteem, the knowing of vanity; as the Dutch physician and philosopher Levinus Lemnius noted in his *Occulta naturae miracula* (1559):

> Looking-glasses that in our days are abused for luxury, and by which some women strive to make themselves beautifull, when they kemb [comb] and dresse themselves by them and paint their cheeks and eyes with stibium and other paints; the industry of wise nature intended for better uses, namely that we might deligently contemplate the dignity of the form of Man, and the excellency of the Divine workmanship . . . Such mirrors were recommended by the ancients so that we could learn how to lead an excellent course of Life . . .[27]

Especially (but not exclusively) in northern Europe, as a result of religious turmoil in the sixteenth century, ambivalence can be seen in male attitudes towards women adorning themselves with cosmetics. Such practices pandered to masculine pride in ownership of women who beautify themselves for men, but also led to fear of female power, enslavement of men by beauty. This is reflected in images of women in front of mirrors: 'in many cases apparently about to apply perfumes, those incitements to lust, or cosmetics, those deceptive corrupters of nature's handiwork'.[28] This is surely the implication behind a mid-sixteenth-century engraving of *Vanitas* by Cornelis Metsys (fig. 47), a satire on Venetian women's love of bodily display, of dyeing their hair (draped over the *solana*) and their extensive use of cosmetics and scents, indicated by the box on the floor and the containers on the shelf to the right. Between the two containers is a vase labelled 'Vanitas', a possible satirical reference to Firenzuola's equation of female beauty with antique vases (discussed in more detail later in this section): he refers to a woman's shoulders rising a little 'in the manner of handles from an ancient vase crafted by a master'.[29]

By this time, representations of perfect beauty in art had extended beyond Italy, most famously in the portraits attributed to François Clouet, the main court

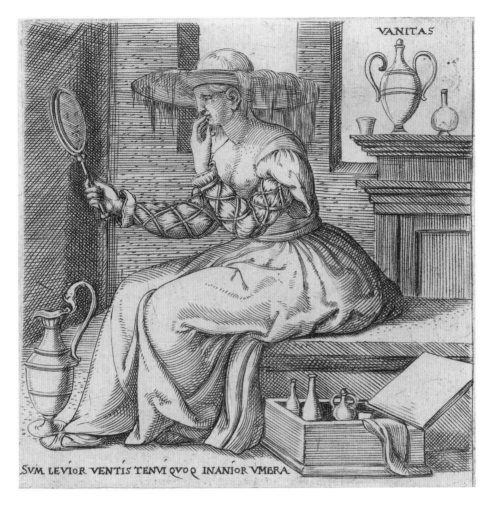

VANITAS

SVM LEVIOR VENTIS TENVI QVOQ INANIOR VMBRA

painter in mid-sixteenth-century France, one of the Fontainebleau School of artists (including Italians) who worked at the eponymous royal palace. A portrait, *Woman at her Toilette* (fig. 48), is typical of the influence of Mannerist Italian art, with its refinement and elegance, on contemporary French painting; it is a style perfectly suited to the depiction in detail of costly and luxurious costume and accessories. Sometimes taken to be Diane de Poitiers, the mistress of Henri II of France, the identity of the sitter is not firmly established; it might be copied from a lost original by Clouet.[30] As with similar contemporary Italian images, one is perhaps meant to see both an ideal beauty and a real woman, carefully posed beside the mirror supported by two caryatids, while – as in Titian's *Venus of Urbino* – a servant searches in a chest for the clothes her mistress will wear. What she wears is a transparent silk mantle embroidered in gold and attached to a small frilled collar, wonderfully impractical and serving only to draw atten-

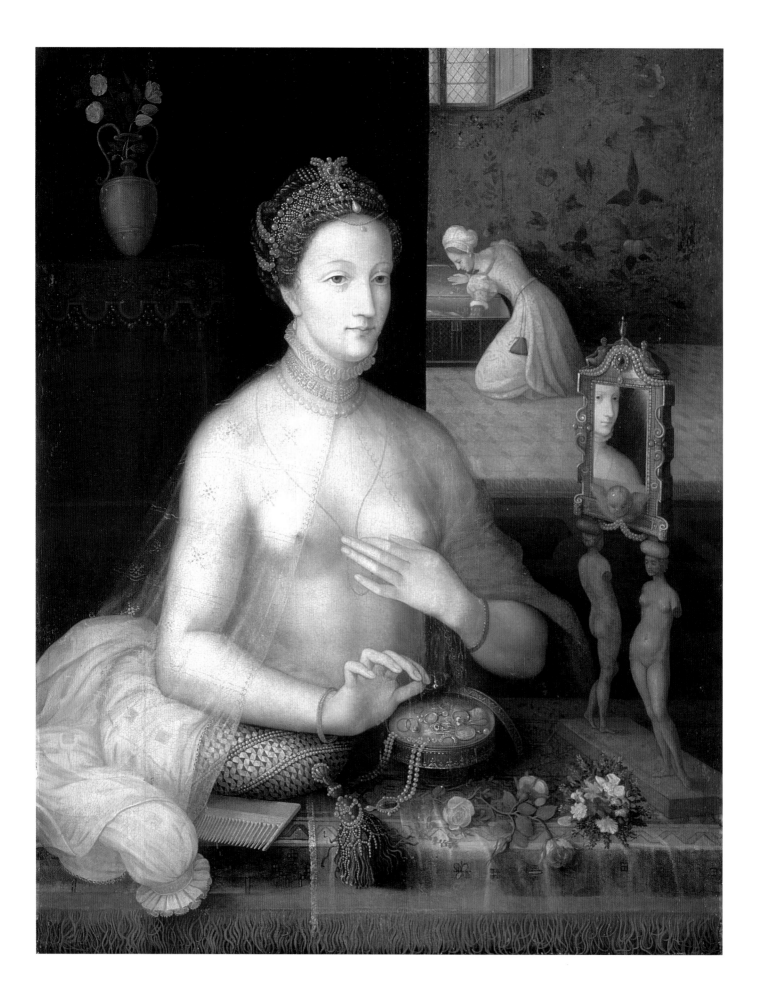

tion to her naked body and breasts. Her perfectly oval face is the paradigm north-ern beauty, finely boned, with large blue eyes, eyebrows plucked and pencilled to create a delicate arch, a long straight nose and a firm mouth with slightly tinted lips.

Discussion of what beauty was, how it could be defined in art and in litera-ture, and what forms it took with regard to the realities of women's appearance, became an absorbing and courtly pastime. In Renaissance Italy the 'conventions of dress and etiquette were founded upon a belief that outward beauty symbol-ized an inner grace';[31] beauty, claimed Castiglione, was a sign of the divine, of virtue. In *De Pulchro et Amore*, Niphus most admired a woman who unites beauty of soul and body, but he found it easier to describe the latter: she had to be elegant and graceful, with a well-proportioned figure, a perfect complexion, to have long hair with gold reflections, blue eyes and a voice like a goddess.[32] In art it sometimes appears that rules for ideal beauty tended to create a lack of individuality in portraits of beautiful women, echoed by the cosmetics used, but it is important to remember that portraits were commissioned to celebrate their subjects according to conventional ideas of beauty. These ideas were also reflected in literature, in the Petrarchan notion that words could best depict beauty; trea-tises on beauty, as Mary Rogers noted, were 'literary portraits of ideal beauties as if specimens of painting or sculpture, rivalling the famed female creations of revered antique artists'.[33] Conduct manuals treated the character and appearance of a woman as part of a holistic concept of the beautiful; for Castiglione in his influential book *The Courtier* (published in 1528 and in sixty editions during the century), beauty was part of aesthetic behaviour regulated by society. Women's dress should be appropriate to their status, rich but not gaudy, and the qualities of deportment and grace were essential components of their beauty. It was important for a woman to be physically beautiful (or to try to be so), as a cour-tesy to others, and thus cosmetics were allowable as long as they were used in moderation. These themes appear over and over again throughout the century, as the idea of dress and appearance being pleasing to others began (unevenly at times) to replace the traditional Biblical belief that such things were indicative of pride and vanity. Firenzuola's book *On the Beauty of Women* emphasised the importance of *leggiadria*, defined as innate elegance, grace, balance, movement and modesty, *maestà* (majesty and good deportment), and *sprezzatura* or the art to conceal art,[34] an elegant dissimulation also discussed by Castiglione's *Courtier*. The *Galateo*, a courtesy book composed in Venice early in the 1550s by Giovanni della Casa, the Archbishop of Benevento, who was also an accomplished poet, advo-cated a grave and respectable charm of manner as the ideal in refined society and, like Castiglione, underlined the importance of fine clothes and beauty of appearance as essential to one's own self-respect and as a courtesy to other people, to the wider community as a whole. More specific advice on the complemen-

48 (*facing page*) School of Fontainebleau, *Woman at her Toilette*, c.1555–65. Worcester Art Museum, Worcester, Mass.

tarity of dress and beauty appeared in Alexander Piccolomini's *Dialogo de la bella creanza de le donne* (A Dialogue of the Fair Perfectioning of Ladies), published in Venice in 1540. The dialogue (which takes place in Siena) is in the form of advice given by an older woman Raffaella to a young woman Margaret, while the latter's husband is away. It includes tips on how to choose clothes – the colours should suit the complexion and the finest linen should be worn – how to dress with elegance, and to show off one's good points, and how to achieve a 'clear, white and delicate' skin with the aid of a modest use of cosmetics.

Yet, although a beautiful woman's appearance was to be considered as a whole, it was the face which was most discussed. 'Why is the Beauty of Women especially seene in the Face?', asked Tommaso Buoni in *I Problemi della bellezza* in 1605. The answer is that one sees the face first, and there can be discerned 'the true resemblance both of the Beauty of the Body and of the Minde . . . as it were in a cleare looking glasse';[35] in Robert Burton's *Anatomy of Melancholy* (1621), the face was 'beauties Tower . . . and of it selfe alone able to captivate'.[36] A number of discourses in the Renaissance tried to classify beauty by Vitruvian proportions, which, Kenneth Clark contended, offered 'exactly that link between sensation and order, between an organic and a geometric basis of beauty which was (and perhaps remains) the philosopher's stone of aesthetics'.[37] Debates on the exact relationship of one part of the face to another – whether there should be equal space from the hairline to the eyebrow as from the brow to the nostrils, and from the nostrils to the chin; whether the height of the ear and the nose should be equal; whether the width of the mouth should be one and a half times that of the nose, and so on[38] – were as enlightening as the medieval notion of how many angels could dance on the head of a pin. Another debate focused on whether proportion or colour was the best guide to beauty, the general consensus being for the former. Annibale Romei in *The Courtier's Academie* of 1598 favoured proportion because it signified harmony and delight – there was, he claimed, nothing good 'in the universall world without proportion' – and declared that as for colour, this could easily be counterfeited by women who 'imploy all their industrie in the beautie of colours, by making their haire like the shining colour of gold, the cheeks like to white lilies and red roses, the lips to rubies, the teeth to the orient whitenes of pearle'.[39]

Firenzuola was one of the writers who tried to adapt Vitruvian concepts to female beauty, listing in some detail the ideal proportions of the face; he suggested, for example, that the tip of the chin to the top of the upper lip should be equal to the distance from the top of the nose to the hairline, and that from the top of the upper lip to the beginning of the nose should be the same as 'from the inner corner of the eye to the middle of the bridge of the nose'. At the same time he admitted the mysterious qualities in beauty, 'because we cannot explain why that white chin, those red lips, those black eyes . . . should produce,

*Vedete come quel collo del uaso primo si rileua in sule
spalle, & quanta gratia da al corpo del uaso la sot*

or arouse, or result in beauty'.[40] He is informative when talking of beauty in
terms that are both 'poetic' and specific; the lips, for example, should 'seem to
be of finest coral, like the edges of a most beautiful fountain', and the teeth
should be perfect, for if not 'laughter cannot be beautiful'.[41] Firenzuola's treatise
on the beauty of women (*Discorsi delle bellesse delle Donne*), dedicated to the ladies
of Prato in 1541 and published in Florence in 1548, was 'probably the most
complete exposition of the beauty of the ideal woman among the multitude of
sixteenth-century treatments of the theme'[42] and thus deserving extended
discussion here.

The author – lawyer, *bon viveur* and man of the world – used the well-
established literary convention of a dialogue to expound his ideas on beauty;
the conversation takes place between one man (Celso, that is, Firenzuola) and
four women, representing the Renaissance humours, or natural elements – earth,
fire, air and water – to reveal aspects of the perfect beauty, a selection akin to
that made by the painter Zeuxis in antiquity. For Firenzuola, a woman's beauty
consisted only of the parts of her body on display, from the face to the breast,
and also the hands. In particular he was obsessed by an analogy between the
shapes of antique vases (fig. 49) and women's beauty; he likens the perfect vase
(the first on the left) to a woman 'with a long and slender throat, and wide,
graceful shoulders', and explains how such a vase can show how the body rises
up from the waist to the throat with an emphasis on the 'fresh and lively' breasts.[43]
There is a clear influence of Mannerist art in his love of the elongated shapes
of such vases.

Firenzuola concentrates mainly on the head, for, he explains, this is how one
can take the measure of the whole person ('& cosi vedete che dalla testa si piglia
la misura di tutta la persona, quella della testa'); the profile was the important
test for beauty which only a few women could pass, and which artists, he
claimed, resolve into a triangle as representing perfection (fig. 51),[44] at which
point the discussion becomes mired in technical detail about ideal geometrical
proportions. If one looks at Bronzino's *Allegory with Venus and Cupid* (fig. 52) –

51 (*right*) 'Profile' from Agnolo
Firenzuola's *Discorsi delle bellesse delle
Donne*, Florence 1548. British Library,
London

52 (*below right*) Bronzino,
An Allegory with Venus and Cupid
(detail), *c*.1545. National Gallery,
London

preſſo de i Greci, fu connumerata tra le arti li=
berali.

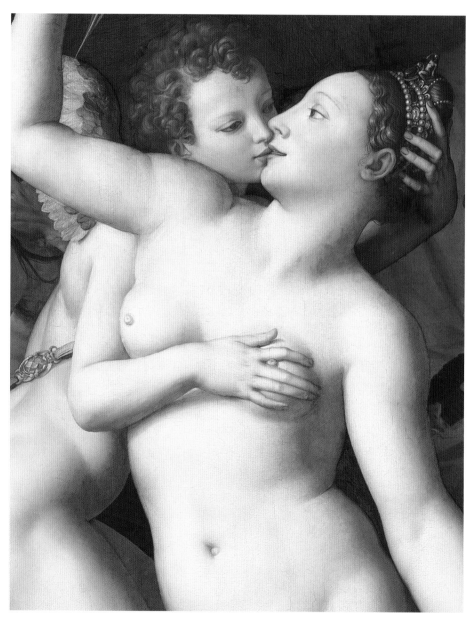

a highly complex and perplexing painting probably of the 1540s – one can see in Venus a perfect profile with a triangular configuration of the kind discussed and illustrated in Firenzuola's work. Possibly commissioned by Cosimo de Medici for François I of France, the focus of the painting is a nude Venus, whose nipple is being fondled by an androgynous Cupid, whom she kisses. Her face is the paradigm of mid-century beauty, polished (like her body), with lightly rouged cheeks and plucked eyebrows; it has to be a work of art and artifice, fit to be set against her carefully curled hair and rich, jewelled headdress. In the light of Bronzino's Venus, Firenzuola's ideal beauty has similar features: long, curling blonde hair, a forehead twice as wide as high, the eyebrows perfect arches and 'fine as silk', eyes of blue or chestnut colour, soft and small ears like pale pink roses or balas rubies, ivory-white cheeks flushed with vermilion, a slightly pointed nose (a turned-up nose would spoil the profile), a smallish mouth with red lips (if the teeth are revealed, it should only be a few upper teeth), a long slender neck, and soft ample shoulders.[45]

On the question as to whether the clothed or the naked beauty was the most perfect, Federigo Luigini chose the latter, or at least the semi-dressed or half-*un*dressed woman, as in Palma Vecchio's voluptuous *Blonde Woman* (see fig. 43). Luigini's *Libro della bella Donna*, published in Venice in 1554, followed a traditional formula; it is set in a villa where the author and his four male friends 'paint' the perfect woman, created from the best features of their mistresses. The resulting composite beauty was poetically conventional – fine golden hair, eyes 'black like the skin of an over-ripe olive, velvety, fathomless, yet shining like twin caverns of gold', cheeks soft and smooth like silk 'and touched with a fresh, faint blush, like the morning's earliest rose, and a throat like the marble of Paros', and 'whiter than untrodden snow, newly fallen from heaven'. More interesting, as it proved a point of contention in the discussion, was women's use of cosmetics, most of the conversation revolving round the dangerous nature of lead-based paints. Light floral scents and unguents were permissible ('Venus used them to adorn her golden tresses') and they 'have a most refreshing effect on the mind, and comfort and raise the spirits'. In an ideal world, it was noted, women should be content with the faces nature has given them, and some do not need their beauty enhanced; but others insist that 'their natural beauty is increased if they adorn themselves, if they take pains to make them beautiful'.[46] As for the clothed beauty, those in support suggested that not only did fine clothes give an air of princely magnificence to a woman but they also served as a foil to her features and especially to the pink and white of her complexion. A portrait of a woman attributed to Scipione Pulzone (fig. 53) shows how the beauty of the face can appear as a piquant contrast to the complexities and richness of Renaissance costume; dated to about 1575, the sitter is probably Italian, wearing Spanish-influenced dress with over-sleeves slit down the front seam to reveal the bodice

beneath.[47] The artist dwells on the rich fabrics of her dress – rose-coloured, gold-braided velvet with acorn-shaped buttons, and a ruff of fine Italian *reticella* lace – and the beautiful enamelled and jewelled headband. Her auburn hair forms a heart-shape frame to her face, curling where it dips in the centre, her features striking in their beauty and enhanced by subtle artifice – the creamy pale skin with the delicate rose tinge to her cheeks admired by Luigini, the lips of 'finest coral' listed by Firenzuola as a requisite of beauty, and huge hazel eyes with dark eyebrows. Eyes were a focal point of beauty, often equated in verse to shining stars; they cannot, however, show emotion and their impact lies in how they are used, by the ways that the eye muscles can be moved – the sideways glance, the lidded glance, the fluttering of the eyelids and so on. The appearance of emotion could be created by dilating the pupils of the eyes with atropine (from belladonna, extracted from the berries of deadly nightshade), which made the eyes seem darker and more glistening; although dangerous, it was especially popular in the sixteenth century with Italian women – thus the plant's name. Art to conceal art, *sprezzatura*, was applied to both behaviour and appearance, to dress and to make-up. Cosmetics were accepted if used with moderation, as an essential part of 'the Fair Perfectioning of Ladies' which Piccolomini described: Raffaella tells Margaret that 'a young lady could not have a complexion so clear, white and delicate if she did not aid it to some degree . . . with art. And they do not reason well who say that a lady, so she have a fair complexion by nature, may ever thereafter set it at naught and neglect it'.[48]

The *querelle des femmes*, initiated by Christine de Pisan early in the fifteenth century, encouraged lively debate as to the superiority of the female sex and urged greater freedoms for them in society. An important work, clearly indebted to Agrippa's work on the pre-eminence of the female sex, was Lucrezia Marinella's *The Nobility and Excellence of Women and the Defects and Vices of Men* (published in Venice in 1600), in which she declared that men – themselves often 'ornate, polished, painted and bleached' – have no right to criticise women for improving their appearance, because they were entitled to preserve and enhance their beauty; 'women who are born beautiful should conserve their beauty, and women who lack beauty should improve themselves' – sentiments which resonated down the centuries and are still applicable today:

> Why should it be a sin if a woman born with considerable beauty washes her delicate face with lemon juice and the water of beanflowers and privets in order to remove her freckles and keep her skin soft and clean? Or if with columbine, white bread, lemon juice and pearls she creates some other potion to keep her face clean and soft? I believe it to be merely a small one. If roses do not flame within the lily pallor of her face, could she not, with some art, create a similar effect? . . . And if writers and poets, both ancient and modern, say that her golden hair enhances her beauty, why should she not color it blonde and make ringlets and curls in it so as to embellish it still further?[49]

53 (*facing page*) Scipione Pulzone (attr.), *Unknown Woman*, c.1575. Private collection

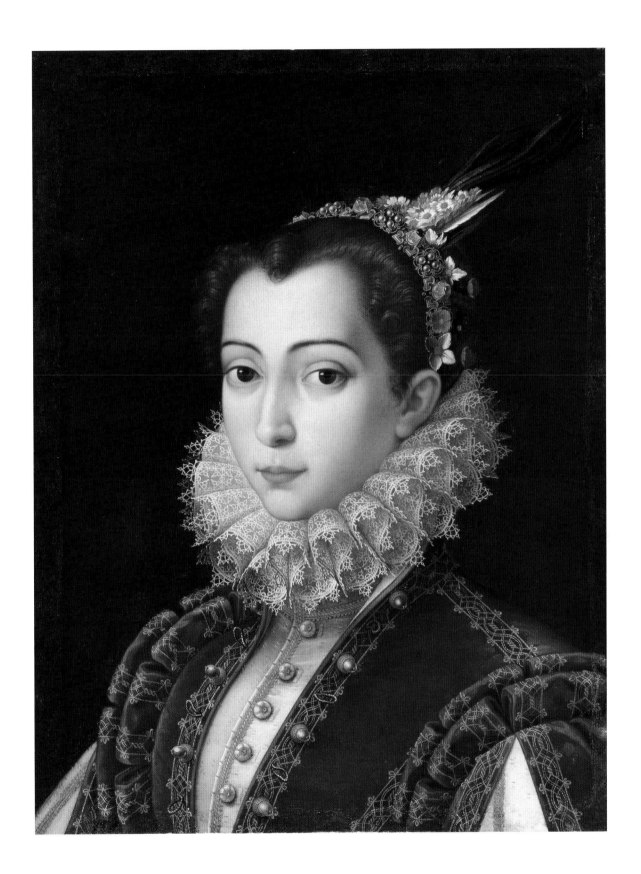

At this point, I should underline the differences between cosmetics and paint, although the terms sometimes overlapped. One of the female discussants in Firenzuola's *Discorsi*, for example, seems to confuse the two, complaining that 'waters and powders were invented in order to remove scales or freckles and other such marks, and today they are used to paint and to whiten the face, not unlike plaster or gypsum on the surface of walls'.[50] Strictly speaking, the word cosmetics meant the various potions, mainly from plants, fruits, vegetables and other natural ingredients, which helped the health and general appearance of the skin and hair; as for paint, this referred to the mineral substances, often poisonous, which were applied to the skin and which could dramatically change the appearance of those wearing them. Giambattista della Porta's *Magiae Naturalis* (*Natural Magick*) gave an unpleasant tip to men who wished to know if a woman used paint:

> If you would know a painted Face, do thus: Chew Saffron between your Teeth, and stand neer to a woman . . . when you talk with her, your breath will foul her Face, and make it yellowish; but if she bee not painted, the natural colour will continue. Or burn Brimstone in the room where she is: for if there be Ceruss or Mercury sublimate on her Face, the smoak will make her brown or black . . .[51]

Most writers dealing with women's beauty (and even critics of female appearance) made a clear distinction between cosmetics, which were usually approved of, and paint, which was condemned. However, many recipes were listed for making paint and unhealthy ingredients found their way into skin preparations which were ostensibly merely cosmetics. When, from the mid-nineteenth century, the wearing of dangerous paints was in decline, the word cosmetics came to mean both skin care and make-up; from the end of the century, the term 'beauty' became popular, encompassing diet, exercise and manipulative practices such as massage, depilation, and – as today – increasingly invasive practices akin to aesthetic surgery. In this book I tend to use 'cosmetics' as a portmanteau word for any kind of embellishment to the face, as it is not always clear whether, for example in painting, make-up or paint is used.

Marinella's father, the physician and philosopher Giovanni Marinello, is sometimes regarded as the father of cosmetology; he was the author of a book defending cosmetics as an aid to beauty, *Gli Ornamenti delle Donne* (1562) whose recipes for improving the complexion were the main source for Jean Liébault's *Trois Livres de l'embellissement et ornement du corps humain*, published in Paris in 1582. The colour and texture of the skin was particularly important and needed help if it was to be delicate, tender, transparent, fresh and polished, as Liébault insisted was *de rigueur* for beauty in women.[52] To keep the skin soft and moisturised the best soap was that of Castile, as it contained olive oil, more expensive than wash-

54 (facing page) Scipione Pulzone (attr.), *Unknown Woman* (detail of fig. 53)

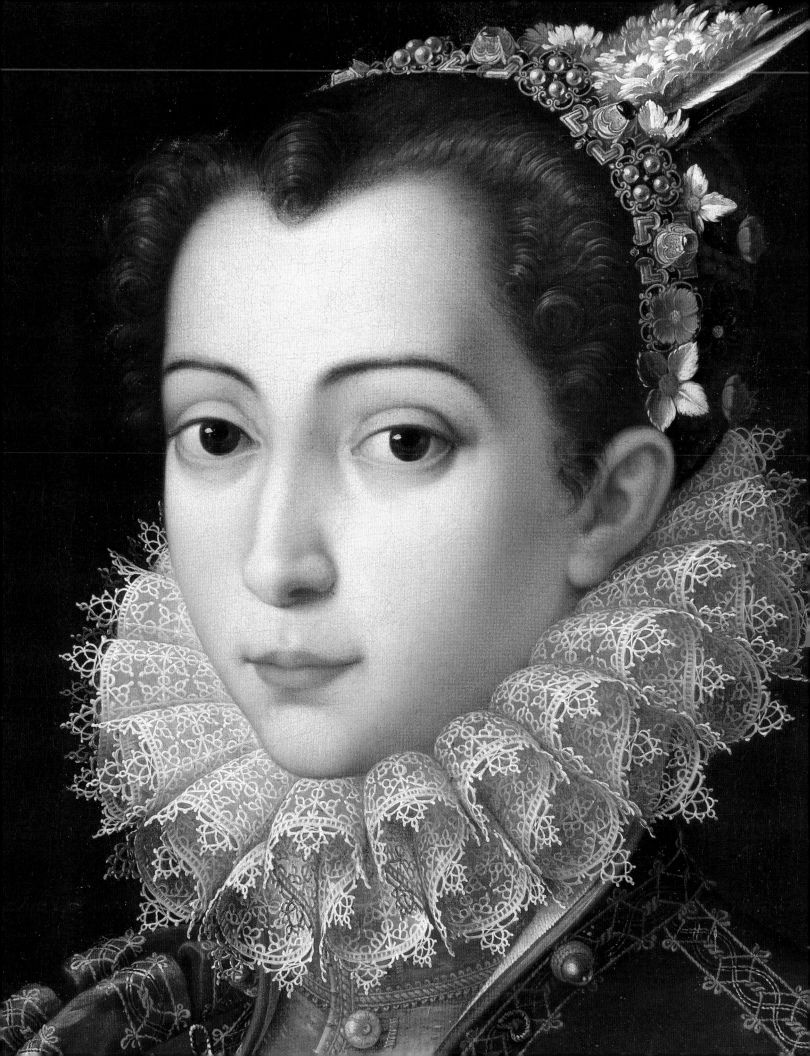

balls, which were often made of cheaper soap mixed with spices or aromatic herbs, and sometimes included ceruse to whiten the skin.

Also recommended were lotions made from almonds, and cold cream, supposedly invented by the Greek physician Galen in the second century CE. This was an emulsion of oil and water, melted with beeswax and then scented; it was cool on the skin, hence its name, and it could also be applied to cloths placed on the forehead to remove wrinkles. To clear the complexion of blemishes and whiten the skin naturally, women were advised by Marinello (as his daughter Lucrezia suggested) to use flower washes, water in which beans had been boiled, lemon juice and soaked breadcrumbs. These preparations were safe alternatives to the fashionable but dangerous lotions such as ceruse and mercury, or alum (aluminium potassium sulphate) which was a powerful astringent, skin whitener and hair brightener. Other recipe books suggested rose-water (an Arab invention which used attar of roses), a lotion made from camphor roots, egg whites, mustard mixed with honey, urine (urea has disinfectant qualities and a synthetic version is used in skin creams today), snake fat (snakes grow a new skin every year) and others. The popular *Secretes of the Reverende Maister Alexis of Piemont Containyng excellente remedies against divers diseases, woundes, and other accidents, with the manner to make distillations, parfumes, confitures . . . colours, fusions and meltynges*, is typical of sixteenth-century (and later) recipe books; there are recipes for cookery and for medical conditions, as well as tips for improving the skin, such as a solution of borax, which 'maketh the skinne very white, fine and cleane', and cosmetic recipes, such as 'a Water of Whyte Melons that maketh a fair Skinne', and rosemary flowers boiled in white wine, which could then be drunk to sweeten the breath.[53] This was necessary as a bad diet, the use of paint and primitive dentistry led to decayed teeth, which is why – although hymned as pearls by poets – they rarely appear in portraits. Recipes suggest that they were cleaned with a linen cloth, followed by various mouth washes, such as honey mixed with vinegar, white wine, strawberry water, powdered tree bark, powdered alum, and even vitriol (sulphuric acid). If the worst came to the worst and the teeth fell out, they could be replaced by false teeth made of bone or ivory, if this could be afforded, but of wood for the less wealthy; inevitably this resulted in the loss of beauty and often caused difficulties in speaking and eating.

Although apothecaries made up recipes for enhancing beauty, similar to those published in the beauty books, women who were skilled enough could prepare their own, many of which were complicated and time-consuming. Piccolomini's *Raffaella* gave a recipe for a famous skin lotion made with pigeons, versions of which remained popular into the eighteenth century. Rather gruesome to modern readers, the recipe required 'a pair of pigeons plucked asunder', stuffed with 'Venice turpentine', lilies, eggs, honey, sea-periwinkles, ground pearls and camphire, and cooked slowly in a glass vial. Into the resulting liquid was infused musk, ambergris, more pearls and 'shreds of silver' (silver is recognised today as

ÆTATIS · SVÆ 21

ANᵒ DOMINY 2 ⁶
1569

a powerful anti-bacterial agent); this lotion was then clarified 'and it becomes a most rare thing'.[54]

The ideal face was a confection of white, pink and red: a whitened skin, tinged with pink on the cheeks, and red lips. In northern Europe, the emphasis was on an almost unnaturally white skin, as can be seen in an anonymous British School portrait of a young woman, of 1569 (fig. 55), tentatively identified as a Swedish

maid-of-honour to Elizabeth I, whose hair (in shades of red and amber) and fine bone structure set standards of beauty at the English court. The jewelled rock-roses in the young woman's velvet cap, the roses embroidered on her white sleeves and the pink placed by her ear (the pink of perfection) are the counterparts of the white and pink of her complexion; little eye make-up is used, except possibly a touch of henna pink shadow, so it was important for the eyes to be large and well shaped, not set too deeply into the head. Elizabeth I was the paradigm of beauty in elite English circles during the second half of the century, celebrated in verse even as an old woman, by which time she had become a kind of dazzling painted icon, depicted in her portraits from the 1580s onwards, a physical presence created by elaborate and patterned clothing loaded with jewellery, and a mask-like face. In a portrait attributed to the queen's Serjeant Painter George Gower of about 1588 (fig. 56), she is shown in an amber-coloured wig (she had a vast 'wardrobe' of wigs in shades of red and gold) on which is set a headdress of diamonds and pearls. Her face is painted white, the fineness of the skin emphasised by the veins on the temple, painted with woad or indigo mixed with ceruse (see fig. 62); the eyebrows are barely visible, the cheeks tinged with pink and the lips reddened. Such an image has little in the way of nuances of light and shade, and the face is almost heraldic in the stark depiction of the painted features; subtle cosmetics could never compete with such an extraordinary costume, with its vast farthingale, 'great sleeves and bombasted shoulders, squared in breadth to make theyr wastes small', as William Averell describes it in his *Mervailous combat of contrarities* (1588). This is a period when elite women's costume was immensely ornate and complex; Tommaso Buoni suggested in 1605 that dress was necessary to complement beauty:

> They crowne themselves with golde and silver, deck themselves with pendants, bracelets, embroderinges, chaines, girdells, ringes, and a thousand tires of sundry fassions. They make a glorious shew with their feathers and fannes, and pearles, and crestes, with their hanging sleeves, their furres of sable, their garments of satine, silke, damaske, velvet, tinsell, cloath of golde, and a thousand the like . . .[55]

'Naturall Beauty', claimed Robert Burton, 'is a strong loadstone of it selfe . . . and pierceth to the very heart, but more when those artificiall entisements and provocations of . . . Clothes, Jewels, Pigments . . . shall be annexed unto it'.[56] Nanette Salomon rightly notes how portraits of Elizabeth I are influenced by the Mannerist style 'with its emphasis on artifice and *maniera*', rather than the reality of the Netherlandish tradition, or paintings by Venetian artists who use 'glorious passages of oil paint' to achieve the 'sensuous absorption of the viewer through the physical into the inner life of the sitter'.[57] With portraits of Elizabeth, there is a symbolic reality that reflects her power and unique position

among other rulers in Europe, and a 'poetic' reality, an exaggerated definition of
her femininity as the Virgin Queen (thus, the emphasis on pearls which were
thought to signify virginity and chastity). Critics like John Knox in his denun-
ciation of the rule of women – 'repugnant to nature, contumelie to God . . . the
subversion of good order, of all equitie and justice' – remarked how 'women in
authority prefer vanity to virtue, ambition and pride to temperancy and
modesty'.[58] Portraits of Elizabeth in later life were more political and cultural
statements than reflections of reality, as the famous description of the queen in
1598 by the German lawyer Paul Hentzner might indicate. She was, he said: 'very
majestic; her face oblong, fair but wrinkled; her eyes small, yet black and pleas-
ant; her nose a little hooked, her lips narrow, and her teeth black [which he
attributed to the English fondness for sugar, but which might be the result of

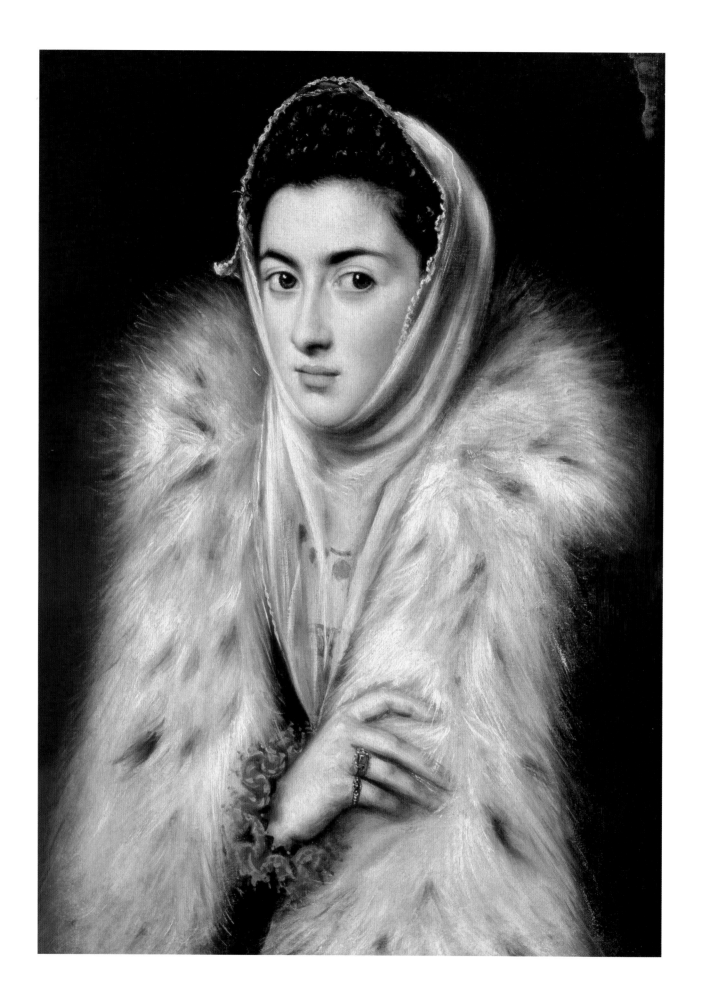

using lead make-up] . . . her hair was of an auburn colour, but false [*crinem fuvum, sed factitium*]'.[59]

The most widely used cosmetic in the Renaissance was ceruse, from the Latin *cerussa* (lead), which was made by exposing lead plates to the vapour of vinegar. Although highly poisonous, it was popular because it went on smoothly and adhered well to the skin; it was widely used well into the eighteenth century. When mixed with colour, it became paint and could also be made into face powder, although safer powders of perfumed starch or alabaster, or crushed mother-of-pearl, were available. As for cosmetics which added red to the cheeks, a rouge known as vermilion could be made of ceruse to which was added such colouring dyes as ochre, madder, sandalwood and henna; in the fifteenth century the red brazilwood tree, found in the East Indies and in South America, was discovered to be a useful cosmetic source for shades of pink. Most famous of all reds was cochineal (from the dried bodies of insects who live on the *coccus* cacti in Mexico), first seen in 1519 by the conquistadores, and this new red dyestuff soon reached Spain and then wider Europe.[60] Most of the cochineal in Europe was used for dyeing textiles but it proved highly popular for cosmetic applications such as rouge and for lip salves – soft pastes or 'pencils' made from 'ground alabaster or plaster of Paris which was powdered down and mixed into a paste with a colouring ingredient . . . rolled into a crayon shape, then allowed to dry and solidify in the sun'.[61] By the late sixteenth century, rouge was regarded as an essential attribute to artificial beauty; it could take liquid or paste form, or be applied to the face from little booklets of paper or leather impregnated with red powdered dye. Spain was – unsurprisingly in view of the early Spanish monopoly of cochineal – famous for its rouge. El Greco's problematic *Woman in a Fur Mantle* (fig. 57)[62] is a portrait of a dark-haired beauty swathed in lynx fur. Her face is a perfect oval, with large, dark eyes and a long, delicate nose. The even perfection of the complexion suggests the use of ceruse, with colour (rouge) on the cheeks and red on the lips.

A Metamorphosis of Fair Faces

What thou lovest in her face is colour, and painting gives that, but thou hatest it. Foole, whom ignorance makes happy, the Starres, the Sun, the Skye whom thou admires, alas, have no colour, but are faire because they seemeth to be coloured.

John Donne *Paradoxes and Problemes*, 1633

Donne's Paradox II, 'That Women ought to paint', is typical of the brilliant and tongue-in-cheek aspect of much of his juvenile work of the 1590s; he notes that as we mend houses and clothes when they fall into disrepair, so – where women

57 (*facing page*) El Greco, *Woman in a Fur Mantle*, 1590s. Pollok House, Glasgow, Stirling Maxwell Collection

are concerned – why not help the face, 'as it bee more precisely regarded', with cosmetics, 'an easie and ready way of repairing'.[63] Is this intended as a satire on face paint as the equivalent of building repairs? Or is one to see here an attack on men's confused attitudes to female appearance, and an acceptance of a woman's right to paint her face?

The 1590s – a decade in which extremes of dress and make-up manifest in Englishwomen's appearance led to increasingly critical comment – also saw conventional notions of beauty beginning to be questioned. Shakespeare most famously turned upside down the established poetics regarding female beauty in Sonnet 80:

> My mistress' eyes are nothing like the sun,
> Coral is far more red than her lips' red:
> If snow be white, why then her breasts are dun . . .
> I have seen roses damask'd red and white,
> But no such roses see I in her cheeks

Far less famous (in fact, completely unknown) as an author is Anthony Gibson – 'one that hath heard much, seene much, but knowes a great deale more': *A Woman's Woorth defended against all the Men in the World* (1599) is clearly indebted to such works as Agrippa's book on the pre-eminence of women (described in the first section of this chapter). Gibson discussed women's beauty, and reconsidered the conventional ideas of a white and pink complexion, in a poem addressed by a dark-skinned woman to her lover:

> My Love, I am a little blacke
> But say that I were much more blacke,
> Mine eyes browne, my face like browne
> Admit my neck and brests more browne.
> My haire and skin all blacke to be,
> Saving my teeth of Ivorie
> Invironed with a corroll fence,
> Which breaths more sweet than frankinsense
> . . .what saist thou then?
> Must I for this my lovely browne
> Have my Love on me to frowne?

The argument continues that Venus loves the 'duskie, sable-blacke' night, when: 'There browne and faire are both as one, / When two sweet soules are so alone: / Tell me then (Love) in such a night / Woulds't thou not thinke the brownest white?' In this context it is not surprising to find Gibson thinking about relative beauty, a theme which gathered momentum from late in the seventeenth century and was examined in some detail during the eighteenth century. He

58 (*facing page*) *Nefertiti* (detail of fig. 18)

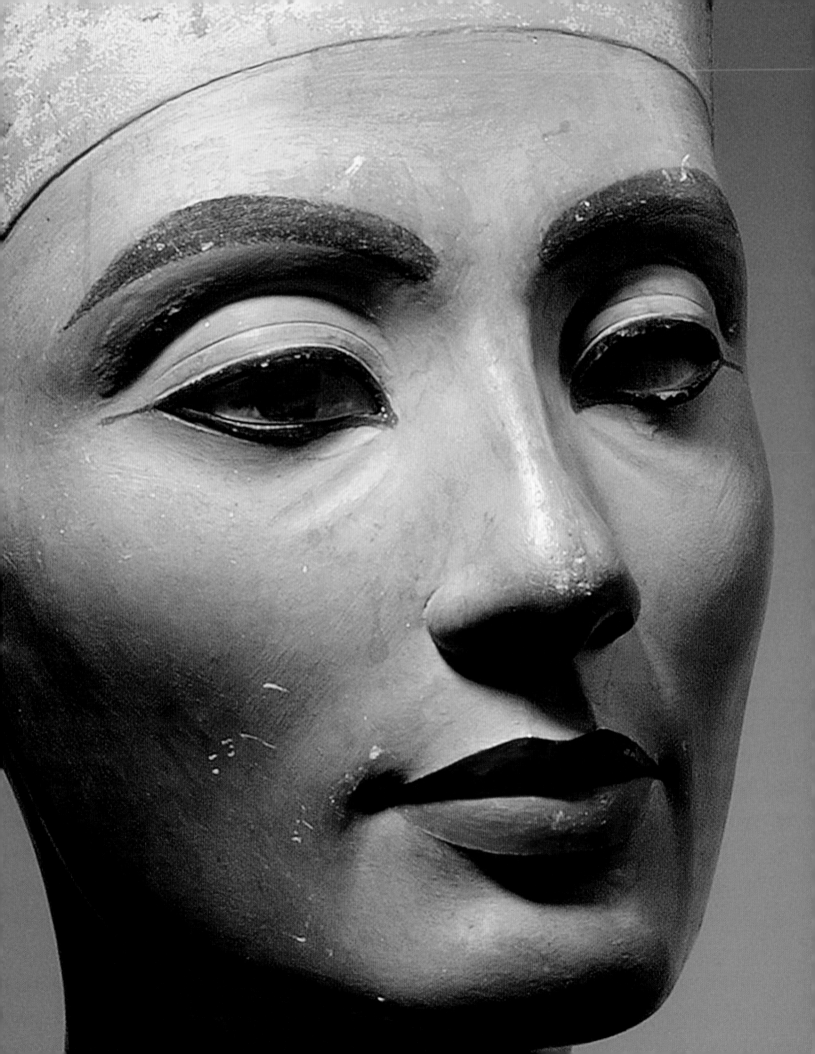

noted how 'nature (the soveraigne worke-mistresse of all beauties), hath made an Ethiopian or Moore perfect', for there should be no rules for women's beauty, 'the very especiall of all formes . . . the onelie mirrour of perfect Ideas'.[64]

What women put on their faces either to enhance their beauty or to make the best of what nature had given them in the way of features and complexion, was attacked on a number of grounds – mainly to do with concerns about health, both medical and spiritual, and worries about the artifice involved in the use of paint, and the deceit it presented to men. Although one modern writer has suggested that 'critical moralists express more concern over the threats women pose to others, than over the threats women pose to themselves',[65] worries about the health risks involved in the wearing of paint were largely genuine. According to Giovanni Lomazzo, 'a Painter of Milane': 'All those paintings and embellishing which are made with minerals and corrosives, are very dangerous; for being laied upon the fleshe, especially on the face of a woman which is very tender & delicate by nature (besides the harme they doe to the naturall beauty) doe much prejudice the health of the body'. Metallic paint (either in the form of ceruse or sublimate of mercury) was especially dangerous, for it had a 'malignant and biting nature', particularly when applied directly onto the skin because it entered the bloodstream more quickly; it blackened the teeth, caused hair loss and ate into the skin leaving it pitted. Women who used it, Lomazzo said, 'have always black teeth, standing far out of their gums like a Spanish mule, an offensive breath, with a face half scorched, and an unclean complexion'.[66] What cannot be known is the number of women who wore dangerous paints, as distinct from harmless cosmetics. The Puritan writer Philip Stubbes, whose diatribes against the appearance of women feature prominently in his *Anatomie of Abuses* (1585), implied, howeveer, that they were too sensible to put poisonous substances on their faces. Although he disapproved of cosmetics in general, on the grounds of expense and artifice, he stated that they were 'tempered with many goodly condiments & holsome confections, I warrant you, else you may be sure they would not apply them to their amorous faces, for feare of harming, or blemishing the same'.[67] Lomazzo stated that women were 'so possessed with a desire of helping their complexions by some artificiall meanes, that they will by no means be dissuaded from the same', and were often unaware of the dangers posed by the poisonous ingredients in mineral paints, so 'insteade of beautifying, they doe most vilely disfigure themselves'.[68]

The links among ill health, a ruined complexion and the use of paint must have been – if not as obvious to us with the benefit of hindsight and better medical knowledge – clear to women over time, even if used sparingly. They might have thought that the aesthetic benefits created by paint of a smooth and even complexion were preferable to a rougher and uneven skin colour and texture. There was also the element of emulation; Buoni argued that the vogue

Facing Beauty

for 'artificiall Beauty' was caused by women who noted how the elite 'excell the rest in bodily Beauty' and wished to follow suit.[69] It is possible that paintings are truthful in their depiction of women's faces painted with relative moderation; George Pettie's translation of Stefano Guazzo's *Civil Conversatione* (1574) recorded men's dislike of glaring paint, but cosmetic make-up could be applied 'so slightly, so discreetly, that the artificial dealing be not seene, or being seene, that it be not misliked'.[70] As always, women's appearance provoked contradictory responses; they were caught between the 'mandates of the beauty culture . . . and the moral indictments of anti-cosmetic polemicists'.[71] In Thomas More's *Utopia* (1516), the inhabitants strongly disapproved of make-up, preferring modesty to physical attractiveness, yet 'one is thought very lazy if one does not try to preserve one's natural beauty'; how such 'preservation' was to be achieved is not described, nor any sanction invoked for wearing cosmetics.[72]

Another conflict appeared with regard to hygiene. In northern Europe notions of cleanliness were heightened by the Reformation and especially promoted by some Protestants who linked it with godliness. Keith Thomas notes that Puritans were 'hostile to the use of perfumes, powders and other cosmetics, which they saw, not just as an interference with God's handiwork, but as an undesirable alternative to washing'.[73] Renaissance manuals prioritised cleanliness as an essential part of good manners, especially for women; cosmetics, unless applied well and with discretion, could make the face look unwholesome and could dirty clothing. Not only could lead-based make-up turn the face dark or 'smoke-coloured' but all cosmetics could 'run' as a result of rain, sweat and the heat, and drop on white linen neckwear. Ben Jonson may not have exaggerated the unlovely aspects of cosmetics in *The Devil is an Ass* (1616) when he noted:

> For any Distemper
> Of heat and motion, may displace the Colours;
> And if the Paint once run about their Faces,
> Twenty to one, they will appear so ill-favoured,
> Their Servants run away . . . (IV: ii)

As well as cosmetics being at times inimical to the appearance of a beautiful face when they failed to work properly, paint in particular was linked to illness, which was 'interpreted as packed with moral, spiritual and religious messages' urging the sufferer to 'be moderate and temperate in habit'.[74] This was especially the case when syphilis (pox) began to ravage Europe late in the fifteenth century; according to Alexander Benedictus in 1497, there 'appeared a new malady, spread by carnal contact, called the French sickness, and unknown to the doctors of antiquity' – the 'French sickness' because France was the first country to be affected.[75] The savage Spanish satirist of the early seventeenth century, Francisco de Quevedo, described the horrifying effects of the pox on a beautiful woman:

'Nothing remains of the perfectly shaped mouth with its coral-coloured lips but a dreadful grimace. She was once decked out in flowers, but now she is decked out in spots; and where once she used beauty creams, she now uses mercurial ointments'.[76] It was a dreadful irony that mercury, used for face paint, was the only treatment on offer for the pox; beauty was destroyed by vice and the only remedy was a mask of mercurial paint. Moreover, the small black patches which became a feature of the fashionable face from the very end of the sixteenth century were also used to cover the pustules caused by syphilis, and were worn by men and women. The painted female face could be seen by critics as an unnatural mask, a compendium of vice; 'Vice' was often represented in sixteenth- and seventeenth-century prints as a figure (either male or female) taking off a mask to show the deformities caused by sexual incontinence.[77]

This was a time when astrology was still thought to have an effect on people's lives and destinies; the four Renaissance humours – the choleric, the sanguine, the melancholic and the phlegmatic – were thought to be revealed in the physical appearance of men and women, as well as in their personalities. These humours were linked to the four elements – fire, air, earth and water – of which the last was connected to women, for their skin, according to Levinus Lemnius, was 'smooth and unhayrie because moisture is above heat'.[78] A print by William Marshall from a series called *The Foure Complexions* of 1636, shows the humour 'Phlegmaticke' (fig. 59) as a 'Faire and Foolishe' young woman walking by a stream; she is the conventional beauty of the 1630s with hair frizzed quite wide at the side, a fringe over her low forehead, an oval face, long nose and small mouth. Fashionably dressed, she holds a feather fan; feathers in certain contexts symbolised foolishness and inconstancy and such fans sometimes contained a small looking glass so the face could be frequently checked. The verse below says: 'Beauty I have share of Rose and Lilly/ But I lack Breeding and my wit is Silly'; beauty without intelligence or other redeeming features was thought merely physical and incomplete.

The four elements were regulated by the movements of the planets and, claimed Lomazzo, water was governed by Luna, the moon, 'the Lady of raine and moisture . . . subduer of carnall affections, Queene of the Worlde'.[79] Popular cosmetic ingredients such as silver and quicksilver (mercury) were thought of as feminine because they were connected to Luna. Ritual and magic played a part in creating cosmetics. Herbs were often gathered by moonlight, and other ingredients at certain times of the year. Charlatans and quacks peddled 'magic' remedies which claimed to cure all illnesses and elixirs to beautify women in miraculous ways. In addition, the transformative nature of make-up was likened to a kind of magic; the 'arts of magic and the arts of beauty have always gone hand in hand: magic is a system for making dreams and fantasies come true, and the cosmetic arts are always reaching desperately for the same end'.[80]

Faire = and Foolish .

Phlegmaticke

W. M. sculp.

In Beauty I haue share of Rose and Lilly
But I lack Breeding. and my witt is silly .

59 William Marshall, 'Phlegmaticke', from *The Foure Complexions*, 1636, British Museum, London

Giambattista della Porta's best-seller *Magiae Naturalis* explained that the 'Ninth Book of Natural Magick' was 'How to adorn Women and make them Beautiful', not just to make them 'pleasing to their Husbands' but for themselves so they could be 'Fair and Beautiful'.[81] *Natural Magick* (first translated into English in 1658) was published in Naples in 1558 and then expanded in further books (twenty by 1589). It is a quirky compilation of science, astrology, occult philosophy and alchemy; among the last is a chapter 'Of counterfeiting Gold', one of the aims of alchemy. The playwright Ben Jonson may have known of this popular work (and others of the same kind), as the themes of charlatanry and alchemy run through his plays such as *Volpone* (1607) and *The Alchemist* (1610). Volpone, pretending to be a mountebank, claims he can extract from Sir Politic Wouldbe's hat 'the four elements: that is to say, the fire, air, water, and earth, and return you your felt without burn or stain'. As for wondrous cosmetics, he tries to impress

the merchant's beautiful wife, Celia, by offering her a priceless 'powder that made Venus a goddess/ . . . that kept her perpetually young, cleared/ her wrinkles, firmed her gums, filled her skin, coloured/ her hair'; this potion was given by Apollo to Venus, then to Helen, 'and at the sack of Troy unfortunately lost; till now in this our age' (II: i). In *The Alchemist* one of the storylines revolves round the greedy and gullible Sir Epicure Mammon, hoping to be made rich by alchemy, a 'science' debunked by the sceptical gamester Surly:

> . . . your elixir, your lac Virginis,
> Your stone, your med'cine, and your chrysosperm
> Your sal, your sulphur, and your mercury,
> Your oil of height, your tree of life, your blood,
> Your marcasite, your tutty, your magnesia,
> Your toad, your crow, your dragon, and your panther . . .

Also – running out of steam – 'worlds of other strange ingredients/ Would burst a man to name' (II: iii). Jonson seems to have had considerable expertise in alchemy, but he cleverly mixed this up with cod-Latin, foreign words, absurd cosmetic recipes, words that sounded 'scientific' but which were nonsensical in this context, and tomfoolery in general. He was aware that the countries which were most famous for cosmetics were Italy and Spain, an additional reason why face paint should be criticised, for it was foreign as well as corrupting. *Volpone* is set in Venice where the women 'had a reputation for face-paint and for dubious morals'.[82] As for Spain, this is a theme running through *The Devil is an Ass* (1616), as Wittipol, 'a young Gallant', pretends to be a Spanish lady in order to pursue the beautiful wife of a 'Squire of Norfolk'. To be successful in this attempt he has to be versed in Spanish fashions, manners and cosmetics, and is presumably heavily made up himself in the Spanish way to add to his disguise of 'the Spanish habit'; this costume is not given in detail, except for the 'Cioppinos' or high shoes, but must also have involved the Spanish farthingale (*verdugado*) – both items would have been used to comic effect on the stage. Wittipol impresses his audience with an invented recipe for the cosmetic of 'Queen Isabella', which when rubbed on the face 'makes a Lady of Sixty/ Look at sixteen'; there is also a recipe for 'the Water of the white Hen, of the Lady Estifanias' (a satire, surely, on the popular 'pigeon water' discussed earlier), which 'keeps the Skin . . . ever bright and smooth' (IV: iv).

Farah Karim-Cooper rightly argues that a 'culture of cosmetics', which she sees in the language and imagery of Renaissance plays, was crucial to dramatic representation. What is more debateable, however, is her belief that the theatre 'contributed to contemporary notions of beauty',[83] for it is not known how much face-paint was worn on the stage, and in any case the exaggerated use of paint necessary to project character (with boys or men taking the female roles)

60 (*facing page*) School of Fontainebleau, *Woman at her Toilette* (detail of fig. 48)

would not have appealed to fashionable female theatre-goers. What the theatre did, to some extent, was to provide women with a site of relative freedom, to encourage female display, which some critics deplored. The Puritan William Prynne in *Histrio-mastix* (1633), a diatribe against the theatre – 'Stage-Playes are the very works and pompes of Satan' – attacked the freedom of 'wanton females of all sorts resorting daily by troopes unto our Playes, our Play-houses, to see and to be seene', which he claimed encouraged 'costly gawdinesse . . . immodest lasciviousnesse . . . fantastique strangenesse'.[84] Presumably, he refers here to dress, but also possibly to the cosmetics that women would have used to enhance their appearance and complement the fashionable clothes they wore. Theatre-going was an occasion; women 'have no sooner ting'd their faces artificially, than some attendant is dispatched to know what Plays are to be acted that day', claimed Hannah Woolley in *The Gentlewoman's Companion* later in the century.[85]

Cosmetics had become a part of women's lives. Annette Drew-Bear notes that Ben Jonson used cosmetic scenes in six of his plays, face-painting being deployed 'as the perfect image for courtly vanity . . . [and] to dramatize vice masking as virtue'.[86] Cosmetics were also used as comic effect, as in the well-known pantomime description of Captain Otter's wife in *Epicoene* (1609), who spends her husband's money on 'mercury and hogs' bones' and whose 'face' is made of purchased features: 'All her teeth were made i' the Blackfriars, both her eyebrows i' the Strand, and her hair in Silver Street' (IV: ii).[87] Yet, in the same play, Jonson enters a more serious debate as to what beauty is, in the characters of Clerimont and Truewit; the former hates what he calls 'pieced beauty' (made up of artifice), the latter praises it, for he claims that women love variety and the potential for change given by the use of cosmetics. A woman, he says, likes to vary her appearance 'every hour; take often counsel of her glass, and choose the best. If she have good ears, show 'em; good hair, lay it out; good legs, wear short clothes; a good hand, discover it often; practise any art to mend breath, cleane teeth, repair eyebrows, paint and profess it' (I: i). Jonson was clearly familiar with the many treatises on beauty which had been published in considerable quantities during the sixteenth century, and also with contemporary works such as Hugh Platt's popular (it went through sixteen editions between 1602 and 1656) work *Delightes for Ladies: to adorne their persons, tables, closets and distillatories with beauties, banquets, perfumes and waters*: 'That Arte might helpe where nature made a faile' is the aim expressed in his poetic epistle, although Jonson suggests that he was little more than a charlatan and a 'bawd who entices woman to practice unnatural face-painting'.[88] Some of the recipes Platt gives are indeed Jonsonian, such as the 'white fucus [paint] or beauty for the face', made from the burnt and sieved jawbones of a hog or sow mixed with 'oyle of white poppey', used by the playwright in *Epicoene*. Several suggestions are sensible, like steaming sweet herbs to cleanse the skin, or birch sap to remove spots and freckles. Some sound

bizarre, like an ointment made from whelks beaten with lemon juice to treat a red face,[89] but were not unique to Platt; John Bate's *Mysteryes of Nature and Art* (1634) had a similar recipe for the same complaint, but made of beaten snails – 'shels and bodies together' – steeped in new milk and then distilled 'with the flowers of white Lillies'.[90] Such recipes might possibly have had some effect – snail mucus, for example, had been used since antiquity as a skin emollient – and at least they were not dangerous to the skin.

It was accusations of vanity and deceit that were mainly directed against women's use of cosmetics and paint. Vanity obviously because of women's pride in contemplating their beauty, especially when it was unaccompanied by virtue. Henry Peacham's famous emblem book *Minerva Britanna* (1612) depicts 'Feminine Beauty' (fig. 61) as a naked virgin on a dragon, holding a dart in her hand and looking in a mirror, or 'christall glasse'; the accompanying verse relates that nakedness is preferable to artifice, that the dragon and the dart indicate 'loves poison' and the lilies on her head signify the 'frailtie (Ladies) of that pride of yours'. As for the 'christall glasse', this is of course the traditional *vanitas* symbol, appearing not just in art but in the titles of moral homilies addressed to women – *A Glasse to view the Pride of vainglorious Women* (Stephen Gosson, 1595), *My Ladies Looking Glasse* (Barnaby Rich, 1614), *A Glasse for Gentlewomen to dresse themselves by* (Thomas Taylor, 1624), *A Looking Glasse for Women, or A Spie for Pride* ('T.H.', 1644) – and in poetry too, such as Thomas Randolph's *To one admiring herself in a Looking-Glasse* (1638). For Barnaby Rich, the looking glass was ideally a metaphor for self-knowledge, but in fact it encouraged women's desire for 'externall beautie', to 'seeme more young, more smooth, and better favoured than they be', whereas they ought to 'display the majestie of the Creator' by virtue and good works.[91] This is the theme, although expressed less stridently, in

Thomas Combe's *Theatre of Fine Devices* (1614) where a woman is shown at her looking glass and urged to add a spiritual dimension to her physical beauty:

> A woman should, and may well without pride,
> Looke in a looking glasse; and if she find
> That she is faire, then must she so provide
> To sute that beautie with so faire a minde . . .[92]

The most famous and detailed criticism of artificial beauty in early seventeenth-century England is *A Treatise against Painting and Tincturing* (1616) by Thomas Tuke, a clergyman from the Puritan wing of the Church of England. This book begins with a sequence of rancorous poems on the theme of deceit by a number of authors,[93] who pursue the idea that a painted woman not only fools herself through her vanity (in a vain attempt to keep old age at bay) but that she also ensnares men by pretending to be what she is not; Tuke himself in a poem 'Of Face and haire-deceits' blamed women for using fucus/paint when they 'meane to cheat'. Thomas Drayton's poem 'Of tincturing the face', describes a 'painted wench' as a 'Physitian well skild in complexions'; Edward Tylman in a verse 'To painted women', attacks 'women-Gallants' for spending all their time looking in the mirror, although all they see is counterfeit beauty 'clouded o'er with paint'. 'I. Sylvester' (perhaps the poet Joseph Sylvester) offers a poem attacking women's 'painted breasts . . . painted cheeks and eyes', lamenting how he was fooled to discover that the beauty of his lover – the 'golde upon her head,/ The lilies of her breast, the Rosie red/ In either cheeke, and all her other riches' – was 'none of hers; it is but borrowed stuffe/ . . . plaine counterfeit'. This is a *leitmotiv* of countless anti-cosmetic tirades, including Tuke's, the idea of a fashionable woman being the sum of parts not her own: 'not her head, her haire, her face, her breasts, her sent, nay not her breath always. She hath purchased lips, haire, hands and beautie more than nature gave her, and with these she hopes to purchase love'.[94]

Tuke used religious authorities to underpin his argument against the use of paint; in a play on words, he stated that a woman's 'religion is not to pray well, but to *die* [dye] well . . . She loves *confections* better a greate deale, than *confessions* . . . and delightes in *facing* and feasting rather than fasting' (Tuke's italics).[95] The religious arguments against painting – women 'that colour their faces deny the Lorde of glorie to be true God', for 'artificiall colours and unnaturall ointment . . . [are] the devill's inventions, to intangle poore soules in the nettes of perdition'[96] – were mainly (but not exclusively) promoted by Puritans (including many clerics). Ferocious polemics against cosmetics – exacerbated by the political and religious struggles in seventeenth-century England – continued throughout the Interregnum; the Puritan cleric Thomas Hall, in his *Divers Reasons and Arguments Against Painting, Spots, naked Backs, Breasts, Arms &c* (1654), equated women

62 (*facing page*) George Gower (attr.), *Elizabeth I* (detail of fig. 56)

Facing Beauty

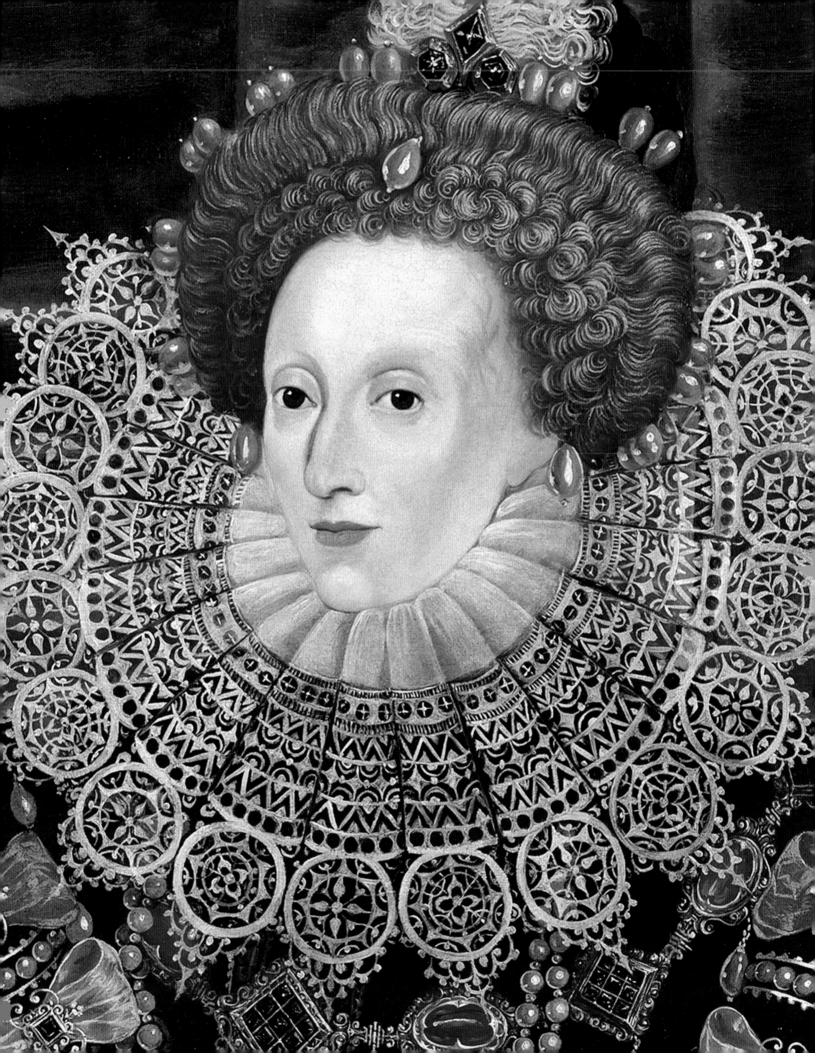

wearing paint to harlots, for 'rotten Posts are painted, and gilded Nutmegs are usually the worst'.[97]

Criticism of the painted woman was concentrated on three areas, the face, the breast and the hair – 'women that be Painted, that be Poudered, that be Periwigde', as Barnaby Rich phrases it in *My Ladies Looking Glasse*. Late in the sixteenth century, women's hair-styles were large and elaborately constructed: 'curled, frisled and crisped, laid out (a world to see) on wreathes and borders, from one eare to another'. Hair could be dyed from recipes given in beauty treatises and women often wore false hair, either whole wigs, as Queen Elizabeth did in later life (see fig. 56), or their own hair eked out with hair pieces, blonde being particularly prized in both cases; it was either bought from poor women, taken from children, as Stubbes claimed,[98] or stolen from corpses. In Shakespeare's *Merchant of Venice*, Bassanio comments that the 'world is still deceiv'd with ornament':

> So are those crisped snaky golden locks
> Which make such wanton gambols with the wind
> Upon supposed fairness often known
> To be the dowry of a second head,
> The skull that bred them in the sepulchre (III: ii).

Women's hair was less ornate by the second decade of the seventeenth century but was sometimes still arranged with 'curled, frisled and crisped' locks, as is possibly the case with *Frances Howard, Countess of Somerset* (fig. 64), a portrait of about 1615 attributed to William Larkin. A famous court beauty, possibly responsible for an attempt to poison her first husband, the Earl of Essex, she was notorious for being embroiled in a sensational court case in 1616, in which she was found guilty (along with her husband, Robert Carr, a favourite of James I) of the murder of Sir Thomas Overbury, who strongly disapproved of Carr's involvement with her. Larkin shows Frances Howard as a sultry and knowing beauty, cleverly using her fine lace ruff to draw the eyes firstly to her face with its creamy complexion, large eyes with pencilled eyebrows and red lips with the lower one larger as though stung by a bee, and to her amber-coloured hair; secondly to her breasts displayed in a low-cut dress, a style favoured at court. Like the face, the breast was also painted with the same ingredients; nipples were coloured with cochineal mixed with egg white, and sometimes blue veins were drawn to emphasise the whiteness and translucency of the skin. Such blue-painted veins may be seen in another portrait attributed to Larkin of about 1614, *Lady Isabella Rich* (fig. 63), which shows her in masque dress, a mantle tied on her shoulder, her blonde hair worn loose and a pearl diadem crowning her head. Her face – the cheeks too chubby and the nose too short to be classed as beautiful – is redeemed by a peaches and cream complexion created by subtle colouring, and the fineness and delicacy of her naturally fair hair.

63 William Larkin (attr.), *Lady Isabella Rich* (detail), *c.*1614. Kenwood House, London

By the second quarter of the seventeenth century, current notions of beauty had changed to a more rounded face, an incipient double chin to match the fuller figure in vogue, a general horizontality exemplified by the hair-style in fashion, and in the detail of dress, especially the large figure-of-eight sleeves seen in the Marshall print of the 'Phlegmaticke' beauty (see fig. 59), flat on top and

MIROIR DES
Plus belles Courtisanes
de ce temps.
SPIGEL DER
Allerschoonste Courtisanen
deses tyts.
THE LOOCKING-GLASS
of the fairest Courtiers
of these tymes.

wide at the sides, and in Rubens's drawing of his beautiful young wife, Helena Fourment (fig. 65), made soon after their marriage in 1630. To some extent this opulence of figure harks back to the great beauties of early sixteenth-century Venice and the Veneto, whose artists were greatly admired by Rubens and his pupil Anthony van Dyck (see fig. 69). Helena represents the feminine ideal of the Netherlands: a comfortably full (not fat) body; a round face with perfectly aligned features; hair flat on top and frizzed out at the sides. Her beauty is emphasised by the way that Rubens depicts the traditional gesture of modesty (*pudicitia*) as she elegantly draws aside the folds of the light floating mantle (*huik*) attached to a cap with a tasselled 'stem' (*tip-huik*) – headwear widely in use in the Netherlands and north Germany and particularly coquettish here. Female beauty, in the context of the largely urban and mercantile culture of the Nether-

66 Crispijn de Passe, title-page of *Le Miroir des plus belles Courtisanes*, 1631

65 (*facing page*) Peter Paul Rubens, *Helena Fourment*, c.1630–31. Courtauld Gallery, London

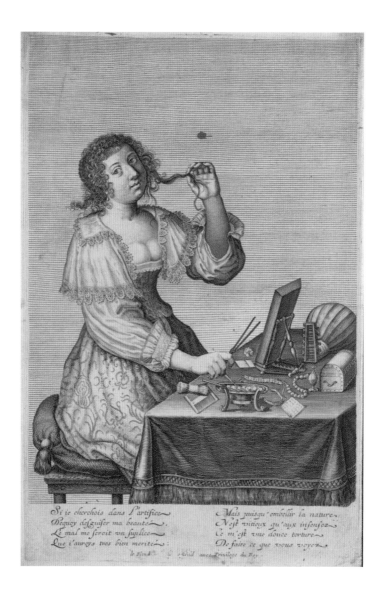

Si ie cherchois dans l'artifice
Dequoy desguiser ma beauté
Le mal me seroit vn suplice
Que i'aurois tres bien merité :

Mais puisqu'embellir la nature
N'est vitieux qu'aux insensez
Ce m'est vne douce torture
De faire ce que vous voyez

Ie Blond *A Paris auec Priuilege du Roy*

lands, especially in the northern provinces which became the Dutch Republic in 1609, was linked to the *burgerlijk* fashions of the ruling classes. In the title-page to Crispijn de Passe's *Miroir des plus belles Courtisanes de ce temps* of 1631 (fig. 66), the beautiful courtesans on offer, displayed in prints on the wall facing out, are depicted mainly in middle-class ruffs, or falling collars, and white linen caps, like the image being shown to a potential customer. One woman has a veil and one a feather in her hat, features of modish 'pastoral' dress (as I discuss shortly); one courtesan appears with hair smoothed back from her face, without a cap and with a low-necked dress, possibly suggesting that she is imitating the appearance of a *cinquecento* Italian beauty.

One of the 'rediscoveries' of antiquity during the Renaissance was that of the concept of Arcadia, as seen in the works of classical writers such as Virgil, who hymned the pleasures of rural life. As court and urban life became increasingly about display, expense and artifice, the attractions of the supposedly carefree and simple life of the countryside increasingly appealed, manifest in literature and in art, notably in the courts of Renaissance Italy, and later (by the end of the sixteenth century) in France, the Netherlands and England. In visual terms, this cultural development specifically led to a new genre of art, the pastoral portrait, and also influenced dress and appearance.[99] Inspired by art, literature and by entertainments such as masques and *tableaux vivants*, elite men and women chose to be depicted in portraiture wearing pastoral dress, which artists conceived to be versions of the clothing of shepherds and shepherdesses as though designed by a theatrical costumier; this conceit lasted well into the eighteenth century. Partly in response to this carefully cultivated pastoral simplicity, dress itself became less obviously artificial than in the years of extravagance from the late sixteenth to the early seventeenth century. Along with greater informality in clothing, beauty also became more subtle, less indebted to striking contrasts of red and white, and with greater emphasis on a perfect complexion. In a fairytale Arcadia, of course, shepherdesses and milkmaids had beautiful features and perfect skin; in the real countryside, milkmaids were famed for their fine skin, undamaged by the smallpox which destroyed city complexions.[100]

Simpler and less patterned costume demanded a corresponding lessening of artifice in the hair; wigs and hair-pieces were less widely used by fashionable women from the 1620s. Hair, however, still needed curling, a time-consuming business with hot irons, lotions and curl papers, as can be seen in an anonymous engraving, *Woman at her Toilette* (fig. 67). She sits in front of a mirror, curling tongs in her hand and a small stove on the table to heat the iron; other items on the table indicate a *vanitas* theme – the comb, the powder brush, the bottle which may contain face paint or scent, and the jewellery; artifice is here depicted as the disguise of beauty.

One aspect of Renaissance beauty was a delight in elegant disorder, a love of the unadorned, the seemingly uncontrived appearance, a naturally blushing complexion, and beautifully disarranged hair – signifiers of sexual awareness at the very least. Castiglione's *Courtier* admired a woman with her own complexion and 'her haire by happe out of order and ruffled',[101] and a hundred years or so later English 'cavalier' poets urged their mistresses to disrobe and to unbind their hair – 'Let it fly as unconfined/ As its calm ravisher, the wind' (Richard Lovelace, *To Amarantha That she would dishevel her hair*, ll. 5–6, 1648). The hair is unconfined (as are the breasts) in the seated figure facing out in Lely's complex painting *The Concert* (fig. 68), possibly made soon after the artist's arrival in England in 1647. According to Louis Guyon's *Miroir de la beauté et santé corporelle* (1643),

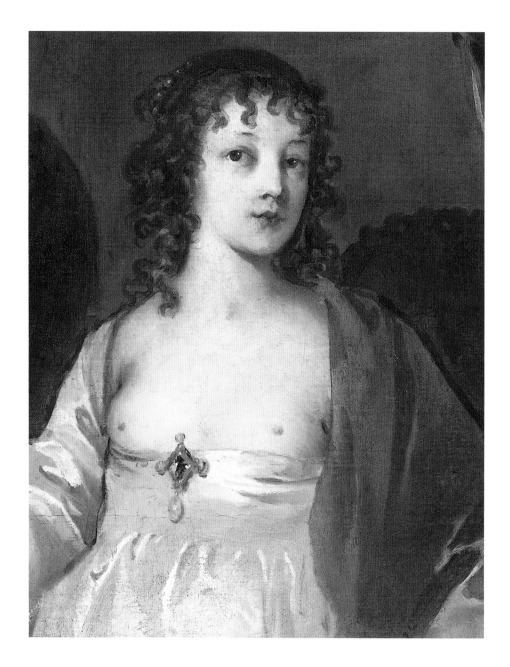

a clear complexion was the most important attribute of beauty along with brilliant and sparkling eyes and a small mouth; almost as important as the face was a white and polished neck and shoulders, and the breasts which should be like two beautiful apples.[102] Apples appear also in a description of the 'Naturall beauties' of the ideal face in John Bulwer's famous book *Anthropometamorphosis: Man transform'd; or, The Artificial Changeling* (1650): the cheeks should be 'fleshie,

rosie, and resembling the red Sun-shine Apples of Autumne'. A beautiful woman must have 'a faire white Forehead, marked with no wrinkles or lines . . . and drawing to a roundnesse about the Temples' . . . a 'little Mouth . . . a nose of a meane size, strait, cleane, with a certain obtusenesse acute'; other features of this 'Face round, pleasant and elegant to behold' include black eyebrows 'subtile, disjoined, soft and sweetly arched', small black eyes 'concave, rolling, laughing, pleasant and shining', and small, delicate ears 'aspersed with the dilucid colour of Roses'. In a departure from the Renaissance norm of following rules for beauty, Bulwer suggested that not all the features on his list were essential, as it was more important for the parts to 'agree and concord aptly with one another'.[103] The ideal beauty, by the 1650s, was no longer the stately, slightly fleshy kind depicted in portraits by Rubens or van Dyck, but more lively and piquant, as in the Lely painting; beauty became more knowing and more consciously charming.

Coda

One of the problems with painting was how to capture the virtue of a sitter as well as the colours and shapes of outward physical beauty. In Thomas Carew's poem *To the Painter* this is the question he addresses: 'can you colour just the same,/When vertue blushes or when shame/When sicknes, and when innocence/Shewes pale or white unto the sence?[104] This was the challenge presented to van Dyck when he was given the commission by Sir Kenelm Digby to paint his wife, Venetia, on her deathbed in May 1633 (fig. 69); perhaps 'vertue' was not so high a priority, however, as John Aubrey in *Brief Lives* referred to her as 'that celebrated Beautie and Courtezane', and she had a somewhat risqué reputation before her marriage in 1625. A 'most beautifull desireable Creature', claimed Aubrey, who described her thus: 'She had a most lovely and sweet-turn'd face, delicate darke-browne haire . . . Her face, a short ovall . . . Darke-browne eie-browe, about which much sweetness, as also at the opening of her eie-lids. The colour of her cheeks was just that of the Damaske-rose, which is neither too hot, nor too pale'.[105] There were rumours when she died that she might have been accidentally poisoned by Sir Kenelm, who insisted that she drink viper wine in order to retain her beauty. Digby, interested in science and alchemy, later published a number of recipes for 'Excellent Cosmetics' and medical remedies, including an 'altogether Astral Water of Paradise', which is 'most potent to drive out all Diseases', and an *Aqua Mirabilis* which he claimed could revive the dying (perhaps because it contained three pints of 'the best sack' or fortified wine).[106] Digby was obsessed by his wife's beauty, which he referred to in his autobiographical memoir-cum-romance, *Loose Fantasies* (1627), in which she appears as 'Stelliana'; he describes her symmetrical features, large forehead, soft brown

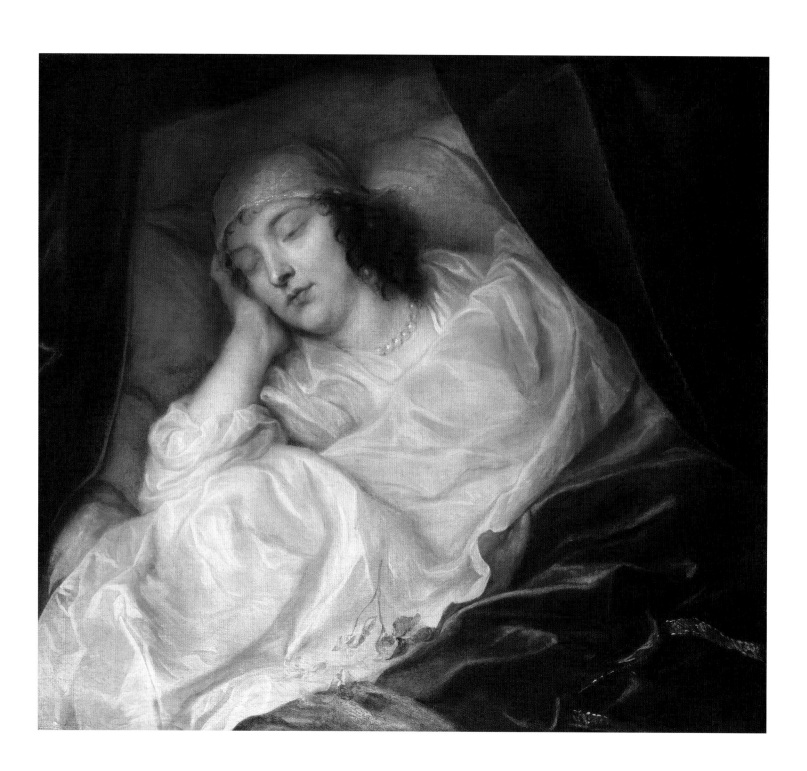

hair, large sparkling eyes, straight nose, small mouth with white even teeth, and skin so fine that blue veins could be seen on her temples. 'In her face one might discern lilies and roses admirably mixed; but in her lips the rose alone did sit enthroned in sweet majesty . . . her cheek reposed upon her alabaster hand';[107] this could easily be a description of van Dyck's portrait, begun the day after her death – a 'poetic' image, clearly in denial of the effects of *rigor mortis*. Only the rose with its petals fallen off indicates that she is dead and not asleep; the pearls in her ears and round her neck are, again, poetic licence, suggesting chastity and purity. Her face may be lightly made up; Venetia's waiting women rubbed her face to bring colour back to it, but 'since there was no circulation of blood, this can only mean that rouge was applied'.[108] So Venetia Stanley was painted in life, in death and in art.

A Discourse of Auxiliary Beauty

> [Beauty] is pleasing, either Natural or Artificial, and both to be admired . . . as Beauty is the Adornment of Nature, so is Art the Adornment of Beauty . . . if Art be commendable, why not in the Face . . .
> Margaret Cavendish, *The Worlds Olio*, 1655[109]

From the middle of the seventeenth century the pros and cons of 'artificial beauty', that is, cosmetics and paint, were increasingly debated in print, and a growing consensus was arrived at by the end of the century in defence of what was also called 'auxiliary' beauty. Margaret Cavendish, Duchess of Newcastle, while opposed to the use of the 'malignant' face paints which 'take away both the Life and Youth of a Face, which is the greatest Beauty', declared that cosmetics enabled a woman to keep the 'lawful affection' of a lover or husband, and there was no reason why she should not augment her physical attractions; moreover, the use of cosmetics, as of dress, was a kind of art, 'the Poetry of Women, in shewing their Fancies'. Beautifying the face and body were 'Arts of Adornment' and the cause of 'employing the greater part of a Commonwealth',[110] a theme taken up by *The Ladies Dictionary* of 1694, which noted how both fashion and cosmetics afforded 'a standing Maintenance to thousands'.[111] By the end of the century, one can perhaps talk of the beginning of the beauty industry, as the use of beauty products (cosmetics and paint), fuelled by a flourishing trade, increased considerably all over Europe.[112]

Cavendish, an original thinker and writer (a less able poet and playwright), wondered how far one could talk of 'true Beauty', for notions of beauty were formed by habit and custom rather than objective analysis; that is, 'in the Opinions of Men rather than in the Lineaments, Symmetry, and Motion of the Body,

69 (*facing page*) Anthony van Dyck, *Venetia Stanley on her Deathbed*, 1633. Dulwich Picture Gallery, London

or the Colour of the Skin'. As for her own view of what she called true or 'Natural Beauty', this proved impossible to define, except as a kind of heightened religious experience: 'a certain Splendor, which flows in a Line, an Air of Lights, from the Spirits, and gives a shining Glory upon the Face'.[113] Rarely, however, could this true beauty be found and Cavendish concluded that most beauty was created not by nature (if we followed nature, we would go naked) but 'by Art, which allures the Mind', and thus cosmetics were not only permissible but desirable. The author of *A Discourse of auxiliary Beauty*, first published in 1656, was largely in agreement; women should not be limited to 'pure and simple naturals, as if Art and Nature were not sisters, but jealous rivals . . . whereas indeed they are from the same wise God and indulgent Father'.[114] This *Discourse* took the form of a debate on the subject of cosmetics; the frontispiece illustration (fig. 70) – an image which has to be read in the context of the religious and political struggles of mid-seventeenth-century England – shows the two protagonists. On the right, with her hand on a Bible, is a homely middle-class woman plainly dressed, whose arguments rely on Biblical authority and the works of the Early Church Fathers; she signifies opposition to the use of cosmetics, holding that 'all colour or complexion added to our skins or faces, beyond what is purely naturall, to be a sin'. This was seen as the argument of the past, no longer relevant, and across from her is a prettier and fashionably dressed opponent holding a fan, who symbolises reasoned support for adorning the face: there is nothing 'materially evil, either in nature or in art, but only as related to the inordinancy of the mind, will and intent of a voluntary and moral agent'. So that, for example, painting the face was only bad if there was a 'wanton or evil purpose'; after all, cosmetics did not alter the proportions or substance of the face but merely added 'a little quickness of *colour* upon the skin'.[115] According to the courtly figure in the illustration, those who criticised women (notably the clergy), were too obsessed 'with bitter invectives against Ladies painting, patching, curling, powdering, perfuming and complexioning', and especially perplexed about the 'curlings of Ladies hair, that they can as hardly dis-intangle themselves as a Bee engaged in honey'.[116]

Later works on the cosmetics argument are clearly indebted to the *Discourse of auxiliary Beauty*. These include Hannah Woolley's well-known conduct manual *The Gentlewoman's Companion* (1673), which noted the widespread use by women of all nations of 'Artificial helps for the advancement of their beauties', such as 'powdering, curling, and gumming the hair, and quickening the complexion'.[117] The *Ladies Dictionary*, a large compendium of articles and advice (of the past and the present) on such matters as fashion and appearance, included many entries in defence of cosmetics, for 'Art and Ingenuity study to help and repair the Defects of Deformity'; such defects might include skin which was red and roughened, pimpled, or scarred by smallpox. Far cheaper than clothing, cosmetic prod-

Νοῦν Χϟη θεάσαϑαι. *Euripid.*

70 Frontispiece illustration for *A Discourse of auxiliary Beauty*, London, 1662. British Library, London

ucts could make a visible difference to a woman's appearance and act as a psychological boost to morale: 'Faces, when clouded by Poverty, Carelessness, or a Kind of disregard, cannot shine so bright . . . as when they are trick'd and trim'd up with all the sprucifying Advantages'.[118] The work most closely linked, both in content and format, to the *Discourse of auxiliary Beauty* is *Several Letters Between Two Ladies Wherein the Lawfulness and Unlawfulness of Artificial Beauty in Point of Conscience Are nicely Debated*, probably by the Anglican cleric Jeremy Taylor, who at the restoration of Charles II in 1660, was made Bishop of Down and Connor. In its pro-cosmetic stance, *Several Letters* actively encouraged women to repair the 'Defects, Deformities and Decayes of Nature and Age'. Brushing aside any Biblical objections to the adornment of the face, the author declared that it would be an affront to God *not* to preserve what He has given to women in the form of cosmetics, to defend the face 'against Sun, Dust, Air and Fire, by Masks, Fans . . . by Unguents and Washes'.[119]

This kind of advice and encouragement to women would have been welcome, albeit taken for granted, at the court of Charles II, 'a Court [according to the Comte de Gramont] which breath'd nothing but Entertainments and Gallantry', and where the 'Beauties studied to charm'. Among the court beauties was Frances Jennings, a maid-of-honour to Anne Hyde, Duchess of York; according to the Comte de Gramont, she was:

71 Samuel Cooper, *Frances Jennings, Duchess of Tyrconnel, c.1665*. National Portrait Gallery, London

> adorn'd with the blooming Treasures of Youth, had the fairest, the brightest and liveliest Complection that ever dazzled mortal Eyes. Her hair, perfectly fair, her Mouth . . . the finest in the World. Nature had endow'd her with those Charms that cannot be express'd, and the Graces had finish'd the Master-piece . . . In a word, her Person reviv'd the Idea of Aurora, or the Goddess of the Spring, such as the Poets represent 'em to us in their gawdy Pictures.[120]

The miniature of Frances Jennings by Samuel Cooper (fig. 71) shows her in a low-cut blue silk dress which shows off her breasts, but while one can appreciate the bright and lively 'Complection' and the naturally blonde hair, the present-day viewer might find it hard to recognise her as a beauty, with her slightly unevenly spaced eyes and very long nose; perhaps the attraction lay in her charm of manner and animation, which helped to enliven what Gramont thought was the insipidity often linked with very fair looks.

At the Restoration court, the most popular artist was Peter Lely, praised by Gramont as 'a Painter celebrated for Face-drawing', and who 'came up the

nearest' to van Dyck.[121] Whereas van Dyck merely hinted at the sexual element in women's beauty, Lely – inspired by the ideal beauties of sixteenth-century Italy – made it explicit. Nowhere more so than his portrait *Diana Kirke, later Countess of Oxford* (fig. 72), in which his subject is depicted in loose studio draperies but with her face, and possibly her breasts, carefully painted, perhaps by the artist himself – on the face as well as on the canvas. This face is the usual artful confection of pink and white, the lips reddened and the eyes elongated and faintly enhanced with shadow; the hair might be 'Venus's Grove, in whose twyning Meanders a pleasing imprisonment shall breed a dislike of former Freedom' – an appropriate conceit, for Kirke holds a rose, one of the attributes of the goddess.

The quotation comes from Thomas Jeamson's work *Artificiall Embellishments; or, Arts Best Directions: How to Preserve Beauty or to Procure it*, published in 1665, about the same time as Lely's portrait was painted. Jeamson's book sometimes anticipates the concerns of a much later period regarding women's appearance, underlining, for example, the importance of diet and exercise, and the need to avoid stress – 'Grief is the moth of Beauty, it frets out the characters of nature's finest Orthography'. His main purpose, however, was to teach his readers how to use 'auxiliary unguents' most skilfully: 'you shall learn how to give the Face such a commanding Beauty, that all who view it shall yield obedience . . . In a word, how to advance your Features to such a pitch of dazeling glory, that shall make Beauty it selfe out of Countenance'.[122] Diana Kirke certainly dazzles in the most seductive way, as does the royal mistress Louise de Kéroualle, the Duchess of Portsmouth, in her portrait by Lely nearly a decade later (fig. 73), painted holding up her abundant dark brown hair in her hand, a gesture seen in Renaissance paintings of ideal beauties, such as Titian's *Young Woman at her Toilette* (Louvre). Not displaying quite as much of her breast, Kéroualle is as beautifully made up as Kirke; like the heroine Harriet Woodvill as described in Etherege's play *The Man of Mode* (1676), 'her features [are] regular, her complexion clear and lively, large wanton eyes, but above all a mouth that has made me kiss it a thousand times in imagination. . . . pretty pouting lips, with a little moisture hanging on them, that look like the Provence rose fresh on the bush e're the morning sun has quite drawn up the dew' (I: i). In a discussion of the requirements for a 'perfect Beauty' of 1694 – 'a Smooth Complexion, white and red, and [that] each colour be truly placed, and lose themselves imperceptibly the one in the other', eyes 'well made of a dark or black colour, graceful and casting a lustre', and a medium sized nose – the *Ladies Dictionary* devotes most space to the mouth, which ought to be small, 'the upper-lip resembling a Heart in shape, and the under somewhat larger, but both of a vermilion colour, as well in Winter as Summer; and on each side two small dimples easily to be discern'd in their moving upwards, which look like a kind of constant smile'.[123]

72 (*facing page*) Peter Lely, *Diana Kirke, later Countess of Oxford, c.1665.* Yale Center for British Art, New Haven, Conn.

Facing Beauty

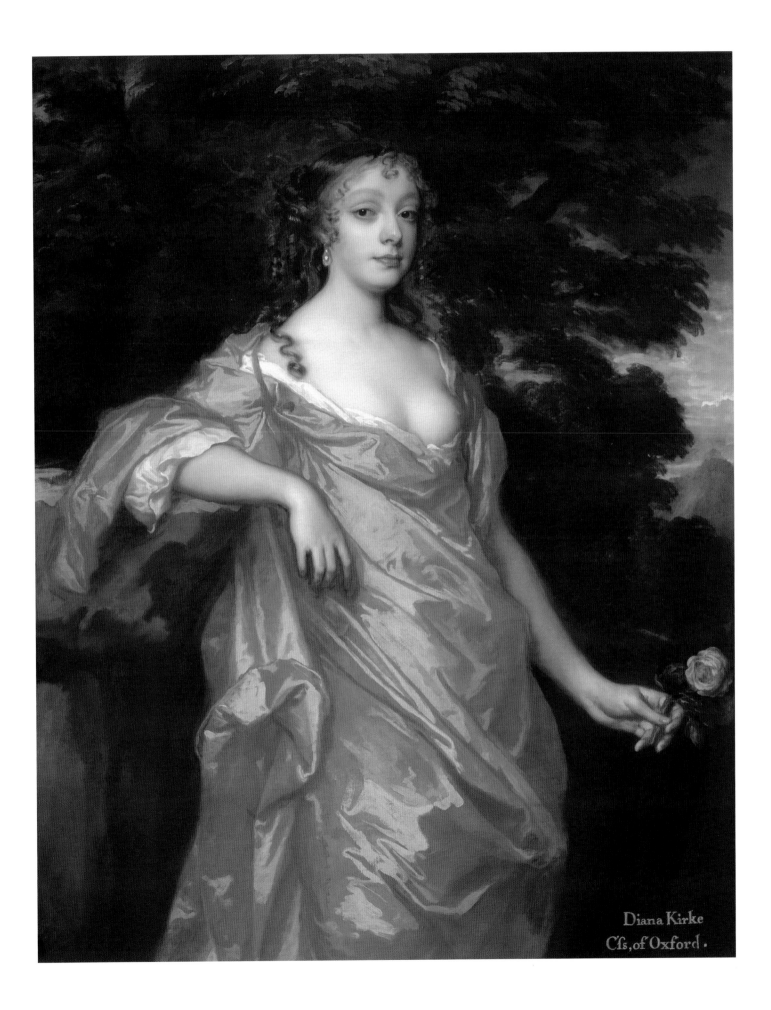

Diana Kirke
Cfs, of Oxford.

In both Lely portraits there is a suggestion of a smile (unlike the compressed lips of *Frances Jennings* in Cooper's miniature); and whereas Jennings is shown in real dress, Kirke wears little more than a sheet of shining amber-coloured silk, and Kéroualle is shown in a 'loose-bodied' morning gown, which may also be a studio creation. This is a period when words like 'easy', 'unaffected', 'wanton' and 'negligence' with regard to the appearance of women were quoted with approval; in a work attributed to Aphra Behn, *The Lady's Looking-Glass, to dress herself by; or, The Whole Art of Charming*, this verse is addressed to her readers:

> Oh, how that Negligence becomes your Air!
> The careless flowing of your Hair,
> That plays about with wanton Grace,
> With every Motion of your Face:
> Disdaining all that dull Formality
> That dares not move the Lip or Eye

Not only, the author claimed, should the figure of a woman be 'free and easie . . . without Constraint, Stiffness, or Affectation', but the face also should be mobile and relaxed,[124] perhaps implying that when in informal clothing, artifice (both in brightness of colour and heaviness of paint/cosmetics) was inappropriate for the face. Yet the fashionable face could not be seen without some make-up, on whatever occasion, and this had to be applied to much of the upper body as well. As the *Ladies Dictionary* noted, women had 'made it their delight to uncover the parts of their chiefest Beauty, as their Faces, swan-white Necks, soft rising Breasts, Ivory Shoulders, and Alabaster Hands'.[125] Such a display of bodily charms attracted comment, some favourable, some more critical; Jacques Boileau's *De l'Abus des nuditez de gorge* (*A Just and Seasonable Reprehension of naked Breasts and Shoulders* is a somewhat free translation) of 1675, accused women of 'over-lacing their Gown-bodies, and so thrusting up their breasts, on purpose that they might shew them half naked', a temptation to men who 'are but weak and staggering in Vertue'.[126]

By this time, much more of the body of the woman was displayed, not just in fashion both formal and informal but in her morning's cosmetic ritual. The second half of the seventeenth century saw the custom of the morning *toilette* all over Europe, derived from the French court at Versailles, which made it into a prolonged and elaborate art form, a ceremony with its own etiquette. Women had, as noted, spent time in front of their mirrors in self-preparation and presentation but this began to expand into a more formal and lengthier occasion, where guests were sometimes invited, affairs (of business and the heart) were discussed and the complicated rites of dress and adornment were undertaken. Whereas in England the custom was not as well established, 'in some Countreys of Europe it is so far from being Scandalous, that the Ladys let their Lovers hold

73 (*facing page*) Peter Lely, *Louise de Kéroualle, later Duchess of Portsmouth*, *c*.1671–4. The J. Paul Getty Museum, Los Angeles

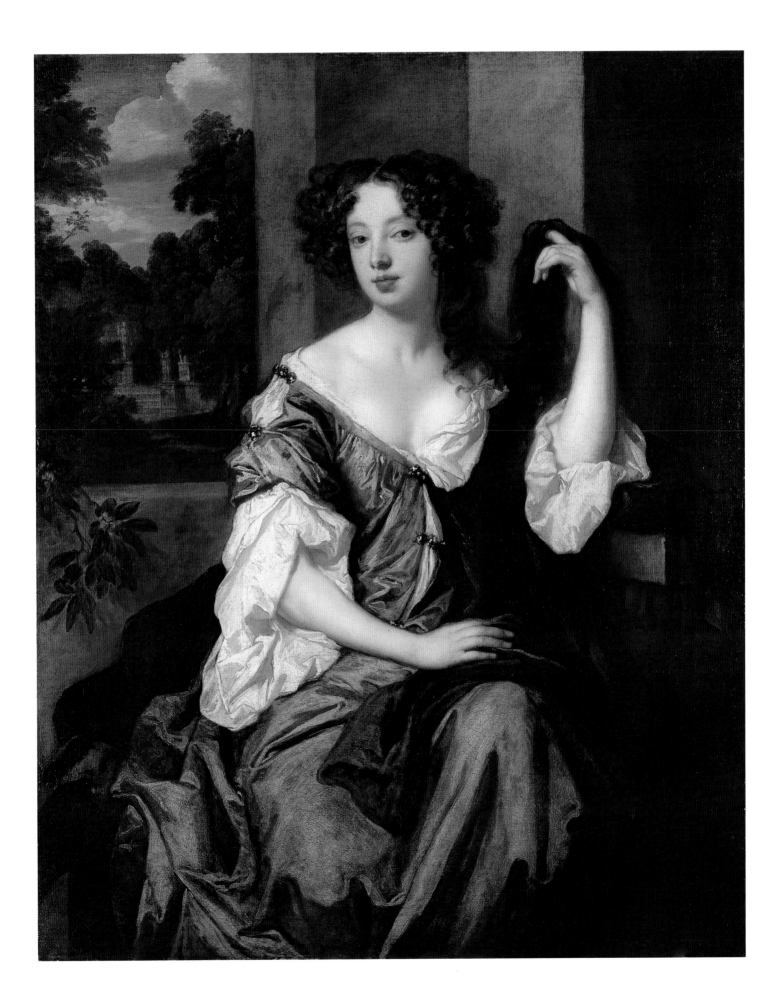

74 (*above*) ?Utrecht School, *Young Woman at her Toilet* (detail of fig. 83)

75 (*facing page*) Henri Bonnart, 'Dame à sa toillette', from *Receuil des modes de la cour de France* (detail of fig. 79)

their Glasses to 'em, while they are Painting themselves, who esteem it as a favour, and are no ways displeas'd at it'.[127] Originally, the word toilet/toilette referred to the piece of white linen (*toile*) draped over the table on which a woman displayed her cosmetics, patch box, brushes, combs, curling irons and so on. The dressing table toilette was often ornamented with lace, matching that which edged the shoulder mantle – 'une voile qui couvre le desabillé' – worn by the woman to protect her clothes from cosmetics and hair preparations. According to the list of articles relating to the toilette which were sold by the master apothecary Jean Fargeon in Montpellier in 1665, dressing table toilettes were not only of white linen but could also be of coloured satin or taffeta, lined with white and sometimes perfumed; they might be decorated either with lace or a fringe. Fargeon was also a perfumer and many of the cosmetics he sold, such as pomades and powders, were scented, as were such items as gloves, fans and under–

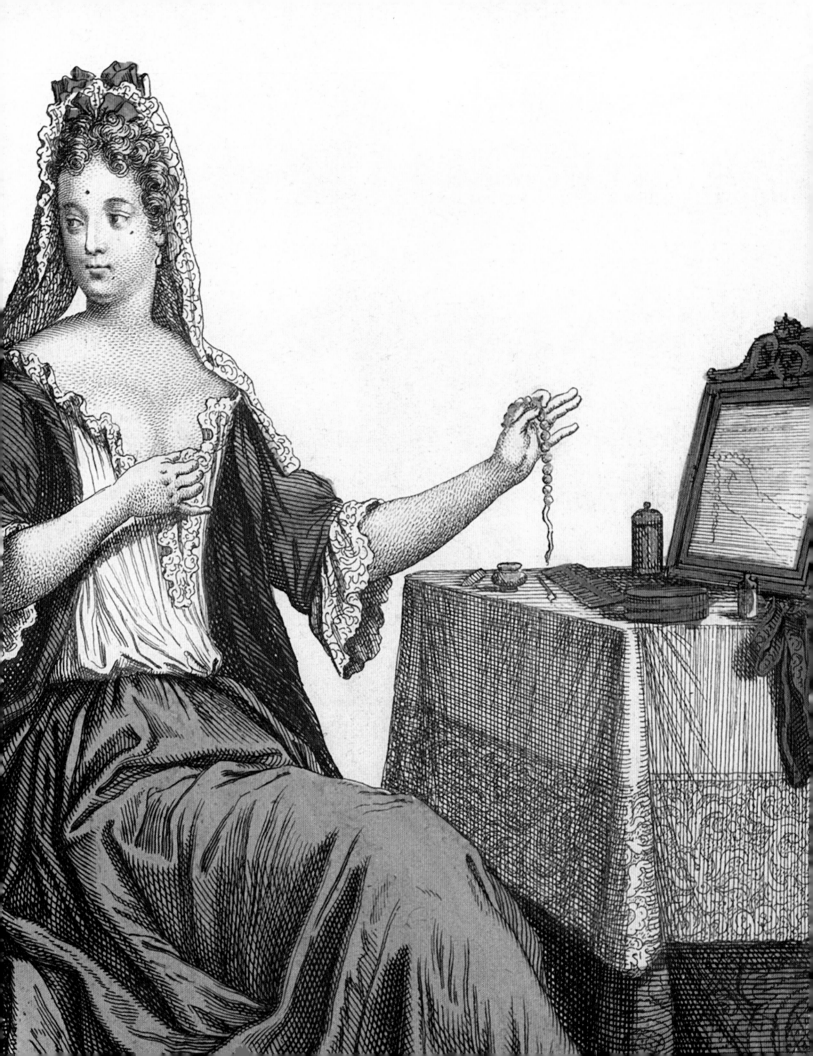

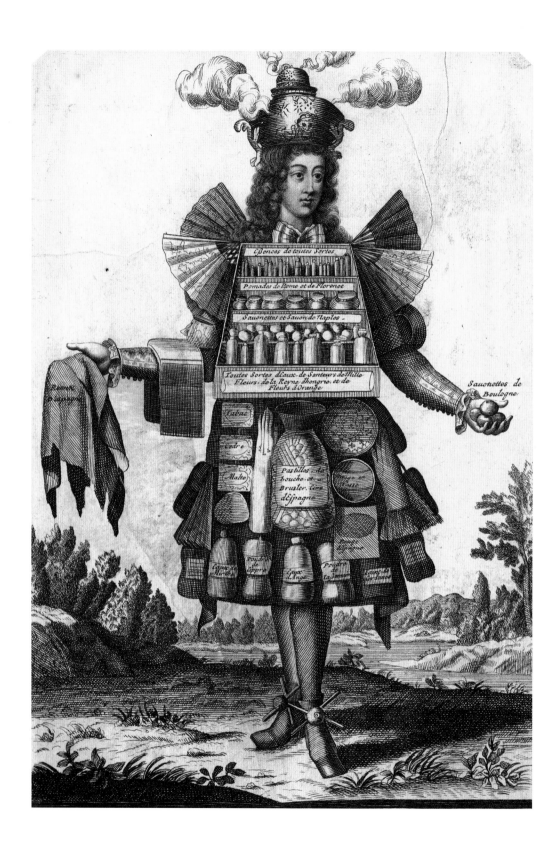

The Lid of a Powder Box

The Side of A Powder Box

The Lid of a Patch Box

The Side of a Patch Box

77 Illustrations from John Stalker and George Parker, *A Treatise of Japanning and Varnishing*, Oxford, 1688. British Library, London

bodices (*pourpoints*) of amber-scented leather.[128] Among Nicolas de Larmessin's well-known theatrical representations of various trades (akin to the costumes which might be worn at a court masque), is the *Habit de Parfumeur* (fig. 76): on his head is a burner which emits scented steam, on his shoulders are fans and the wares on offer include scents, pomades, powders and soaps.

As the notion of the toilette became more elaborate, more specialised containers for cosmetics and perfumes were necessary; these could be expensive and ornate for the elite woman but cheaper and attractive versions were available for her middle-class sister. In late seventeenth-century England, japanned work – imitation of Asian lacquer – was particularly popular; the most famous work, *A Treatise of Japanning and Varnishing* (1688) by John Stalker and George Parker, included 'oriental' patterns for boxes to hold face powder and patches (fig. 77). From the second half of the century, the meaning of the toilette extended from cloths on the table and on the person, to include cosmetic objects (the toilet set), the luxurious boxes or containers which held them; it also embraced the performance of dressing, selecting accessories, applying make-up and arranging the hair; thus by synecdoche, fabric and beauty items (things) became a ritual as well (similarly, the word *bureau* in the Middle Ages meant the woollen covering on a desk and then came to mean the desk itself). Since the concept of the toilette was primarily French – as fashion, in the sense of novelty and

76 (*facing page*) Nicolas de Larmessin, *Habit de Parfumeur*, 1695. British Museum, London

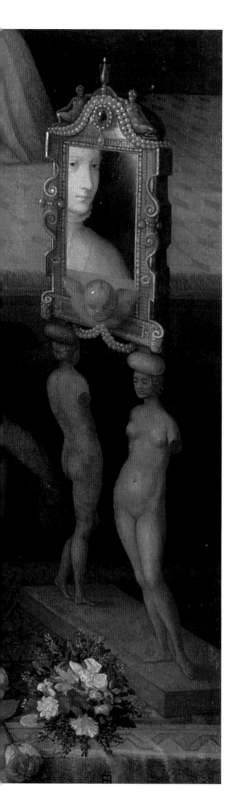

change for change's sake, was determined by Versailles – images of this essential routine of an elite woman's day can be seen in the French fashion plates which for the first time regularly recorded the modes and customs of high society. Depictions of women at what was increasingly called a dressing table, present factual information about the toilette, without the moral message contained in earlier representations. Occasionally, an accompanying verse hinted tongue-in-cheek at the vanity of adornment, suggesting that the naked or natural beauty was preferable to artifice; this is the case in Henri Bonnart's *Dame à sa toillette* (fig. 79). Here the fashionable woman about to select her jewellery is already painted and patched, although still in her informal dressing gown and not yet laced into her stays, as she sits before the table covered with a linen cloth heavily bordered with fine lace. According to the *Ladies Dictionary*, as soon as women awoke, 'the first thing they do is to salute their Glass, and consult with it, to know whether they have gain'd or lost any Graces since they last convers'd with it'. Their first concern was to make up the face and arrange the hair with 'little rings upon their Fore-heads, which they fasten with mouth-glew' (saliva), and only then did they put on their stays.[129]

Increasing numbers of writers during the second half of the century praised the worth of what the anonymous author of *Wits Cabinet* (about 1700) referred to as 'Beautifying Cosmeticks': 'Amongst all the various sorts of Cosmetics, there are none that are so much regarded by the Ladies, as those that do adorn the Face; which is not improperly called the Seat of Beauty'.[130] The word 'beautifying' was frequently used in the modern sense that one might use it today, that is, of cosmetic products which add beauty to a woman's appearance; the *Ladies Dictionary* refers to 'Cosmetick or Cosmeticks [which] are of divers kinds, and highly in use for beautifying the face and hands'; a lengthy entry under 'Beauty' was largely supportive of cosmetics provided they were used with discretion.[131] Jeamson, in *Artificiall Embellishments* (1665), addressing the readers of his beauty manual, declared: 'Ye Ladies . . . are the Dearlings that Art most respects, and for whose sake are composed such Aromatique unguents, such beautifying oils and essences, that would you accept their profer'd assistance, there is none of you but might equalize a Hellen'.[132]

In a period when the complexion was subject to many problems, like skin eruptions and illnesses such as smallpox, most contemporary recipe books concentrated on various ways to clean, brighten, soften and smooth the skin. The majority of the recipes for such face washes were made from natural ingredients such as flowers, herbs, white wine, breadcrumbs, rice flour, plantain water, egg whites, lemons, honey, dairy products (especially the milk of goats and asses), animal fats, waxes, chamber lye (urine) and so on; they had proved their worth over time. There are a number of references to 'woman's milk', which must have been readily available due to the frequency of pregnancy; among Jeamson's

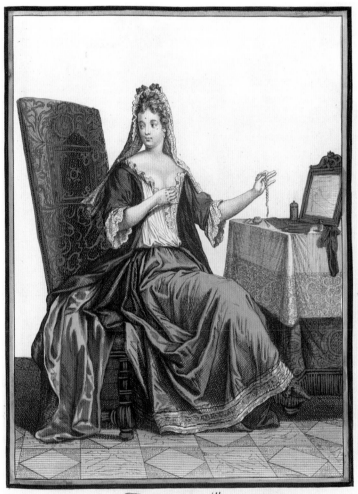

Dame a sa toillette

Vous prenes soin d'orner vostre beauté Mais a quoy bon? est il quelque Amant degouté
On vous voit richement vestüe, Qui n'aime mieux la beauté toute nüe.

Chez JBonnart vis auis les Mathurins au coq auec priui'

79 Henri Bonnart, 'Dame à sa toillette', 1687, from *Receuil des modes de la cour de France*. Los Angeles County Museum of Art. Purchased with funds provided by the Eli and Edythe L. Broad Foundation, Mr. and Mrs. H. Tony Oppenheimer, Mr. and Mrs. Reed Oppenheimer, Hal Oppenheimer, Alice and Nahum Lainer, Mr. and Mrs. Gerald Oppenheimer, Rick and Marvin Ring, Mr. and Mrs. David Sydorick, the Costume Council Fund and members of the Costume Council (M. 2002.57.81)

recipes to 'whiten a tan'd Visage, and to keep the Face from Sunburn', was a lotion of rose-water, woman's milk, oil of myrrh and egg whites.[133] As well as printed works which could be bought (doubtless some were more effective than others), many households had their own collections of tried and tested recipes. A number of such books, compiled by women, survive from the late seventeenth century; they include cosmetic, medical and cookery recipes – sometimes it is not easy to distinguish one from another. Mary Doggett's *Booke of Receits* (1682) included distilled waters and pastes or ointments known as pomades or pomatums (the words were used interchangeably) for the skin, lip salves, hand creams

78 (*facing page*) School of Fontainebleau, *Woman at her Toilette* (detail of fig. 48)

and instructions on how to make scented powders and how to 'Perfume after the spanish manner'; Mary Glover's *Booke of Receipts* (dated 1688 although the entries continue into the 1690s), also included recipes for pomades, herbal and floral bath lotions, lily-water to remove freckles and so on.[134] Neither woman mentioned dangerous lead-based preparations, which might suggest that the more expensive paints were limited to the elite (or to women who traded on their 'beauty' to make a living), or that some consumers realised the hazards of face paint. Yet some of the more arcane Renaissance recipes continued to appear; pigeon water, claimed *Wits Cabinet*, was 'much in use for beautifying and preserving the Complexion' and many variants of this were published.[135] However, the world was changing and the kind of old-fashioned and absurd recipes for improving the skin at which Jonson had poked fun early in the century were increasingly decried. In the famous scene in Congreve's *Way of the World* (1700), when Mirabell tells Millamant that she must 'continue to like your own face as long as I shall', he forbids her to use night masks 'made of oiled-skins and I know not what – hog's bones, hare's gall, pig water, and the marrow of a roasted cat' (IV: v).

For those women who wished to whiten their skin in a more effective way than could be achieved by natural ingredients, and who rejected hazardous face paints, a new cosmetic had become popular by the middle of the seventeenth century, known as Water of Talc (talk, talcque). Based on a solution of powdered talc (magnesium silicate), this smoothed the skin, covered over the scars of small-pox and made a foundation on which women could then add powder and/or rouge; according to Jeamson, 'water of Talcque applied to the face makes it as white as alabaster'.[136] To make it more effective, oil of pearls (pearls dissolved in distilled vinegar, added to gum arabic – acacia tree gum – and then scented with rose-water) was sometimes added and then it was called Water of Talc and Pearl, as in an advertisement from late in the century (fig. 80), which suggests a multitude of ways in which it could improve the appearance.

Still, skin preparations based on lead and mercury continued to be promoted in some publications and advertised for sale; these included, of course, the famous ceruse and a related lotion known as '*Lac Virginis* or Virgins Milk'. This was made by adding water to lead dissolved in vinegar and – according to *The Accomplish'd Ladies Delight* (1686) – would 'make the Face, Neck, or any part of the Body fair and white';[137] references to women bathing in milk probably mean animal milk but occasionally *Lac Virginis*. One writer suggested that the demand for white lead cosmetics actually increased towards the end of the century, as the quality improved and it became more adhesive. For in 1661 Sir Robert Moray, one of the founders of the Royal Society, discovered a better way of producing white lead, by placing rolled-up thin sheets of lead in a jar with 'an inch or two of vinegar at the bottom'; the jar was then stacked in a bed of stable manure (which

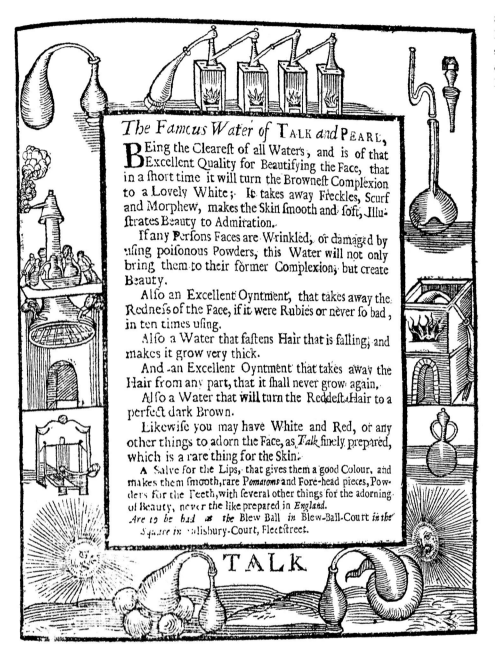

80 'Famous Water of Talk and Pearl', advertisement, (?)late seventeeth century, from *A Collection of Early Advertisements*. British Library, London (C112.f.9, f.126)

created warmth) for three weeks and then the lead unrolled and beaten to flake off the ceruse. This method was in use until the late nineteenth century,[138] though far less. Mercury and lead were sometimes used in the powder women needed to prevent make-up from sliding off the face, and to create a matte complexion, but there were also safer powders made from ground alabaster, from

pearls (today still used in cosmetics to brighten the skin) and, by the late seventeenth century, from fine Venetian talc; powder was also scented with a range of floral perfumes and by violet-scented orris from the roots of the Florentine iris.

So that the face did not appear too white, a touch of pink or red was needed on the cheeks and on the lips. Potions to add pink to the complexion could be made from ingredients available in the kitchen or the garden, and della Porta suggested clove-scented gillyflowers, boiled nettles and distilled strawberry water; a more elaborate recipe which produced a red 'that cannot be detected' and 'will delude all men', included cardamom seeds, 'raspings of Brasil, and Spirit of Wine distilled'.[139] Red powder made from cochineal, or the bark of the Brazil tree, made the famous Spanish rouge, available in leather or paper form; the *Ladies Dictionary* states: 'A sort of Spanish paper must not be forgot in a Ladies Dressing Room, to give her Cheeks and Lips a pleasant rosie colour'.[140] This might remind the reader of the famous scene in Congreve's *Way of the World*, when old Lady Wishfort, asking for the 'red', is brought ratafia or cherry brandy (which would have brought colour to the cheeks), which she pretends is not what she wanted; claiming her face is an 'errant ash colour', she berates her maid: 'I mean the Spanish paper, idiot, complexion darling. Paint, paint, paint, dost thou understand that, changeling?' (III: i). The most dangerous, but durable, red fucus (paint) was that made from vermilion (red mercuric sulphide) and was sometimes known as cinnabar; over a period of time and with prolonged use, it caused the same deleterious effects as ceruse. Equally dangerous was Jeamson's suggestion that in order to make the eyes black, a lotion including powdered antimony (as in kohl, a lead-based eye-paint), 'lapis lazuli, musk, aloes, camphire and saffron' should be placed in the eyes overnight; 'in the morning they will be black as if they had been so naturally'.[141]

Whereas there was a limit to the transformation which make-up could provide for the face, there was greater opportunity in what could be done to the hair, in curling and styling it and, by the end of the seventeenth century, adding perfumed pomades which made the hair smell good and which enabled powder (of various scents and colours) to adhere to it. Hair-styles during this period were often complex and required body through curl; this could be created by various lotions, used in conjunction with hair rollers and hot irons, although heat used extensively damaged the hair. For this reason the recipe books contained many remedies to preserve and strengthen the hair, among them the popular bear's grease, on the premise that as the animal had a thick pelt of hair, there must have been some inherent quality of sturdy growth in its fat; this remedy remained fashionable until well into the nineteenth century. The author (possibly Nicholas Culpeper) of *Arts Masterpiece; or, The Beautifying Part of Physick* (1660) had a recipe for a hair restorative entitled 'Cleopatra's Ointment', made from reed roots and

81 (*facing page*) Peter Lely, *Diana Kirke, later Countess of Oxford* (detail of fig. 72)

Facing Beauty

dried flies 'mixt . . . with Bears fat and oyl of Cedars'; other suggestions sound more dubious, such as 'burnt Bees mixt with honey' or 'Oyl of Earth-worms', but presumably honey and any kind of fat or oil might have encouraged hair growth or at the least made it shine.[142] Shine was important especially in the 1660s when – as in the portraits of English court beauties like Frances Jennings and Diana Kirke (see figs 71 and 72) – hair was smooth and curled in loose ringlets, a style especially appropriate for fashionable 'undress'. Jeamson in 1665 commented that 'twining curls are now much the mode', adding rather whimsically that no women were 'thought paragons for Beauty, save those whose gracefull locks do reach the breasts, and make spectators think those ivory globes of Venus are upheld by the friendly aid of their crispy twirls'. These 'crispy twirls', he says, were created by wetting the hair with a solution of 'gum arabick or mouth glew in water', or beer, and then putting in clay curlers overnight or by using 'a hot Tobacco pipe or iron'. Alternative curling potions were given in other books, including John Shirley's *The Accomplished Ladies Rich Closet of Rarities* (1687), which suggested a mixture of powdered pine-nut kernels, 'wall-flower water, and oil of myrtle'.[143] From the 1670s, hair-styles became more elaborately curled, in the French style, as Lely's portrait of Louise de Kéroualle (see fig. 73) indicates, and which can also be seen in the *Unknown Woman* (fig. 82) by Jakob Ferdinand Voet, a Flemish artist working in Rome from 1663 to 1678. Voet was much in demand by travellers on the Grand Tour for the flattering way he depicted appearance and especially the details of fashion. The sitter, a vivacious beauty who may have been either French or Italian, wears a dress of embroidered pink silk, with a stiffened bodice; striped silk gauze ribbons tie up the sleeves of her chemise, which is edged with fine Venetian point lace. To complement the costly formal attire, the hair-style is appropriately complicated and fashionable, a version of the coiffure *hurlu-brelu* created in Paris by a Mlle Martin in 1671. In the spring of that year, Madame de Sévigné reported on the style to her daughter, describing how the hair was cut short on the top and at the sides, and with so many curls that a hundred curl papers were needed; the width of the style usually required false hair to be added at the sides, sometimes the blonde curls as seen in the Voet portrait.

In the sixteenth century, as remarked, fair hair had been the most covetable and a wide range of recipes enabled women to become blondes. For Giambattista della Porta, 'yellow, shining and radiant' hair was the ideal, to be achieved with a dye made from the lees of white wine, honey, celandine roots, saffron, oil, cumin seeds and box-tree bark; this was left on the hair for twenty-four hours, then removed, and the hair washed with a 'Lye made of Cabbage-Stalks, Ashes, and . . . Rye-Staw'.[144] Other recipes included similarly natural ingredients such as honey, lemon juice, mistletoe and rhubarb, but also some hazardous substances like alum and vitriol; all these were equally used to brighten and lighten

the face. By the end of the seventeenth century, an article in the *Ladies Dictionary* declared that blonde hair was no longer in fashion, because a golden colour was 'a sign of a lustful Constitution', as it signified the heat of the body; instead, dark hair was in favour, which could be achieved by a dye made from the husks of green walnuts, oak bark, red wine and oil of myrtle.[145] Black was the most fashionable colour for hair, for it made the skin look white; blackberries, oil of tartar, powdered oak galls, ox marrow mixed with soot, iron filings boiled in vinegar, leeches steeped in red wine and even 'Oyl made of green Lizards [which] doth black the hair' were typical of some of the dyes on offer.[146] Many of these recipes referred to the necessity of changing red hair by dyeing it black, for

although in the sixteenth century shades of red hair had been much in vogue – henna was used to preserve the colour and to add a reddish tinge to brown or auburn hair – a hundred years later red hair was heartily disliked, a feeling which lasted well into the nineteenth century. The reasons for this long-lived antipathy are not clear; in *As You Like It*, Shakespeare refers to it as the 'dissembling colour', probably because Judas supposedly had red hair, but it may have been simply that its rarity made it suspect.

Compared to the vitriolic complaints of the early seventeenth century, about the ways in which women enhanced their beauty through cosmetics and paint, critical comment by the end of the period was more muted and with far less religious invective. Make-up was sometimes attacked on aesthetic grounds, Margaret Cavendish disliking the 'Sluttishnesse' of cosmetic preparations, such as face masks 'which are not only horrid to look upon . . . but the stink is offensive'; as for pomatums, they were 'wet and greasie', and in the hot weather women 'fry (as it were) in Grease'.[147] The word 'Sluttishnesse' has overtones of impropriety, of a woman too free with her sexual favours, an accusation often levelled by critics at women who spent too much time on self- adornment. A Utrecht School painting, of around the mid-1650s, *Young Woman at her Toilet* (fig. 83), depicts a somewhat slatternly scene, with a rumpled bed and a privy in the background; the gesture made with thumb and index finger by the seated woman suggests a sexual appetite. She is almost certainly a prostitute and the greatest attention is given not to her surroundings but to her appearance, for she is well dressed in yellow silk, and the table contains beauty products and jewellery.

The main reason behind any anti-cosmetic discourse was that of falsity – falsity of the claims made for face paint, falsity of the mask created by artificial beauty. By the end of the seventeenth century, with the greater availability of newspapers and journals, advertisements for an increasing range of goods and services included those for cosmetics. Leafing through lists of beauty products for sale, and early advertisements, one is struck by the appearance of wondrous all-embracing products which claimed to cure a host of ailments as well as enhancing beauty; specific ingredients were rarely given, except for the absence of harmless substances. Fargeon's merchandise in 1665 included 'Mouchoirs de Venus', linen handkerchiefs steeped with a secret substance (possibly a preparation he had invented and almost certainly lead-based), which whitened the skin in such a way that one would not have believed possible ('d'une manière qu'on n'y peut rien connoitre'), and which he claimed would last a whole year.[148] Many of the exaggerated claims in advertisements related to the preservation of beauty well into old age: one for 'an eminent and highly approved Balsamic Essence' states that 'there is nothing of Paint relating to it; the Aged it makes appear Fair and Young, and preserves Beauty to their lives ends'. Names of celebrities were

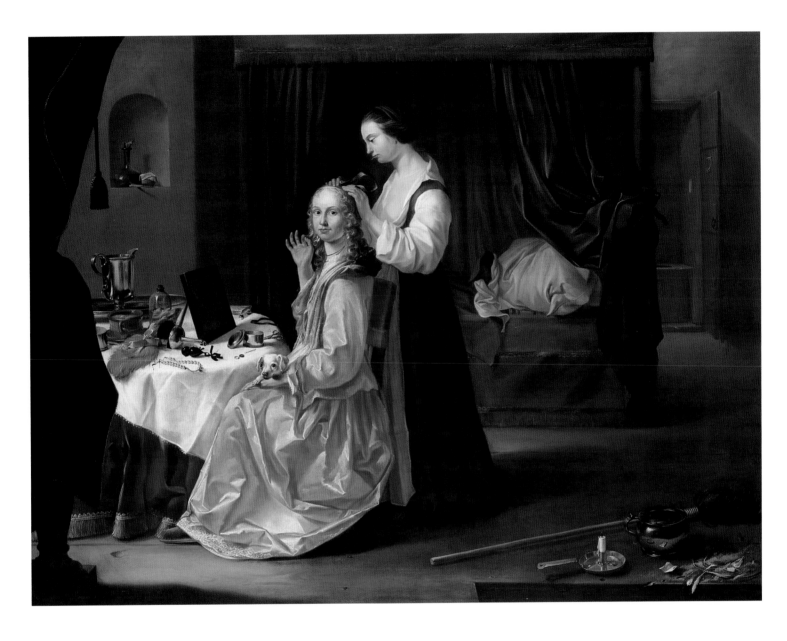

sometimes invoked, such as Madame de Montespan (mistress of Louis XIV), who 'has made her Beauty famous all over the habitable Earth'; by the use of 'Princesses Powder', which 'she has used all her life . . . she does not appear above eighteen or twenty years of Age, though she be above fifty-five'.[149] Many of the advertisements seem to be for businesses kept by women, who usually refer to themselves as gentlewomen, implying perhaps their familiarity with elite beauty routines; one such woman, expert 'in things relating to the Female Sex', offered (among a range of products) a beautifying wash, which 'leaves such an agreeable

83 Utrecht School, *Young Woman at her Toilet*, mid-1650s. Minneapolis Institute of Arts, The Putnam Dana McMillan Fund

Lustre, that the most curious Eye cannot perceive Art to be used, but will judge it to be the true product of Nature'.[150] Such claims, of course, were (and are) the common currency of beauty advertising and make one wonder how far they were taken seriously at the time, either by those selling such nostrums or those buying them.

For there is a sense of theatricality and make-belief involved in making up the face, and women must have relished the choices available to them, no matter what critics might have said: variety and the ability to change the appearance were essential to being fashionable. The author of *A Metamorphosis of Fair Faces* (1662) remarked:

> Our English ladies . . . think they have too much colour, then they use art to make them pale and fair; now they have too little colour, then Spanish Paper, red leather, and other Cosmetical Rubricks must be had; yet for all this it may be the skins of their faces do not please them; off they go to Mercury-water, and so they remain like peel'd Ewes, until their faces have recovered a new Epidermis . . .[151]

Without make-up, the Renaissance face looked bare, especially when set beside the colourful complexities of high fashion. A fashion plate by Jean Dieu de Saint-Jean, 'Femme de qualité estant a sa toilette' (fig. 84), shows a woman with a 'naked' face sitting before a dressing table on which are two mirrors, the smaller one for close-up detail. A lace mantle over the back of her chair will protect her clothing during the ritual of make-up; the toilette will also include the final stages of dressing, and a rich overgown will be added to the bodice and skirt she wears, to complete the *tout ensemble*. The final touches will involve selecting what jewellery to wear and dressing the hair, then placing in it ribbons, lace, feathers, jewelled ornaments and so on, of the kind seen in a fashion plate by Antoine Trouvain of 1694 (fig. 85), of a woman seated before her dressing table, mask in hand, and in her hair an aigrette (heron feather), and ruby ornaments, including a *tremblant* jewel, made to quiver with movement. Her hair is arranged with two curls like small curved horns, a style explained by the *Ladies Diction-ary* as: 'A Passager, is a Curled Lock, next the Temple, and commonly two of them are used';[152] by the end of the century a whole vocabulary had emerged for a wide range of hair-styles. For from the late 1680s, styles were high and complicated, often with the addition of false hair as well as an array of accessories of the kind seen here; the word 'head' was used to mean 'headdress', so essential a part it played in a fashionable woman's appearance. Such 'Parures de Tête', as the author of a *Traité contre le luxe des coeffures* (1694) referred to them, were completely artificial; they were, he said, the plaything of caprice ('le joüet de caprice'), unregulated by reason and completely against nature.[153]

It is therefore unsurprising that cosmetics and paint were thought to create a mask of beauty which hid the 'real' woman, who might, underneath, be ugly. In

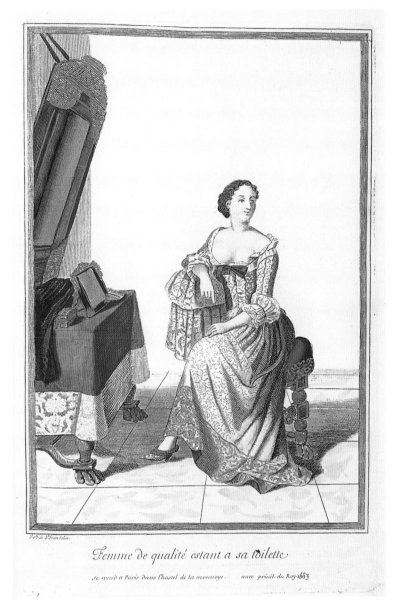

84 Jean Dieu de Saint-Jean, 'Femme de qualité estant a sa toilette', 1683, from *Receuil des modes de la cour de France*. Los Angeles County Museum of Art. Purchased with funds provided by the Eli and Edythe L. Broad Foundation, Mr. and Mrs. H. Tony Oppenheimer, Mr. and Mrs. Reed Oppenheimer, Hal Oppenheimer, Alice and Nahum Lainer, Mr. and Mrs. Gerald Oppenheimer, Rick and Marvin Ring, Mr. and Mrs. David Sydorick, the Costume Council Fund and members of the Costume Council (M. 2002.57.81)

Femme de qualité estant a sa toilette

se vend a Paris dans l'hostel de la monnoye· auec privil. du Roy 1683

Delights for the Ingenious, Nathaniel Crouch's emblem book published in 1684, Emblem XXVII (fig. 86), a woman holds up a 'youthful vizard' over her own less attractive features, 'an old Edition, by the Eye'. Her real face has bulging cheeks, suggesting that she has unsuccessfully attempted to create the fashionably rounded and fleshy look by inserting 'plumpers', round discs made of cork, leather or wax 'which old Ladies that have lost their side Teeth hold in their mouths to plump out their Cheeks, which would else hang like Leathern bags'.[154] The accompanying verse to this image expresses in general terms the need to

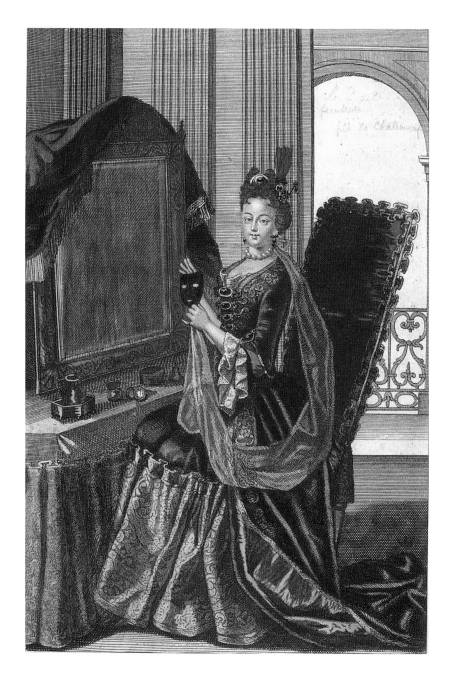

be aware of possible deceptions in appearance, for 'Deformity within may be/ Where outward Beauty we do see':

> I hate a painted Brow; I much dislike
> A Maiden-blush, daub'd on a furrowed Cheek
> And I abhor to see old Wantons play

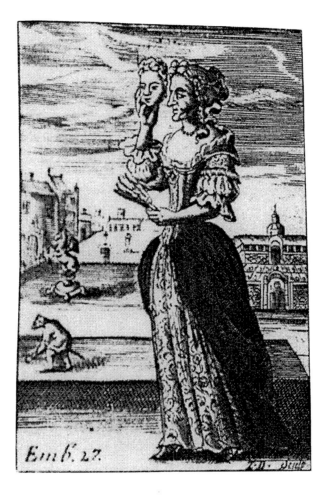

86 'Bella in Vista, Dentro Trista', Emblem XXVII from Nathaniel Crouch, *Delights for the Ingenious: Emblems Divine and Moral, Ancient and Modern*, London, 1684. British Library, London

And suit themselves, like Ladies of the May,
Now, you thus warned are, advice embrace
And trust not gawdy Clothes, nor painted Face (ll. 15–20)[155]

It is highly unlikely that a mask of youthfulness created by face paint would have been so transformative as truly to deceive the eye; this was one of the games men pretended to play with regard to the female appearance – on the one hand in love with beauty, on the other hand disliking how it might be achieved in practical terms. A constant refrain was the impossibility of women being 'read' by how they looked, that their moods were as artificial and unpredictable as their faces. This was one of the themes in Samuel Butler's *Hudibras* in which he mocked men who address their mistresses with inflated descriptions of their beauty – that the red and white in their cheeks were only colours used by artists, 'Indian Lake and Ceruse' – and as for the sun and moon being eclipsed by a woman's 'bright Eyes', these were merely fashionable black patches:

The Sun and Moon by her bright Eyes
Eclips'd, and darken'd in the Skies,
Are but black Patches that she wears,
Cut into Suns, and Moons, and Stars:
By which Astrologers, as well
As those in Heav'n above, can tell
What strange Events they do foreshow
Unto her Under-World below
 (*Hudibras* II, 1663, ll. 9–16)

Hudibras was an anti-Puritan work, and it is one of the curiosities of the Interregnum in England, an ostensibly Puritan and anti-luxury regime, that so much attention (in the form of publications and prints) was given to the wearing of patches, which suggests that the custom was widespread, at least in London and major centres of population. In Francis Hawkins's *Discourse . . . against powdring of Hair, Naked-Breasts, Black Spots, and other unseemly Customes* (1653), the frontispiece illustration shows personifications of *Vertue and Vice* (fig. 87) as, respectively, a woman in a black hood and modest dress, and a woman in low-cut dress, with long curled hair tied at the front in lovelocks and with patches on her face. Hawkins was not against a modest use of cosmetics as an 'imbellishment a Woman bestows on her own Beauty' but was firmly opposed to 'that upstart impudence of naked Breasts, with that other apish trick of patch'd faces'.[156]

Butler put forward the idea, perhaps tongue-in-cheek, that the placing of patches was linked to astrology, a subject highly popular during the short-lived English republic; Keith Thomas suggests that it 'offered a systematic explanation for all the vagaries of human and natural behaviour'.[157] According to astrology, certain areas of the face were governed by the signs of the zodiac – Capricorn the chin, Aquarius the left eye, and so on – so that patches placed on the face could echo this respectable link, this time equating such sites with emotions related to love and sexual invitation; this game, perhaps not taken seriously by women at least, was played well into the eighteenth century.

Patches had been used since antiquity to cover scars and pimples on the face and neck, and were thought to reduce headaches and migraine, but the first references to black patches as beauty spots are from the later sixteenth century, in England and France. The theory was, explained John Lyly in *Euphues* (1578), that any imperfection heightens the beauty of the face: 'in all perfect shapes, a blemish bringeth rather a liking every way to the eyes, than a loathing any way to the mind . . . Venus had her mole in her cheek, which made her more amiable'; 'amiable' here is used as we now might say 'loved' or 'desirable'.[158] References to Venus being the inspiration for the beauty patch are manifold; the physician and natural philosopher John Bulwer in his celebrated book *The Artificial Changeling* (1650) commented: 'Our Ladies here have lately entertained a

87 Illustration to *A Discourse upon some Innovations of Habits and Dressings against powdring of Hair, Naked-Breasts, Black Spots, and other unseemly Customes*, by Francis Hawkins, 1653. British Library, London

vaine Custome of spotting their Faces, out of an affectation of a Mole to set off their Beauty, such as Venus had', his view being that 'these spots in a beautifull face adde not grace to a Visage, nor increase delight'. In an anti-French polemic he gave grudging praise to the French, who, suffering more from bad skin and pimples, invented the beauty spot; they thus 'shewed their witty pride, which could so cunningly turne Botches into Beauty, and make uglinesse handsome'.[159]

Bulwer's approach to his subject did not – as would have been the case earlier in the century – involve a lengthy discussion of Biblical authorities; it was mainly anthropological, not aiming to single out such European cultural practices alone for critical comment, but to attack all 'abusers of their Bodies, who have new made and deformed themselves'. The sub-title of his book attacks 'the mad and cruel gallantry, foolish bravery, ridiculous beauty, filthy finenesse, and loathsome lovelinesse of most nations, fashioning & altering their bodies from the mould intended by nature'. Non-European peoples who tattoo and pattern their faces, who pierce the skin with various ornaments, and hide their faces in masks ('derived first from the Numidians [Berbers of North Africa] who cover their Faces with a black Cloath with holes, made Maske-like to see thorow'), were, he believed, the inspiration for various English facial fashions, so in the second edition of *The Artificial Changeling* (1653) he illustrated 'The Pedigree of the English Gallant' (fig. 88). In order to make his satirical point, Bulwer equated the irreversible decoration or the incisions made in the skin with the harmless wearing of masks and patches; in the latter case the number, size and variety of patches is exaggerated, but the image of the woman with her coach-and-horses patch was taken seriously by later writers, and is still mentioned as fact in some works today.

The French word for the black beauty spot is *mouche*; an early reference is in Charles Sorel's romance *L'Orphize de Chrysante* (1626), where a black patch on a woman's face is described as like a fly in milk.[160] Such patches were worn to make the skin look whiter and, in a period when skin pallor was admired, this was especially effective when used by those with darker skin. Made of black taffeta or velvet, sold already gummed, or to be stuck on with some kind of adhesive or by mouth-glue (saliva), patches were widely used from the second half of the seventeenth century, and attracted, according to Antoine Furetière in his *Dictionnaire Universel* (1690), considerable censure from the devout as 'une marque de grande coquetterie'; coquetry in France, however, was not even a venial sin and in some quarters it was actually a virtue. Context was crucial, and the grand lady in fine clothes and wearing patches was not – in spite of what critics claimed – easily confused with the prostitute in too many patches and tawdry imitations of finery. Even in the ostensibly more censorious climate of England, there were relatively few serious critics of black patches by the late seventeenth century, and many defenders of what was essentially a harmless, if

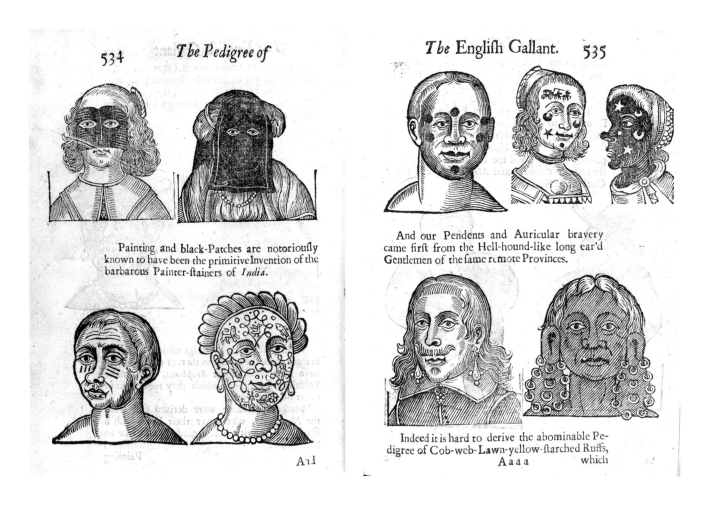

88a and b John Bulwer,
The Artificial Changeling, London
1653. Wellcome Library, London

silly, custom. The author of *The Challenge* (1697) upheld the right of women to wear 'an innocent Patch or two', for their faces were their own to decorate how they liked; the *Ladies Dictionary* also defended the mask – 'the Skreen of modest Blushes, as well as the shelter of Beauty from the too warm Kisses of the Sun, or parching of the Northern wind' – as 'but one great spot to cover the face'.[161] Yet, while there are fashion plates showing elite women wearing black patches, there are no seventeenth-century portraits of women with beauty spots (although they sometimes hold masks); this is all the more curious given the longevity of the vogue, which lasted well into the following century, and I have yet to find a satisfactory explanation.

Paint and Painting: The Veil of Art

One of the reasons that makes the Renaissance fascinating to study is the wide-ranging variety of views about the whys and wherefores of human existence; divergent philosophies could encompass on the one hand a late medieval astrological system in which humanity was guided by the movements of the planets, and on the other hand the beginnings of serious scientific enquiry. These ideas were not always mutually exclusive, as men attempted to work out new thought systems which could harmonise abstract ideas of religion and philosophy with new concepts of rationalism and applied science. There was no contradiction, for example, to a man like Sir Kenelm Digby, in thinking that alchemy was as worthy a study as experiments in science. In both instances, it might be said, there were attempts to define what matter is, how it could be manipulated and presented to the human eye both in real terms and represented in art. In his famous work of natural philosophy, *Two Treatises*, published in Paris in 1644, he noted how 'colours of bodies are but various mixtures of light and shadowes diversely reflected to our eyes';[162] this is metaphysical conceit, scientific rationalism and a kind of neo-Berkeleyan philosophy based on the primacy of subjective perception, and even a questioning as to what reality is. Digby's description of the 'colours of bodies' is germane to how women painted themselves to present an image to the world and how they were represented in art; some of the connections between painting the face and painting a portrait form a conclusion to this chapter.

A running joke throughout the period under discussion, and well beyond it, linked a painted woman to a painted picture. Richard Haydocke's translation of Lomazzo's 1584 *Trattato dell'arte de la Pittura* suggested that the custom of women using make-up was like an artist painting over an already painted canvas; they practised 'Painting upon the Life, where a knowne Naturall shape is defaced, that an unknown Artificiell hewe may be wrought thereon'.[163] In Thomas Tuke's anti-cosmetic treatise of 1616, the 'Painted woman', unsatisfied with her appearance as created by God, re-created herself 'as *a picture*'; 'too much love of beautie hath wrought her to love painting; and her love of painting hath transformed her into a picture'.[164] Almost a hundred years later, Richard Steele, in an essay critical of face paint, presented a fake advertisement purporting to be from a miniature painter, a 'young Gentlewoman . . . who Paints the Finest Flesh-colour . . . and is to be heard of at the House of Minheer Grotesque, a Dutch Painter in Barbican. N.B. She is also well skilled in the Drapery-part, and puts on Hoods, and mixes Ribbons so as to suit the Colours of the Face with great Art and Success' (*The Spectator*, no. 41, 17 April 1711). 'Drapery' is used here both in the sense of the fabrics and accessories sold in drapers' shops and also of 'drapery painters' (usually anonymous) who helped artists such as van Dyck, Lely and

Kneller by painting the costume (often generalised) and draperies required. Another kind of artistic deceit, claimed a verse *Satyr against Painting* (1697), was that the portrait painter or 'Face-mender' would make sitters look more attractive than they really were, in the same way that women disguise themselves with 'Trick and Fucus', although the wise man would soon realise that such 'Glories quickly tarnish/ Of fading Colours made, and Varnish'.[165] Lomazzo defended the way in which 'artificiall comeliness' (comeliness he defines as the 'most pleasing proportions', an essential part of beauty) aided a portrait of a woman. The artist could lessen 'anie disproportionate parte in her bodie' and improve her complexion 'to helpe it a little with the beawtie of his colours', but with 'a sweete discretion . . . that the defect of nature may be pretilie shadowed with the veile of Arte'.[166] The practice of helping nature with the 'veile of Arte' must have been widespread and makes one wonder when looking at a portrait of a beautiful woman if her face has been painted by herself or 'enhanced' by the artist.

In many contemporary published works on art there was often an elision between painting techniques and painting the face; paints were mixed with turpentine which was also used in cosmetics, and women applied paint with a brush or a cloth like artists did. Treatises on art sometimes read like treatises on cosmetics; to paint flesh in art, said John Bate in his *Mysteryes of Nature and Art* (1634), 'First you must lay on a white colour tempered with gumme-water, and when it is drie . . . you must temper ceruse and vermillion together'.[167] Gum Arabic or 'gumme-water' was used for cosmetics and hair lotions, and for miniatures; miniature painters also used 'glair' (egg-white, also widely included in cosmetic preparations), appropriately so, as miniaturists needed to concentrate on an accurate depiction of the face.[168] In Edward Norgate's *Miniatura or the Art of Limning* (1648), he made explicit the link between painting flesh in art and in real life, and in both cases the 'first in Order is Ceruse and white lead'.[169] How far the ceruse (or any of the pigments artists used, such as vermilion, brazilwood, carmine and crimson lake – reds from cochineal) were identical to those in face paint is not clear, but the composition must have been similar, with colours for cosmetics possibly being more finely ground. Artists bought their colours sometimes from specialist suppliers, and also from the apothecaries, who sold both the ingredients for cosmetics as well as cosmetic preparations they might have made themselves. Lynn Festa has a telling anecdote: 'Criticized by a client for depicting her complexion inaccurately, the painter Hyacinthe Rigaud ripostes, "It's astonishing – for my rouge comes from the same merchant as yours"';[170] such comments continued well into the eighteenth century. Given that women who painted their faces with ceruse and vermilion suffered serious side effects, one wonders if artists also experienced lead poisoning; certainly such paints would have got on their skin but – as they were not rubbed in as face paint was – not in a sustained way so as to cause damage.

The language of art treatises resonates with the same colour concepts applied to the face as can be found in beauty manuals, or in poetry. Lomazzo noted that 'Vermilion and lake make the colour of ripe strawberries, roses, red lippes, rubies . . . the same mixtures with white, make the colour of red cheeks, of faire carnation and damaske roses'; but concluded that 'it is not the red and white which giveth the gratious perfection of Beauty, but certain sparkling notes and touches of amiable cheerfulnesse, accompanying the same'.[171] Beauty, in short, cannot be confined to colour, however beautifully applied.

Such ambiguity running through a discussion of paint and painting when applied to women and their portraits might be summed up, curiously enough, by John Stalker and George Parker in their *Treatise of Japanning and Varnishing* (1688), where they praise painting, but where their comments might be equally applicable to a woman skilfully painting herself like a masterpiece of art that will survive time:

> Painting will certainly make us survive our selves, and render the shadow more lasting than the substance, when the colours are laid in the right place, and by the Painter's hand . . . Painting only is able to keep us in our Youth and perfection. That Magick Art [is] more powerful than Medea's charms . . . [and] happily prevents grey hairs and wrinkles; and sometimes too, like Orpheus for Euridice, forces the shades to a surrender, and pleads exemption from the Grave. Mahomet's is truly the Painter's Paradise, for he alone can oblige with a Mistress for ever young and blooming . . .[172]

Enlightenment

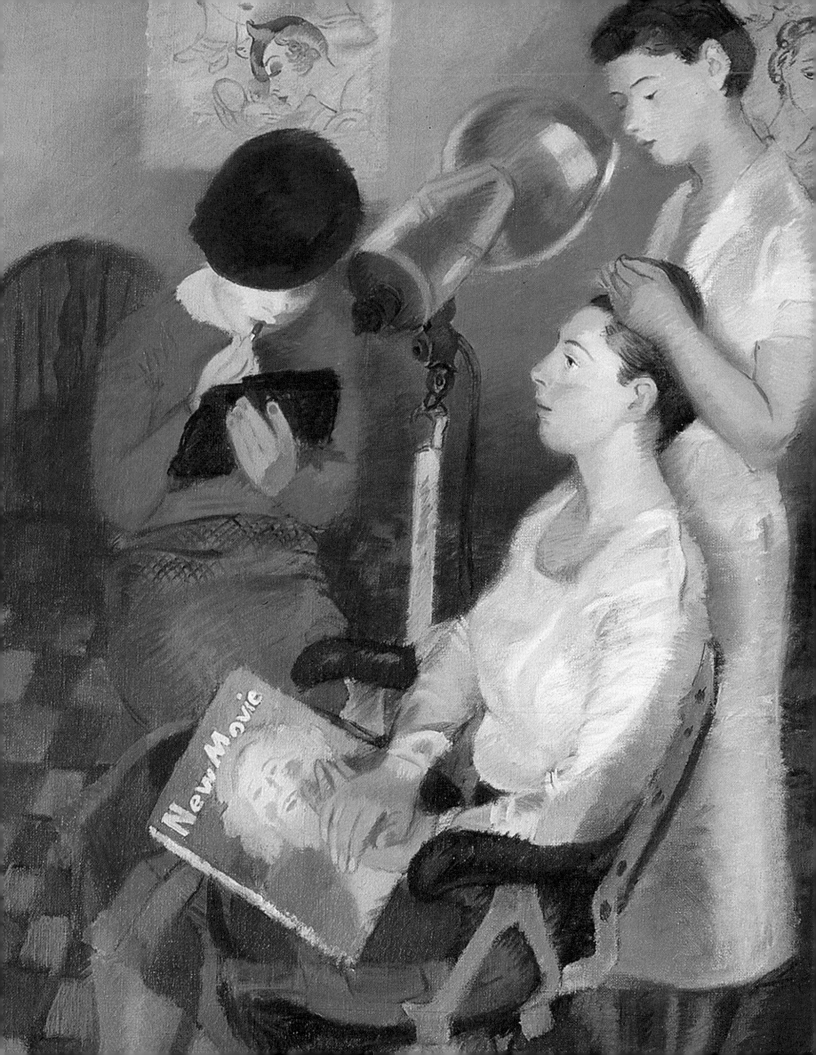

Property of the House of Hohenzollern, HRH Georg Friedrich Prince of Prussia, SPSG, Photographer: Jörg P. Anders: 141

The J. Paul Getty Museum, Los Angeles: 142, 162, 177

British Museum, Photo: Courtauld Institute of Art: 143

British Museum: Banks Collection, Photo: Courtauld Institute of Art: 144, 145

Bayerische Schlösserverwaltung, München: 158

akg-images: 166

Image © The Metropolitan Museum of Art/Art Resource/Scala, Florence: 170, 180

© RMN (Musée d' Orsay)/Hervé Lewandowski: 183

© RMN (Musée d' Orsay)/Jean-Gilles Berizzi: 184

© Musée d' Orsay, Dist. RMN/Patrice Schmidt: 185

Courtesy of Jersey Heritage: 187

© RMN (Musée d' Orsay)/Droits réservés: 188, 199

Hammer Museum, Los Angeles: 189

Photograph © 2010 Museum of Fine Arts, Boston: 193

National Galleries of Scotland, Edinburgh: 194

© de Laszlo Foundation/Courtauld Institute of Art: 201

© National Museums Liverpool: 205

© RMN/Agence Bulloz: 211

Photography © The Art Institute of Chicago: 213

© Estate of Doris Clare Zinkeisen/National Portrait Gallery, London: 214

© Thomas Lowinsky/V&A Images/Victoria and Albert Museum, London: 215

Royal Academy of Arts, London: 221

Photograph Credits

veins and blue colouring 82, 98, 159, 190, 270
Velázquez, Diego: *The Toilet of Venus ('The Rokeby Venus')* 28, *28*
Venice
 courtesans and feminine ideal 61, 63–4
 fashion for blonde hair 64–7, 68, 76, 271
 glass and mirror manufacturing 44, 68
 Venus as figure of beauty 2, 4, 5, 15, 28, *28*, 289
 imperfection of mole 132–3, 192
 overwhelming beauty of Medici Venus 156
 sacred and profane in 19, 21, 57–9, *58–9*
 Venus *naturalis 16*, 19, *20*, 21, 56, 57
vermilion
 lip colouring 38
 rouge (cinnabar) 85, 122, 136, 166, 182, 251
Verni, Maria 316, 322
Vernon, Gertrude, Lady Agnew 283–4, *283*
Versailles court 112, 117–18, 180, 182
Victorian turn to past 257–8, 262, 264
violet powder 281
Virgil 103
Virgin Mary 44
'Virgins Milk' 120, 201, 218, 251
virtue and beauty 13–23, 325
 coquetry and patches 133
 moderation or abstinence in use of make-up 89, 108, 132, 182, 219–21
 nineteenth-century esteem of innate beauty 219–21, 224, 226–37, 282
 Plato's idealism 2, 9, 214, 226
 in Renaissance thinking 71–2, 95–6
visual depiction of beauty 2, 6–9
 see also art; portraiture
Vitruvian proportions and beauty 72
vivacity of French women 161–2
Voet, Jakob Ferdinand: *Unknown Woman* 124, *125*
Vogue (magazine chain) 306–7, 324, 328–9

Wale, Samuel: *The Economy of Beauty* illustration *158*
Walker, Alexander: *Beauty* 232, *233*, 238
Walpole, Horace 180, 200
wartime maintenance of beauty 324–3
Water of Talc and Pearl 120, *121*
Watts, George Frederic: *Choosing (Ellen Terry)* 258–9, *258*
Weyden, Rogier van der: *Unknown Woman* 40, *41*
Wharton, Edith: *The House of Mirth* 288
Whistler, James McNeill 247
white skin ideal
 in antiquity 38
 and cosmetics in portraits 98, 162
 'enamelling' vogue 252–3, 270
 Enlightenment era 152–3, 156, 162, 178, 190, 201, 218, 219
 flattering effect of black 133, 230, 232
 'French white' 347n.132
 'liquid whiteners' in Victorian era 281
 Modern age 238, 239, 251, 292, 310, 319
 nineteenth-century conventional beauty 230, 238
 Renaissance and early modern period 64, 72, 75, 76, 80, 81–2, 94, 104, 105, 120–22, 136
 skin colour and relative beauty 86, 88, 156, 310, 343n.153
 skin whitening recipes and preparations 118–19, 120–22, 156, 178, 218
 see also harmful effects of mineral-based cosmetics; paint (for face); red and white colour combination
Whitman, Walt 4
wigs and hairpieces
 Enlightenment era 166, 178, 204, 205, *205*, 216
 Modern age 279, 292
 as profitable business in nineteenth century

249, 264
 Renaissance period 82, 85, 98, 103
Wilde, Oscar 267, 273, 278–9, 328, 329
 The Picture of Dorian Gray 12, 25, 50, 256
Wilding, Alexa 262
Williams, Neville 318
Wilmot, Anne 6
Wilson, Enid, Countess of Chesterfield 284, *285*
Winterhalter, Franz Xaver
 Empress Elizabeth of Austria 241, *242*
 Empress Eugénie 241, 243–4, *243*
 Princess Leonilla zu Sayn-Wittgenstein-Sayn 235, *235*–6
 Pauline Metternich 30–31, *30*, 244
Wits Cabinet 118, 120
Wolf, Naomi 42
'woman's milk' preparations 118–19
women's equality in Enlightenment era 149–50, 213–14
Woolf, Virginia 294–5, *295*
 Mrs Dalloway 295, 303
 To the Lighthouse 47–8
Woolley, Hannah 94, 108
Woolner, Thomas 262
Woolnoth, Thomas: *Facts and Faces* 27, 232–4, *234*, 236–7

Yeats, W. B.: 'A Woman Young and Old' 333
youth and beauty 12–13, 44–8, 152, 212–13
 advertising and promise of youth 48–9, 126–7, 217–18, 313
 and 'cosmeology' 216–19
 modern processes and pursuit of 330, 331

Zdatny, Steven 331
Zeuxis 26, 27, 50
 Picture of an Exact Beauty 36
zinc oxide 270, 274, 281
Zinkeisen, Doris: *Self-portrait* 310, *311*, 322

Index

Stalker, J., and G. Parker, 1688, *A Treatise of Japanning and Varnishing*, Oxford

Steele, V., 1985, *Fashion and Eroticism: Ideals of Feminine Beauty from the Victorian Era to the Jazz Age*, Oxford

Steiner, W., 2001, *The Trouble with Beauty*, London

Stendhal [Henri Beyle], 1975, *On Love* (1822), trans. G. and S. Sale, London

Stevens, G. A., 1772, *An Essay on Satirical Entertainments. To which is added Stevens's New Lecture upon Heads*, London

Stewart, J., 1782, *Plocacosmos: or the whole art of hairdressing*, London

Strauss, R., 1924, *The Beauty Book*, London

Strong, R., 1972, *The Masque of Beauty*, National Portrait Gallery, London

Stubbes, P., 1585, *The Anatomie of Abuses*, London

Swift, J., 1958, *Poems*, ed. H. Williams, 3 vols, Oxford

Swinburne, A. C., 1868, *Notes on the Royal Academy Exhibition 1868*, London

Symonds, J. A., 1857, *The Principles of Beauty*, London

Taylor, J., 1701, *Several Letters Between Two Ladies Wherein the Lawfulness and Unlawfulness of Artificial Beauty in Point of Conscience Are nicely Debated*, London

Thomas, A.-L., 1987, *Essai sur le Caractère, les moeurs et l'esprit des femmes dans les différens siècles* (1772), intro. C. Michael, Paris and Geneva

Thomas, K., 1971, *Religion and the Decline of Magic*, London

—, 1994, 'Cleanliness and Godliness in Early Modern England', in Fletcher and Roberts, pp. 56–83

Travitsky, B. S., and A. F. Seeff (eds), 1994, *Attending to Women in Early Modern England*, London and Cranbury, N.J.

Treveris, P., 1526, *The Grete Herball*, London

Tseëlon, E., 1995, *The Masque of Femininity: The Presentation of Women in Everyday Life*, London

Tuke, T., 1616, *A Treatise against Painting and Tincturing*, London

Turner, F., 1991, *Beauty: The Value of Values*, Charlottesville and London

Uzanne, O., 1902, *L'Art et les artifices de la beauté*, Paris

Veblen, T., 1899, *The Theory of the Leisure Class*, New York

Verni, M., 1934, *Modern Beauty Culture*, London

Walgrave, J. (ed.), 1998, *The Laboratory of Seduction*, Antwerp

Walker, A., 1836, *Beauty*, London

Wecker, J., 1660, *Eighteen Books of the Secrets of Art and Nature* (1582), trans. R. Read, London

West, S., 2004, *Portraiture*, Oxford

Williams, N., 1957, *Powder and Paint: A History of the Englishwoman's Toilet*, London

Wolf, N., 1991, *The Beauty Myth*, London

Woodforde, J., 1992, *The History of Vanity*, Stroud

Woolley, H., 1673, *The Gentlewoman's Companion*, London

Woolnoth, T., 1852, *Facts and Faces; or the mutual connexion between linear and mental portraiture morally considered and practically illustrated . . . With a dissertation on personal beauty*, London

Young, J. H., 1882, *Our Deportment, or The Manners, Conduct and Dress of the most refined Society*, Detroit

Zdatny, S., 1997, 'The Boyish Look and the Liberated Woman: The Politics and Aesthetics of Women's Hairstyles', *Fashion Theory* 1, 4 (Oxford), pp. 367–97

—, 1999, *Hairstyles and Fashion: A Hairdresser's History of Paris 1910–1920*, Oxford and New York

Miscellaneous

Collections of early advertisements, London, British Library (C.112.f.9 and 551.a.32)

F. Gillham, Excerpts on fashion and fashion accessories 1705–1915, London, Victoria and Albert Museum (25.L.3/4)

Beauty Parlour collection, John Johnson Collection, Bodleian Library, Oxford

Trade cards, Banks and Heal Collections, British Museum; Waddesdon Collection

Mossé, J. M., *c.*1830, *L'Art de plaire*, Paris

Nehemas, A., 2007, *Only a Promise of Happiness: The Place of Beauty in a World of Art*, New Jersey

Nelson, R. S., and R. Shiff (eds), 2003, *Critical Terms for Art History*, Chicago and London

Norgate, E., 1997, *Miniatura or the Art of Limning* (1648), ed. J. Miller and J. Murrell, New Haven and London

Norville, Comtesse de, 1894, *Les Coulisses de la Beauté: Comment la Femme séduit*, Paris

Oberkirch, Baroness d', 1852, *Memoirs of the Baroness d'Oberkirch, Countess de Montbrison* (1786), 3 vols, London

Ovid (Publius Ovidius Naso), 1959, *The Art of Love*, trans. J. L. May, London

—, 2003, *Ars Amatoria*, Book 3, trans. and ed. R. K. Gibson, Cambridge

Pacteau, F., 1994, *The Symptom of Beauty*, London

Panofsky, E., 1976, *Meaning in the Visual Arts*, London

Passe, C. de, 1635, *Le Miroir des plus Belles Courtisanes de ce Temps*, Amsterdam

Peacham, H., 1612, *Minerva Britanna*, London

Peiss, K., 2002, 'Educating the Eye of the Beholder: American Cosmetics Abroad', *Daedalus*, CXXXI, 4, pp. 101–9

Percival, M., 1999, *The Appearance of Character: Physiognomy and Facial Expression in Eighteenth-Century France*, Leeds

Perrot, P., 1984, *Le Travail des Apparences, Ou les transformations du corps féminine XVIIIe–XIXe siècles*, Paris

Philippy, P., 2006, *Painting Women: Cosmetics, Canvases and Early Modern Culture*, Baltimore

Piccolomini, A., 1540, *Dialogo de la bella creanza de le Donne*, Venice

—, 1968, *Raffaella*, trans. and ed. J. L. Nevinson, London

Piper, D., 1992, *The English Face*, ed. M. Rogers, London

Pitman, J., 2003, *On Blondes*, London

Platt, H., 1602, *Delightes for Ladies: to adorne their persons, tables, Closets and Distillatories with beauties, banquets, perfumes and waters*, London (notebooks in British Library, MS Sloane 2203)

Pointer, S., 2005, *The Artifice of Beauty: A History and Practical Guide to Perfumes and Cosmetics*, Stroud

Pope, A., 1757, *Works*, 6 vols, London

Porta, G. della, 1669, *Natural Magick* (1558–89), London

Porter, R., 1985, 'Making Faces: Physiognomy and Fashion in Eighteenth-Century England', *Etudes Anglaises* XXXVIII, 4, pp. 385–96

—, 1993, *Disease, Medicine and Society in England 1550–1860*, Basingstoke

—, 2001, *Bodies Politic: Disease, Death and Doctors in Britain 1650–1900*, London

—, 2003, *Flesh in the Age of Reason*, London

Poucher, W. A., 1923, *Perfumes and Cosmetics*, London

—, 1926, *Eve's Beauty Secrets*, London

Prettejohn, E., 2005, *Beauty and Art*, Oxford

—, 2009, 'Pre-Raphaelite Beauty', in Ahlund, pp. 52–65

Priestnall-Holden, I., 1935, *Every Woman's Guide to Beauty*, London

Prior, M., 1712, *The Present State of the Court of France and City of Paris*, London

Pye, H. J., 1766, *Beauty: A Poetical Essay*, London

Raisson, H., 1829, *Code de la Toilette*, Paris

Ribeiro, A., 1987, *The Female Face in the Tate's British Collection 1569–1876*, London

—, 1990, 'Concerning Fashion: Théophile Gautier's *De La Mode*', *Costume*, XXIV, pp. 55–68

—, 2003, *Dress and Morality*, Oxford and New York

Rich, B., 1613, *The Excellency of good women*, London

—, 1616, *My Ladies Looking Glasse*, London

Roche, D., 1994, *The Culture of Clothing: Dress and Fashion in the 'ancien régime'*, trans. J. Birrell, Cambridge

Rogers, M., 1988, 'The Decorum of Women's Beauty: Trissino, Firenzuola, Luigini, and the Representation of Women in Sixteenth-century Painting', *Renaissance Studies* II, 1, pp. 47–88

Romei, A., 1598, *The Courtier's Academie*, trans. 'I.K.', London

Rubinstein, H., 1930, *The Art of Feminine Beauty*, London

Ruppert, A., 1892, *Livre de Beauté*, Paris

Ruscelli, G., 1558, *The Secretes of the Reverende Maister Alexis of Piemont* (1555), trans. W. Warde, London

Ruskin, J., 1903–12, *The Complete Works*, ed. E. T. Cook and A. Wedderburn, 39 vols, London

Rye, W. B., 1865, *England as seen by Foreigners in the Days of Elizabeth and James I*, London

Salmon, W., 1672, *Polygraphice*, London

Salomon, N., 1994, 'Positioning Women in Visual Convention: The Case of Elizabeth I', in Travitsky and Seeff, pp. 64–95

Scarry, E., 2000, *On Beauty and Being Just*, London

Schiller, F., 2004, *On the Aesthetic Education of Man* (1795), trans. R. Snell, New York

Schwarz, H., 1952, 'The Mirror as Art', *Art Quarterly*, XV, pp. 97–118

Shaftesbury, A. Ashley Cooper, Earl of, 1711, *Characteristicks of Men, Manners, Opinions, Times*, 3 vols, London

Simmel, G., 1964, *Sociology* (1908), trans. and ed., K. H. Wolff, New York and London

—, 1984, *On Women, Sexuality, and Love* (1911), trans. and intro. G. Oakes, New Haven and London

Smith, A. M., 1838, *Etiquette for Ladies*, Philadelphia

Smollett, T., 1766, *Travels through France and Italy*, 2 vols, Dublin

Sontag, S., 2002, 'An Argument about Beauty', *Daedalus*, CXXXI, 4, pp. 21–6

Sozinskey, T. S., 1877, *Personal Appearance and the Culture of Beauty*, Philadelphia

Spence, J., 1752, *Crito; or, a Dialogue on Beauty*, London

Higgins, K.M., 2000, 'Beauty and Its Kitsch Competitors', in Brand 2000, pp. 87–111

Hogarth, W., 1997, *The Analysis of Beauty* (1753), ed. and intro. R. Paulson, New Haven and London

Holme, R., 1688, *An Accademie of Armory*, Chester

Houdoy, J., 1876, *La Beauté des Femmes dans la littérature et dans l'art*, Paris

Hume, D., 1772, *Four Dissertations*, London

Hunt, L., 1847, *Men, Women and Books*, London

Hutcheson, F., 1726, *An Inquiry into the Origins of our Ideas of Beauty and Virtue*, London

Hutton, H., 1619, *Follie's Anatomie: Or, Satyres and Satyricall Epigrams*, London

Jacob, P.L. [P. Lacroix], 1858, *Les Secrets de Beauté de Diane de Poitiers*, Paris

James, C., 1865, *Toilette d'une Romaine au Temps d'Auguste, et Cosmétiques d'une Parisienne au XIXe siècle*, Paris

Jeamson, T., 1665, *Artificiall Embellishments; or, Arts Best Directions: How to Preserve Beauty or to Procure it*, Oxford

Jefferys, S., 2005, *Beauty and Misogyny: Harmful Cultural Practices in the West*, London

Jones, C., 2002, *Madame de Pompadour: Images of a Mistress*, London

Jones, M., 2008, *Skintight: An Anatomy of Cosmetic Surgery*, Oxford and New York

Joslen, S., 1937, *The Way to Beauty: A Complete Guide to Personal Loveliness*, London

Karim-Cooper, F., 2006, *Cosmetics in Shakespearean and Renaissance Drama*, Edinburgh

Kelso, R., 1978, *Doctrine for the Lady of the Renaissance*, Urbana, Ill.

Kirwan, J., 1999, *Beauty*, Manchester and New York

Knight, R.P., 1805, *An Analytical Inquiry into the Principles of Taste*, London

Kovach, F.J., 1974, *Philosophy of Beauty*, Norman, OK

Laermans, R., 1998, 'The Face as a Social Work of Art', in Walgrave, pp. 11–30

Lakoff, R.T., and R.L. Sherr, 1984, *Face Value: The Politics of Beauty*, London

Langtry, L., 1925, *The Days I Knew*, London

Lawrence, D.H., 1954, *Selected Essays*, London

Le Camus, A., 1754, *Abdeker: or, The Art of Preserving Beauty*, London

Le Fournier, A., 1530, *La Décoration d'humaine nature et a ornament des Dames . . .* , Paris

Lémery, N., 1711, *New Curiosities in Art and Nature*, London

Lemnius, L., 1633, *The Touchstone of Complexions*, trans. T. Newton, London

—, 1658, *The Secret Miracles of Nature*, London

Leverson, R. [Madame Rachel], 1863, *Beautiful for Ever!*, London

Lichtenstein, J., 1998, 'On Platonic Cosmetics', in Beckley and Shapiro, pp. 83–99

Liébault, J., 1582, *Trois Livres de l'embellissement et ornement du corps humain*, Paris

Lillie, C., 1822, *The British Perfumer*, London

Linton, E.L., 1868, *The Girl of the Period*, London

—, 1883, *The Girl of the Period*, 2 vols, London

L'Isle André, Y.M. de, 1767, *Essai sur le beau*, Amsterdam

Lipovetsky, G., 1994, *The Empire of Fashion*, trans. C. Porter, Princeton, N.J.

Lomazzo, G.P., 1970, *A Tracte containing the Artes of Curious Paintinge, Carvinge and Buildinge* (1598), trans. R. Haydocke, Farnborough

Luigini, F., 1907, *The Book of Fair Women* (1554), trans. E.M. Lang, London

McDonough, E.G., 1937, *Truth about Cosmetics*, New York

MacKenna, S., 2002, 'Plotinus on Beauty', in *Daedalus*, CXXXI, 4, pp. 27–34

McLaughlin, T., 1972, *The Gilded Lily*, London

Malcolm, J.P., 1810, *Anecdotes of the Manners and Customs of London* (1808), 2 vols, London

Mallarmé, S., 2004, *Mallarmé on Fashion: La Dernière Mode*, trans. and ed. P.N. Furbank and A. Cain, Oxford and London

Marinella, L., 1999, *The Nobility and Excellence of Women, and the Defects and Vices of Men* (1600), trans. and ed. A. Dunhill, Chicago and London

Martin, M., 2003, 'Casanova and Mlle Clairon: Painting the Face in a World of Natural Fashion', *Fashion Theory*, VII, 1, pp. 57–77

Marwick, A., 1988, *Beauty in History: Society, Politics and Personal Appearance*, London

Meister, H., 1799, *Letters written during a residence in England*, London

Mercier, L.S., 1782–8, *Tableau de Paris*, 8 vols, Amsterdam

—, 1791, *Costumes des Moeurs et de l'Esprit françois avant la grande révolution, pouvant servir d'appendice au Tableau de Paris*, Lyon

—, 1798, *Le Nouveau Paris*, 6 vols, Paris

Miller, Jonathan, 1998, *On Reflection*, London

Miller, Joshua, 2002, 'Beauty and Democratic Power', *Fashion Theory*, VI, 3, pp. 277–97

Minty, N., 1989, *The Victorian Cult of Beauty*, Toronto

Minuit, G. de, 1587, *De la Beauté*, Lyon

'Miso-Spilus', 1662, *A Wonder of Wonders; or A Metamorphosis of Fair Faces . . .* , London

Monin, E., 1886, *L'Hygiène de la Beauté*, Paris

Montagu, F. (ed.), 1838, *The Ages of Female Beauty*, London

Montez, L., 1858, *The Arts of Beauty*, London

Morin, E., 1957, *Les Stars*, Paris

Dick, R., 1857, *The Connexion of Health and Beauty*, London

Digby, K., 1683, *Chymical Secrets and Rare Experiments in Physick and Philosophy*, London

—, 1689, *Remedes souverains et secrets . . .* , Paris

—, 1968, *Loose Fantasies*, ed. V. Gabrieli, Rome

Dodoens, R., 1578, *A Niewe Herball*, trans. H. Lyte, London

Dodsley, R., 1735a, *The Toy-Shop*, London

—, 1735b, *Beauty: or, The Art of Charming*, London

Dolan, F., 1993, 'Taking the Pencil out of God's Hand: Art, Nature, and the Face-Painting Debate in Early Modern England', *Publications of the Modern Language Association of America*, CVIII, 2, pp. 224–39

Donne, J., 1633, *Juvenilia or Certaine Paradoxes and Problemes*, London

—, 1652, *Paradoxes, Problemes, Essayes, Characters . . . Epigrames*, London

—, 1925, *A Defence of Women for their Inconstancy and their Paintings*, London

Donoghue, D., 2003, *Speaking of Beauty*, New Haven and London

Drew-Bear, A., 1994, *Painted Faces on the Renaissance Stage*, Lewisburg and London

Ducasse, C. J., 1992, 'The Art of Personal Beauty', in Alperson, pp. 617–24

Duffeyte-Dilhan, J., 1857, *Aux Femmes: De la beauté physique et morale*, Paris

Ebin, V., 1979, *The Body Decorated*, London

Eco, U., (ed.), 2004, *History of Beauty*, trans. A. McEwen, New York

Ellmann, R., 1988, *Oscar Wilde*, London

Etcoff, N., 1999, *Survival of the Prettiest: The Science of Beauty*, New York

Fargeon, J., 1665, *Catalogue des Marchandises*, Montpellier

Festa, L., 2005, 'The Changing Faces of England and France', *Studies in Eighteenth-Century Culture*, XXXIV (Cleveland), pp. 35–54

Feuillet, F. S., and A. Baschet, 1865, *Les Femmes blondes selon les peintres de l'école de Venise*, Paris

Finck, H. T., 1887, *Romantic Love and Personal Beauty*, 2 vols, London

Fischer, L., 2003, *Designing Women: Cinema, Art Deco, and the Female Form*, New York

Firenzuola, A., 1548, *Discorsi delle bellesse delle Donne*, Florence

—, 1992, *On the Beauty of Women*, trans. and ed. K. Eisenbichler and J. Murray, Philadelphia

Fletcher, A., and P. Roberts (eds), 1994, *Religion, Culture and Society in Early Modern Britain: Essays in Honour of Patrick Collinson*, London

Fletcher, E. A., 1899, *The Woman Beautiful*, New York

Flügel, J. C., 1930, *The Psychology of Clothes*, London

Fordyce, J., 1766, *Sermons to Young Women*, 2 vols, London

Fowler, L. A., 1864, *How to preserve the skin and increase personal beauty*, London

Franco, V., 1998, *Poems and Selected Letters*, trans. and ed. A. R. Jones and M. F. Rosenthal, Chicago and London

Frick, C. C., 2002, *Dressing Renaissance Florence*, Baltimore

Furman, F. K., 1997, *Facing the Mirror: Older Women and Beauty Shop Culture*, New York

Garb, T., 1998, *Bodies of Modernity: Figure and Flesh in Fin-de-Siècle France*, New Haven and London

Garches, M. de, 1894, *Les Secrets de Beauté d'une Parisienne*, Paris

Garland, M., 1957, *The Changing Face of Beauty*, London

Gaskell, I., 2003, 'Beauty', in Nelson and Shiff, pp. 267–80

Gattefossé, R.-M., and H. Jonquières, 1946, *Technique des Produits de Beauté*, Paris

—, 1949, *Technique of Beauty Products*, London

Gautier, T., 2005, *Mademoiselle de Maupin* (2 vols, 1835 and 1836), trans. and ed. H. Constantine, London

Genlis, S. F., comtesse de, 1818, *Dictionnaire Critique et Raisonné des Etiquettes de la Cour*, 2 vols, Paris

Gibson, A., 1599, *A Woman's Woorth*, London

Gilbert-Rolfe, J., 1998, 'Beauty and the Contemporary Sublime', in Beckley and Shapiro, pp. 39–52

Goffen, R., 1997, *Titian's Women*, New Haven and London

Gombrich, E. H., 1970 'The Mask and the Face: The Perception of Physiognomic Likeness in Art and in Life', in M. Black, E. H. Gombrich and J. Hochberg (eds), *Art, Perception and Reality*, Baltimore and London, pp. 2–46

Goudar, A., 1765, *The Chinese Spy: or, Emissary from the Court of Pekin* (1764), 6 vols, London

Grose, F. (intro.), 1796, *A Guide to Health, Beauty, Riches and Honour*, London

Guazzo, S., 1581, *Civile Conversation* (1574), trans. G. Pettie, London

Gunn, F., 1973, *The Artificial Face*, Newton Abbot

Guyon, L., 1643, *Le Miroir de la Beauté*, Lyon

Haiken, E., 1997, *Venus Envy: A History of Cosmetic Surgery*, Baltimore

Hall, T., 1653, *The Loathsomnesse of Long Haire*, London

—, 1654, *Divers Reasons and Arguments Against Painting, Spots, naked Backs, Breasts, Arms &c*, London

Hamilton, A., 1714, *Memoirs of the Life of Count de Gramont*, trans. A. Boyer, London

Haskins, S., 1993, *Mary Magdalen: Myth and Metaphor*, London

Haweis, E. A., 1878, *The Art of Beauty*, London

Hawkins, F., 1653, *A Discourse upon some Innovations of Habits and Dressings; against powdring of Hair, Naked-Breasts, Black Spots, and other unseemly Customes*, London

Hickey, D., 1995, *The Invisible Dragon: Four Essays on Beauty*, Los Angeles

Boccaccio, G., 2003, *Famous Women*, trans. V. Brown, Cambridge, Mass., and London

Boileau, J., 1678, *A Just and Seasonable Reprehension of naked Breasts and Shoulders* (1675), trans. E. Cooke, London

Boudier de Villemert, P.-J., 1758, *L'Ami des Femmes*, Paris

Bourdieu, P., 1984, *Distinction: A Social Critique of the Judgement of Taste*, trans. R. Nice, Cambridge, Mass.

Bradstock, L., and J. Condon (eds), 1936, *The Modern Woman: Beauty, Physical Culture, Hygiene*, London

Brain, R., 1979, *The Decorated Body*, London

Brand, P. Z., 'Bound to Beauty: An Interview with Orlan', in Brand 2000, pp. 289–313

— (ed.), 2000, *Beauty Matters*, Bloomington, Ind.

Brown, D. A. (ed.), 2001, *Virtue and Beauty*, Princeton, N.J.

Brown, P. F., 2004, *Private Lives in Renaissance Venice*, New Haven and London

Brown, S. J., 1856, *Toilet Table Talk*, London

Browning, H. E., 1898, *Beauty Culture*, London

Bruys, F., 1730, *The Art of Knowing Women: On the Female Sex Dissected*, London

Buc'hoz, P. J., 1787, *A New Collection of the most easy and approved methods of preparing baths, essences, pomatums, powders, perfumes, sweet-scented waters and opiates for preserving the teeth and gums, and sweetening the breath; with receipts for cosmetics of every kind that can smooth and brighten the skin, give force to beauty, and take off the appearance of age and decay*, London

Buffon, G. L. L., Comte de, 1797, *Natural History*, trans. J. S. Barr, 10 vols, London

Bulwer, J., 1650 and 1653, *Anthropometamorphosis: Man transform'd; or, The Artificial Changeling*, London

Buoni, T., 1605, *I Problemi della bellezza*, Venice

—, 1606, *Problemes of Beautie*, trans. S. Lennard, London

Burger, W. (Théophile Thoré), 1856, 'De la beauté dans les arts', *Revue Universelle des Arts* II (Brussels), pp. 193–202

Burke, E., 1757 and 1759, *A Philosophical Enquiry into the Origin of our Ideas of the Sublime and Beautiful*, London

Burton, R., 1621, *The Anatomy of Melancholy*, Oxford

Butler, J. D., 1968, *Four Philosophies*, New York

Byers, M., 1939, *Designing Women: The Art, Technique and Cost of Being Beautiful*, London

Bynum, W. F. and R. Porter, 1987, *Medical Fringe and Medical Orthodoxy 1750–1850*, London

Caron, A., 1806, *La Toilette des dames*, Paris

—, 1808, *The Lady's Toilette*, London

Casa, G. della, 1914, *A Renaissance Courtesy Book: Galateo of Manners and Behaviours*, trans. R. Peterson, London, 1576, intro. J. E. Spingarn, London

Castelbajac, K. de, 1995, *The Face of the Century: 100 Years of Makeup and Style*, London

Castiglione, B., 1974, *The Courtyer*, trans. Sir Thomas Hoby (1561) and intro. J. H. Whitfield, London

Cavendish, M., 1671, *The Worlds Olio* (1655), London

Cher, E., 1865, *A Popular Treatise on the Human Hair, with some Observations on the Use of Powders, Face Paints, Cosmetics and hair Dyes*, London

Chilson, F., 1934, *Modern Cosmetics*, New York

Clark, K., 1976, *The Nude: A Study of Ideal Art*, London

—, 1980, *Feminine Beauty*, London

Cochet, V., 1998, 'Le Fard au XVIIIe siècle: Image, Maquillage, Grimage', in D. Rabreau (ed.), *Imaginaire et Création Artistique à Paris sous l'Ancien Régime*, Paris, pp. 103–15

Cochin, C.-N., 1771, *Recueil de quelques Pièces concernant les Arts*, 3 vols, Paris

Cooley, A. J., 1866, *The Toilet and Cosmetic Arts in Ancient and Modern Times*, London

Corry, J., 1820, *The English Metropolis; or, London in the Year 1820*, London

Corson, R., 1965, *Fashions in Hair*, London

—, 1972, *Fashions in Makeup*, London

Coryat, T., 1611, *Coryat's Crudities*, London

Cosmetics and Toiletries: The International Magazine of Cosmetic Technology, 2006, CXXI, 8 (Carol Stream, Ill.), www.cosmeticsandtoiletries.com

Cousin, V., 1854, *Lectures on the True, the Beautiful, and the Good*, trans. O. W. Wight, Edinburgh

Cozens, J., 1777, *The Economy of Beauty*, London

Crane, T. F., 1920, *Italian Social Customs of the Sixteenth Century, and their Influence on the Literatures of Europe*, New Haven, Conn.

Cropper, E., 1976, 'On Beautiful Women, Parmigianino, Petrarchismo, and the Vernacular Style', *Art Bulletin* LVIII, 3, pp. 374–94

Crouch, N., 1684, *Delights for the Ingenious: Emblems Divine and Moral, Ancient and Modern*, London

Currie, E., 2000, 'Prescribing Fashion: Dress, Politics and Gender in Sixteenth-Century Italian Conduct Literature', *Fashion Theory*, IV, 2, pp. 157–77

Daedalus: Journal of the American Academy of Arts and Sciences, 2002, CXXXI, 4

Danto, A. C., 2000, 'Beauty and Beautification', in Brand 2000, pp. 65–83

—, 2002, 'The Abuse of Beauty', in *Daedalus* CXXXI, 4, pp. 35–56

Darcie, A., 1612, *The Honour of Ladies*, London

Debay, A., 1846, *Hygiène de la beauté*, Paris

—, 1856, *Les Parfums de la toilette*, Paris

DeGalan, A. M. 2002, 'Lead White or Dead White? Dangerous Beauty Practices of Eighteenth-Century England', *Bulletin of the Detroit Institute of Arts*, LXXVI, pp. 38–49

Adams, 1790, *Woman: Sketches of the History, Genius, Disposition, Accomplishments, Employments, Customs and Importance of the Fair Sex*, London

Agrippa, H. C., 1652, *The Glory of Women: or A Looking-Glasse for Ladies*, trans. 'H.C.', London

—, 1996, *Declamation on the Nobility and Preeminence of the Female Sex*, trans. and ed. A. Rabil, Chicago and London

Ahlund, M. (ed.), 2009, *The Pre-Raphaelites*, Stockholm

Alison, A., 1790, *Essays on the Nature and Principles of Taste*, Dublin

Alperson, P. (ed.), 1992, *The Philosophy of the Visual Arts*, Oxford

Ames-Lewis, F., and M. Rogers (eds), 1998, *Concepts of Beauty in Renaissance Art*, Aldershot

Andrews, J., 1783, *Remarks on the French and English Ladies, in a Series of Letters*, Dublin

Anon., *The Accomplish'd Ladies Delight*, 1686, London

—, *The Art of Beauty, or A Companion for the Toilet, In which the Charms of the Person are Considered and Explained: Under the several Heads of Shape, Features and Complexion. To which are added Easy, Safe and Certain Methods of attaining External Beauty*, 1760, London

—, *The Art of Beauty; or, The Best Methods of improving and preserving the Shape, Carriage, and Complexion*, 1825, London

—, *The Art of Being Beautiful*, 1902, London

—, *The Art of Making Love, or Rules for the Conduct of Ladies and Gallants in their Amours*, 1676, London

—, *Arts Masterpiece; or, The Beautifying Part of Physick*, 1660, London

—, *Beauties Treasury; or The Ladies Vade-Mecum*, 1705, London

—, *Beautiful Women: or The Album Book of Beauty*, 1858, London

—, *Beauty and how to keep it*, 1889, by 'A Professional Beauty', London

—, *Beauty and the Preservation of Youth*, 1905, by 'an M.D.', London

—, *Beauty's Mirror*, 1839, London

—, *Beauty: What it is, and how to retain it*, 1873, London

—, *The Challenge . . . or The Female War, wherein the Present Dresses and Humours of the Fair Sex are Vigorously attackt by Men of Quality, and as Bravely defended . . .*, 1697, London

—, *A Closet for Ladies and Gentlewomen*, 1611, London

—, *Cosmeology; or, The Art of Preserving and Improving Beauty*, 1816, London

—, *Delights for the Ingenious*, 1711, London

—, *A Discourse of auxiliary Beauty; or, artificiall Hansomenesse, in point of Conscience between two Ladies*, 1656 and 1662, London

—, *Englands Vanity; or, the Voice of God against the Monstrous Sin of Pride in Dress and Apparel*, 1683, London

—, *Etiquette for Ladies*, 1828, Philadelphia

—, *Hebe; or, The Art of Preserving Beauty*, 1786, London

—, *How to preserve good looks: Beauty and Cosmetics*, 1871, London

—, *The Ladies Dictionary*, 1694, London

—, *A Looking-Glasse for the Ladies*, 1812, London

—, *Manuel de la Toilette et de la Mode*, 1771, Dresden

—, *The Mirror of Beauty*, c. 1830, London

—, *The Mirror of the Graces*, 1811, London

—, *The New London Toilet; or, a compleat collection of the most simple and useful receipts for preserving and improving Beauty, either by outward Application or internal Use*, 1778, London

—, *Ornatus Mulierum: L'Ornement des Dames*, ed. P. Ruelle, 1967, Brussels

—, *A Satyr against Painting*, 1697, London

—, *Sylvia's Book of the Toilet: A Ladies' Guide to Dress and Beauty*, 1886, London

—, *The Toilet: A Dressing-table Companion*, 1839, London

—, *Wits Cabinet*, c. 1700, London

Arlen, M., 1924, *The Green Hat*, London

Askinson, G. W., 1915, *Perfumes and Cosmetics: Their Preparation and Manufacture* (1907), New York

Austin, W., 1637, *Haec Homo, wherein the Excellency of the Creation of Woman is described*, London

Baker, N., 1986, *The Beauty Trap: How Every Woman Can Free Herself from It*, London

Banner, L., 1983, *American Beauty*, New York

Barthes, R., 1993, *Mythologies*, trans. A. Lavers, London

Bate, J., 1634, *The Mysteryes of Nature and Art*, London

Bayard, M., 1876, *The Art of Beauty, or Lady's Companion to the Boudoir*, London

Beaton, C., *The Book of Beauty*, London, 1930

Beaumont, H., *see* Spence

Beauvoir, S. de, 1953, *The Second Sex*, trans. and ed. H. M. Parshley, London

Beckley, B., and D. Shapiro (eds), 1998, *Uncontrollable Beauty: Toward a New Aesthetics*, New York

Beerbohm, M., 1922, *A Defence of Cosmetics* (1894), New York

Beeton, I., 1861, *The Book of Household Management*, 2 vols, London

Bell, T., 1821, *Kalogynomia, or the Laws of Female Beauty*, London

Benjamin, W., 1999, *The Arcades Project*, trans. H. Eiland and K. McLaughlin, Cambridge, Mass.

Berger, J., 1992, 'Ways of Seeing Women' in Alperson, pp. 248–59

Berkeley, G., 1714, *The Ladies Library*, 3 vols, London

Berry, S., 2000, *Screen Style: Fashion and Femininity in 1930s Hollywood*, Minneapolis

Bigg, G. S., 1899, *Face and Figure*, London

Black, P., 2004, *The Beauty Industry: Gender, Culture, Pleasure*, London

Bland, J., 1733, *An Essay in Praise of Women*, London

Blessington, Countess of (ed.), 1835, *Heath's Book of Beauty for 1836*, London

—, 1838, *Heath's Book of Beauty for 1839*, London

Select
Bibliography

tissue rebuilding hormones into massage creams'.

19 Bare Escentuals www.bareescentuals.co.uk, accessed 26 July 2010.

20 'Cosmeceutical' has been a controversial concept and the term has not been recognised by the US Food and Drug Administration. If the manufacturers exaggerate claims that definite physiological changes are created by their cosmetics, then these products might become subject to strict drug regulations and this could affect profit margins.

21 Black 2004, pp. 51 and 35.

22 Zdatny 1997, p. 385

23 Writing in 1999, Nancy Etcoff, p. 6, claimed that in the US 'more money is spent on beauty than on education or social services'. According to the London edition of the daily free newspaper *Metro* of 1 November 2006 the cosmetics industry in the UK is worth £1 billion.

24 A Cosmetics Directive from the European Community established 'a prohibition to test finished cosmetic products and cosmetic ingredients on animals' from 11 March 2009; this was intended to apply to cosmetic products in Europe and outside. Given the opposition from some European countries, notably France, it remains to be seen how effective the ban will be.

25 Jefferys 2005, p. 178.

26 Higgins 2000, p. 105.

27 Baker 1986, pp. 245–6.

28 Higgins 2000, p. 105.

29 Lakoff and Scherr 1984, pp. 284 and 297.

30 Higgins 2000, p. 104.

224 (*following page*) Pierre Thomas Le Clerc, 'Jeune Dame se faisant coëffer à neuf' (detail of fig. 133)

story, Lerbier marries and grows her hair, a signifier of her restored femininity.

151 *Gazette du Bon Ton*, April 1920, pp. 78–82.

152 American *Vogue* quoted in Corson 1972, p. 453.

153 Rubinstein 1930, p. 252.

154 Beaton 1930, p. 63.

155 Acton quoted in A. Chisholm, *Nancy Cunard*, London, 1979, p. 60.

156 Strauss 1924, p. 55. Brilliantine was a perfumed, oily liquid pomade for men's head (and facial) hair around 1900.

157 Arlen 1924, pp. 41–2, 11, 45, 9; George Barbier's *Falbalas et Fanfreluches*, a collection of 60 pochoir (stencil) prints, appeared in 5 vols, 1922–6.

158 Chisholm, *Cunard*, p. 81.

159 B. Nichols, *Crazy Pavements*, London, 1927, pp. 11, 33, 44–5.

160 Chilson 1934, p. 301.

161 Poucher 1923, pp. 426–7 and 431. By the 1930s the main ingredients for face powder were 'zinc oxide, purified kaolin [clay], talc, the metallic stearates – particularly zinc stearates – precipitated chalk and magnesium carbonate' (Chilson 1934, p. 53); stearates are white crystallised fatty acids from animal or vegetable fats. Rice powder, though still available, was rarely used by this time, but in recent years it has revived in popularity.

162 Rubinstein 1930, p. 257.

163 McDonough 1937, pp. 10–11.

164 Berry 2000, p. 105.

165 Williams 1957, p. 149.

166 Rubinstein 1930, p. 32.

167 Beerbohm 1922, p. 5.

168 McDonough 1937, p. 7.

169 Sozinskey 1877, p. 104. He noted that 'painting the face and other exposed parts of the person is practised as an art'; for a similar equation of art with face painting – 'the epidermis is used as a canvas and various designs or pictures are imposed upon it' – see McDonough 1937, p. 106.

170 Fletcher 1899, pp. 151–2; she referred to iodine skin peeling and 'bleaches which eat off the epidermis'.

171 See the *British Medical Journal*, 29 April 1893 and 13 January 1894. The *British Medical Journal* of 29 April 1893 described Ruppert's *modus operandi*: '"Consulting rooms" are taken in a fashionable street, the portrait of the heaven-sent curer, arranged in becoming costume, appears in the windows of photographers' (p. 911); she then advertised lectures on the subject of cosmetics (sometimes with 'orchestral entertainments'), which were reported in the newspapers, along with details of the 'becoming costume'.

172 Rubinstein 1930, pp. 249–50 and 252.

173 *Pinpoints* 1 January 1939, pp. 12 and 3.

174 Verni 1934, p. 4. By 1930 there were 40,000 beauty salons in the US (Banner 1983, p. 270).

175 Williams 1957, p. 136.

176 Castelbajac 1995, p. 65.

177 Beaton 1930, pp. 46–7.

178 Barthes 1993, pp. 56–7.

179 Beaton 1930, p. 46.

180 Barthes 1993, pp. 56–7. Barthes was writing in the 1950s when Garbo was in retirement (her last movie *Two Faced Woman* of 1941, had been a box-office failure) and Audrey Hepburn was the fashionable beauty. For Barthes, however, Hepburn was 'woman as child, woman as kitten', with no spark of the divine essence possessed by Garbo: 'The face of Garbo is an Idea, that of Hepburn, an Event'.

181 J. Kobal, *The Art of the Great Hollywood Portrait Photographers 1925–1940*, London, 1980, pp. 20, 35, 8.

182 Rubinstein 1930, p. 264.

183 Morin 1957, p. 170.

184 Peiss 2002, p. 102.

185 Castelbajac 1995, p. 43; instead of thick sticks of greasepaint, Max Factor created a thinner form of greasepaint in a jar, which was lighter and easier to use.

186 Berry 2000, p. 95.

187 Byers 1939, pp. 269–70.

188 *Ibid.*, p. 103.

189 Morin 1957, pp. 168 and 170.

190 McDonough 1937, p. 170.

191 Verni 1934, p. 268.

192 *Ibid.*, p. 1.

193 *Ibid.*, pp. 41 and 4.

194 Priestnall-Holden 1935, preface by the publisher p. vii.

195 Joslen 1937, p. 141.

196 J. Adam, *Beauty Box*, London, 1940, p. 5.

197 British *Vogue* quoted in Castelbajac 1995, p. 90.

198 British *Vogue*, November 1939, p. 65; my thanks to Jennifer Daley for the reference.

Coda: Now

1 M. V. Ames, *Introduction to Beauty*, New York, 1931, p. 10.

2 Ellmann 1988, p. 40.

3 Byers 1939, p. 99.

4 *Daily Express*, 8 February 1989.

5 *Vogue*, November 2008, pp. 243–8. Kate Moss also appeared in the top 50 beauties selected by *The Times* in London (1 June 2005), along with other celebrities, actresses and a smattering of minor royalty.

6 Beerbohm 1922, p. 14.

7 Sontag quoted in Baker 1986, p. 240.

8 Ducasse 1992, pp. 624 and 620.

9 Rubinstein 1930, p. 275.

10 S. Gilman, *Making the Body Beautiful: A Cultural History of Aesthetic Surgery*, Princeton, 1999, pp. 296 and 303.

11 Useful surveys of the differing approaches to the topic include Haiken 1997 and Jones 2008.

12 Haiken 1997, p. 10.

13 Etcoff 1999, p. 147.

14 *Daily Mail* 15 November 1902, in Gillham II, 40. The 'electric wrinkle remover' was a small roller attached to a battery. The report also referred to the 'decided tonic' of an electric bath, where 'electricity [was] applied while in the water', which sounds rather hazardous.

15 Verni 1934, p. 120. She defined electrolysis as 'the art of permanently removing certain facial blemishes' – such as superfluous hair, moles, red thread veins – 'with the aid of an electric battery and a very fine platinum needle'.

16 Banner 1983, p. 274.

17 Rubinstein 1930, p. 35.

18 Hormones (a term first used early in the twentieth century) are 'substances formed by specialized cells or tissues, which are conveyed by the blood stream to other organs, whose function they stimulate' (*Cosmetics & Toiletries* 2006, p. 62). According to Verni 1934, p. 8, Rubinstein's 'latest contribution to scientific beauty culture is the incorporation of the skin-and-

106 *Ibid.*, p. 57.

107 Fletcher 1899, p. 191.

108 Hunt 1847, p. 275.

109 From Robertson's *Reminiscences*, quoted in M. Rizzi, *Sarah Bernhardt teatro e arte della moda*, Lecce, 2005, p. 123.

110 Banville quoted in Gunn 1973, p. 139.

111 The 'Bernhardt Wrinkle Eradicator' was made of alum, almond milk and rose-water; see Corson 1972, p. 435. For Pyr hairpins, see *Beauty Parlour*, 1: 48.

112 The word 'make-up' appears first in theatrical usage; the earliest example I have found is in a book entitled *How to 'Make-Up': A Practical Guide for Amateurs*, by 'Harefoot and Rouge', London, 1877. 'Harefoot' because rouge was sometimes applied with a hare's foot.

113 Fletcher 1899, pp. 191–2. Petroleum jelly was invented in the United States in 1872; Vaseline, a brand of petroleum jelly, was (and is) used as a skin protectant.

114 Violet powder was so-called not because of the colour, although it could have a very faint lilac tint, but because it was scented with orris (root from the Florentine iris) which made it smell of violets. According to *Sylvia's Book of the Toilet* 1886, violet powder sometimes included poisonous ingredients (p. 97); these were presumably lead or arsenic.

115 Fletcher 1899, p. 390. Fletcher stated that there were reasons for the use of kohl in Muslim lands, as Mahomet 'prescribed the practice for Arabian women . . . in order to protect them from the glaring light of the sun on the desert sands'; thus she claimed that this was 'a hygienic practice which had nothing in common with modern *coquetterie*' (p. 389). A recent theory is that the lead in kohl helped to fight the bacteria which cause eye infections and the low levels (of lead) posed no real health hazard.

116 Uzanne 1902, pp. 12 and 8.

117 Fletcher 1899, p. 132.

118 Finck 1887, II, 437.

119 *The Art of Being Beautiful* 1902, p. 41.

120 M. Maynard, '"A Dream of Fair Women": Revival Dress and the Formation of Late Victorian Images of Femininity', *Art History*, XII, 3, 1989, p. 322. Tennyson's poem (1833) talks of 'A daughter of the gods, divinely tall/ And most divinely fair', a reference to Helen of Troy, the paradigm of late 19th-century ideas of beauty in England.

121 Fletcher 1899, pp. 32–3.

122 Veblen 1899, pp. 147–8.

123 *Beauty and how to keep it* 1889, p. 17.

124 Bigg 1899, p. 19.

125 Fletcher 1899, pp. 71 and 429.

126 Beerbohm 1922, p. 9.

127 Fletcher 1899, p. 21.

128 Another inspiration was the work of Sargent; while in London, Gibson stayed in Sargent's studio. Gibson claimed that he never intended to create 'the nation's model of beauty in women' and that it was a composite model (Banner 1983, pp. 161 and 159); one of the models was his elegant wife, Irene Langhorne. In 1904 the 'Gibson Girl', personified by Camille Clifford, appeared on the London stage.

129 In the 1870s, a nose à la Langtry was in vogue; one medical writer in the 1870s suggested, for less fortunate women, a 'nose-machine' [i.e. splints] bound on the nose at night, which would 'transform acceptably those tip-tilted affairs which mar so many faces' (Sozinskey 1877, p. 99). From the 1880s a 'tip-tilted' nose became fashionable, an aspect of the healthy informal style of beauty favoured in the United States.

130 E. Wharton, *The House of Mirth*, ed. C. G. Wolff, London 1985, pp. 4–5. Lawrence Selden, the one sympathetic (but ineffectual) male character in the book, 'admires Lily's beauty, and he stubbornly resists acknowledging the fact that without her carefully arranged artistic appearance, she would not excite his interest' (p. xxii).

131 McDonough 1937, p. 97.

132 Askinson 1915, p. 299, referred to 'French white' (from talcum, oil of lemon and oil of bergamot) as 'the best of all powders'; glycerine 'has a powerful beautifying effect on the skin', making it 'white, supple, soft, and glossy' (p. 243), and casein (a protein from milk) was used in face creams and powders (p. 245). Not all cosmetics, however, were harmless; one cosmetic chemist mentioned that 'lotions sold as complexion beautifiers frequently contain small quantities of mercuric chloride' (Poucher 1923, p. 402).

133 Liquid paraffin is 'a purified, clear, oily liquid obtained from petroleum' (Poucher 1923, p. 105).

134 Zdatny 1999, p. 13. 'The most eminent coiffeurs were traditionally also the greatest artists of postiche, and the masterpiece they created for a client was often the most expensive item on her head' (p. 15).

135 *Ibid.*, p. 21; it was achieved by a new kind of curling iron, which created 'a wave that was soft, supple and relatively durable'. By the time he retired in 1897, Grateau was a millionaire (Zdatny 1997, p. 373).

136 Beaton 1930, p. 5.

137 *Ibid.*, pp. 65–6. Her portrait by Ambrose McEvoy of 1916 (private collection) is a conventional image of a society beauty, no more.

138 *Ibid.*, pp. 7 and 37.

139 *Ibid.*, pp. 65 and 36; the file on Sitwell in the National Portrait Gallery archives has photographs by Beaton which respond to her 'Gothic' looks; one of 1927, depicts her 'as an Effigy'. Virginia Woolf described her in 1918 as 'a very startled young woman wearing a permanently startled expression', in 'a green silk head-dress concealing her hair' (quoted in J. Mackrell, *Bloomsbury Ballerina*, London, 2009, p. 143).

140 Le Gallienne quoted in Corson 1972, p. 447.

141 Beaton 1930, p. 40.

142 Bigg 1899, p. 20.

143 Castelbajac 1995, p. 15; Rubinstein 1930, p. 252.

144 Castelbajac 1995, p. 15.

145 Banner 1983, p. 205.

146 Arlen 1924, pp. 16 and 47.

147 Strauss 1924, p. 67.

148 Against the use of making up in public was Lady Laura Troubridge in *The Book of Etiquette*, 2 vols, London, 1926, II, 221. As innocent coquetry, see Dorothy Cocks, *The Etiquette of Beauty*, New York, 1927.

149 Flügel 1930, pp. 188–9.

150 V. Marguerite, *La Garçonne* (1922) trans. H. Burnaby as *The Bachelor Girl* (an imperfect translation of the French title), London, 1923, pp. 65–6; at the end of the

ne nous les représente la peinture ou le marbre. Elles se plaisaient à soigner leur beauté avec intelligence. Combien elles étaient dans le vrai!' (Norville 1894, p. 84).

63 Minty 1989, p. 2.

64 W. Scott, *Ivanhoe*, ed. I. Duncan, Oxford, 1996, pp. 59–60 and 93–4.

65 Quoted in V. Cumming, 'Ellen Terry: An Aesthetic Actress and her Costumes', *Costume*, 1987, p. 68.

66 *How to preserve good looks* 1871, p. 6.

67 Swinburne 1868, pp. 46–7. Mikael Ahlund 2009, p. 32, remarks that by the 1860s, Rossetti's women were increasingly mystical and sensual, 'marked by a very pronounced aestheticism, colouristic refinement and a clear erotic tension'. Such portraits demonstrate an almost hallucinogenic hyper-realism alongside the imaginative invention of the artist. One sees a form of doubling, 'both the model and the imagined character at once', and this is 'the principal motive in Rossetti's later paintings'; see E. Prettejohn, 'The Pre-Raphaelite Model', in *Model and Supermodel: The Artist's Model in British Art and Culture*, ed. J. Desmarais, M. Postle and W. Vaughan, Manchester and New York, 2006, p. 28.

68 Prettejohn in Ahlund 2009, p. 53.

69 *Ibid.*, p. 60.

70 Given that a number of women in Pre-Raphaelite circles rejected the fussy details and artifice of high fashion and designed their own simpler styles of dress, it is legitimate to wonder if they also refused to wear cosmetics. In private life, simplicity of dress may have been complemented by an absence of face paint but, with regard to the models in Pre-Raphaelite painting, their faces are usually heightened by art, whether that of the painter or the sitters themselves. Exceptions, however, may have occurred, esp. perhaps in medieval subjects where it might be thought that little make-up was worn; Rossetti's *Fair Rosamund* of 1861 (National Museum of Wales) is an example, where the model (Fanny Cornforth) appears to have a bare face with naturally blushing cheeks, emphasising the meaning of her name.

71 F. G. Stephens, *Dante Gabriel Rossetti*, London, 1894, p. 70.

72 Swinburne 1868, pp. 46–7.

73 *Ibid.*, p. 46.

74 *The Art of Beauty* 1825, p. 195.

75 *A Legend of Camelot* was published in *Punch* in 1866 in five parts: 3 March (Part I), 10 March (Part II), 17 March (Part III) and 31 March (Parts IV and V), and in book form in 1898. My thanks to Leonee Ormond for drawing my attention to the original *Punch* poems and illustrations.

76 Symonds 1857, p. 39.

77 Swinburne 1868, p. 50.

78 Haweis 1878, p. 274. Ellen Browning (1898, p. 27), noted that the Pre-Raphaelite artists 'have taught us that ugliness does not exist, either in the world of art, or in the realms of nature', and that character was more important than 'mere fleeting loveliness, which is always, more or less, dependent on youth'.

79 Finck 1887 II, 118 and 135.

80 Haweis 1878, pp. 3, 196, 258, 198.

81 *Beauty and how to keep it* 1889, p. 19; Browning 1898, p. 28.

82 Mallarmé 2004, p. 192; opoponax is sweet myrrh, ylang-ylang is from the flowers of the Malayan tree *Cananga odorata*, Exora (ixora) is a tropical flowering shrub related to the gardenia, and Nard Celtique is spikenard.

83 W. Fowlie, *Mallarmé*, Chicago and London, 1962, p. 192.

84 *Woman's World*, 1888, p. 521; Crème Simon was a popular kind of cold cream made with glycerine.

85 Beerbohm 1922, pp. 4, 11, 6, 4, 28.

86 Bayard 1876, pp. 9 and vi.

87 Monin 1886, pp. 79–80. 'Mineral' rice powder included such subsances as bismuth and zinc oxide. Rice powder was usually lightly tinted with rose or cream colour, since white was too stark and could make the face look whitewashed.

88 *Beauty and how to keep it* 1889, p. 9. By the end of the 19th century some women had taken up cigarettes but critics like Fletcher declared that smoking caused wrinkles round the lips, stained the teeth, and was altogether an 'unfeminine vice' (1899, p. 352).

89 'How to be beautiful', an essay in the catalogue for Shaw's 'Hair and Beautifying Bazar', New York, 1883, pp. 32–3, in *Beauty Parlour*, 1: 52.

90 Rowland's *Kalydor* (1824) was a popular skin tonic, widely advertised. It was recommended in many publications, such as *How to preserve good looks* 1871, where the author suggested that it was an 'excellent lotion for improving the complexion, and removing sunburn' (p. 72). Arnold Cooley 1866, p. 406, in contrast, thought it was falsely advertised as 'pretending to possess extraordinary powers of beautifying the skin', when it was mainly a mixture of borax, glycerine, distilled water and orange-flower water.

91 Browning 1898, p. 169.

92 *How to preserve good looks* 1871, p. 49. In *Beauty and how to keep it* 1889, the author noted Egyptian women's use of kohl: they 'darken the eyelids with a mixture of scented oil and powdered chalk which they lay on with the aid of a fine camel's hair brush' (p. 20).

93 *Beauty and how to keep it* 1889, p. 40.

94 Haweis 1878, p. 274.

95 *Sylvia's Book of the Toilet* 1886, p. 30.

96 Edmond et Jules de Goncourt, *Journal: Mémoires de la vie littéraire II 1866–1886*, Paris, 1889, p. 581. By the spring of the following year, bright blonde hair was no longer in fashion and women began to powder their hair to make it *cendré* (ash blonde), according to the *Journal des Modes*, April 1875.

97 *Sylvia's Book of the Toilet* 1886, p. 37.

98 *How to preserve good looks* 1871, p. 71.

99 Haweis 1878, pp. 154–5.

100 According to the *Secrets de Beauté d'une Parisienne* (1894), little black or white spotted veils – 'une parure piquante, qui dissimule bien des imperfections et fait ressortir bien des joliesses' – gave freshness to the complexion and brilliance to the eyes (Garches 1894, p. 124).

101 *The Art of Being Beautiful* 1902, p. 34.

102 Haweis 1878, p. 4.

103 Ellmann 1988, pp. 89 and 106.

104 Beaton 1930, pp. 13–14.

105 Langtry 1925, p. 38. Her Jersey modiste was 'Madame Nicolle, the fashionable dressmaker of St. Heliers [sic]' (p. 43).

in 1866 became a 'Dame du Palais'.) Ella Fletcher 1899, p. 384, remarked how 'a slight droop of the outward corners enhances the beauty of the eye, and it was one of the charms of the unfortunate Empress Eugénie'.

35 Hegermann-Lindencrone, *In the Courts of Memory*, p. 31.

36 H. Delaborde, *Mélanges sur l'art contemporain*, Paris, 1866, p. 94.

37 *The Toilet . . .* 1839, p. 4.

38 Montez 1858, p. 71; she claimed to recall a recipe from 'a celebrated beauty in Munich, who treated her hair every morning with whipped egg-white, which was then left to dry, and was followed by a wash made of equal parts of rum and rose-water' (p. 81). As well as powdered bran, another form of 'dry washing' was to wet the hair 'with a mixture of the yolk of eggs and lemon juice' and brush out when dry (Bayard 1876, p. 22).

39 Brown 1856, pp. 7–8.

40 Beeton 1861, II, 979–80. She suggested a number of ingredients to be added to water to make hair washes, such as borax, olive oil, camphor and rosemary; when dry, the hair was glossed with scented oil or pomade. One of the jobs of a maid was to prepare a hair fixative (known as bandoline) which was used to keep the hair in place, and as a curling agent; Beeton's recipe was made from water, gum, rum and essence of almonds (p. 982). Marie Bayard's recipe for bandoline was to boil quince seeds in water 'for several hours'; the liquid was then strained through muslin and scent added (1876, p. 26). Proprietary brands were on sale by the 1880s.

41 Corson 1965, pp. 474 and 477.

42 Cher 1865, pp. 80 and 66; the author explained that the hair was cleaned and sorted, and curled by baking; the prepared hair was then sold to the hairdresser 'who works it up into wigs, curls, plaits, &c, &c'.

43 Bayard 1876, p. 19. Among other hairpieces from the second half of the 19th century, the Museum of London has a frisette (false hairpiece) of the 1860s (64.120/4); it is made of plaited horsehair which is flexible and can expand to twice the size.

44 *Englishwoman's Domestic Magazine* 1867, p. 214.

45 T. Bourgeau, *Les Usages du monde*, Paris, 1864, pp. 283 and 285. It is not clear what the 'parfums excitants' are but Constantin James 1865, p. 178, suggested that they might include rose, lily and jasmine; in their place he proposed thyme, lavender and verveine as restorative and invigorating.

46 James 1865, pp. 199, 221, 227, 189, 218.

47 *La Mode Illustrée* 15 January 1865, p. 22. Debay 1846, p. 9, attacked similar names, such as 'Lait de Vénus', 'Crème de Diane', 'Eau de Ninon', 'Pommade des Sultanes, etc'.

48 Linton 1868, p. 4. The fast woman's paint is 'blanc de perle', 'rouge de Lubin' which creates a 'sympathetic blush' and doesn't wash off, and 'kohl for the eyelids' (Linton 1883 I, 315). A topical reference to Linton's book is in the caricature of Madame Rachel (see fig. 174) which is 'Dedicated to the old "Girls of the Period" '.

49 Dick 1857, p. 48; he stated that arsenic should only be taken under a doctor's supervision.

50 Fletcher 1899, p. 189.

51 Similar stories appeared in many periodical publications. *Judy, or the London Serio-Comic Journal* for 11 June 1879 had an article entitled 'A Dreadful Revelation', in which a man supposedly observes from the window of his lodgings a woman (the fact that she is foreign is emphasised) in the process of transforming herself from a 'rather plain mortal' to 'as beautiful a creature as ever dipped finger in pomatum'. She does this, of course, with false hair, face paint and powder, eye make-up and a 'luscious cherry redness' on the lips.

52 *Punch* 19 April 1862.

53 Leverson 1863, pp. 21–2. In 1774 'Lady Molyneux's Italian Paste, so well known to the Ladies for enamelling the Hands, Neck and Face of a lovely white' (Gillham II, 10), sounds similar to Leverson's. Lois Banner 1983, p. 119, defines enamelling as a 'plastic enamel, built round an arsenic or lead base, in order to attain a smooth, light complexion', a

practice first introduced to New York on the stage in 1868; what this '*plastic* enamel' (my italics) was, is not made clear.

54 Williams 1957, p. 73.

55 *The Extraordinary Life & Trial of Madame Rachel at the Central Criminal Court, Old Bailey, London*, London, 1868, p. iv. Leverson 1863, pp. 19–20. The account of the trial listed the high prices of some of the treatments on offer: the infamous Magnetic Rock Dew Water of Sahara cost 2 guineas, as did face creams such as 'Eugenie's Cream' and 'Alexandra's Cream', and the 'Circassian Golden Hair Wash'; for 1 guinea a client could have the 'Sultana's Beauty Wash', 'Favourite of the Harem's Pearl White' (face powder) etc. There were special beauty treatments such as 'Venus's Toilet, 10 to 20 guineas' and most costly of all was the 'The Royal Arabian Toilet of Beauty as arranged for the Sultana of Turkey, the facsimile of which is used by the Royal European Brides, from 100 to 1000 guineas' (pp. vi–viii).

According to the National Archives Currency Converter, £2 in 1870 would today be worth £90, and £100, about £4,500.

56 A Mrs Borradaile paid £1000 for beauty treatments and the same sum for the promise of a titled husband.

57 G. du Maurier, *Trilby*, London, 1895, p. 14. *Trilby* is set in the 1850s, when the eponymous heroine's athletic and big-boned style of beauty (she 'would have made a singularly handsome boy') was not considered attractive when set against 'lofty foreheads, oval faces, little acquiline noses, heart-shaped little mouths, soft dimpled chins, drooping shoulders, and long side ringlets that fell over them' (p. 128).

58 Beerbohm 1922, p. 2.

59 Gautier 2005, p. 120.

60 W. Pater, *The Renaissance: Studies in Art and Poetry*, London, 1877, pp. ix and x.

61 Gautier 2005, pp. 50–51.

62 Hunt 1847, p. 230. A later writer testified to the truth of beauty as depicted in such portraits: 'Rien n'est plus réel que ces portraits; ces créatures splendides ont vécu, mille fois plus belles sous la transparence idéale de leur peau satinée que

noted that as recently as ten years before, one would have seen a number of faces disfigured by smallpox.

160 Raisson 1829, p. 167; alkanet is a red dye from the roots of the plant *alkanna tinctoria*.

161 Caron 1808, pp. 123–6 and 133.

162 *The Art of Beauty* 1825, p. 195, had a recipe for 'Talc white'; this was made by sieving Briançon chalk to powder, leaving it in distilled vinegar for two weeks, then pouring off the vinegar and washing the residue 6 or 7 times in clean water; dried and sifted again, it could be left in powder form or 'wetted and formed into cakes, like those sold by the perfumers'.

163 Caron 1808, p. 186.

164 *The Art of Beauty* 1825, p. 150; the author confessed to a liking for 'a little dash of sunburn, or a sprinkling of nice, little, delicate freckles' (p. 117), which must be the first time in the history of beauty that freckles were admired and not obliterated by cosmetics.

165 Corry 1820, pp. 70 and 282.

166 *Ibid.*, p. 282.

Modernity

1 Haweis 1878, p. 274.

2 Beerbohm 1922, pp. 2 and 18.

3 Peiss 2002, p. 101.

4 Cousin 1854, p. 165.

5 Smith 1838, p. 126.

6 Cousin 1854, pp. 173 and 145.

7 Gautier 2005, pp. 121 and 162. 'Above all things I love the beauty of form . . . There are some curves, certain finely chiselled lips, certain types of eyelid, certain ways of holding the head, certain long, oval faces, which attract me beyond all expression, and which transfix me for hours together' (p. 121).

8 *Ibid.*, p. 308.

9 Duffeyte-Dilhan 1857, p. 228.

10 Hunt 1847, p. 244. See also Robert Dick's *Connexion of Health and Beauty*, 1857, p. 6, where he noted that 'perfect corporeal beauty' is 'the multiform result of a faultless physical and moral organization'.

11 Hunt 1847, p. 244. He found that the most beautiful women were not always

the most fascinating because they thought too much of their own beauty, which he referred to as 'mere beauty' (pp. 284–5).

12 Fletcher 1899, p. 26.

13 Gautier 2005, p. 49.

14 Walker 1836, pp. 148–50, 232, 355, 275, 267.

15 Woolnoth 1852, pp. 182, 187, 184, 195.

16 Symonds 1857, pp. 38, 52, 38. The author, a medical doctor (1807–71), was the father of the more familiar John Addington Symonds (1840–93), the famous poet and critic.

17 G. Ramsay, *Analysis and Theory of the Emotions with Dissertations on Beauty, Sublimity and the Ludicrous*, Edinburgh, 1848, pp. 127–8.

18 Woolnoth 1852, pp. 188, 194, 244.

19 Cooley 1866, p. 123.

20 *How to preserve good looks* 1871, pp. 10 and 12.

21 *Ibid.*, p. 47.

22 In *The Ages of Female Beauty* of 1838, a keepsake album edited by Frederick Montagu, there is a story of a coquette, a beauty with 'dark, glossy ringlets', in love with the pleasures of life in the 'gay metropolis' and with 'dressing and devising becoming *costumes*'; she loses her lover, and when her name is mentioned, she is referred to as having 'lost everything in consequence of being such an *incorrigible coquette*' (pp. 15–19). Walker 1836, pp. 17 and 19. According to the author of *Female Beauty* (London, 1837, attributed either to Alexander Walker or his wife), 'Dresses very low on the bosom, with the round part of the shoulder exposed, are proofs of coquetry and in very bad taste' (p. 349).

23 Raisson 1829, p. 247.

24 *The Toilet* . . . 1839, p. 4. The text advised readers on how to set up the toilet table, with such items as a pincushion with pins, scissors, brushes and combs, curl papers, oils and pomatums, rose-water, lavender, cold cream, tooth powder and brushes, smelling salts and 'Fumigating Pastilles' (pp. 58–60).

25 Advertisement for Pears soap 1861; reference is also made to 'Pears Rouge and Pears Pearl Powders . . . in use by the fashionable world for more than thirty

years, and are most essential to all who value personal beauty, as by their use, the most beautiful complexion may be maintained' (Victoria and Albert Museum, London, Prints & Drawings Department Box GG81).

26 Cooley 1866, pp. 427–8, 409, 429.

27 E.g., in Debay 1856.

28 Montez 1858, pp. 4, 25, 29, 36, 91, 37, 39. On the subject of vegetable rouge, this – according to *Beauty's Mirror* 1839, pp. 117–18 – was 'quite harmless' and made from sandalwood, 'orchanet' (alkanet), 'bastard saffron' (safflower) or brazilwood. Carmine from cochineal was an excellent rouge, but readers were warned against cheap carmines which might be 'adulterated with red lead or vermillion'. Dragon's blood (resin which has the appearance of dried blood), from the *Dracaena* species of trees, esp. *Daemomorops draco* and *Dracaena cinnabar*, was also used in rouge.

29 Cher 1865, p. 62; French chalk, *craie de Briançon*, is powdered soapstone.

30 C. Baudelaire, *Eloge du Maquillage* in *Curiosités esthétiques: L'Art romantique et autres Oeuvres critiques*, ed. H. Lemaitre, Paris, 1962, pp. 489–94. Baudelaire's theory that make-up only helped the woman who was already beautiful, was echoed in the fashion magazine *Sylvia's Book of the Toilet: A Ladies' Guide to Dress and Beauty* 1886, p. 67, where the editor remarked: 'It is a fact, and a curious one, that it is generally women with rather good natural complexions who are most addicted to cosmetics. They have learned to value their good colouring, and think that they can improve upon nature's handiwork by heightening the contrast between the reds and the whites'.

31 Gautier quoted in Ribeiro 1990, pp. 63 and 31–2.

32 *How to preserve good looks* 1871, p. 49.

33 L. de Hegermann-Lindencrone, *In the Courts of Memory*, New York, 1912, pp. 127–8.

34 Mme Carette, *My Mistress The Empress Eugénie; or Court Life at the Tuileries*, London, 1889, pp. 149–50. (In 1864 Carette was appointed 'second Reader' (i.e., maid-in-waiting) to the Empress and

white which Pearl Powder [i.e. with bismuth] gives, but a lively and beautiful white' (Gillham II, 12). For milk cosmetics, the list of toiletries offered by James Love (see fig. 115) included 'Milk of Roses'. Milk cosmetics could also be used for cleaning the face, as they were often kinder to the skin than soap; in 1798 an advertisement for 'Italian Lily Paste' informed the reader that it was to be dissolved on the face and neck with water and thus 'forms a rich cream of Lilies' (Gillham II, 21).

127 Adams 1790, p. 368.

128 'L'art de la Coëffure est sans contredit celui qui approche le plus de la perfection' (Mercier 1782–8, II, 112). This belief was well established in France by Legros de Rumigny and his fellow artists. The author of *L'Enciclopédie Carcassière ou Tableaux des Coiffures à la mode* (1763) commented that although France had lost colonies to England, they (the French) had set hair-styles for the rest of the world to follow, including the English even though they had no idea how to dress hair properly (pp. v, xi). (*Carcasse* is described as the structure or edifice of a woman's hair, 'le Bâtiment d'une Coiffure de femme'.)

129 W. Barker, *A Treatise on the Principles of Hair-Dressing*, London, 1780, pp. 52–3.

130 Gillham II: 21. The Waddesdon collection of trade cards has two early nineteenth-century labels for bear's grease, sold by the perfumer Demarsons in Paris (3686. 3.38.95); they are inscribed as true Siberian bear's grease for making the hair grow and illustrated with rather sad images of captured bears.

131 F. Burney, *Evelina*, ed. K. Straub, Boston, Mass., 1997, p. 73; T. Smollett, *The Expedition of Humphry Clinker*, 3 vols, Dublin, 1777 I, 136. In *A Guide to Health, Beauty, Riches and Honour*, a satirical selection of advertisements by the antiquarian Francis Grose 1796 ('it will inspire foreigners with a due reverence for old England'), one is for 'Flora Cushions' which weigh only 1½ oz and are 'so light and easy that they will never cause the head to ach, an inconvenience almost inseparable from every other cushion yet invented' (p. 50).

132 Lillie 1822, p. 7. Many advertisements and beauty manuals warned against powders 'adulterated with pernicious ingredients such as unflaked lime, dried bones, or bones calcined to whiteness, shells of fish calcined, and worm-eaten or rotten wood, which are sifted through a fine hair sieve, after they have been beaten to powder'; *Hebe* 1786, pp. 19–20, urged the use of 'plain, unadulterated starch powder'. Starch powder was subject to a tax of 1 guinea per person in 1795, although a concession was made for fathers with more than two daughters, who only had to pay the fee for the first two.

133 Piper 1992, p. 190. Roy Strong 1972, p. 6, noted Romney's role as 'the earliest phenomenon of the systematic promotion of a model into a reigning beauty; Emma, Lady Hamilton was exposed for contemplation as no other English beauty had been to that date'.

134 *The European Magazine* 1785, p. 25.

135 Adams 1790, pp. 369–70.

136 Meister 1799, p. 202.

137 Cochin 1771, I, 146.

138 Piper 1994, p. 176.

139 Perrot 1984, p. 140.

140 Genlis 1818, I, 79.

141 Malcolm 1810, II, 355; he noted, however, later on the same page, that some women had taken sartorial freedom too far and were immodest in their dress. Knight 1805, p. 3, had no such reservations, for he had no regrets for the dress of the recent past: 'Only a few years ago a beauty equipped for conquest was a heterogeneous combination of incoherent forms, which nature could never have united in one animal, nor art blended in one composition; it consisted of a head, disguised so as to resemble that of no living creature, placed upon an inverted cone, the point of which rested upon the centre of the curve of a semieliptic base, more than three times the diameter of its own.' Horace Raisson 1829, pp. 157–8, celebrated the way that the French Revolution had banished such ridiculous fashions as high hair-styles, hoops, rouge and patches, and noted that heavy make-up was now to be seen only in the the-atres. However, the fashions of the late 1820s had begun, according to some critics, to approach the artifice of the *ancien régime*.

142 M. Fairweather, *Madame de Staël*, London, 2006, p. 306.

143 Caron 1808, pp. 37 and 56.

144 *Ibid.*, p. 266.

145 *The Mirror of the Graces* 1811, p. 96.

146 Napoleon quoted in Fairweather, *Madame de Staël*, p. 212.

147 Mme de Staël quoted in Marwick 1988, p. 140.

148 Caron 1808, p. 33.

149 H. de Balzac, *Cousin Bette* (1847), trans. M. A. Crawford, London, 1965, p. 32.

150 On Camper, see Etcoff 1999, p. 42. Knight 1805, pp. 430–32.

151 Caron 1808, pp. 7 and 20.

152 *Ibid.*, p. 25.

153 Bell 1821, pp. 51–2 and 68; his preference was for the 'fine mixtures of red and white' of northern European beauty, and the way colour suffused their faces, than for 'that immoveable veil of black which covers all the emotions of the other race' i.e., 'Negresses' (p. 98).

154 Banks Trade Cards 94: Peruke Makers, British Museum; a full headdress cost from 6 to 30 guineas, and a half-headdress from 4 to 10 guineas – extremely expensive prices. In 1800, £5 would have had the same spending power as £160 today, according to the National Archives Currency Converter (www.nationalarchives. gov.uk/currency).

155 *Cosmeology* 1816, pp. 9 and 15–16.

156 *The Art of Beauty* 1825, p. 151. Mme Récamier's pomade is also mentioned in Smith 1838, p. 216, but by the 1830s vigorous exercise was no longer thought ladylike, as 'the graces accommodate themselves little to labour, perspiration and sun-burning' (p. 101).

157 Dr W. Buchan, *Advice to Mothers on the Subject of their own Health; and on the Means of promoting the Health, Strength, and Beauty of their Offspring*, London, 1811, pp. 8 and 10.

158 *Ibid.*, p. 16; Caron 1808, p. 36.

159 *The Lady's Monthly Museum* 1811, p. 86; *The Art of Beauty* 1825, pp. 168–9, acknowledging the influence of Jenner,

or spirit of lemon and a dash of clove oil. The resulting white paste was then potted up' (Pointer 2005, p. 134). Legros de Rumigny's recipe for pomatum was a mixture of beef marrow, hazelnut oil and lemon (Corson 1965, p. 332).

84 Goudar 1765, I, 49, IV, 172, II, 246.

85 Stevens 1772, p. 58.

86 *Morning Chronicle* quoted in Piper 1992, p. 143.

87 In the famous discussion of cosmetics in the play (II: ii), a 'Miss Vermilion' is described as a 'pretty woman' with a 'charming fresh colour', to which Lady Teazle riposte 'when it is fresh put on', adding 'it goes off at night, comes again in the morning'. They then talk of older women, particularly 'the widow Ochre', about whom Sir Benjamin Backbite remarks ''tis not that she paints so ill – but, when she has finished her face, she joins it on so badly to her neck, that she looks like a mended statue, in which the connoisseur may see at once that the head is modern, though the trunk's antique!' Although the play exaggerates, Henri Meister 1799, p. 221, thought it gave 'the most striking and best pictures of the present manners'.

88 Corson 1972, p. 249; Oberkirch 1852, III, 198.

89 Lillie 1822, pp. 275–7. Lillie's book *The British Perfumer* was not published in his lifetime but assembled from his notes made around 1740; it is one of the most comprehensive works on perfumed cosmetics. He remarked that the best 'Spanish wool' was made by Jews in London; it gave a better, more subtle colour than the wool manufactured in Spain which was too dark a red for English taste. As 'wools' contained gum, 'they are apt to leave a shining appearance on the cheek, which too plainly shews that artificial beauty has been resorted to' (p. 279); for that reason, he preferred powdered rouge, put on by a fine camel-hair brush.

90 G. de Lairesse, *The Art of Painting*, trans. J. F. Fritsch, London, 1738, p. 351.

91 A. Ramsay, *A Dialogue on Taste* (1755), London, 1762, p. 25.

92 Cochin 1771, II, 70.

93 M. Fend, 'Body and Pictorial Surfaces: Skin in French Art and Medicine, 1790–1860', *Art History*, XXVIII, no. 3, 2005, pp. 312–13.

94 Cochin 1771, I, 47.

95 *The World*, 1755, p. 6; *The Connoisseur*, 1754, p. 84.

96 Goudar 1765, II, 148–50.

97 L'Isle André 1767, p. 18.

98 M. Bakhtin, *Rabelais and His World*, trans. H. Iswolsky, Cambridge, Mass., 1968, p. 40.

99 *The Morning Post*, 5 January 1789, quoted in Corson 1972, p. 250.

100 Marwick 1988, p. 153. Apropos the notion of beauty being troublesome, Lady Jane Coke wrote to a correspondent in 1751 about 'the eldest Miss Gunning, whose beauty you must have heard of. I wish it may make her fortune, for I think generally speaking it is very little use, and oftener does our sex more harm than good'; the following year Maria Gunning married the Earl of Coventry (*Letters from Lady Jane Coke to her friend Mrs Eyre 1747–1758*, ed. Mrs A. Rathbone, London, 1899, p. 75).

101 Undated 18th-century advertisement in *Beauty Parlour* 2, 46, John Johnson Collection, Bodleian Library, Oxford.

102 *The Gentleman's Magazine* 1736, p. 377.

103 William Cowper, *Letters and Prose Writings*, ed. J. King and C. Ryskamp, 5 vols, Oxford, 1979–86, II, 241–2; he noted, citing Lady Coventry as an example, that 'all white paints or lotions or whatever they be called are . . . poisonous, consequently ruinous in time to the constitution' (243).

104 Berkeley 1714, I, pp. 78–9.

105 *The Lady's Magazine* 1760, p. 246.

106 'qui relevoit infiniment sa beauté, rendit Paris amoureux & causoit la guerre de Troie': *Manuel de la Toilette* 1771, pp. 11–12. Madame de Genlis 1818, I, 407, recalled 'une très belle personne aux Tuileries avec une de ces grandes mouches, entourée de petits brillans', but the fashion did not catch on.

107 Le Camus 1754, pp. 148–52.

108 This is a glass box in the collections of the Science Museum, London (A 158810); it contains a selection of small black silk patches, cork-lined leather plumpers for

the cheeks, and false eyebrows made of hair, possibly mouse; see fig. 126.

109 *The Lady's Magazine* 1759, p. 169.

110 Thanks to Joanna Sheers at the Frick Collection, New York, who kindly examined the portrait for me. In Gainsborough's 1778 full-length canvas of Grace Dalrymple Elliott (Metropolitan Museum of Art, New York) the sitter's face is shown in profile and black paint to elongate the eyes is clearly visible.

111 Quoted in A. Ribeiro, 'Fashioning the Feminine: Dress in Goya's Portraits of Women', in *Goya: Images of Women*, ed. J. A. Tomlinson, Washington, D.C., 2002, p. 75. See also for a discussion of *majismo*.

112 S. Symmons, *Goya: A Life in Letters*, London, 2004, p. 246; the portrait of Alba to which Goya referred is probably his first full-length painting of her, in white, of 1795 (Alba Collection).

113 *Hebe* 1786, pp. 166 and 11–12.

114 Knight 1805, p. 5.

115 Schiller 2004, pp. 128 and 81–2. Schiller's ideas on beauty are confusing, maybe because, as Prettejohn 2005, p. 46, notes, 'the mind is open to all possibilities. It is a state of nothingness, in one sense; yet it is also a state of infinite potentiality, and therefore can allow the invention of the truly new'.

116 'Nous ne voyons dans un tableau qu'une action momentanée, souvent le moindre partie de l'action totale, dont le Peintre nous veut rapeller le mémoire' (L'Isle André 1767, p. 88).

117 Benjamin 1999, p. 64.

118 Alison 1790, p. 67.

119 E. Jules Meras, *Recollections of Léonard, Hairdresser to Queen Marie-Antoinette*, London, 1912, pp. 72–3.

120 *Horace Walpole's Correspondence with the Countess of Upper Ossory*, ed. W. S. Lewis and A. D. Wallace, New Haven and London, 1965, p. 253.

121 Oberkirch 1852, I, 42.

122 Hunt 1847, pp. 257–8.

123 Meister 1799, p. 222.

124 *Hebe* 1786, pp. 12 and 167.

125 *Ibid.*, p. 10.

126 An advertisement for cosmetic powder in 1782 claimed that it made the skin 'delicately fair and white, not that dead livid

sometimes it was made with alum and chalk; Abdeker's recipe for Spanish White included 'Oil of Ben [benzoin], Bismuth and Wax', which was then dissolved in 'Flower-de-Luce [iris] Water' to 'whiten the Face' (p. 81).

37 *Beauties Treasury* 1705, p. 19; the author, 'J. W.', gave two recipes to restore 'a fair Smooth and polished Skin' spoilt by smallpox; one included ceruse, the other was a safer combination of turpentine, mastic and gum Arabic (resins from two different acacia trees), olive oil and oil of myrrh (p. 20). Variolation was the process of infecting patients with material from the pustules of those who suffered from a mild form of the disease (*variola minor*); although not completely safe, the survival rate for those who contracted smallpox and had undergone variolation was much higher than for those who had not.

38 Spence 1752, pp. 23, 28, 38, 36, 30.

39 Andrews 1783, p. 202.

40 *The Lady's Magazine*, 1772, III, pp. untraced.

41 Cozens 1777, pp. i and iv.

42 Porter 1985, p. 393.

43 Percival 1999, p. 175; the face is like a canvas, 'the place where subtle nuances are rendered' (p. 29). Buffon 1797, IV, 65, noted: 'We are so habituated to judge by external appearances, that we too often decide on men's talents by their physiognomy'.

44 Flügel 1930, p. 62.

45 Goudar 1765 II, 105–6.

46 Le Camus 1754, pp. 107–13. Aromatic vinegars had a restorative purpose; small sponges soaked in such vinegars were placed in decorative containers (vinaigrettes) and could also be carried in a pocket. The anti-wrinkle head bands were made of chamois leather or 'chicken-skin' (the skin of unborn calves), 'lined' with cold cream or scented oil and left on the forehead overnight.

47 Beauvoir 1953, p. 572.

48 *Manuel de la Toilette* 1771, p. 82; the toilette, the author said, was the domain of the coquette, 'un spectacle enchanteur & délicieux' (p. 29).

49 Andrews 1783, pp. 42 and 203.

50 Thomas, 1987, p. 81.

51 Andrews 1783, pp. 41, 4, 37.

52 Stevens 1772, p. 58.

53 Le Camus 1754, pp. 15–16. The cimarre (simarre, chimere, zimarra, etc.) was a clerical vestment.

54 'un meuble spécifique qui permet de contenir tous les utensils à la toilette': Cochet 1998, p. 105.

55 The author recorded the perils of many of the 'beauty' treatments, in the character of Tabitha Runt, a lady's maid, visiting Bath, who had spent so much time and money on such treatments both internal and external that she had read about in the papers, that she became ill: 'she spent so much money/ In *Water-dock Essence* and *Balsam of Honey*;/ Such tinctures, elixirs, such pills have I seen,/ I never could wonder her face was so green' (Part I, Letter II, ll. 58–61).

56 Mercier 1782–8, VI, 145–6, 143–4; for the illustrations to the *Tableau de Paris*, see *Costumes des Moeurs et de l'Esprit françois avant la grande révolution*, Lyon, 1791.

57 Martin 2003, p. 70.

58 Mercier 1782–8, VI, 146.

59 *Ibid.*, VI, 304.

60 Le Camus 1754, p. 34. On the wearing of Turkish dress at masquerades, see A. Ribeiro, 'Turquerie: Turkish Dress and English Fashion in the Eighteenth Century', *Connoisseur*, CCI, no. 807, 1979, pp. 16–23.

61 Berry 2000, p. 132; the harem promised 'a fantasy of feminine beauty unfettered by Christian taboos against female sexuality'.

62 I. Grundy, *Lady Mary Wortley Montagu*, Oxford, 1999, p. 143. Balm of Mecca was still in use in the early nineteenth century; Caron 1808, p. 123, described it as one of the most highly esteemed cosmetics, very expensive, and that it was difficult to obtain the genuine article in Europe. As it was so aromatic and pungent, he advised diluting it with almond oil to avoid a skin reaction.

63 *New London Toilet* 1778, p. 44; Buc'hoz 1787, pp. 71 and 83; Gillham II, 13.

64 For Bloom of Circassia, 1786, see Gillham II, 19; for the skin cleanser, an undated advertisement of the 1770s/1780s, in *Beauty Parlour* 2, 80.

65 Adams 1790, p. 51.

66 See P. Stein, 'Madame de Pompadour and the Harem Imagery at Bellevue', *Gazette des Beaux-Arts*, CXXIII, no. 1500, Jan. 1994, pp. 29–44.

67 See E. Goodman-Soellner, 'Boucher's *Madame de Pompadour at her toilette*', *Simiolus*, XVII, no. 1, 1987, pp. 41–58. For critical comment on this interpretation, see A. R. Gordon and T. Hensick, 'The Picture within the Picture: Boucher's 1750 Portrait of Madame de Pompadour identified', *Apollo*, CLV, no. 480 (N.S.), Feb. 2002, p. 27.

68 Gordon and Hensick, p. 24.

69 Jones 2002, p. 80.

70 See J.-N. Dufort de Cheverny, *Mémoires*, ed. P. A. Weber, Paris, 1969, I, 89; quoted in Jones 2002, p. 158.

71 Marwick 1988, p. 114.

72 Cochin 1771, I, 45.

73 Corson 1972, p. 215.

74 Goudar 1765, I, 245, II, 75–6.

75 Festa 2005, p. 11.

76 Cochin quoted in Percival 1999, p. 90.

77 Le Camus 1754, pp. 87 and 197. *The New London Toilet* 1778, 76, suggested that to remove sunburn, a woman should rub her face with strawberry juice on going to bed.

78 *Hebe* 1786, p. 1.

79 Spence 1752, p. 50.

80 Pye 1766, pp. 10–11.

81 Fordyce 1776, I, 71; in contrast to contemporary French art, he praised the 'simplicity' of antique art and the Old Masters whose aim is 'Beauty in all her finest forms' and whose 'females' are depicted with 'chaste, sober, and unaffected graces' (pp. 70–71).

82 *Horace Walpole's Correspondence with Sir Horace Mann*, ed. W.S. Lewis and G.L. Lam, New Haven and London 1967, p. 345. As a result of what the King thought was an imprudent marriage, George III in the following year, 1772, passed the Royal Marriages Act, whereby any descendant of George II had to have the consent of the sovereign before marrying.

83 Goudar 1765 II, 256–7. Pomatum was 'usually just a mixture of mutton suet and lard, carefully cleaned and melted, then beaten while cooling with a little essence

grande', in *Description de l'île de portraiture et de la ville des portraits*, ed. M. Debaisieux, Geneva, 2006, p. 90. Thanks to Bert Watteeuw for drawing my attention to Sorel's work.

161 *The Challenge* 1697, p. 72; *Ladies Dictionary* 1694, p. 415 (from Woolley 1673, p. 244).
162 K. Digby, *Two Treatises*, Paris, 1644, p. 262.
163 Lomazzo 1970, p. 127.
164 Tuke 1616, p. 57.
165 *Satyr against Painting* 1697, pp. 5 and 7.
166 Lomazzo 1970, p. 23.
167 Bate 1634, p. 125; the references are to ceruse from Venice, so it may have been similar (even identical) to that which women wore on their faces.
168 Norgate 1997, p. 127. William Salmon's *Polygraphice*, London, 1672, p. 130, states: 'Ceruse, grind it with glair of Eggs, and it will make a most perfect white'. As for the cosmetic use of glair, Sir Kenelm Digby 1689, p. 283, had a cosmetic lotion for the face, which includes glair, alum, camphire and borax.
169 Norgate 1997, p. 59.
170 Festa 2005, p. 9.
171 Lomazzo 1970, pp. 104 and 133.
172 Stalker and Parker 1688, pp. ix–x.

Enlightenment

1 Roche 1994, p. 515.
2 Hutcheson 1726, p. 7.
3 Shaftesbury quoted in Porter 2003, p. 138.
4 Shaftesbury 1711, pp. 405 and 417. According to David Hume (1772, pp. 213 and 223), beauty required 'a perfect serenity of mind, a recollection of thought, a due attention to the object', and for this we need practice, for by 'comparison alone we fix the epithets of praise or blame, and thus learn'.
5 Shaftesbury 1711, p. 404.
6 Hutcheson 1726, pp. 13–15.
7 Dodsley 1735b, p. 8.
8 *The Gentleman's Magazine*, 1736, p. 377.
9 See, e.g., Gainsborough's *The Hon. Mary Graham as a Housemaid* 1782–6 (Tate Britain).
10 Cochin 1771, I, 124; III, 207; III, 176.
11 Burke 1759, p. 218.

12 *Ibid.*, p. 203.
13 Spence 1752, p. 11.
14 Burke 1757, p. 100.
15 On the influence of the Rococo on fashion, see A. Ribeiro, '"A Most Extraordinary Figure, Handsome and Bold": Gainsborough's Portrait of *Ann Ford*, 1760' in B. Leca (ed.), *Thomas Gainsborough and the Modern Woman*, Cincinnati Art Museum, 2010, pp. 111–40.
16 Burke 1759, pp. 222 and 299. The author of *The Art of Beauty* 1825 took Burke to task for his theory that beauty was about being 'little, smooth, delicate' and that it had the effect of 'agreeable relaxation': 'If this were the case, labour and warm rooms and hot tea would be the most beautiful of all things, because they produce relaxation . . . If what is little and smooth be the character of beauty, then are garden peas more beautiful than lilies' (p. 338).
17 Hogarth 1997, pp. 34–5 and 39.
18 *Ibid.*, p. 58.
19 Piper 1992, p. 137.
20 Buffon 1797, IV, 90.
21 Spence 1752, pp. 6, 48–9, 53–4. Spence's reference to Rubens was echoed in the translation of Auguste Caron's 1806 *Toilette des dames* (*The Lady's Toilette* 1808, p. 17), where he cited the artist's *Three Graces* as 'three tall, robust, fat, Flemish wenches', and certainly not role models for 'our handsome females'.
22 *Delights for the Ingenious* 1711, p. 144. Yves Marie de l'Isle André, 1767, p. 18, among others, noted the arbitrary nature of beauty, commenting that while European women wore earrings, women in India wore nose rings, while Frenchwomen had their hair curled and powdered, the native inhabitants of Canada had long, straight greased hair falling to the shoulders.
23 Hume 1772, pp. 203 and 236. Regarding the question of changing ideas of beauty in the past, he posed the rhetorical question: 'Must we throw aside the pictures of our ancestors, because of their ruffs and fardingales?' (p. 236).
24 Buffon 1797, IV, 88.
25 Adams 1790, p. 94.
26 Boudier de Villemert 1758, p. 87.

27 Roche 1994, pp. 462 and 476; such magazines admittedly warned against the 'moral dangers of fashion', but praised its 'power and efficacity' (p. 493).
28 Le Camus 1754, p. 19.
29 *Ibid.* pp. 5 and 34–5. Curiously, Roy Porter, 2003, p. 243, sees the fashion for slimness only appearing at the end of the 18th century but this was an ideal throughout the century until the 1780s, when larger women like Georgiana Duchess of Devonshire set the fashions; the vogue for really slim women was more a feature of the early 19th century.
30 Buffon 1797 IV, 66; Caron 1806, p. 253 (*The Lady's Toilette* 1808 is used throughout, unless it diverges from the original French text).
31 Jean-André Rouquet, *The Present State of the Arts in England*, London, 1755, p. 46.
32 Le Camus 1754, pp. 4–5.
33 Hogarth 1997, p. 35.
34 Spence 1752, pp. 7–8, 10, 15.
35 Not until the 1920s did suntan lose its associations with manual labour and become fashionable as an attribute of leisure. A play entitled *The New Cosmetic; or The Triumph of Beauty* by Courtney Melmoth (Samuel Jackson Pratt), 1790, is set in Antigua where a European beauty, Louisa Winstone, has 'lost' her looks, i.e. become tanned; in order to retain her lover, she needs to recover what he calls 'the red and white roses in her cheeks' (I: ii). She does this by way of a cosmetic made of cashew oil mixed with 'a little old rum' which, after nine days, removes the tan and reveals her original beauty; the moral of the rhetorical question is: 'who would not undergo a little pain to redeem lost beauty, or to give delight to the man we love?' (II: ii).
36 Le Camus 1754, pp. 4 and 69. Buffon, 1797, IV, 257, stated that women from Georgia 'enjoy from Nature graces superior to those of any other race . . . their faces are truly charming'. Bismuth white was made by dissolving metallic bismuth in nitric acid; it was then precipitated in water to produce a powder which was used for Spanish White or pearl white. Spanish White was usually a mixture of bismuth white and chalk or starch but

wash, which is more visible, but which can also be removed.

116 *A Discourse of auxiliary Beauty* 1662, pp. 84 and 233.

117 Woolley 1673, p. 242.

118 *Ladies Dictionary* 1694, pp. 227 and 412.

119 Taylor 1701, pp. 3 and 122; it seems likely that this treatise was composed after 1660.

120 Hamilton 1714, pp. 95, 176, 236.

121 *Ibid.*, p. 197. In a list of 'Men Famous for the Art of Painting', Randle Holme included 'Sir Peter Lilly, for Womens Faces'; see R. Holme, *An Accademie of Armorie*, Chester, 1688, III, pp. 155–6.

122 Jeamson 1665, pp. 21 and 70–71.

123 *Ladies Dictionary* 1694, p. 315.

124 A. Behn (attr.), *The Lady's Looking-Glass, to dress herself by; or, The Whole Art of Charming*, London, 1697, pp. 4 and 16.

125 *Ladies Dictionary* 1694, p. 399.

126 Boileau 1678, p. 3 and 33.

127 *The Challenge* 1697, p. 122; the *Discourse of auxiliary Beauty* 1662, p. 219, notes that although in England women use a 'commendable discretion' in preferring a private toilette, in other countries there was a more open 'culture and office of womens adorning', a greater acceptability of painting in public.

128 Fargeon 1665, pp. 15–17 and 22.

129 *Ladies Dictionary* 1694, p. 399.

130 *Wits Cabinet c.*1700, p. 20.

131 *Ladies Dictionary* 1694, p. 12; entry on 'Beauty' on pp. 49–66.

132 Jeamson 1665, p. 3.

133 *Ibid.*, p. 83. Oil of myrrh was frequently used in cosmetics and imported in quantity from the Middle East to Europe. Imports to England came via the British East India Company factory in Surat (Gujarat); an advertisement dated July 1664 noted that the cargo of the *Loyal Merchant* out of Surat had arrived in London with '27 bales Mirrh', among other precious cosmetic ingredients, spices, silks and cottons (British Library (BL), Collection of Early Advertisements C.112.f. 9, f. 119). *New Curiosities in Art and Nature* (translated from the chemist Nicolas Lémery's *Nouveau Receuil de Curiositez . . .* 1674) 1711, p. 200, gives a recipe for making this oil, which involves replacing the yolk of a hard-boiled egg

with 'Powder of Myrrh [then] set it in a moist Place till the Myrrh is dissolv'd, and runs with an Oil or Liquor'.

134 Mary Doggett, BL, Add. MS 27466; Mary Glover, BL, Add. MS 57944.

135 *Wits Cabinet c.*1700, p. 22; other recipes for pigeon water appear in Porta 1669, p. 240; Jeamson 1665, p. 33, etc.

136 Jeamson 1665, p. 95; *The Ladies Dictionary* 1694, p. 220, suggested that lemon juice added to oil or water of talc and steeped for 10 to 12 days, made a particularly effective lotion for whitening a 'swarthy' face.

137 *Accomplish'd Ladies Delight* 1686, pp. 90–91.

138 McLaughlin 1972, pp. 74–5.

139 Porta 1669, p. 233.

140 *Ladies Dictionary* 1694, p. 13.

141 Jeamson 1665, p. 134.

142 *Arts Masterpiece* 1660, pp. 55 and 64 (a work based on recipes published by the 16th-century Swiss physician Johann Jacob Wecker). *The Accomplish'd Ladies Delight* 1686, p. 88, offered recipes to 'make the Hair grow thick', such as 'the Ashes of frogs burnt to increase Hair, as also of Goats-dung mingled with Oyl'.

143 Jeamson 1665, p. 110; J. Shirley, *The Accomplished Ladies Rich Closet of Rarities*, London, 1687, p. 67.

144 Porta 1669, p. 233.

145 *Ladies Dictionary* 1694, p. 212.

146 *Arts Masterpiece* 1660, p. 56. Curiously, there is a recipe for green hair, although one wonders why (unless it was for a theatrical purpose); according to an English translation, Wecker 1660, p. 83, the 'distilled water of Capers will make your hair green'.

147 Cavendish 1671, p. 178.

148 Fargeon 1665, p. 23.

148 Fargeon 1665, p. 23.

149 BL, 551.a.32, f. 171; C.112.f. 9, f. 19.

150 BL, 551.a.32, f. 230. Another advertisement, f. 199, is for 'Agnodice; the Woman Physician' who claims she 'Cureth all Diseases subject to Infants and young Children' and 'any sort of Leprosie'; among the cosmetics on offer are dentifrices, pomatums for the hair and an 'Italian Wash' to remove all skin problems, 'making the Face most Fair and Clear'.

151 'Miso-Spilus', *A Wonder of Wonders; or, A Metamorphosis of Fair Faces voluntarily transformed into Foul Visages; or, an Invective against Black-spotted Faces* 1662, n.p.

152 *Ladies Dictionary* 1694, p. 11.

153 Abbé de Vassetz, *Traité contre le luxe des coeffures*, Paris, 1694, p. 4.

154 *Ladies Dictionary* 1694, p. 12. La Bruyère's *Caractères* (Paris, 1688) attacked female artifice, such as the 'hideous and frightful White and Red' and 'Balls to plump out their Cheeks' (*The Characters or Manners of the Age*, London, 1699, p. 53).

155 Crouch 1684, pp. 107–8.

156 Hawkins 1653, p. 55. See the Select Bibliography for similar works.

157 Thomas 1971, p. 383. The woodcut illustrating Laurence Price's satire on fashion, *Here's Jack in a Box* of 1656, shows a pedlar with a range of fashionable merchandise, including patches, and the accompanying verse refers to 'patches of every cut,/ Here's all the wandring planet signes,/ And some oth' fixed stars/ Already gum'd to make them stick,/ They need no other sky' (BL, Thomason Tract E 1640).

158 J. Lyly, *Euphues: The Anatomy of Wit, and Euphues and His England*, ed. L. Scragg, Manchester, 2003, p. 32. The *Ladies Dictionary* also has the story: 'Venus, the Goddess of Beauty, was born with a Motticella, or natural Beauty-spot, as if Nature had set forth a Pattern for Art to imitate' (p. 38).

159 Bulwer 1650, pp. 261–2 and 272. Bulwer claimed that Englishwomen ('phantastical Ladies') wore too many patches (p. 261), a comment also made by Henri Misson almost 50 years later, *Mémoires et Observations Faites par un Voyageur en Angleterre*, The Hague 1698, p. 305. He claimed that whereas in France only the young and pretty wore patches, women of all ages in England wore them and in large quantities.

160 Sorel, *L'Orphize*, p. 146; see also the same author's reference in a novella of 1659 to a black patch as a 'petit défaut', which makes the face look more beautiful in contrast: 'les mouches qui, par leur noirceur relevaient l'éclat du tient et en faisaient paraître sa blancheur plus

63 Donne 1925, pp. 6–7. Paradox II was published along with Paradox I, as *A Defence of Women for their Inconstancy and their Paintings*, in 1925, when the widespread use of make-up among young women of all social classes was a common talking point.

64 Gibson 1599, pp. 56–60. Tommaso Buoni, 1606, p. 26, also comments on the idea of relative beauty: 'to the eye of the Moore, the blacke or tawny countenance of his Moorish damosell pleaseth best, as to the eye of another, a colour as white as the Lilly, or the driven snowe'. He explains this by saying that beauty does not so much consist in colour 'as in the illumination . . . of those coulours which giveth grace and lustre to every countenance, and without which all Beauties are languishing'. For a somewhat satirical image of relative beauty, see Bulwer 1653 and fig. 88b here.

65 Dolan 1993, p. 229.

66 Lomazzo 1970, pp. 132–3.

67 Stubbes 1585, p. 32.

68 Lomazzo 1970, p. 129.

69 Buoni 1606, pp. 33–4.

70 Guazzo 1581, p. 7.

71 Philippy 2006, p. 12.

72 T. More, *Utopia*, ed. and intro. P. Turner, London 1965, p. 105. Compare Tommaso Campanella's *City of the Sun* (1602), in which women who wear cosmetics are punished by death.

73 Thomas 1994, p. 63.

74 Porter 1993, pp. 25 and 27.

75 See C. Quétel, *History of Syphilis*, trans. J. Braddock and B. Pike, Cambridge, 1990, p. 34.

76 *Ibid.*, p. 72.

77 See e.g. an engraving by C. de Passe of *Hercules standing between Virtue and Vice* in Gabriel Rollenhagen's emblem book *Nucleus Emblematum Selectissimorum*, Utrecht, ?1611; a female figure of Vice lifts her mask to reveal a deformed and ugly face.

78 Lemnius 1633, p. 67.

79 Lomazzo 1970, p. 20. Of the seven planets which are the 'governours of the worlde', two are female – Venus and Luna (p. 17).

80 McLaughlin 1972, p. 87.

81 Porta 1669, p. 233.

82 Drew-Bear 1994, p. 63. Gabriel de Minuit in his treatise *De la Beauté* (1587) suggested that the French were influenced by Venetian customs in adopting low-necked dress which necessitated make-up on the breasts, and using paint such as 'le vermeil d'Espagne', Spanish vermilion (p. 142).

83 Karim-Cooper 2006, pp. 3 and 23. References to stage make-up are few and not always clear; e.g. John Earle's short character sketches, *Micro-cosmographie, or A Peece of the World Discovered* (1628) equated an actor to 'our painting Gentle-women, seldom in his owne face', which might refer to the use of paint on the stage as well as to the way he acts different roles, or perhaps not (n.p. but sketch no. 22).

84 W. Prynne, *Histrio-mastix: The Players Scourge or Actors Tragedie*, London, 1633, pp. 48, 992, 216.

85 Woolley 1673, p. 36.

86 Drew-Bear 1994, p. 81.

87 The quotation continues: 'She takes herself asunder still when she goes to bed, into some twenty boxes; and about next day noon is put together again, like a great German clock'. The idea of a painted woman being the sum of the contents of her cosmetics box is also expressed in Charles Sorel's *L'Orphize de Chrysante* (Paris, 1626): 'Tous les soirs avant de se coucher, elles enferment leurs beautés dans une boîte' (p. 146).

88 Drew-Bear 1994, p. 85.

89 Platt 1602, n.p., recipe 17.

90 Bate 1634, p. 177. Porta, 1669, p. 241, also suggested that the liquid left by snails 'as they creep' makes an unguent 'that polisheth the skin exceedingly, and makes it contract a silver gloss'.

91 Rich 1616, pp. 2 and 15.

92 Combe quoted in Karim-Cooper 2006, p. 23. Combe's work is a translation of Guillaume de la Perrière's *Théâtre des bons engins*, Paris, 1539.

93 The poems by Tuke, Drayton, Tylman and Sylvester are unpaginated.

94 Tuke 1616, p. 60.

95 *Ibid.*, p. 58.

96 Stubbes 1585, pp. 31 and 33.

97 Hall 1654, p. 101.

98 Stubbes 1585, pp. 34–5.

99 See A. Ribeiro, *Fashion and Fiction: Dress in Art and Literature in Stuart England*, New Haven and London, 2005, pp. 129–47.

100 Milkmaids (and others who worked on farms) were perhaps immunised by getting a mild dose of the disease from their cows.

101 Castiglione 1974, p. 66 (Hoby's 1561 trans.).

102 Guyon 1643, pp. 350, 351, 420.

103 Bulwer 1650, pp. 131–3.

104 From Carew, *Poems*, London, 1640.

105 John Aubrey, *Brief Lives*, ed. J. Buchanan-Brown and M. Hunter, London, 2000, pp. 294–5.

106 Digby 1683, p. 180. *The Queen's Closet Opened*, 1662 (the Queen was Henrietta Maria and the book was first published in 1655) contains Digby's *Aqua Mirabilis* (p. 290). For more on Venetia Stanley, see A. Sumner (ed.), *Death, Passion and Politics: Van Dyck's Portraits of Venetia Stanley and George Digby*, London, 1995.

107 Digby 1968, p. 85.

108 Catalogue entry by Judy Egerton in *Van Dyck 1599–1641*, ed. C. Brown and H. Vlieghe, Antwerp and London, 1999, p. 251.

109 Cavendish 1671, p. 177.

110 *Ibid.*, p. 179.

111 *Ladies Dictionary* 1694, p. 209.

112 Williams 1957, p. 43. In December 1684 a Dutch ship at the Port of London was entirely filled with toilet articles such as cosmetics, paints and perfumes; see Port of London Books E. 190, National Archives, Kew.

113 Cavendish 1671, pp. 188–9. According to the author of *The Challenge* 1697, p. 29, 'we count a mixture of White and Red beautiful, because it has Anciently been accounted so. . . . Beauty is founded in Custome, not Nature'.

114 Cavendish 1671, p. 187. *A Discourse of auxiliary Beauty* 1662, p. 89; the work is sometimes attributed to the Royalist divine John Gauden.

115 *A Discourse of auxiliary Beauty* 1656, p. 5; *A Discourse of auxiliary Beauty* 1662, pp. 49 and 57. *The Challenge* 1697, p. 117, is in agreement here, pointing out that face paint was merely a more 'substantial' face

to bleach her hair and paint her face . . . you let her show up with curls dangling around her brow and down her neck, with bare breasts spilling out of her dress'.

13 *Ibid.*, p. 37.

14 Coryat 1611, p. 261.

15 *Ibid.*, p. 266.

16 Firenzuola 1992, p. 46.

17 Luigini 1907, p. 24.

18 Firenzuola 1992, p. 15.

19 Coryat 1611, pp. 262–3. This reference also includes his description of Venetian women curling their hair 'in curious locks with a frisling or crisping pinne of iron'; Pompeo Batoni's painting *The Triumph of Venice* (1737; North Carolina Museum of Art) depicts a woman whose blonde hair is being curled on a rod – curled blonde hair was a signifier for the Venetian woman.

20 Feuillet and Baschet 1865, pp. 2 and 84.

21 Ruscelli 1558, f. 76 and *passim*. Ruscelli's book *De' secreti del reverendo donno Alessio Piemontese* was published in Venice in 1555 and in English in 1558.

22 E.g., in Pietro Bertelli's *Diversarum Nationum Habitus*, Padua, 1594.

23 Schwarz 1952, p. 112.

24 Philippy 2006, p. 165.

25 See F. Cummings, 'The Meaning of Caravaggio's "Conversion of the Magdalen"', *Burlington Magazine*, CXVI, 859, 1974, p. 576.

26 Ducasse 1992, p. 619.

27 Lemnius 1658, p. 144. The English *The Secret Miracles of Nature* is from the French version, *Les Occultes Merveilles*, published in Paris, 1567. *Stibium* is antimony, a lead-based cosmetic, largely used for eye make-up.

28 Rogers 1988, p. 63.

29 Firenzuola 1992, p. 61.

30 As well as a number of versions of this portrait, such as that at the Musée des Beaux-Arts, Dijon, there are other images clearly based on the likeness of Diane de Poitiers; e.g. a Fontainebleau School painting of Sabina Poppaea, the second wife of Nero, clearly modelled on Diane de Poitiers (*c*.1550–60; Musée d'Art et d'Histoire, Geneva).

31 See J. Bridgeman, '"Condecenti et netti . . .": Beauty, Dress and Gender in Italian Renaissance Art' in Ames-Lewis and Rogers 1998, p. 48.

32 Niphus cited in Houdoy 1876, p. 95.

33 Rogers 1988, p. 48.

34 Firenzuola 1992, pp. 34 and 41.

35 Buoni 1606, p. 31.

36 Burton 1621, p. 557. Burton's features of ideal beauty were: 'a high browe like unto the bright heavens, white and smooth like polished alabaster, a paire of cheeks of Vermilion colour, a blacke browe, corall lippe, a white and round necke, dimple in the chinne . . . sweet breath, white & even teeth . . . a fine soft round pappe' (*ibid.*).

37 Clark 1976, p. 13. The idea of Vitruvian man derives from a famous drawing by Lonardo da Vinci of *c*.1487, which depicts the ideal human proportions of the ideal male body with the classical orders of architecture as described by the architect Vitruvius in the 1st century BCE.

38 Etcoff 1999, p. 17.

39 Romei 1598, pp. 27 and 29.

40 Firenzuola 1992, pp. 25 and 14.

41 Firenzuola 1992, p. 28. Giambattista Porta, 1669, p. 250, urged women to use dentifrices, 'for there is nothing held more ugly than for a woman to laugh or speak, and thereby to shew their rugged, rusty and spotted Teeth: for they all almost, by using Mercury sublimate, have their Teeth black or yellow'.

42 Cropper 1976, p. 374.

43 Firenzuola 1992, pp. 61–3, and Firenzuola 1548, pp. 75–6.

44 Firenzuola 1548, p. 76.

45 Cropper 1976, pp. 383–4.

46 Luigini 1907, pp. 24, 36, 51, 66 (ideal beauty) and 117–18 and 141 (cosmetics).

47 Information on the dress from Margaret Scott.

48 Piccolomini 1968, p. 32.

49 Marinella 1999, pp. 166–7. Marinella's *La Nobilità et excellenza delle Donne* was published in response to a diatribe against women, Giuseppe Passi's *Dei Donne schi diffeti* (The Defects of Women), 1599. She followed Agrippa in declaring that 'the Idea of women is nobler than that of men. This can be seen by their beauty and goodness, which is known to everybody' (p. 53). In support of Plato's idea that external beauty is the image of divine beauty, she stated that female beauty 'is a grace or splendour proceeding from the soul as well as from the body' (p. 57).

50 Firenzuola 1992, p. 54.

51 Porta 1669, p. 253.

52 Liébault 1582, p. 13.

53 Ruscelli 1558, ff. 69v, 72v, 107. Another recipe using melons is given in *A Nieue Herball* translated in 1578 from the famous *Cruijdeboeck* by the botanist Rembert Dodoens (Antwerp, 1554); melon seeds pounded with their juice and with meal 'doth beautifie the face' when rubbed into the skin (p. 589).

54 Piccolomini 1968, p. 34. Venice turpentine was made from the resin of the larch tree (*larix occidentalis*); camphire (*lawsonia inermis*) or henna is most famous for hair dye (from the leaves) but the fragrant flowers were used as scent and a facial cosmetic; ambergris is a digestive product from the sperm whale, an expensive ingredient in perfumery. As for the pearls, these were freshwater pearls from freshwater mussels; a much cheaper alternative was mother-of-pearl.

55 Buoni 1606, p. 63.

56 Burton 1621, p. 563.

57 Salomon 1994, p. 69.

58 *The First Blast of the Trumpet against the Monstrous Regiment of Women*, Geneva, 1558, pp. 9 and 11.

59 Hentzner quoted in Rye 1865, p. 104.

60 For further information on cochineal, see A. B. Greenfield, *A Perfect Red: Empire, Espionage and the Quest for the Colour of Desire*, London, 2006.

61 Gunn 1973, p. 76. Lip salves were also made with the red dye from alkanet root, mixed with olive oil and white wax (Lillie 1822, p. 283).

62 The painting is problematic because the attribution to El Greco has been questioned, as has the date, although it is usually given as the late 1570s, shortly after the artist's arrival in Spain. The woman might be Greek (as suggested by the headdress and the necklace she wears), or she could be Spanish (the lynx-lined mantle). Her hair-style suggests a date later than the 1570s (*c*.1600).

indicate similar findings regarding symmetry and regularity of features. Tests indicate that 'averaged' faces were thought more attractive than individual ones; possibly we measure 'the looks of every new person we see against this internal composite' (Etcoff 1999, p. 146). The flaw in such tests, then, results in faces that, while attractively average, are not beautiful. I am grateful to Kiki Smith for drawing my attention to the *New York Times* articles.

48 Donne 1652, p. 7.
49 Boccaccio 2003, p. 71.
50 Woolnoth 1852, p. 243.
51 Cochin 1771, II: 72.
52 See C. R. Barratt, *John Singleton Copley and Margaret Kemble Gage*, Timken Museum of Art, San Diego, 1998, pp. 7 and 13. For a discussion of this portrait, see A. Ribeiro, *The Art of Dress*, New Haven and London, 1995, p. 226.
53 *Portrait of a Lady* 1771; LACMA Aquisition Fund 85.2. I am indebted to Deborah Gage for information on her ancestor's appearance and for the suggestion that the LACMA portrait may be of Margaret Kemble Gage.
54 Lichtenstein 1998, pp. 84 and 87–8.
55 Etcoff 1999, p. 14.
56 Castiglione 1974, p. 66; trans. Sir Thomas Hoby, 1561.
57 Brain 1979, p. 14; he states that in the west we restrict the amount of skin to be used as a 'cosmetic language' (p. 185). In short, clothes are our second skin.
58 Ducasse 1992, pp. 622–3. See also Sheila Jefferys, 2005, p. 126, on the limitations of make-up as an aspect of female creativity: 'Women are not in a position to paint sunsets on their foreheads, but are required to conform to strict rules in order to function in workplaces and escape criticism and discrimination.'
59 Garve's essay *On Fashion*, published in D. L. Purdy (ed.), *The Rise of Fashion: A Reader*, Minneapolis, 2004, p. 67.
60 Quoted in Corson 1972, p. xxiii.
61 Stalker and Parker 1688, p. x.
62 *Ladies Dictionary* 1694, unpaginated preface.
63 Pope 1757, VI, 4.
64 Simmel 1964, p. 339. Simmel's remarks include specific references to jewellery but can be extended to include adornment generally; the word *Schmuck* can be translated as relating to both.

65 Laermans 1998, p. 11.
66 Bourdieu 1984, p. 57.
67 Perrot 1984, p. 48.
68 Brain 1979, p. 52. Contemporary sources suggest that tattooing continued in Britain until the 12th century.
69 Quoted in Etcoff 1999, p. 96.
70 Ovid 2003, p. 175.
71 *Ibid.*, p. 149.
72 From 'The Instructor', in *The Writings of Clement of Alexandria*, trans. W. Wilson, Edinburgh, 1867, p. 319.
73 St Cyprian, *De Habitu Virginum*, ed. A. E. Keenan, Washington, D.C., 1932, p. 59.
74 *Summa Praedicantium* quoted in Haskins 1993, pp. 152–3.
75 *Le Roman de la Rose par Guillaume de Lorris et Jean de Meun*, ed. and intro. E. Langlois, Paris 1914–24, IV, 1922, ll. 13294–5.
76 Sontag 2002, p. 23.
77 Wolf 1991, pp. 167 and 1. The historian Steven Zdatny, 1997, p. 383, accurately notes that Wolf's book is underpinned by 'a generalised hostility to popular fashion'.
78 Etcoff 1999, pp. 4, 243, 6–7.
79 Jefferys 2005, pp. 124 and 20; make-up, according to Jefferys, p. 13, is incompatible with feminism and turns women into 'sex and beauty objects' (p. 30).
80 Steiner 2001, p. 29.
81 De Beauvoir 1953, p. 273.
82 Simmel 1984, p. 89.
83 Berger 1992, p. 250.
84 Schwarz 1952, p. 105.
85 Miller 1998, p. 142.
86 Berger 1992, p. 251.
87 *Art of Making Love* 1676, pp. 41 and 101.
88 Ducasse 1992, p. 621.
89 Luigini 1907, p. 136.
90 *Beauties Treasury* 1705, p. 47.
91 Benjamin 1999, p. 79.
92 Tseëlon 1995, p. 114.
93 Lecture by Orlan (b. 1947) at the Courtauld Institute of Art, London, 7 February 2008. Although Orlan's 'Reincarnation' concept was created via computer-generated amalgamation, it 'can only be realised through real surgery': Jones 2008, p. 173.
94 Brand 2000, pp. 289–90. See also www.orlan.net

Renaissance

1 Crane 1920, p. 138.
2 Firenzuola 1992, pp. 10–11.
3 Clark 1976, p. 1. See also Camille Lemonnier's *Salon de 1870*, in which he posited a difference between the nude ('le nu') and the undressed ('le déshabillé'). The nude in art 'must be impersonal and must not particularize . . . it makes itself seen as a whole'; the nude is pure, whereas the undressed woman is impure and is for sale. Quoted in T. J. Clark, *The Painting of Modern Life: Paris in the Art of Manet and His Followers*, New York, 1985, pp. 128–9.
4 Niphus cited in Houdoy 1876, p. 169.
5 Firenzuola 1992, p. 37, where he also describes *Venus Coelestis* as 'daughter of Heaven . . . celestial, chaste, and holy'; this Venus represents 'those things that are lovely rather than sensual'.
6 Buoni 1606, p. 69.
7 Lomazzo 1970, p. 20.
8 Goffen 1997, p. 35.
9 Agrippa 1996, pp. 50–51. Agrippa's book inspired a number of similar works, some free translations and even poetry, such as a humdrum offering by 'H. C. Gent', *The Glory of Women: A Looking-Glasse for Ladies* (1652), of which the following lines are typical: 'Therefore the man is but the work of Nature/But woman is the print of the Creator/She's full of Beauty to inrich her fame/She's often found abounding with the same'.
10 Cropper 1976, p. 391.
11 See Christina Neilson, *Parmigianino's Antea: A Beautiful Artifice*, Frick Collection, New York, p. 42.
12 Franco 1998, p. 1. Among Franco's letters is one to a mother who was considering the career of a courtesan for her daughter, in which she states her disapproval of overt sexuality; addressing the mother, Franco states, p. 38, that whereas at one time she had dressed her daughter modestly, now she encourages her 'to be vain,

Introduction

1 M. de Montaigne, 'On Physiognomy' in *The Complete Essays*, trans. M. A. Screech, London, 1991, p. 1199.

2 Burger (Théophile Thoré) 1856, p. 197.

3 C. Lennox *The Female Quixote; or, The Adventures of Arabella*, London, 1752, p. 288.

4 Sontag 2002, pp. 24–5.

5 S. Gundle, *Glamour: A History*, Oxford, 2008, p. 118.

6 Higgins in Brand 2000, pp. 87, 98.

7 Romei 1598, p. 5.

8 C. Ripa, *Iconologia*, London, 1709, p. 10.

9 Strong 1972, p. 6.

10 Smith 1838, p. 33. Etty's portrait was painted 2 years later but the quotation is appropriate for this image.

11 Clark 1980, p. 7.

12 From Tennyson's poem *Maud* (1855), II, ll. 6–7; in the following verse he refers to her as 'passionless', 'ghostlike', 'deathlike' and her face, 'cold and clear-cut' like a gem.

13 Stephen MacKenna's translation of Plotinus's *On Beauty, Daedalus* 2002, pp. 27–8; although symmetry, Plotinus says, is important along with 'a certain charm of colour', sometimes 'the one face, constant in symmetry, appears sometimes fair and sometimes not'. Beauty therefore escapes from rules about the proportions of the face; it is 'wonderment and a delicious trouble, longing and love, and a trembling that is all delight' (p. 30).

14 Houdoy 1876, pp. 144, 94.

15 Burke 1757, p. 107.

16 Prettejohn 2005, p. 52. I am indebted to Elizabeth Prettejohn's discussion of Kant's *Critique of Judgement* (1790) in *Beauty and Art*. Kant, it has been stated, proved 'unable to provide necessary and sufficient conditions for the concept of beauty'; see Gaskell 2003, p. 273.

17 Burger 1856, p. 197.

18 Eco 2004, p. 415.

19 Nehemas 2007, p. 5.

20 See *The Writings of Albrecht Dürer*, ed. A. Werner, London, n.d., p. 248.

21 See e.g. Guazzo 1581, p. 67v.

22 *The Challenge* 1697, p. 201.

23 Lakoff and Scherr 1984, p. 67.

24 Lomazzo (1598) 1970, p. 81.

25 For Ruskin's views on the face, see Minty 1989, p. 18. For Ruskin on images of women, see Ruskin IV, 1903, pp. 182 and 190; on 'the sensation of beauty', see *ibid.*, p. 49.

26 Eco 2004, p. 10.

27 Stendhal 1975, p. 66. It would be interesting to know if Stendhal was aware of Lichtenberg's aphorism: 'The prerogatives of *beauty* and *happiness* are quite different from one another. For one to enjoy the advantages of beauty, *other* people have to believe one is beautiful; there is no necessity at all for this, however, in the case of happiness: that one believes it *oneself* is perfectly sufficient'. See 'Aphorisms Notebook K 1793–1796', in *Georg Christoph Lichtenberg: Aphorisms*, trans. and ed. R. J. Hollingdale, London, 1990, p. 167.

28 Houdoy 1876, p. 179.

29 Lawrence 1954, pp. 15–16; this comes from an essay 'Sex Versus Loveliness' published in the *Sunday Dispatch*, 25 November 1928.

30 Etcoff 1999, pp. 24–5.

31 Porter 2001, p. 74.

32 Flügel 1930, p. 189.

33 See S. Buck, 'Framing the Image: Lucas Cranach's *Adam and Eve* and Book Illustration', in *Temptation in Eden: Lucas Cranach's Adam and Eve*, ed. C. Campbell, Courtauld Institute of Art Gallery, London, 2007, p. 37.

34 Gautier 2005, p. 59.

35 L. Junot, Duchesse d'Abrantès, *Mémoires sur la Restauration*, Paris, 7 vols, 1836–7, V, 58.

36 Boccaccio 2003, p. 20.

37 *Ibid.*, p. 72.

38 Darcie 1612, p. 49.

39 Haskins 1993, p. 135.

40 This painting (YORAG 967) has been attributed to a number of schools and artists, but is of high quality and Cano seems a distinct possibility. It was originally catalogued as St Apollonia but conservation indicated some overpainting (now removed); the palm was possibly an early addition. The identification of the woman as St Elizabeth seems to me very tentative. The sitter may be a saint or she may be represented as a theatrical personification of a saint or she may have adopted the humble woollen working-class dress she wears as a sign of humility or penance. My thanks to Jenny Alexander of York Art Gallery for information on the painting.

41 Pacteau 1994, p. 15.

42 *Ibid.*, p. 203, quotes Angela Carter's review (*London Review of Books*, 16 February 1989) of Marwick's book in which she suggests as a subtitle 'Women I have fancied throughout the ages with additional notes on some of the men I might have fancied if I were a woman'.

Carter's comment could also be applied to Clark's *Feminine Beauty*, and Eco's *History of Beauty*, suggesting gendered attitudes to beauty cannot be avoided.

43 Lawrence 1954, p. 15.

44 Marwick 1988, pp. 34 and 44. Eco, 2004, p. 14, opts out by suggesting that although beauty is relative, 'there may be some single rules valid for all persons in all centuries' and that it is up to the readers of his book to make their own judgements.

45 J. A. Tyldesley, *Nefertiti*, London, 2003, pp. 191 and 4.

46 Nehemas 2007, p. 64.

47 Etcoff 1999, p. 23. Two articles in the *New York Times* referred to experiments in evaluating female beauty. The first (5 August 1986, p. C8) by Daniel Goleman reported on the work of the psychologist Michael Cunningham of the University of Louisville, Kentucky. Cunningham asked 150 white male college students to look at pictures of 50 women (including 7 black and 6 Asian women) and to grade them for the 'ideal of the attractive female face'; the responses were consistent in praising symmetry of features, large eyes, small nose and chin. The calibrated proportions of the face are similar to those admired in the Renaissance manuals discussed in Chapter 1 of this book. The second article (21 March 1994, p. A14) by Jane E. Brody discusses 'an accumulating body of evidence that concepts of attractiveness may be universal and hard-wired into the brain'. More recent experiments with computerised images of beauty

Notes

As the book you are reading indicates, there has been over the centuries an uncomfortable cohabitation between the two kinds of beauty (now threatened perhaps with divorce), a reflection of the prioritising in western culture of theory over practice. The pursuit of beauty is certainly a difficult and complex ideal but women should not be patronised if, in different ways, they try to achieve it. In W. B. Yeats's poem 'A Woman Young and Old' (1928), the two kinds of beauty are one, the Platonic paradigm of the ideal beauty, before time and experience mutate it into the everyday:

> If I make the lashes dark
> And the eyes more bright
> And the lips more scarlet,
> Or ask if all be right
> From mirror to mirror,
> No vanity's displayed.
> I'm looking for the face I had
> Before the world was made.

223 (*following page*) 'Venetian Woman bleaching her Hair', from Richard Balfour, *Album Amicorum* (detail of fig. 45)

products[23] and an equal (related) anxiety over the testing of cosmetics on animals.[24]

Beauty and Beauty

There is no doubt that even when the packaging of cosmetics states how 'natural' they are (and this is more a psychological boost to the customer who thinks she is being ecological and healthy than a reality), they are still cosmetics, that is, they are intended to intensify and enhance the characteristics of a face. Some critics of make-up suggest that it be abandoned altogether, as it has been by many professional women (the majority of female academics in Britain and North America, for example, either do not use cosmetics or use them only sparingly). Like John Carl Flügel in 1930, Sheila Jefferys, sixty-five years later, hoped that, in the future, women would abandon make-up: 'A look in the mirror in the morning could be cursory before they strode or skipped out of the house without caring who looked at them or what they saw'.[25] Kathleen Higgins, in a more reasoned argument, suggests that make-up is acceptable, as long as it does not become 'an end in itself or a project of obsessive defense against one's flaws'.[26]

As for the ideal of beauty, writers seem divided on what this is and how (if at all) it might be achieved. For Nancy Baker, the 'beauty trap' (also the title of her book) occurs when women chase 'elusive and transient feminine beauty' at the expense of 'real power, economic freedom, and self-reliance'.[27] She is among a number of writers who suggest the cultivation of 'inner beauty' (a rather Victorian phrase). But what might this be? A 'larger aspiration for wholeness in a human being' is one answer.[28] Robin Lakoff and Raquel Scherr propose that women must learn to see a 'wider range of physical attributes as potentially "beautiful"' and propose new canons of beauty such as experience, competence and thoughtfulness. Yet this extends the concept of beauty so widely that we lose the sense of what makes beauty special, and it seems to contradict an earlier comment in their book that we 'value beauty highly because it gives us pleasure, often of a kind that unites intellect and heart in one. The thrill at the encounter with any kind of beauty, personal or not, has mystery and grandeur'.[29] Higgins poses the question: 'Should we consider beauty an inappropriate ideal or simply an ideal that is not promoted by an industry devoted to selling its surrogates?'.[30] She suggests that we cut the chain between beauty and 'beauty', between the ideal and the applied art, between theory (what philosophers, almost exclusively male, have thought over the centuries) and practice. The proposal is for a renewed power for beauty and a demotion for 'beauty' (which we may now wish to think of with inverted commas) to the toilette, the salon, the dressing table. It is a profoundly anti-feminist and elitist stance, which denies the validity of the everyday experience of millions of women.

greatest inventions of modern facial science', removed facial blemishes.[15] Today a great number of remedies to improve the skin are available, such as botox injections (to reduce wrinkles), various exfoliating and 'resurfacing' processes, skin fillers (to fill in frown lines and enhance the lips), laser treatments (for scars and other skin defects) and so on. Some of these treatments are invasive and may have long-term effects, an argument to be set against the increase in self-esteem and youthfulness that they may supply.

Youthfulness was, and is, the holy grail of the beauty industry. Lois Banner writes that, in the pursuit of youth, 'to be beautiful has involved the adoption of artificial means, whether cosmetics, hair curling, hair coloring, or even plastic surgery'; she sees youthfulness as an idea dating from the 1920s,[16] but it has always been one of the attendant goals of the search for beauty. Rubinstein, writing in 1930, foresaw a time in the not-too-distant future when the concept of age as we know it would be replaced by 'early youth' and 'late youth'; fifty would be the new thirty and a woman of seventy would 'enjoy a vigorous maturity'.[17] On the premise that only surgery can alter the features of the face, the beauty industry's focus has been on the skin. Over the course of the twentieth century, innovations in skin care and cosmetics included the use of hormones in the 1930s to increase the suppleness of the skin (promoted by Rubinstein in her skin creams),[18] the introduction of hypoallergenic cosmetics in the 1950s, followed by make-up that claimed to be 'organic' and anti-pollution, to incorporate sunscreens and so on. Silicones are a popular alternative to oils and waxes in cosmetics, especially in hair products, and another development has been make-up made from crushed mineral pigments, which – according to the website of the original brand – claims to be free of 'preservatives, talc, oil, fragrance and other chemicals that can irritate skin' and gives 'the amazing look and feel of bare skin', 'makeup so pure you can sleep in it'.[19] Increasingly cosmetics claimed to be validated by the science of dermatology and in the 1970s the term 'cosmeceutical' was coined, an amalgam of 'cosmetics' and 'pharmaceutical', leading to some exaggerated claims made by the manufacturers of cosmetics for their products[20] – *plus ça change, plus c'est la même chose.*

Readers of this book will have their own ideas as to whether cosmetics are a harmless, joyful and liberating force, or exploitative and divisive, and whether the beauty industry is, as the sociologist Paula Black thinks, 'deeply oppressive and reactionary'. Black is right to suggest that cosmetics are 'sold to women as bringing out their real inner beauty, or as enhancing their true nature. Artificiality is sold under the guise of a natural, already present femininity'.[21] She is wrong, in my opinion, to suggest that this is somehow demeaning, that there is – as the historian Steven Zdatny notes – 'something artificial and pernicious about consumerism'.[22] Having said that, there is a legitimate concern about the amount of money that is spent on a bewildering range and number of beauty

ment and the acquisition of beauty were seen as laudable aims. Although reconstructive surgery – the removing of flesh from one part of the body to another – had been in use since the sixteenth century, the techniques were primitive and dangerous, even after the invention of anaesthetics (1846) and antisepsis (1867); it was the medical experience gained during the two world wars that allowed plastic surgery to develop further.

Facelifts (pioneered at the beginning of the twentieth century) were (and are) among the most popular forms of cosmetic surgery; the cult of youth during the 1920s made them fashionable. Helena Rubinstein, however, thought they were for lazy women who 'want quick results in removing the traces of the years from their faces'.[9] In his book *Making the Body Beautiful*, Sander Gilman, noting that the 'desire for rejuvenation in the West is as old as myth', comments that, although the transformation of a woman by aesthetic surgery 'provides a mask of youthfulness . . . it does not provide a resolution of the problems that confront the character and her world'.[10] (The same could be said of the men who are increasingly opting for aesthetic surgery.) Views on cosmetic surgery vary widely, from those who denounce it as self-obsessed and dangerous, to those who see it – like cosmetics themselves – as liberating and empowering to women.[11] Aesthetic surgery has the potential to create what the name implies, the perfect face based on the philosophy of the beautiful. In multi-cultural societies the ideal no longer has to be exclusively a white, western European one, although opinions vary as to how far a diversity of facial types exists in cosmetic surgery. Elizabeth Haiken in 1997 thought that the ideal face copied by the surgeon still 'clearly derived from and relied on Caucasian, even Anglo-Saxon traditions and standards'.[12] Two years later, Nancy Etcoff suggested that from the second half of the twentieth century, surgeons had noted a change from the 'hyper Westernized' type of beauty to darker skin tones, wider noses, plumper lips; 'Asian, African and Hispanic features are helping to recalibrate norms and re-envision beauty'.[13]

Beauty and its Discontents

In the quest for youthful beauty over the past hundred years, a range of options, apart from surgery, has been offered to women. These options tend to focus on the skin, with the aim of achieving a beautiful complexion and because the skin is obviously subject to the aging process more than any other component of the face. Early in the twentieth century, what the *Daily Mail* called the 'mysterious and invisible force of electricity' could be used for the 'production and perpetuation of beauty', such as smoothing out wrinkles:[14] electrolysis, 'one of the

makes you stop and look again'; but – inevitably, perhaps, as a fashion journalist – she proposes 'the faces of the moment', such as the model Kate Moss (see fig. 13), for her 'look of innocence cut with rebelliousness'.[5] Moss is undeniably attractive, but is possibly too much of her time to be able to transcend time. Maybe the very concept of time-transcending beauty has vanished for ever, to be replaced by a more accessible 'beauty' (perhaps the word itself should no longer be used), with contemporary appeal.

Wilde stated that beauty is a wonder based on appearance, and no one is able to resist appearance, for this comes into our notion of ideal beauty in the mind, as well as beauty in the flesh. To Max Beerbohm in the 1890s, 'personal appearance is art's very basis. The painting of the face is the first kind of painting men can have known . . . To make oneself beautiful is a universal instinct'.[6] A hundred years later, the notion that women are visually and socially constructed through their appearance, and especially by cosmetics – 'I make up therefore I am' – is no longer regarded as part of 'natural' femininity. Susan Sontag noted that

> a woman's face is the canvas upon which she paints a revised portrait of herself. One of the rules of this creation is that the face *not* show what she doesn't want it to show. Her face is an emblem, an icon, a flag. How she arranges her hair, the type of makeup she uses, the quality of her complexion – all these are signs, not of what she is 'really' like, but of how she asks to be treated by others, especially men.[7]

This view from the early 1970s is partly explained by its timing – at the height of the second wave of feminism, the beginning of the Women's Liberation movement – but now appears rather dated, even if it were true at the time. For women, rightly or wrongly, there has always been a tension between nature and art; we may choose to arrange our hair and our faces (if we do not, or seem not to care, that also counts as a decision) with cosmetics but this does not substantially alter our appearance. Nor did (or do) women see themselves as victims of male-fabricated judgements of appearance, for they themselves are involved in establishing the ideals of beauty; women choose their clothes and their make-up, not with men in mind, but themselves.

As an aspect of beauty, the use of make-up has throughout history been either deplored or admired. For the philosopher Curt Ducasse in the mid-twentieth century, it was the latter: 'one of the manifestations of the incurable perfectionism that marks off mankind from the animal tribes'. He accepted, however, that there were 'limits to the transformations of our appearance that can be accomplished even . . . with the help of beauty doctors, plastic surgeons, and other high priests of the cosmetic art'.[8] At the time he was writing, plastic surgery (now known as cosmetic or aesthetic surgery) had become an important part of the beauty industry, notably in the United States of America, because self-improve-

*T*O MANY PEOPLE NOW THE IDEA OF BEAUTY IS A MEANINGLESS CONCEPT, NOT WORTH SEARCHING FOR AND REDUCED TO THE LOWEST common denominator, to desire or gratification. This view was expressed by a writer in 1931: 'Anything that is regarded with deep satisfaction or longing, because it answers to desire, is beautiful. A doll, a dog, a hat, an automobile, may be valued enough to be contemplated as a thing of beauty'.[1] My concern here is not with the notion of desire, because this can be evoked by a woman's beauty, but with the fact that there is nothing else *but* desire involved in the author's definition of beauty. Beauty must surely engage the head as well as the heart for, alongside a sense of awe and wonder, there should be an intellectual and an emotional reaction to the sight and presence of outstanding physical beauty. Wilde knew this; in spite of the famous deliberately provocative and double-edged comment quoted at the head of this section, his biographer perceptively noted that he 'writes about beauty as a believer about God', although 'his veneration . . . while more than a flourish was less than a creed'.[2]

One problem lies in defining the indefinable, in working out what we mean by beauty which, as this book suggests, is fraught with difficulty, notably whether it is universal or specific to the aesthetics of a particular period. If famous beauties in the past could appear in the flesh to us, would we think they were beautiful? Would we, for example, say, as the playwright J. M. Barrie was supposed to have said, that he would stand out all day in the street (or all night in the rain) to see Consuelo Marlborough get into her carriage? Possibly yes in this case, as she was one of the relatively few great beauties of any age. Great beauty, however, is so rare as to be frightening because it is so uncompromising, so absolute. For this reason, if you ask people – as I did – for names of famous beauties, you will get hardly any suggestions, except of women whose images are familiar, such as movie stars of the golden age of Hollywood, perhaps because their faces, through the medium of the camera, have assumed a relative homogeneity composed of symmetry of features, with large eyes and a perfect complexion. Occasionally, beauty books and newspapers revive classical and Renaissance ideas of proportion; Margaretta Byers in 1939 stated that the ideal face should be 'broken into three equal parts by the brow and the tip of the nose'[3] and fifty years later the *Daily Express* published the same equation in an article entitled 'In search of Classical Beauty'.[4] As has been discussed, symmetry and harmony were important in the definition of beauty for hundreds of years, and still appear as valid standards of comparison when people are asked to judge images of attractive women; they also feature in computerised projections of ideal beauty, although the composite models produced are inevitably bland and sterile. For beauty, paradoxically, is more than the sum of perfect parts, which is why we find it so hard to pin down. A fairly recent (2008) article in British *Vogue* by the editor Alexandra Shulman tries to define beauty. She starts, promisingly enough, by declaring that beauty has presence and that it 'demands a kind of originality that

222 (*previous pages*) Marc Quinn, *Siren* (detail of fig. 13; © Marc Quinn)

Coda

Coda: Now

Beauty is the wonder of wonders. It is only shallow people who do not judge by appearances.

Oscar Wilde, *The Picture of Dorian Gray*, 1891

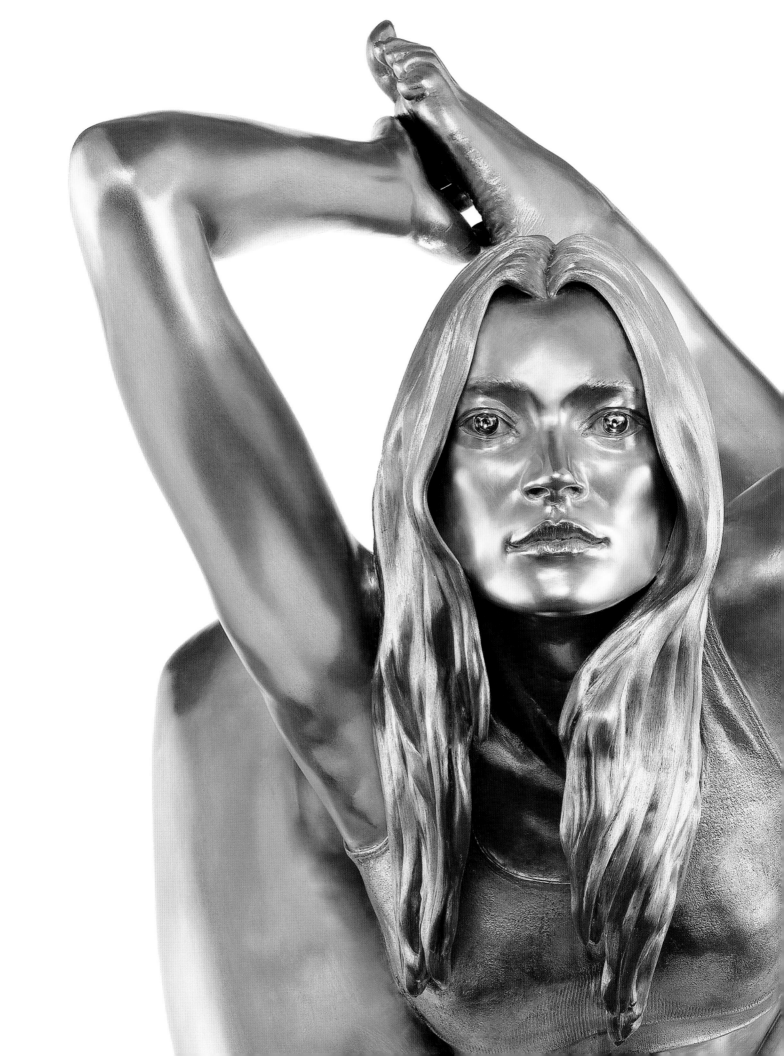

the real woman, and it had largely (if not completely) become free from association with immorality and sexual temptation. Most of all, beauty was regarded as something achieved by cosmetics, by science, rather than inherited; it was a commodity, no longer elitist but democratised.

With regard to beauty in the Platonic sense, as linked to virtue and to the spiritual, and to that indefinable sense of wonder and delight that great beauty evokes, have we reached the end of the affair?

ment, the achievement of beauty is all the more worthwhile because it has been worked for; as Sonya Joslen remarked in *The Way to Beauty* (1937): 'When beauty is a possession that depends only on the love of the gods, it dies young. Like greatness, beauty has a higher value and is more enduring when it is an achievement than when it is thrust upon an individual at birth'.[195] Beauty in such assessments is a self-made virtue; 'Being beautiful is being yourself' is the first sentence of a beauty book by Jill Adam (1940). In the mid-nineteenth century this would have meant the unadorned appearance, where beauty was untainted by cosmetics, but a hundred years later might be interpreted as a Freudian exploration of the subconscious, the inner being which might, or might not, be in discord with the physical self. However, the author means us to understand that she has make-up in mind, by which every woman 'can achieve a certain harmony that amounts to beauty'.[196] Beauty was no longer a *coup de foudre* but a devalued word, the creation of cheap and cheerful make-up; by 1940 it was little more than a modest 'Make Do and Mend', just like the war-time slogan in Britain.

Glamour was an indulgence that vanished with the war; British *Vogue* declared in 1940: 'Today you want to look as if you thought less about your face than about what you have to face . . . You want to look beautiful, certainly – what woman in what age hasn't wanted to? . . . but you want to be a beauty that doesn't jar with the times, a beauty that's heartlifting, not heart-breaking; a beauty that's beneficial, but not beglamoured, and a beauty that's responsive – not a responsibility'.[197] Only a quarter of the cosmetics that had been made in peacetime were made during the war, as manufacturers switched their production lines to wartime needs. Metal, glass and plastics for make-up containers were in short supply, along with some of the ingredients for make-up, such as perfume essences from occupied France. So it was literally 'Make Do and Mend' as women searched for cosmetic substitutes, returning in some cases to old recipes, such as rose-petals soaked in wine or spirits for rouge, lampblack for eye make-up; beetroot to dye lips, boot polish for mascara and oil or margarine for removing make-up. As women moved into war work, hair was covered up with a turban or rolled up round a length of old stocking. However, although the availability of cosmetics was limited, make-up was not rationed because it was regarded as important for morale; in uniform, in war work or at home, women dyed their hair and wore powder, mascara and lipstick. In particular, lipstick acted as a red badge of courage; Rubinstein created *Regimental Red* which, according to *Vogue* in November 1939, 'makes your face gleam like a jewel, especially against subdued khaki and service blue'.[198] While in terms of clothing (which *was* rationed) it was fashionable to be unfashionable, where the face was concerned, it was a patriotic duty to be as beautiful as circumstances allowed, with the aid of cosmetics. By the end of the war, make-up was entrenched as the essential signifier of femininity; it was no longer associated with deceit, with disguising

metics are shown, cold cream (Ponds, created in the mid-nineteenth century, was a favourite), lipstick, rouge, a container with cake mascara and its brush, skin food, astringent, foundation lotion, and powder; it is a recognisable picture even today.

During the 1920s many women had cut their hair very short; the Eton crop of 1924 (shorter than a man's haircut, and often cut and shaved at the back by a barber), was sometimes attacked as a denial of femininity. Yet some women had never cut their hair; Doris Zinkeisen's self-portrait shows her dark hair gathered in a bun at the back and with slight waves on the crown of her head, a hint of the more 'feminine' hair-styles to appear in the 1930s. The 'Modern Woman' of 1936 has her hair curled, and possibly dyed; Everett McDonough (in 1941 a pioneer of the 'cold wave' perm, still used today) naturally claimed that 'beautiful hair' was 'one of women's greatest adornments . . . [whether] straight, curly or permanent waved; dyed, bleached or natural grey . . . blonde, red or brunette'.[190] 'No woman can be considered to be truly and entirely beautiful, even with regular features and a well-cared-for skin, unless her hair is so well groomed that it seems a fitting frame to her face', claimed Maria Verni in *Modern Beauty Culture* (1934).[191] 'Grooming' was a key word of women's appearance in the 1930s; it signified a cool and collected, streamlined femininity. Verni noted that 'the atmosphere of serenity and self-possession expressed by a skilfully groomed woman never fails to make an instant impression of charm wherever she goes'.[192] This is certainly the effect of Pauline Gunn's appearance in *Pauline Waiting*, of 1939 (fig. 221); the artist's second wife is poised and elegant as she sits in Claridge's hotel in her black costume, matching hat, gloves and bag, leopard-skin muff, diamond ear-clips and brooch. Not perhaps classically beautiful with her sharp nose and slanting eyes, she has made herself a beauty by cleverly softening her features with the net of her hat veil and by perfectly applied make-up; darker powder accentuates the cheekbones, lightly applied mascara makes the eyes larger and her lipstick matches her nail varnish. She is a triumph of the cosmetic art, but more than just an image from *Vogue*, for her make-up also hints at her personality; like a character from an Elizabeth Bowen novel, there may be hidden depths beneath her well-groomed exterior. Verni's *Modern Beauty Culture* encouraged women to experiment with different cosmetics and beauty treatments to discover what suited their face and their personality; beauty 'is never entirely absent from any face; it is often hidden through lack of knowledge of the right way to enhance it'.[193] All women were free to make the most of their appearance, to think themselves into beauty, as the authors of *The Modern Woman* suggest. The pursuit of beauty was a liberating force, not vanity, 'but another aspect of the inward urge of the human race to attain complete mastery over the body, Nature, the Earth, and even the Universe'; it was 'our destiny to improve ourselves as far as is humanly possible'.[194] In this argu-

221 (*facing page*) Sir James Gunn, *Pauline Waiting*, 1939. Royal Academy, London

azines constantly referred to the way the stars made up their faces, and advertisements by the major cosmetic companies proclaimed how their products were used by the great names of the silver screen. In Margaretta Byers's *Designing Woman: The Art, Technique and Cost of Being Beautiful* (1939), there is a postscript on 'That Indefinable Something': 'The French call it chic. The fashion magazines call it distinction. The stage calls it appeal, Hollywood calls it glamour', and glamour, according to the author, is 'the modern ideal of beauty'.[187] It is curious to find notions of 'chic' and 'distinction', understated qualities of style and sophistication, in the same company as glamour, which is more akin to the sex appeal of the It-girl (a phrase coined by the novelist Elinor Glyn in the 1920s). For it was Hollywood's manipulation of the face via make-up which was thought to create the most glamorous appearance, and which had become available to the wider public. Byers's book was published the year after Max Factor produced a new make-up (Pan-Cake) in response to Technicolor film; presented in cake-form, this make-up (appearing in Europe after the war as Pan-Stik) gave a quicker-drying matte coverage and was offered in different shades. The face could be contoured and sculpted; 'Modelling the Face With Foundations' was, as Byers claimed, first seen in Hollywood, but now 'the beauty people have been recommending it for women in private life'.[188] As Edgar Morin notes in his book *Les Stars*, Hollywood was the source of modern make-up, for the products created for the movie stars were copied by women all over the world: 'les soins de beauté donnés aux vedettes par Max Factor et Elisabeth Arden, les onguents et les fards crées pour elles se sont multipliés pour tous les visages du monde'. The stars, claimed Morin, were creatures of myth and merchandise, seducing women into copying their faces via cosmetics. Chemistry and magic joined together in the mimetic rites of making up the face as dictated by Hollywood, and created in front of the mirror – 'Chimie et magie se conjugent dans les rites mimétiques du matin et du soir: une image nouvelle, un visage hollywoodien, se créent devant le miroir'.[189] Stars were divine but also dependent on selling themselves; seeing their faces replicated many times, they risked losing their individuality, becoming little more than beautiful masks.

Not every woman adopted the glamorous looks of Hollywood, particularly for daytime. The 1930s saw a beauty that was less strident than that of the 1920s, that was less complicated and time-consuming than the routines practised by the movie stars. It was a simpler and healthier beauty based on cosmetics which were increasingly tested for quality, on diet, exercise and thorough cleansing of the skin; the title of Lilian Bradstock's and Jane Condon's book *The Modern Woman. Beauty. Physical Culture. Hygiene* (1936) is typical of the decade's beauty books. 'The Modern Woman' (fig. 220) is sensibly dressed in a suit for work or shopping, but in the evening puts on a glamorous outfit; framing the two figures are her daily beauty routines based on cleanliness and exercise. On the left, her cos-

220 Lilian Bradstock and Jane Condon, illustration from *The Modern Woman* (1936). British Library, London

empty . . . the Forties star, brightly lit and coloured, was the ultimate Disney cartoon'. The photographers who immortalised Garbo, 'the definitive image of beauty for the twentieth century', were equated with 'Raphael's Madonnas and Botticelli's angels; Gainsborough's society beauties and Romney's portraits of Emma Hamilton'; they were, in Kobal's eyes, 'artists who succeeded in conveying something more than just a sitter whose beauty held an age enthralled'.[181]

'Photogenic' was a word often used for the fashionable face in the 1930s; it did not necessarily denote a beautiful face but one that was striking and where the features were brought out by the camera. It was a face with a good bone structure, with symmetrical features, a high forehead, a medium to large mouth and large eyes which had not to be too deep-set for the camera to exploit their light and expression. It was a face, therefore, which relied on cosmetics: the heavily emphasised eyes of Garbo (Rubinstein told women to use eyeblack above and under the eye and, to give the eyes brilliance, 'a touch of rouge may be placed at the inner corner of the eye'[182]), the bright, savage, red lips of Joan Crawford ('la bouche naturelle s'efface sous une seconde bouche, sanglante, triomphante', created by Max Factor[183]) and on bright hair, often blonde (the film *Platinum Blonde* of 1931, starring Jean Harlow, set the vogue for hair of the same colour). Kathy Peiss rightly notes that the emergence of Hollywood 'legitimized an image of American beauty that included make-up and "natural artifice"': 'Makeup, lighting, camera work, and the choice of actors came together to create an aura of glamour that went beyond symmetry of form and regular features. At the same time, Hollywood replaced elite distance and the exclusivity of beauty with the knowing look and accessibility of Everywoman'.[184] In this context, make-up was crucial, especially for close-up photography; it hid any defects and emphasised the beauty of the skin and the features. To cope with the gaze of the camera and with studio lighting, specialist make-up was needed; a number of cosmetic firms which exist today had their origins in make-up for the theatre or for the movies. Bourjois, for example, established in Paris in 1863, began as manufacturers of theatre make-up and then branched out into cosmetics in general; the company was famous for its rouge and rice powder (Sarah Bernhardt used Bourjois make-up on and off the stage). Max Factor, arriving in Hollywood in 1908 (trained as a wig-maker, he had worked at the Imperial Russian court), founded a company supplying theatrical make-up; in 1914 he developed a 'flexible greasepaint', which allowed the skin to move, the first make-up especially for the movies.[185] In the 1930s the firm of Max Factor, using the expertise gained from making up movie stars, expanded into make-up lines for ordinary women, 'cosmetics to correspond with a range of complexions, hair and eye colors';[186] salons were opened in Los Angeles and in London.

Hollywood's influence on women's appearance – fashion as well as make-up – was a phenomenon of the developed world; beauty manuals and women's mag-

219 Cecil Beaton, *Greta Garbo*, 1930s. National Portrait Gallery, London

lative state of beauty than the essence of her corporeal person, descended from a heaven where all things are formed and perfected in the clearest light'; she personified the *idea* of beauty. Her 'deified' face he described as a mask, sculpted and totemic, like 'snow at once fragile and compact'.[178] Beaton commented on the 'unearthly whiteness' of her skin, which gave her the look of 'some pale being that belongs beneath the water, some ephemeral sprite or naiad'.[179] Garbo was not, of course, a mythological creature but a modern woman and could turn from the ideal to the real, from what Barthes called an 'absolute state of the flesh', 'the flesh as essence', to the 'lyricism of woman'; this transition 'from awe to charm' seems to me to be an important definition of beauty. Garbo remains an icon of beauty because, as Barthes remarked, she did not allow the public to see its 'ominous maturing'; 'the essence was not to be degraded, her face was not to have any reality except that of its perfection'.[180]

When photographing movie stars in the 1930s, black and white was best, for it showed light and shade, the contours of the face and the character of the sitter. The film historian John Kobal in his *Art of the Great Hollywood Portrait Photographers* thought that film stars in the 1930s had 'power, mystery and soulfulness', whereas the images from the 1940s turned 'something that had been intensely powerful into something that was too bright, too cheery, and ultimately

or girlfriend. Another of Soyer's friends, Lillian Stein Cirker, engages the attention of the spectator as she has a manicure, while behind her a woman undergoes the rather tortuous process of having her hair permed. On the left a beautician, in white uniform, examines a client's skin with the aid of a lamp, preparatory to suggesting some treatment; the customer has on her lap a magazine about the movies, for the influence of Hollywood was a dominant force in beauty and make-up during the 1930s.

Garbo, glamour and the face

In a decade when movie stars largely dictated ideals of beauty, no one was as successful as Greta Garbo; she 'had a greater influence on the appearance of women in the nineteen-thirties than any other single person', claimed Neville Williams in his history of cosmetics.[175] For Kate de Castelbajac in her history of twentieth-century make-up and style, *The Face of the Century*, Garbo might *be* the title; her 'look of assertive, self-confident, yet ambiguous sexuality, as well as her almost perfectly symmetrical face, afforded a strong and naturally defined image. Her influence was so great that it could well be said that Garbo alone changed the idea of femininity in the twentieth century'.[176] Looking at any portrait of Garbo – I have selected an undated photograph by Beaton from the 1930s (fig. 219) because once her image was created, her beauty remained largely unchanged during the lifetime of her career – one notes the symmetry of her features, the emphasis on her eyes, the wide and perfectly painted mouth. Beaton, including her in his *Book of Beauty*, declared rather unoriginally that she was 'the most glamorous figure in the whole world . . . the Queen of Hollywood'. The word 'glamour', much used of Hollywood stars, has attracted both praise and distaste – praise for a sense of radiance, of enchantment in some women, distaste for a kind of self-conscious, manufactured beauty, a face reconfigured into an ideal, perfect but inert state, lacking imagination and character. Trying to define how Garbo invented herself as a beauty, Beaton stated that she had learnt to paint her face 'in a very definite and unusual way, with the eyelids blackened heavily, and the brows plucked in the shape of a butterfly's antennae'. Her features were not, he claimed, those of a conventional beauty: 'She has pointed features in a round face, her mouth is wide and knife-like. Her teeth are large and square and like evenly matched pearls; her eyes are pale, with lashes so long that when she lowers her lids they strike her cheeks'.[177] Garbo was transfigured by the camera, turned into an unattainable goddess on the screen, but such a cold and fragile beauty was not necessarily what women wished to create for themselves; her appeal lay less in her specific features than in the way she represented the possibilities of beauty inherent in any woman. For Roland Barthes, Garbo possessed the unreality of the divine, which was less to do with 'a super-

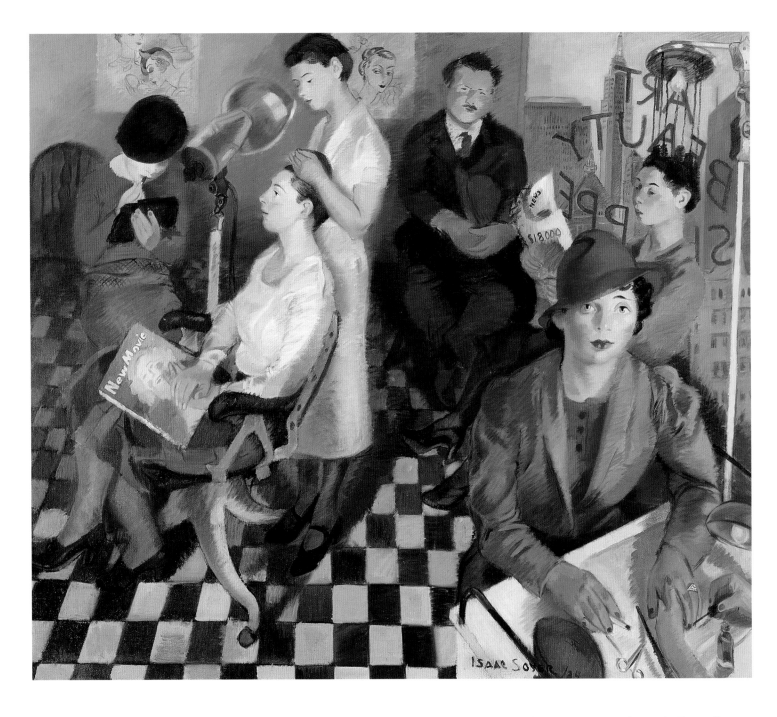

of beauty and artistry. This may explain why a painting of 1934, *Art Beauty Shoppe*
(fig. 218), is so called, for Isaac Soyer, a Russian-American Social Realist artist,
believed that the artist should discover beauty and meaning wherever he found
himself, and should describe the physical appearance of people and the details
of their surroundings. In a working-class New York salon, three women are
shown engaged in the arts of beauty, while in the background another client
lipsticks her mouth and a man (a friend of the artist) perhaps waits for his wife

218 Isaac Soyer, *Art Beauty Shoppe*,
1934. Dallas Museum of Art

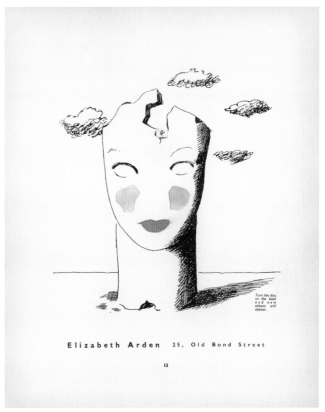

217a and b Illustrations for an advertisement for Elizabeth Arden, *Pinpoints*, 1939. Courtauld Institute of Art, London, History of Dress Collection

an advertisement for Elizabeth Arden (fig. 217a and b) has a disc at the back which can revolved so that different colours on cheeks and lips appear; number 4, 'Carmencita' (fig. 217b), was intended to suggest 'warmer, more natural shades' for the spring of 1939. First published in January 1939 by the fashionable Danish milliner Aage Thaarup and stylishly designed for women 'of good taste', *Pinpoints* aimed to promote 'a better understanding of beauty';[173] the Arden advertisement clearly demonstrates the influence of Surrealism, in particular the work of the Italian artist Giorgio de Chirico, with its sense of a displaced relic of an ancient civilisation in the sands of time.

By the 1930s, the beauty salon employed thousands of women and flourished at all levels of society; it provided the paradigmatic female space where women could relax and relish being pampered; it was a time for mental as well as physical enjoyment. Maria Verni noted in her *Modern Beauty Culture* (1934) that clients would leave their beauty salons or beauty parlours 'with soothed nerves and with permanently renewed hope, as well as temporarily renewed beauty'.[174] 'Beautistry' (a word coined in America in 1932 for the profession of beauty) was an amalgam

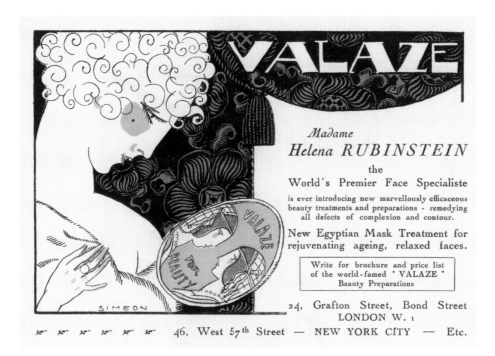

216 Advertisement for Helena Rubinstein's Valaze, *Gazette du Bon Ton*, 1920. Courtauld Institute of Art, London, History of Dress Collection

lization'; a beautiful woman 'sits down before her mirror as an artist in front of his canvas'.[172]

Both Rubinstein and Arden were astute enough to realise that not only did cosmetics have to be harmless (a negative quality) but they also had to be positively good and, if possible, there had to be some scientific or medical input to validate the claims made for the products, especially with regard to their putative rejuvenating qualities. In order to raise the status of the profession, salons were sometimes called clinics or institutes of beauty; in 1908 Rubinstein was the first to open an Institute of Beauty in London's Mayfair and in 1938 the venerable firm of Guerlain set up a *clinique de beauté* in Paris. Elizabeth Arden – the Canadian-born Florence Nightingale Graham – spent a brief time at nursing school, where she met a biochemist working on damaged skin; this inspired her early ventures into cosmetics such as tonics and creams and, having set up a salon in New York (in 1910 she became Arden), she used a firm of chemists to make her products on a large scale. Like Rubinstein, she soon added make-up, rouges and tinted face powders to her skin range. Shades of red and pink were her forte, apparently inspired by Venice (homage, perhaps, to the city where cosmetics had been 'born'); her salons had red doors, the décor was pink with a 'Venetian' theme and her line was named the Venetian beauty line. From the magazine *Pinpoints*, published for the Fashion Group of Great Britain (established in 1935),

as I suggested at the beginning of this chapter, Madame Rachel was the last of the serious fraudsters in the beauty business, there were still a few rogue practitioners, one of whom was Anna Ruppert, about whom little is known except that she had salons in Paris and London in the early 1890s and described herself in her *Livre de Beauté* (1892) as 'le célèbre spécialiste Américaine pour le teint'. Expert at promoting her own products – 'poudre Ruppert', 'rouge Ruppert', 'emollient Ruppert' – which she claimed were made from the finest ingredients and completely harmless, she gave lectures on the subject of beauty and make-up, which were reported in the newspapers, reports she included in her *Livre de Beauté* and its English translation. However, the most expensive of her cosmetics was a tonic which contained mercury, causing a number of her clients to become seriously ill; the adverse publicity created may have ended her career, or – for all I know – she may have assumed another name and identity and taken her beauty business elsewhere. The *British Medical Journal* made Ruppert a *cause célèbre* in its campaign to have beauty salons better regulated;[171] it is not clear how far by the end of the century her case was an isolated example of the unscrupulous and unqualified practitioner in a profession which then and now sells dreams rather than realities to the public.

The most famous names in the beauty business in the first half of the twentieth century were Helena Rubinstein (1870–1965) and Elizabeth Arden (1878–1966); both women were ambitious and ruthless, their celebrated rivalry, played out in the media, helping not just their own businesses but the business of cosmetics as well. They raced each other in opening new salons (Rubinstein won) and offering more beauty products (Arden was the winner here); they both knew the importance of at least a veneer of 'science' in the cosmetics they offered for sale but they also knew the value of keeping their recipes secret. The Polish-born Rubinstein made her name by selling a skin cream, from a family recipe, in Australia, where she opened a small salon in Melbourne in 1902; it was basically a cold cream, to which she gave the name of *crème Valaze*; 'Valaze' became the name of her products (and her salons). Traditionally, beauty salons were mainly about procedures to care for the skin but when Rubinstein saw how, after their treatments, her clients then put on their own make-up, she resolved to create her own, 'the purity of which was absolutely sure'. An advertisement for Valaze beauty preparations from the *Gazette du Bon Ton* of 1920 (fig. 216) features a blonde young woman whose fashionable appearance is equated with Renaissance ideals of beauty; her perfectly made-up face (Valaze cosmetics, of course) has a similar profile to the late fifteenth-century Milanese beauties she gazes at, notably the classical Greek nose. In Rubinstein's promotional *Art of Feminine Beauty* (1930), she recalled how she 'haunted the art galleries of London, to study the various shades of colouring in the portraits of all ages', in the belief that 'extensive and elaborate make-up has often gone with a high state of civi-

products and on advertising them (with the help of celebrities and of the new colour photography) were prodigious; 'feminine beauty, once the Creator's business, is now Big Business'.[164] From the mid-nineteenth century, department stores – lavish public spaces for consumers and spectators – offered a growing number of commercial cosmetic products for sale, at a wide range of prices which allowed women of all classes to buy into the culture of beauty; drug stores and chemists added more and more cosmetics to their pharmaceutical products. The most famous chemists today in England, Boots, began in 1877 when Jesse Boot took over his father's shop selling herbal remedies and began to stock a range of toiletries and cosmetics; in 1935 their range, No. 7, was introduced and still flourishes today. Fashion magazines also promoted cosmetics and how to use them; in 1930 the British journal *Woman and Beauty* was founded 'to instruct women of all ages how to make the most of their beauty, with all the aids that the modern beauty-box afforded'.[165] What Helena Rubinstein referred to as 'the great democratization of beauty' in the years after the First World War,[166] had been anticipated in the 1890s by Max Beerbohm who believed that cosmetics would 'create Beauty within easy reach of many who could not otherwise hope to attain it',[167] and echoed by McDonough who stated that make-up was 'the one topic that every woman has in common with her sister'.[168] As hair-styles became increasingly complex from the 1870s, many department stores provided hairdressing salons, which sometimes also offered basic beauty preparations. Hair-dressers were usually men, but beauty salons were the province of women. Separate beauty salons had existed from the mid-nineteenth century, most famously in Paris, where – according to Thomas Sozinskey, the author of *Personal Appearance and the Culture of Beauty* (1877) – there were 'artists who will under-take to do wonderful things, even to restore at their touch, to the most haggard, a complexion like "immortal Hebe's, fresh with bloom divine", as Homer would say. Some of the public cosmetic *salons* are very elegant places, and are well patronized'.[169] Sozinskey sounded reasonably convinced of the efficacy of such salons but not all his fellow Americans agreed; Ella Fletcher referred to 'the rapidly swelling ranks of the so-called "complexion-specialists"' who promised 'youth and beauty as the reward for using their expensive lotions, powders and creams', and subjected their clients to such dubious practices as skin peeling, that is, removing the top layer of skin to reach the smoother skin beneath.[170]

Late in the nineteenth century, a number of women opened salons, using the products they had developed and building on their own appearance and ability at self-promotion. The majority of these beauty salons were reputable, including those of Frances Hemming who established an elite brand called Cyclax in London in 1896, and Harriet Hubbard Ayer (a Chicago socialite impoverished by her husband's bankruptcy in 1883) who launched a range of beauty products under the name of the Recamier Manufacturing Company in 1886. Although,

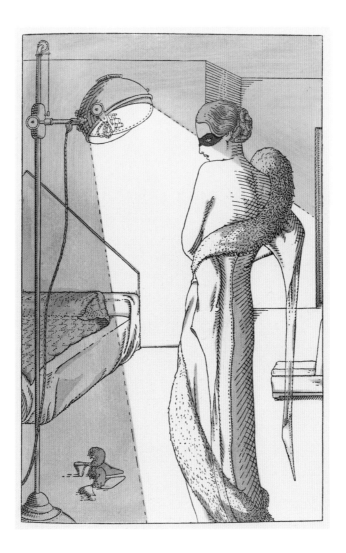

215 Thomas Lowinsky, 'Clytie abandons the old sun for the new', from Raymond Mortimer, *Modern Nymphs*, 1930. Victoria and Albert Museum, London

The beauty business

When, early in the 1820s, Lucien de Rubempré, the hero of Balzac's novel *Lost Illusions*, arrived in Paris from the provinces, he soon found 'a world in which the superfluous is indispensable', in short, that luxury goods were essential for civilised living. So it was with cosmetics in the twentieth century. Everett McDonough, noting in 1937 that 'civilization is measured largely by the broadening recognition of many goods which earlier generations considered solely as luxuries', took as a prime example the expenditure of 'between 100 and 200 million dollars every year' on cosmetics, a major contribution to the economy of the United States.[163] The figures can be queried (other writers suggest different amounts) but all agreed that the sums of money spent on beauty

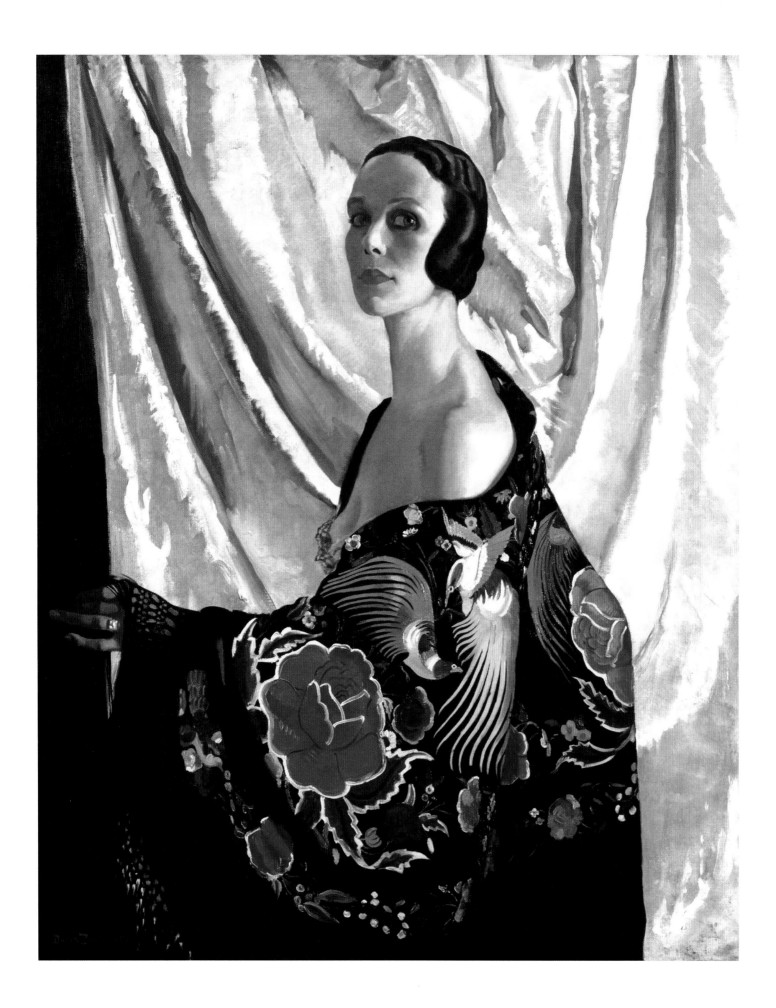

She then covers her eyelids and below the eyes with pale mauve powder (oddly, no other eye make-up is described); rose-coloured powder is added to her cheeks and chin and then the 'dead white powder' for her forehead, nose, neck and shoulders. 'And when her mouth had been carved out in crimson, she dabbed her whole face with a clean puff, tapping it afterwards with her finger-tips'.[159] This was make-up for the evening, when not just the face but the neck, bust and arms required powder; a New York publication of 1934 mentioned high-opacity powders for this purpose, commonly known as evening powders or 'night whites'.[160] This may be what Doris Zinkeisen uses in a self-portrait of 1929 (fig. 214); an artist and costume designer for the stage, she presents herself in a theatrical way, the long white column of her neck rising out of an embroidered Chinese shawl, her eyes enhanced with shadow and eye-pencil, her cheeks with rouge and her lips a bright pillar-box red.

Not everyone went through such an elaborate cosmetic routine as described in *Crazy Pavements*, not everyone wore dramatic make-up, as Zinkeisen does, even for evening. Although the fashionable emphasis was on the lips and eyes, many women just wore face powder, usually flesh colour ('naturelle'), which, according to William Poucher's *Perfumes and Cosmetics* of 1923 (still a bible of the cosmetic chemist), was the most popular shade; powder, he stated, was a 'fascinating wonder worker', which 'will immediately transform a shiny skin into the peach-like bloom of softest velvet', and in compact form they 'now command a large sale, chiefly on account of their convenience'.[161] By the end of the 1920s, darker powders became popular for daytime, because they brought out the whiteness of the teeth but mainly 'because they suggest health and out-of-doors'[162] and were linked to the new fashionability of a tan, which was encouraged by the discovery in 1922 of vitamin D (which boosts the immune system and is important for the absorption of calcium), which we get naturally through sunlight. In reverse of the idea held throughout the centuries that a pale skin signified wealth and leisure and that a brown skin indicated an outdoor existence, pallor began to suggest an unhealthy factory job and suntan an active life with fashionable sporting pursuits and time at one's own disposal. The first suntan lotions came out in the mid-1920s, and in 1936 L'Oréal introduced *Ambre Solaire*, still perhaps the most recognisable name. A short cut to a tan was to use a sun-lamp; in Thomas Lowinsky's reworking of classical themes for Raymond Mortimer's book *Modern Nymphs* (1930), one of his illustrations shows Clytie who has slipped off her high-heeled mules and is about to do the same with her towelling robe, as she stands in front of a sun-lamp. Clytie, a nymph in love with Apollo, constantly turned to him (the sun) and she eventually became a sunflower, thus the title of Lowinsky's illustration is 'Clytie abandons the old sun for the new' (fig. 215).

214 (*facing page*) Doris Zinkeisen, *Self-portrait*, 1929. Estate of Doris Clare Zinkeisen/National Portrait Gallery, London

Facing Beauty

Strauss in *The Beauty Book* (1924): 'the hair is cropped closely to the head at the back, and long pieces are left at the sides to be trained and waved to come over the ears', and then brilliantine was applied to give it shine.[156] More poetically, when the narrator (Michael Arlen) in *The Green Hat* saw Iris March (based on Nancy Cunard), he noted that her tawny hair 'seemed to dance, from beneath her hat, a very formal dance on her cheeks'; 'it waved like music . . . It was like a boy's hair, swept back from the forehead, which was a wide, clear forehead, clean and brave and sensible as a boy's' – clearly a *coupe à la garçonne*. He recalled her sad white face (later referred to as 'gardenia-white', which implies a creamy white colour), her painted mouth 'purple in the dim light'; not only was she 'a tower of beauty in the morning of the world' but she also represented chic, for early in *The Green Hat* she was described as a fashion plate, standing in a stylish slouch, 'like the women in George Barbier's *Falbalas et Fanfreluches*, who know how to stand carelessly'.[157] Arlen was one of Cunard's lovers, as was Aldous Huxley, in whose novels she appeared – as Myra Viveash in *Antic Hay* (1923) and Lucy Tantamount in *Point Counter Point* (1928); both men were fascinated by her 'unusual beauty and sexual power'.[158] Fashion and cosmetics were crucial ingredients of many contemporary novels; whereas in the past, writers concentrated on the hair and complexion of their heroines, in the 1920s they often focused on the make-up they wore and how it was applied. Beverley Nichols's *Crazy Pavements* (1927) is the story of a gay young gossip columnist (like the author himself) attracted to an aristocratic beauty, Lady Julia Cressey (he 'had been the first to chronicle the fact that she had shingled her blue-black hair'), who was 'endowed with a white skin and lips so scarlet that they glistened'; there is a lengthy description of her toilette which, as he admits, 'reads like an advertisement of a beauty specialist', but is the only interesting part of a slight and tedious novel:

> In front of her was a jar of cold cream, a dead white powder, a rose-coloured powder, a powder of palest mauve, a bottle of astringent, two lip-sticks, crimson and vermilion, and an eyebrow pencil. She sat down before a triple mirror and began. She applied the cold cream, wiped it off, and then patted on astringent: 'One could feel the skin tightening. It had an effect that exhilarated mentally as well as physically. And so it should at three guineas a bottle. The groundwork was now prepared. She took the vermilion lip-stick and turned her right cheek to the glass. (If a male reader imagines that lip-sticks are only made for lips, he is much mistaken). She then drew a series of tiny lines, thick near the cheekbone, very faint lower down. When it was finished, her face looked like a human chess board. Putting down the lip-stick, she proceeded to smooth these lines, gently and imperceptibly, into each other. When they were all merged, her right cheek had an appearance of glowing health. The same process was repeated with the left.

than Nancy Cunard, the rebellious shipping heiress, writer and political activist. In a photograph by Man Ray (fig. 213), the African bangles she wears are both fashionable (early twentieth-century western art was profoundly influenced by African art) and evoke her deep engagement with black culture. The image is of an imperious and hieratic beauty, with a pale face, black-rimmed eyes and vivid lips. To many homosexual men, she seemed to be a wondrous and striking *objet d'art*; Beaton noted her 'very Egyptian' appearance, 'with Nefertiti's long upper lip and slightly pouting mouth, which she paints like a crimson scar across her face',[154] and the scholar and aesthete Harold Acton was also attracted by her brittle and remote 'crystalline' beauty, commenting that her 'small head, so gracefully poised, might have been carved in crystal with green jade for eyes'.[155] In Man Ray's photograph, Cunard's hair is shingled, a style described by

(Helena Rubinstein's words[153]) is evident in many of the glamorous fashion publications of the period. 'Le Grand Décolletage' (fig. 212), an illustration from *Le Bonheur du Jour* (1924) by the great French illustrator and costume designer George Barbier, is as much about the paraphernalia of beauty as about the painted woman in the exiguous dress powdering her face; on her dressing table are scent bottles and various cosmetics including eye pencils, rouge and powder.

As I suggested earlier, the 1920s was a decade in which women were shouting their freedom in their appearance and behaviour, and none more so

Van Dongen's *Femme aux Chrysanthèmes* of 1925 (fig. 211), a 'Christmas present to the City of Paris', depicts an unidentified sitter in evening dress (the cleavage was sometimes emphasised with dark powder); her face, arms and bust have a slight greenish pallor, against which the painted eyes, vivid lips and glossy dark hair stand out in relief. According to American *Vogue* in 1920, every woman could 'increase her piquancy and charm by a little dash of artificiality': 'out upon the dressing-table come the little jars and boxes . . . creams and lotions, rouges and powders that delight'.[152] Delight in cosmetics as 'part of a decorative scheme'

van Dongen was able, like Constantin Guys in mid-nineteenth-century Paris, to capture aspects of women's lives and appearance ignored by more 'serious' artists. In a pochoir print of 1920 (fig. 210) entitled *Le Rimmel*, the model, hair cut short in a bob, applies mascara to her heavily painted eyes. (Rimmel was in some countries a generic name for mascara, for the firm was the first to introduce a non-toxic product in the nineteenth century, and after the First World War had become a mass-market manufacturer.) In 1915 a mascara made of coal dust mixed with vaseline was created by a New York chemist for his sister Maybel, and the company he founded, Maybelline, was an amalgam of her name and Vaseline; in 1917 Maybelline created a cake mascara, which was applied to the eyelashes with a small brush, and this remained in use until after the 1939–45 war.

209 Sir John Lavery, *Hazel in Rose and Gold* (detail of fig. 205)

At the time Flügel was writing, it often seemed that women presented mask-like faces, the 'plastered blobs of red and white' of their cosmetics. Compared with the more subtle dress and make-up of women in the following decade, the 1920s witnessed fashion and cosmetics which were deliberately provocative, a reflection perhaps of post-war questioning of conventional beliefs about sexuality and society, and of women newly empowered by easier divorce and far greater opportunities for employment. Monique Lerbier, the heroine of Victor Margueritte's novel *La Garçonne* (1922), takes drugs and lovers (of both sexes) and signifies her liberated life-style by cutting her hair short and dyeing it. At a first night at the theatre in Paris, each woman 'whether beautiful or not, flaunted [her] nakedness from the shoulder to the hips, revealed through the cutaway sides of the light dresses . . . The array of coiffures, ranging from blue-black to a reddish blonde, the paint on lips and cheeks, all gave to the show of peacock faces a fictitious brilliance as of painted masks';[150] stage make-up was sometimes worn in the evening, especially when dancing, to create dramatic effects.

Lips and eyes especially were the focal points of make-up, as Lavery's *Hazel in Rose and Gold* suggests, and were a feature of much of the work of Kees van Dongen. An article in the *Gazette du Bon Ton* of 1920, remarking on van Dongen's perceptive but gentle malice towards women (not the malice of perversity of an artist like Félicien Rops), noted how he captured reality, claiming that he was as much a portraitist as Holbein or Ingres and 'le dernier peintre de la femme'.[151] This is surely overstating the case with regard to such a stylised artist but

les femmes de toutes les conditions se fardent et elles ont joliment raison, puisque le fard les embellit' was the theme of an article in the stylish magazine *Gazette du Bon Ton* for April 1920 (figs 206–8): that all fashionable women were right to use make-up, because it enhanced beauty and character, and symbolised modernity and the active life. The illustrations by Maggie Salzedo depict the attractive receptacles which held cosmetics, art forms which required showing off in public. In Michael Arlen's preposterous but oddly engaging novel *The Green Hat*, a *succès fou* when it appeared in 1924, the author dwelt on the stylish cosmetics deployed by the heroine, Iris March, such as a jade cigarette case chained to 'a hectagonal black onyx' powder case (both by Cartier) and the 'tube of gold' with which she painted her lips;[146] by the 1920s it was chic to be seen using the new twist-up metal lipstick containers. The year 1925 saw the publication of Woolf's *Mrs Dalloway*, in which Clarissa's former lover Peter Walsh, returning to England after five years in India, was surprised and gratified to see 'the delicious and apparently universal habit of paint. Every woman, even the most respectable, had roses blooming under glass; lips cut with a knife; curls of Indian ink; there was design, art, everywhere; a change of some sort had undoubtedly taken place'. This change was connected to a radical transformation in what women wore, especially by the mid-1920s – knee-length loose dresses in simple styles and rectangular shapes. It was as though the vivid colours of make-up were needed as a foil to set against understated clothing which, to some extent, revealed more of the figure but which might be perceived as denying femininity; Rita Strauss in *The Beauty Book* (1924) referred to the 'very slim, boyish type of figure devoid of curves',[147] which the French called the *garçonne*. Woolf's Peter Walsh remarks on women 'taking out a stick of rouge, or a powder-puff, and making up in public', a custom which attracted much comment, being either deplored or praised; several etiquette books, for example, declared that making up in public was vulgar and ill-bred but others found it innocent coquetry, for it was open and not furtive.[148] A more considered, if ambivalent, response came from John Carl Flügel, the author of *The Psychology of Clothes* (1930); while acknowledging that short skirts and artificial complexions were 'symbols of the new-won liberty of women' (the majority of women in the west gained the vote in the interwar years) and 'a victory over old habits of sexual repression and social subordination', he was concerned that the 'constant and flaunting use of powder and lipstick in public implies a preoccupation with self', a sign of narcissism, which suggested 'a relative indifference to other things or persons'. Flügel hoped that in the future, when women would have gained more confidence in their abilities, 'they may find it unnecessary to bolster up their self-assurance with plastered blobs of red and white, but will show a greater faith by trusting the unaided power of the complexion that Nature has provided';[149] his wish (as I remark in the conclusion to this book) may be only partially fulfilled.

rapetisse et lui donne un regard vulgaire.

Comme toutes choses de ce monde le maquillage a une mode. Il y a quelques années, s'enduire la figure de crême semblait indispensable : on était pâle comme un clair de lune. Les fortes créatures d'autrefois prenaient toutes un aspect anémique et mourant, celles d'aujourd'hui, si minces, si frêles, sont actives, robustes, ne veulent être ni souffrantes, ni malades, aussi ne le sont-elles jamais.

Ce souci de paraître fortes, ce désir de vouloir être belles ennoblit le maquillage. Le geste de la femme qui se farde ne fait plus aujourd'hui sourire personne. Sans peut-être se l'expliquer, on a compris que non seulement il n'est pas puéril mais que, bien au contraire, il a la force d'un symbole.

SYLVIAC.

88

désirs, mais l'intention est louable et ne peut que flatter ceux qui les contemplent. Ils auraient tort, ceux-là, de dénigrer le maquillage. Adroitement employé, il rectifie le visage, diminue la joue, agrandit l'œil, fait briller la dent blanche sur la lèvre rouge. Il rend plus jolie la jolie, charmante la médiocre, et grâce à lui la laide transforme sa disgrâce en originalité, piquant, ou drôlerie. Un visage irrégulier artistiquement arrangé acquiert très souvent un style, un cachet plus attrayant que la simple beauté. Le maquillage est un art car il consiste non seulement à colorer ou aviver le teint ou les traits, mais surtout à les accentuer dans le caractère où ils ont été créés. Il est aussi une science. Ce qui embellit l'une, enlaidit l'autre.

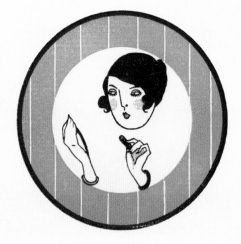

Certains rouges qui donnent à la joue mate des brunes l'aspect du brugnon en fleur, noircissent la peau bleutée des blondes ; une prunelle très claire prend facilement une expression féroce quand elle est encadrée de kohl ; et si l'œil est agrandi par l'estompe ou le crayon brun, un trait noir trop appuyé le

Elles se maquillent,
Elles ont raison,

car

si le bon ton jadis l'ordonnait,
si plus tard il l'interdisait,
aujourd'hui il le recommande
presque. Liberté, égalité.
Toutes les femmes de toutes
les conditions se fardent et
elles ont joliment raison,
puisque le fard les embellit. Elles ne se donnent même plus la
peine de dissimuler. Regardez-les, au dancing entre un tango
et un fox-trott, au restaurant
à la fin du repas... La belle
prend la petite glace et se
regarde sévèrement, passe la
houpette sur son nez, le bâton
de rouge sur ses lèvres, un
doigt mouillé sur ses cils et
d'un index précis consolide
une mouche de velours ; personne n'y fait
attention puisque chaque table voit le
même manège.

C'est l'usage et
il est charmant. Les
femmes veulent être la plus belle
et elles ont bien raison. Le résul-
tat ne répond pas toujours à leurs

startling contrast to the soft and tender, ultra-'feminine' beauty of the turn of the century. Cosmetics *as* art were influenced *by* art – the vivid colours seen in the work of the Fauves and in the clashing and barbaric beauty of designs for the Ballets Russes. Make-up was more visible than it had ever been – visible in the sense of the intense colours and contrasts it created in the face, visible as women increasingly felt free to make up their faces in public. Richard Le Gallienne declared in *McClure's Magazine* (1916) that it was 'the age of the powder puff and the vanity box'; natural beauty he saw as 'so much raw material which the artist has the right to adapt and enhance', asserting 'some complexions are such masterpieces that one often longs to know the name of the artist'.[140] Among such 'masterpieces' might be included Hazel Lavery, the wife and muse of the artist Sir John Lavery. American-born and of Irish descent (she became the personification of Ireland on the new republic's banknotes), she was famous for her beauty, was photographed by Cecil Beaton for *Vogue* and – more prosaically – was one of the well-known 'faces' advertising Pond's cold cream. Sir John's *Hazel in Rose and Gold*, of 1918 (fig. 205), shows her fine delicate features, her huge eyes and wide lips emphasised with make-up. Beaton referred to her 'strikingly Gaelic and easily recognisable mask . . . her complexion like white china, her cheeks like the fire through china, her hair bright red, and with her preference for lipstick and powder she is like a very sophisticated squirrel'.[141]

From the end of the nineteenth century a number of writers began to equate a woman's beauty with her success in life; good looks were 'the stepping-stone to social success or commercial prosperity', according to one critic in 1899.[142] In 1910 the *New York World* reported the widespread adoption of make-up in the workplace, encouraged by employers who wished staff to look vivacious and actively engaged, the implication being that without cosmetics their employees might look tired and washed out, a point taken up some years later by Helena Rubinstein, who thought the pace of life in the United States demanded that women 'heighten and enhance the appearance' by cosmetics.[143] Beauty was – like the city – an essential element in modern life; every 'restaurant, hotel, and store of any importance kept a supply of cosmetics in their dressing rooms or bathrooms for use by female patrons'.[144] Beauty was not just the kind of 'physical capital' (Bourdieu's phrase), that is, assets of attractiveness which women cultivated to gain a lover or husband, but an aim in its own right, especially in the world of work. Lois Banner notes, apropos the first Miss America contest (in Atlantic City in 1921), that beauty was an essential element of success and regarded as the 'natural right' of American women.[145] By this time, beauty was within the reach of all women, for after the First World War, cosmetics were cheaper and widely advertised; a true mass market had appeared, either in response to, or the creator of, avid female consumerism. 'Liberté, égalité. Toutes

205 (*facing page*) Sir John Lavery, *Hazel in Rose and Gold*, 1918. National Museums, Liverpool

206, 207 and 208 (*pages 300–02*) 'Elles se maquillent, Elles ont raison', with illustrations by Maggie Salzedo, *Gazette du Bon Ton*, April 1920. Courtauld Institute of Art, London, History of Dress Collection

203 Percy Wyndham Lewis,
Edith Sitwell, 1921. National Portrait
Gallery, London

204 (*facing page*) Natalia
Goncharova, *Maquillage*, 1913–14.
Dallas Museum of Art, Texas

of her face are well expressed in a pencil drawing by Wyndham Lewis (fig. 203),
her 'Gothic' looks – straight hair, long face, hooded eyes and dominant curved
nose – emphasised by a strange helmet-like headdress. Six feet tall and gaunt,
Sitwell was an example of a plain woman who transformed herself into a
striking beauty through her historically inspired and exotic clothes and head-
wear, and by exaggerating the character of her face. Beaton saw her as an amazing
objet d'art, 'a limpid Gothic saint'; 'she is an outstandingly beautiful object,
aesthetically flawless, with her profile as lyrical as a waterfall and as delicate as a
fountain spray' and with the 'mad moon-struck ethereality of a ghost'.[139]

Sitwell's strange Vorticist 'beauty', however, has the sharp angles and drama that
is characteristic of modern visual aesthetics. The painting *Maquillage* by the
Russian Cubist painter Natalia Goncharova (fig. 204) shows the bright primary
colours and abrupt angular lines that she saw in contemporary make-up, a

202 George Beresford, *Virginia Woolf*, 1902. National Portrait Gallery, London

'poignant beauty' (with the virtue of hindsight one might see a haunted beauty here), her 'timid startled eyes set deep, a sharp bird-like nose and firm pursed lips'; her face did not alter much over the years, nor did her hair-style really change. In her novel *Mrs Dalloway* (1925), Woolf partly describes herself in the character of Clarissa Dalloway: 'light, tall, very upright . . . a narrow pea-stick figure; a ridiculous little face, beaked like a bird's'. Beaton noted that she was 'one of the most gravely distinguished-looking women I have ever seen', but it is not clear whether he ever met her, for he only assumes that she wore little or no make-up: 'one cannot imagine her being powdered and painted: the mere knowledge that *maquillage* exists is disturbing in connection with her'.[138]

If Woolf's beauty was subtle and melancholy, that of the poet Edith Sitwell (another choice by Beaton) was extraordinarily dramatic. The architectonic planes

by McEvoy'.[137] Sargent's charcoal sketch of Manners (fig. 201) swiftly (it took
only two hours) captured her appearance, her long neck, oval face, high cheek-
bones, small nose and rose-bud mouth, her hair cut short in a bob, the dress and
jewellery only tentatively suggested. This portrait certainly suggests a strong-
minded and imperious beauty with a whim of steel.

It comes as a surprise, even among Beaton's unusual 'beauties', to find
Virginia Woolf, and the author admitted that a vast difference separated her from
conventional beauties, compared with whom 'she would look like a terrified
ghost'. If Manners was an obvious beauty, Woolf came under the category of
beautiful women who were 'so subtle that they do not blaze upon one's vision
but rather grow upon acquaintance'. Looking at George Beresford's photograph
of her (fig. 202), taken in 1902, one can see why Beaton described her nervous

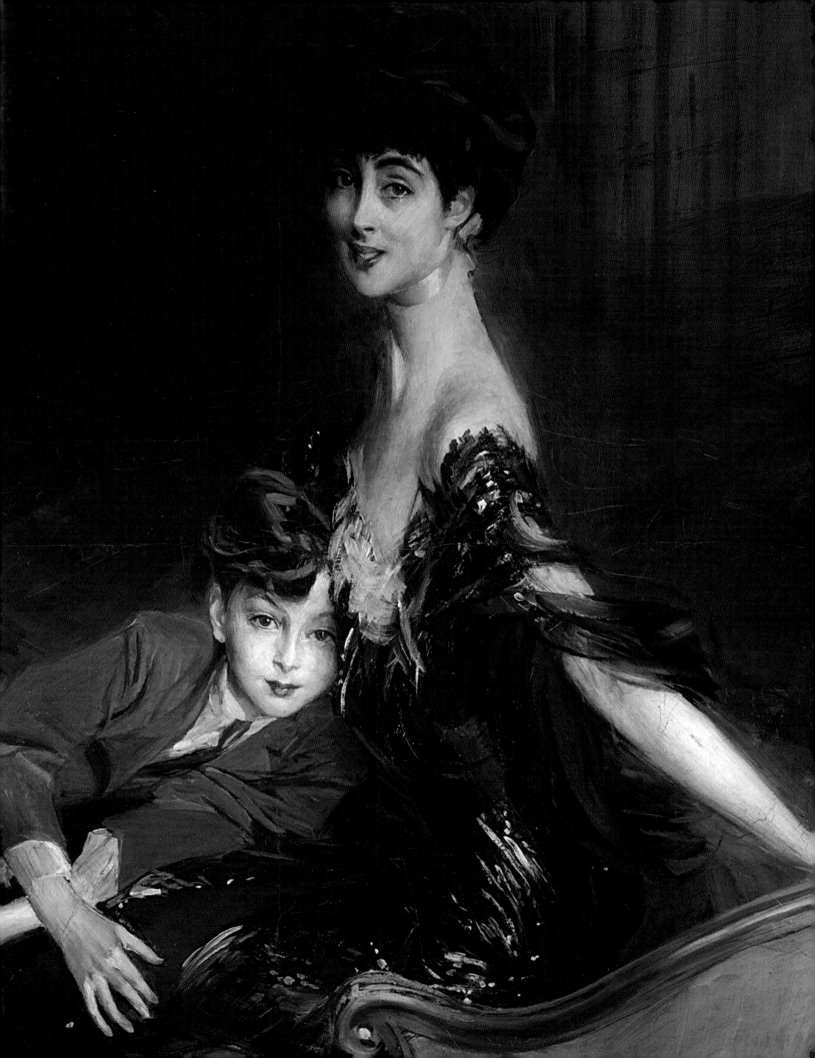

conventional women), the basic ideal of facial beauty continued to be that of a delicate white complexion, slightly tinged with pink. Large hair-styles, often enhanced with false hair pieces known as 'transformations' or *postiches*, added to the stately feminine appearance in vogue, as well as being 'ornamental aids to coquetry'.[134] It was hairdressing that led the way in the creation of a new look and a new kind of modern woman. In 1908 the couturier Paul Poiret cut the hair of his models short, and the following year Antoine de Paris invented the 'bob', the first hair-style a woman could manage by herself without the help of a maid. Short, bobbed hair became *de rigueur* in the worlds of the arts and entertainment and was adopted enthusiastically by many women during the First World War, especially those involved in war work. Late nineteenth-century experiments in curling the hair, such as the Marcel wave (created in the 1880s by the Parisian Marcel Grateau[135]), were overtaken in 1906 by the invention of the permanent wave by Charles Nestlé; giving body to short hair, it ensured the continuing popularity of the bob. The bob was identified principally with youth, a trend that discouraged grey hair, and as a result, safer hair dyes were developed. In 1907 the first synthetic dye appeared: 'Auréole'. It was the invention of Eugène Schueller, a young French chemist who in 1909 founded what would become the firm of L'Oréal, now the largest cosmetics and beauty company in the world.

Books of beauty

If, as I suggested earlier, cosmetics were equated with beauty in this era, did the traditional idea of beauty totally disappear? If one takes beauty as relative homogeneity of face and figure, as in the lavish beauty albums of the Edwardian period discussed earlier in this chapter, then the answer is probably yes. When in his *Book of Beauty* (1930), Cecil Beaton referred to 'this beauty-glutted age' with its 'superfluity of paint and good looks', he was careful to make a distinction between the way in which 'with a pot of paint and a brush of mascara, any woman can, and does, make herself look attractive',[136] and the way in which true beauty was manifest among widely different women. As his selection is highly diverse and at times unexpected, I want to examine some of his choices, which he admitted would not be to everybody's taste. Among the obvious beauties (Beaton refers to them as 'traditional' and 'super-pretty') were Lillie Langtry (see pp. 273–4 above) and, early in the twentieth century, Lady Diana Manners. Beaton saw the latter as the perfect English type of fair beauty with flawless features, 'snow-white skin, rose-petal cheeks, flaxen hair and . . . sky-blue eyes'. In a *Vogue*-like journalistic flurry of excitement, Beaton exclaimed, 'she is Diana, the fleet-footed Greek goddess, she is a petulant Botticelli Madonna, an arrogant Infanta, a pensive Charles II Court lady, a swooning Greuze, an immaculate Winterhalter lady-in-waiting, and she is the cool and fragrant débutante painted

200 (*facing page*) Giovanni Boldini, *Consuelo Vanderbilt, Duchess of Marlborough, and her Younger Son* (detail of fig. 196)

Facing Beauty

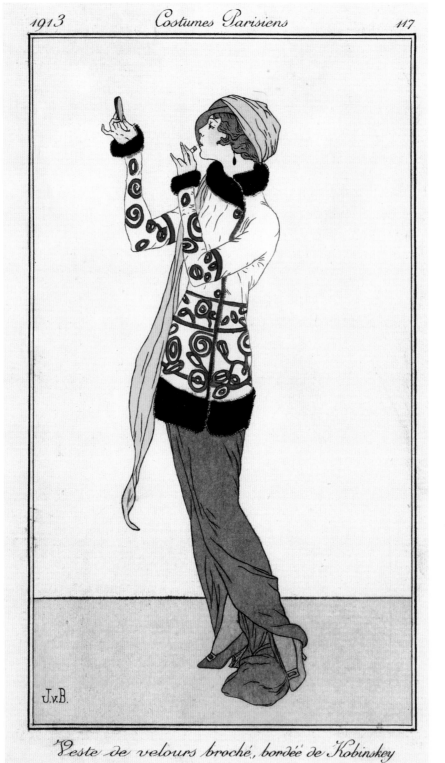

J.v.B.

Veste de velours broché, bordée de Kobinskey

198 (*facing page*) Rupert Bunny, *Après le Bain, ou La Toilette*, 1904. Musée d'Orsay, Paris

199 (*left*) Fashion plate by Jan van Brock from the *Journal des Dames et des Modes*, 1913. Courtauld Institute of Art, London, History of Dress Collection

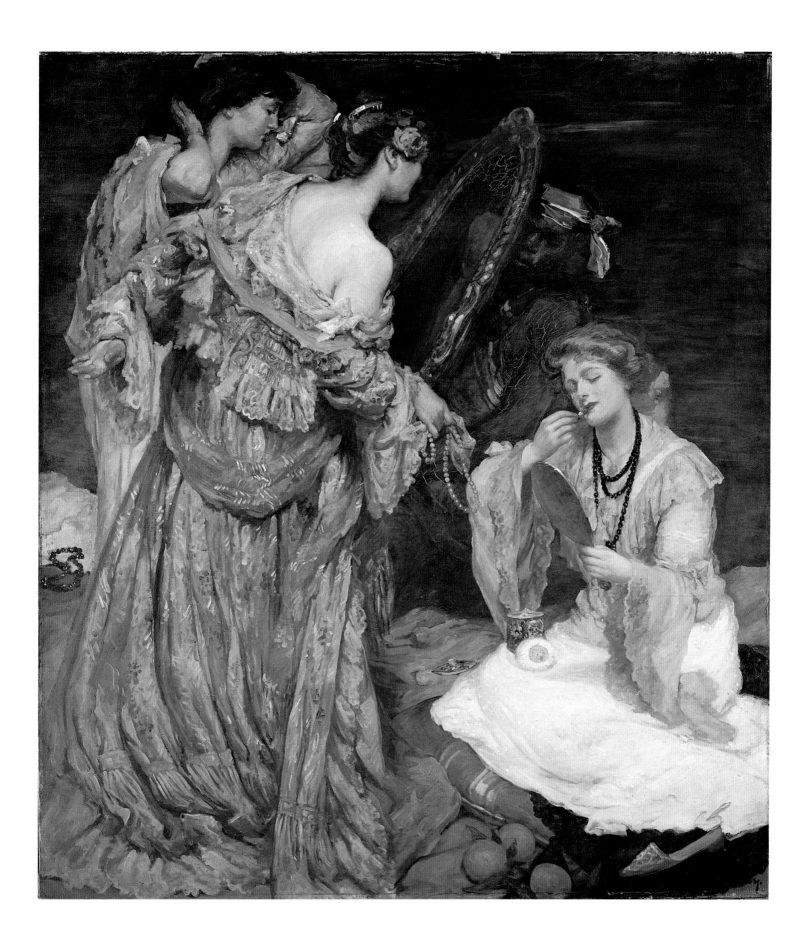

Beauty and the Modern Woman

> The desire to be beautiful has created an artistic appreciation in nearly every woman, so that almost naturally she harmonizes everything in her own life to her own individual age, personality and physique. Hat, dress, hosiery and shoes are selected with judicious care. The hair is styled, the make-up applied, and nails manicured with a thought to their effect as a whole. Artificialities become naturalities by becoming a part of an entity, and the results achieved are an enhancement of beauty.
>
> Everett McDonough, *Truth about Cosmetics*, 1937[131]

Two images, less than ten years apart, serve to suggest the rapid changes in the appearance of women in the early years of the twentieth century: Rupert Bunny's *Après le Bain, ou la Toilette* of 1904 (fig. 198) and a fashion plate by Jan van Brock from the *Journal des Dames et des Modes* of 1913 (fig. 199) show women making themselves up. Bunny's painting depicts three beautiful women meant to represent the Three Graces, handmaidens to Venus, the central one with her back to the spectator, as tradition dictated; the large mirror into which Euphrosyne and Thalia gaze is an attribute of Venus, as are the golden apples in the right foreground. Translated from classical antiquity (the Three Graces were usually depicted nude), they are shown here in contemporary pastel-coloured lace-trimmed silk *robes de chambre*. Aglaia, the grace of adornment and beauty, is a handsome Edwardian beauty, singled out from her sisters by the more precise way her dress is painted, by her jewellery, by her fashionable hair-style and by the fact that she makes up her face, wielding, somewhat inexpertly, a lip salve, and has a box of powder and a swansdown puff on her knees; by this date, cosmetics had become beauty. Compared to the languid and flowing Art Nouveau silhouette of the late Victorian and Edwardian type, the fashionable woman of the second decade of the twentieth century – at least in France – was altogether a different being; van Brock's fashion plate shows a young woman with short hair and a slim figure accentuated by a tight-fitting jacket and a hobble-skirt slit in front. Holding a tiny mirror (possibly from a powder compact, first created by the firm of Bourjois in 1890), she paints her lips; the word 'lipstick' came into use in the years before the First World War.

By this time, improvements in health and hygiene had largely eradicated the need for heavy make-up and the skin began to look more natural. George William Askinson's *Perfumes and Cosmetics: Their Preparation and Manufacture* (1907), one of the many American publications which signalled the importance of the US market in cosmetics, both in terms of innovation and consumption, records a wide range of skin preparations whose ingredients did no harm to the skin;[132] new ingredients such as liquid paraffin made smoother cosmetics which were also easier to remove.[133] Until the 1910s (and for some time after that for more

197a and b Two plates from Charles Dana Gibson, *A Widow and her Friends*, 1901. Courtauld Institute of Art, London, History of Dress Collection

he met in London en route to Paris late in the 1880s.[128] The Gibson Girl, the first distinctively American beauty type, was tall and regal, with high-piled hair and youthful features, including a short, slightly turned-up nose, a style which had in the 1880s become popular, especially in America.[129] A description of the beautiful Lily Bart, the heroine of Edith Wharton's novel *The House of Mirth* (1905), is reminiscent of Gibson's images: Lawrence Selden admires 'the crisp upward wave of her hair – was it ever so slightly brightened by art? – and the thick planting of her straight black lashes. Everything about her was at once vigorous and exquisite, at once strong and fine. He had a confused sense that she must have cost a great deal to make'; Wharton's subtle suggestion that Lily's hair might be 'brightened by art' (she is in her late twenties) hints at the beginning of despair in the attempts of her sensitive, impoverished heroine to keep up appearances, and to find her own identity and a settled place in society – a search that ultimately ends in tragedy.[130]

❧ ❧ ❧

The concept of a collection of 'fair women', which had first appeared at the court of François I in the early sixteenth century, had vanished by the First World War, for a woman who existed solely on the strength of her beauty was no longer acceptable in the modern world: strong and attractive women were to be admired, rather than conventional beauties. This view was articulated by the American economist Thorstein Veblen in his *Theory of the Leisure Class* (1899), where he dismissed an ideal of beauty that 'takes cognizance chiefly of the face and dwells on its delicacy', that regards women as expensive and decorative objects of conspicuous leisure and objects of male consumption. In his opinion there was a change in feminine ideals from a 'lady' to a 'woman', from 'the infirmly delicate, translucent, and hazardously slender, to a woman of the archaic type', the 'robust, large-limbed woman' as seen in the archaic statues of ancient Greece.[122] Beauty was declared to be active not passive, to reside not just in the face but in the whole figure; without a healthy body, 'no woman can possibly look beautiful, do what she will', proclaimed *Beauty and how to keep it* in 1889.[123]

From the late eighteenth century onwards, the writers of beauty manuals had indicated the importance of health to the attainment of beauty. This idea gathered momentum over the next hundred years, and physicians entered the debate, attacking the cumbersome and body-constricting clothes women wore, as well as denouncing dangerous beauty products and practices. Admittedly, some writers paid lip-service to the notion that health and beauty were linked, rather than holding firm convictions of its worth, but others were convinced that 'Beauty and Health are synonymous terms, and therefore the cultivation of beauty is in reality the preservation of health'.[124] Good health, according to Ella Fletcher in *The Woman Beautiful* ('woman' by the end of the nineteenth century had largely replaced the term 'lady' in beauty books), resulted from exercise and sport, her ideal being a 'Grecian Diana . . . perfected, graceful, wholesome womanhood, the symmetrical development of her stately form being the result of devotion to the chase and all out-of-door sports'. While Fletcher approved of bicycling, a craze of the 1890s ('a democratic leveller of people and classes'), she warned her readers against too much indulgence in this new sport, as it might cause 'bicycle face' – a phenomenon that, sadly, she does not explain.[125] (Beerbohm, in his persona as a dandy, wondered about the effects of sport on beauty, claiming that women looked best in repose, for with 'bodily activity, their powder will fly, their enamel crack'[126]). Fletcher's ideal beauty had to have 'a skin of fine texture, be it *brune* or blonde; regular features, with slender straight nose and well-formed upper lip above a round chin; large eyes under narrow arched eyebrows, and shaded by long, curling lashes; delicate small ears set close to the head; abundant, glossy, well-kept hair'.[127] She might here be referring to the well-known images of American beauty, the Gibson Girls, created by the graphic artist Charles Dana Gibson (fig. 197) for *Life* magazine and inspired by George du Maurier, whom

196 (*facing page*) Giovanni Boldini, *Consuelo Vanderbilt, Duchess of Marlborough, and her Younger Son*, 1906. The Metropolitan Museum of Art, New York

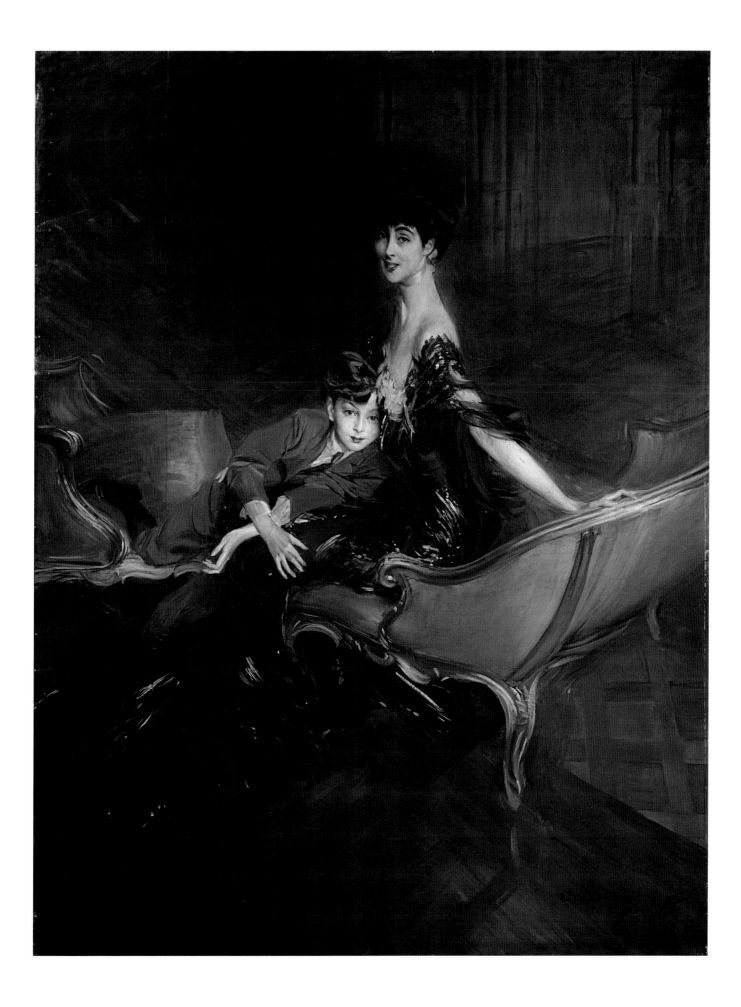

striking is Consuelo Vanderbilt, the beautiful wife of the 9th Duke of Marlborough; the accompanying text refers to her 'wealth of pretty dark hair and lovely expressive hazel eyes'. The portrait of her by Giovanni Boldini (fig. 196), a prime example of what the artist Walter Sickert referred to as 'the wriggle and chiffon school of portraiture', is an almost Mannerist image of a rarefied slender woman with a graceful long neck; her features are piquant and expressive with a slightly tip-tilted nose and a sweep of dark hair. The marriage was famously unhappy and in the year the portrait was painted Consuelo separated from her husband; they eventually divorced in 1920.

a Scottish baronet, was a great success when exhibited at the Royal Academy in 1898 and launched her as a society beauty. Real beauties of the 1890s were often striking and self-confident and Lady Agnew was no exception, with her vivacious beauty in the American style, which clearly appealed to the artist; she has a long face with a pointed chin, dark eyebrows unevenly matched and large eyes outlined with black paint. As part of the *fin-de-siècle* taste in Britain for eighteenth-century English art and dress, she wears a tea gown of white satin and chiffon, clearly inspired by the chemise dress of the 1780s. The author of the *Art of Being Beautiful* (1902) urged women towards the 'picturesque' in dress and to think about it like an artist, and in particular to study the work of Gainsborough and Romney.[119] Before appearing at the Royal Academy, Lady Agnew's portrait had been exhibited in the exhibition of 'Fair Women' held at the Grafton Galleries in 1894 (the title derived from Tennyson's poem 'A Dream of Fair Women'). The exhibition, a collection of paintings of women from Holbein to the 1890s (the majority from the late eighteenth century), has since been considered – perhaps exaggeratedly so – as representing a denial of contemporary art, and of the demands of the 'New Woman' for access to the vote and higher education. It certainly presented 'a kind of untroubled loveliness that seemed to prove that beauty could be perennially preserved'.[120] British society, according to Fletcher, 'worships before the shrine of Beauty with all the ardour of the ancient Greeks', and the reigning beauty at the end of the 1890s, she claimed, was Enid Wilson, the daughter of a millionaire steamship owner; tall, healthy and sports-loving, she seems to have typified for Fletcher a new, modern type of beauty. Fletcher thought that she was more beautiful than the famous Georgiana, Duchess of Devonshire, and her beauty was 'said to be of a kind that makes women forget to envy'. She had a perfect red and white complexion and light brown hair 'rippling in undulating waves all over her perfect head . . . [and] so abundant as to recall Lady Godiva's veil of tresses'.[121] An engraving (after a popular society artist, Ellis Roberts) of Enid Wilson (fig. 195) shows a conventional beauty of the period, her 'veil of tresses' arranged in a style reminiscent of the late eighteenth century, and with the regular features of the many wealthy and aristocratic women (Wilson became both, for in 1900 she married the 10th Earl of Chesterfield) who featured in the beauty albums of the late Victorian and Edwardian period. *England's Beautiful Women*, published in 1909 by the photographic studio of Bassano in London, gives some indication of the genre; an imposingly thick album, it begins with Queen Alexandra – 'In a land of beautiful women Her Majesty has the distinction of being the most beautiful' – who kept her beauty and slim figure into old age. Not all the women are beautiful to modern eyes, but they are all stately, conscious of their rank and with a presence resulting from ample hair-styles and jewellery and elaborate court or evening gowns. Of all those photographed by Bassano for this album, the most

194 John Singer Sargent, *Gertrude Vernon, Lady Agnew*, 1892–3. National Galleries of Scotland, Edinburgh

if they cultivated the fine arts and expressed their emotions more: 'After a few generations of sense-refinement the lower part of the English face will become as perfect as the upper part is now. Cultivation of the fine arts and freer facial expression of the emotions are the two great cosmetics which will put the finishing touch on English Beauty'.[118]

In the late nineteenth century, the artist who most cleverly captured the beauty of elite women was the American Sargent (Rodin called him 'the van Dyck of our times'). His portrait of Gertrude Vernon, Lady Agnew (fig. 194), the wife of

dramatic effect) and with mascara on the lashes. Ella Fletcher observed acidly
that 'American tastes, and morals too, will have to change entirely before
smudged eyelids will ever be looked at in real life other than askance',[115] but
her fellow American was in another country, one which celebrated art over
nature. Octave Uzanne in his *L'Art et les artifices de la beauté* (1902) lamented
what he saw as the death of cosmetics ('le goût de la cosmétique se meurt'),
which he ascribed to an Anglo-American fondness for sport and an active life.[116]
The demise of make-up, however, was exaggerated, and Englishwomen in the
last years of the nineteenth century presented in appearance a kind of half-way
house between the healthy and active American beauty and the delicate artifice
and individuality of French beauty.

 The ideal English beauty of the 1890s might be represented by Burne-Jones's
Head of a Woman, of about 1895 (fig. 193); the sitter's blonde hair is drawn into
a simple knot at the back, and she has a straight nose of medium length, full
lips, a firm chin and a creamy complexion. This is a beauty still influenced by
Pre-Raphaelite art, as well as by classical simplicity; according to Fletcher the
perfect beauty was one of purity, that is, a good bone structure with high cheek-
bones, and 'a clear complexion of delicate tint and texture' like that of Carrara
marble or alabaster.[117] Burne-Jones's *Head of a Woman* has a firm, possibly slightly
too large chin; Finck argued that Englishwomen would be even more beautiful

possesses the sharp cut features of the lady who introduced this head dress in this country [the United States]'. Unsurprisingly, famous actresses, whose images were familiar through photographs and advertisements, whose doings were chronicled in popular journals and newspapers, and who, therefore, had high public profiles, became role models for fashion and for cosmetics, even though (or perhaps because) their private lives were often morally elastic. Morality was no longer a concern in this respect – only laughter greeted Lord Goring's description of Mrs Cheveley – 'a genius in the day-time and a beauty at night' – as wearing 'far too much rouge . . . and not quite enough clothes' (Oscar Wilde, *An Ideal Husband*, 1895, Act II).

By the 1890s, the word 'make-up' (from theatrical usage) was coming into vogue[112] and society women, completely accepting the fact of cosmetics, copied the way in which actresses applied them; they learnt how to adapt the dramatic effects of stage make-up, such as painting the eyes with eye-shadow and emphasising bone structure by rouge on the cheekbones. They became better informed about cleansing the skin and preparing it for make-up; Ella Fletcher advised women to follow a routine of applying 'pure white vaseline, cold cream, or oil, before any powder, rouge, or liquid paint is applied. This is well understood in all stage make-up, and it protects the skin . . . from the injurious effects of the *maquillage*'.[113] 'Liquid paint' by this time is less likely to mean mineral paint than what were called 'liquid whiteners' made from zinc oxide, glycerine and scented floral waters. Face powder was sold in three main shades, pink, rachel (cream) or white, although the last was increasingly regarded as 'unbecoming', rather deadening and also associated with the *demi-monde*. However, if a woman wanted to show off an unusual beauty and to create a dramatic appearance, she might use violet powder, popular in the theatre and in high society since the middle of the century, and which gave a slightly eerie and ghostly look to the skin. This is what Virginie Gautreau wears in her portrait by John Singer Sargent (fig. 192); an American professional beauty of French ancestry, whose family fled Louisiana for Paris during the civil war, she was notorious for her lovers (possibly why she is depicted as Diana, the goddess of the hunt) and the theatricality of her appearance. When Sargent's *Madame X* was exhibited in the Salon of 1884 it caused a scandal because one of the diamanté straps on her dress had fallen down over her arm, a feature considered sexually provocative (as was the dress itself, although it would have been so well structured that it could not have fallen down); the artist had to repaint the strap as it now appears. Going against the grain of a more natural and healthy beauty, she is a creature of complete artifice with her henna-dyed hair and her startling cosmetics; Sargent emphasised Gautreau's pointed nose and wide nostrils, the make-up on the eyes, the red on the lips and the ears, and most of all the extreme pallor of the skin, which would have been created by *blanc de perle* (Spanish White) and then violet powder.[114] Gautreau's eyes are enhanced with black on the eyelids (perhaps kohl for

192 (*facing page*) John Singer Sargent, *Madame X (Virginie Gautreau)*, 1883–4. The Metropolitan Museum of Art, New York

THE SARAH BERNHARDT COIFFURE.

FIGURE No. 1.

FIGURE No. 2.

This Coiffure, stylish, fashionable, and coquettish, improves the appearance of many a lady charmingly, especially if she possesses the sharp cut features of the lady who originally introduced this head dress in this country. It is arranged in the following manner: Figure 1.—The lady's own hair is combed from the front and sides to the crown; part the hair in the back, from ear to ear, across the back of the head, about half way from the crown to the nape of the neck; comb the upper part to the crown and tie up with the front and side hair. A Sarah Bernhardt front piece (see page 8), properly adjusted across the front of the head, is all that is necessary for the front Coiffure. Loosen the hair tied up in the crown and divide in two equal parts; make a rope twist of each part and bring both forward, turning the ends gracefully to each corresponding side resting on the edge of the Sarah Bernhardt front piece; fasten the ends underneath the tied portion on the crown, or fasten on each side with a bow of handsome satin ribbon or a bouquet of flowers just touching the still loose portion of the hair in the neck; the lower part of the hair in the back to be made into two, three, four or five loose curls. A handsome comb of gold, silver, tortoise shell, coral, amber, or a string of beads adjusted in front of the rope twists and one of the handsomest and most stylish Coiffures is produced.

A perfectly elegant, yet simple but very becoming head dress is shown in Figure No. 2, a bride in the Sarah Bernhardt Coiffure, arranged in the following manner: Comb the hair of the front, sides and back of the head to the crown and tie up temporarily. A Sarah Bernhardt front piece (No. 2, page 8) with hair falling back, is properly adjusted on the front of the head; loosen the hair on the crown; add to it the hair of the front piece and divide in two parts; make of each part a handsome braid, and adjust them nicely on the back of the head, as shown in the Victoria Coiffure, back view, page 15. In case a lady's hair is insufficient to produce this Coiffure, a Marie Antoinette switch twisted in with her own hair and natural curls (Figure No. 1) of any desirable length, will remedy the deficiency and answer the purpose. Ornaments should be carefully chosen to produce the necessary effect, always according to the color of the hair, as, for instance, ornaments of gold, amber, or coral, will never do in blonde hair, where tortoise shell, silver, garnet, or jet, will have a splendid effect.

the poet and theatre critic Théodore de Banville thought that she had 'one of those delicate, expressive heads that the illuminators of the Middle Ages painted in the miniatures of their manuscripts'.[110] Bernhardt's name was used to help sell products as wide-ranging as the 'Bernhardt Wrinkle Eradicator', Pyr hairpins ('the only ones I have ever dared to sleep in')[111] and various cosmetics such as a translucent rice powder. Jules Chéret's illustration for *Poudre de Riz Sarah Bernhardt* (fig. 190) shows her in a low-cut dress (suitable for a nightclub or a *café concert*) and a white swansdown boa; her hair is dyed gold, the face expertly painted and the earlobes rouged, a trick employed on the stage and by professional beauties to make the eyes sparkle. Hair-styles were named after her, such as the 'Sarah Bernhardt Coiffure' (fig. 191), a complicated arrangement requiring false hair (the 'Sarah Bernhardt front piece'), and promoted in the catalogue of L. Shaw's 'Hair and Beautifying Bazaar' in New York, in an essay entitled 'How to be beautiful' (1883): 'This Coiffure, stylish, fashionable, and coquettish, improves the appearance of many a lady charmingly, especially if she

figuration. This strange dream-like beauty was impossible to transfer to canvas;
no portrait of her holds even the shadow of it.[109]

In short, Bernhardt had the chameleon habit of transforming herself as circum-
stances or her own genius dictated, and so her appearance changed with each
description of her. To Wilde, her profile was like 'that on a Roman coin' and

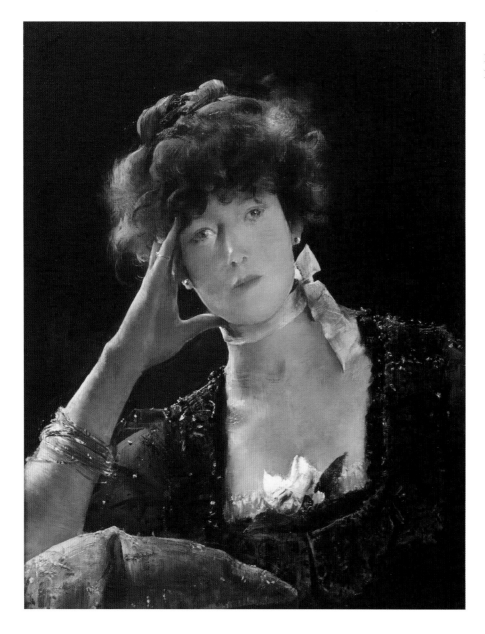

189 Alfred Stevens, *Sarah Bernhardt*, 1885. Gift of the Armand Hammer Foundation. Hammer Museum, Los Angeles

Beauty was with her a garment which she could put on and off as she pleased. When she let it fall from her, she was a small woman with very delicate features, thin lips, a small beautifully modelled nose, hooded eyes of grey-green shadowed by a fleece of red-gold hair, strong slender hands, and a manner of nervous energy. But when she would appear beautiful, none of these details were to be perceived; her face became a lamp through which glowed pale light, her hair burned like an aureole, she grew tall and stately; it was trans-

apply to Bernhardt. Dressed in a black silk evening dress decorated with glittering French jet, her arm encircled in many wire-thin bangles, a pale blue ribbon as a necklace, she offers a challenging gaze to the viewer. She was not a conventional beauty, with her small eyes set unevenly in her head (as the photograph shows) and a slightly pointed nose. Graham Robertson posed the question: 'Was Sarah Bernhardt beautiful? Was she even passably good looking?' He confessed that he did not know:

186 Carte-de-visite of Lillie Langtry as Pauline in *The Lady of Lyons*, Lafayette studio, *c.*1885. National Portrait Gallery, London

187 *(facing page)* John Everett Millais, *Lillie Langtry*, 1878. Jersey Heritage Trust

for her day, when classical perfection was all that was asked of Venus'.[104] When she first appeared in London society in May 1876 she was in mourning for her youngest brother and wore, as she recalled, a 'very simple black, square-cut gown (designed by my Jersey modiste), with no jewels – I had none – and with my hair twisted carelessly on the nape of my neck in a knot, which later became known as the "Langtry".'[105] This is how she appears in the Millais portrait of her in 1878 (fig. 187) – so popular when exhibited at the Royal Academy that it was roped off – in her plain black gown with a white lace collar, her only ornament a white gardenia, and holding a Guernsey lily in her hand. The artist told her that she 'looked just beautiful for about fifty-five out of sixty minutes, but for five in every hour I was amazing'; Langtry thought this portrait the best, most accurate image of herself.[106] In 1877 Langtry caught the eye of the Prince of Wales and became his mistress; the liaison lasted until June 1880, by which date it was fading, partly eclipsed by the visit to London in 1879 of Sarah Bernhardt, with whom the Prince also had an affair. By the early 1880s, in debt and her marriage failing, Langtry went on the stage; a *carte-de-visite* from the Lafayette studio of about 1885 (fig. 186) shows her in the character of the beautiful Pauline Deschapelles in a romantic drama *The Lady of Lyons* by Edward Bulwer-Lytton, set in the late 1790s. Her face has the pure lines of a Neo-classical cameo, her hair arranged in an approximation of Directoire style, gathered in loose curls on the crown of her head. When Langtry first appeared on the scene, she stunned society by the beauty of her natural, unenhanced complexion but she soon began to use make-up. In photographs (the way in which professional beauties were promoted), skin blemishes showed up, so that cosmetics – 'discreetly and artistically managed' – were needed; one writer recommended a 'mixture of a little oxide of zinc and glycerine, thinned with rose-water to the consistency of cream'.[107] By the late 1870s Langtry was promoting herself as a society beauty; clothes and accessories (bonnets, shoes and dress-improvers, that is, bustles) were named after her. Women copied her hair-styles and she endorsed such beauty products as Pears soap, various cosmetics including 'Lillie Powder' for the face and hair lotions; as she became famous she dyed her brown hair a fairer colour, just as later Princess Diana did, a woman whose beauty was somewhat reminiscent of Langtry's.

Sarah Bernhardt, the daughter of a courtesan, had a different kind of beauty, less classical and statuesque, more vivacious and changeable, more modern; whether just wrapped up in a burnous, as in an early photograph of her by Nadar (fig. 188), or in stylish evening dress, as in her portrait by Alfred Stevens (fig. 189), she has an intense physical and intelligent presence. The elegance of her dress and appearance in Stevens's painting negates the theory of critics like Leigh Hunt that fashion was inimical to beauty: 'The spirit of fashion is not the beautiful, but the wilful; not the graceful, but the fantastic';[108] all these adjectives

best quality being made of crushed gold leaf; gold, silver and diamond powders were 'used extensively for elaborate head-dresses at balls, and give great brilliancy to the hair', according to a beauty manual of 1871.[98] As well as being worn at parties, hair powder was also worn on quotidian occasions; it could ring the changes to a woman's appearance and serve to soften the harshness of badly dyed hair. As early as 1859 *Punch* (12 March) noted the revival in Paris of 'powder, paint and patch', suitable accompaniments to the crinoline, a form of the hooped skirts of the eighteenth century. Haweis, with her love of what she saw as the 'artistic' fashions of the past (she admired the 'Gainsborough hat' in vogue at the time she wrote), also praised grey hair powder as 'becoming . . . both to young and old. It softens the whole face, gives a strange brilliancy to the eyes and complexion, and makes the eyebrows and eyelashes appear much darker than they really are'. As for patches, she declared they were 'one of the most harmless and effective aids to beauty ever invented', the perfect finishing touch to the face – 'like the seal on a letter, or the frame to a picture'.[99] On the same principle of making the skin look whiter against the black of a patch, black spotted veils were much in fashion from the 1870s.[100] Renoir's *Jeune femme à la Voilette* of about 1875 (fig. 185) is a study in black and white, with her plaid mantle and *toque* to which the veil is attached; the artist cleverly focuses on the earring of French jet, as the unknown sitter turns her head away from the viewer, so one can only speculate about an elusive beauty.

The art of being beautiful

This is the title of a book published in 1902 by a 'Society Beauty' whose thesis was that 'by the obstinate desire of beauty', a woman could make herself beautiful;[101] the final part of this section deals with the different ways in which women created themselves as great beauties. Some famous beauties were born beautiful, such as Lillie Langtry, whose beauty was exceptional; she was one of the great beauties of whom Haweis noted: 'The immortal worth of beauty lies in the universal pleasure it gives. We all love it instinctively . . . the beauty of faces passes into our souls'.[102] Langtry was admired as the classical ideal and likened to the Venus de Milo; Oscar Wilde, who met her in the spring of 1876, wrote a poem 'To Helen, formerly of Troy, now of London'. Wilde declared she was 'the loveliest woman in Europe' with her 'grave low forehead, the exquisitely arched brow; the noble chiselling of the mouth, shaped as if it were the mouthpiece of an instrument of music; the supreme and splendid curve of the cheek; the augustly pillared throat which bears it all'.[103] Cecil Beaton in his *Book of Beauty* (1930) described her 'staggering' complexion, 'strawberries and cream; her skin of an extraordinary whiteness . . . her kind eyes were like violets, peaceful and quiet, her features flawlessly classical; and her beauty was absolutely right

185 (*facing page*) Pierre-Auguste Renoir, *Jeune Femme à la Voilette*, *c.*1875. Musée d'Orsay, Paris

itself'.[95] Blonde hair too was popular in the 1870s – the Goncourt brothers noted in their *Journal* for July 1874 'une passion de devenir blondes' (especially flamboyant Venetian blonde) among brunette Parisiennes[96] – and in the 1880s, although one English beauty book stated with the firmness of dogma: 'Golden hair makes a woman look young only while she is on the sunny side of five-and-thirty', after which it became 'ageing'.[97] For those who did not wish to risk the bleaching effects of hydrogen peroxide, golden hair powder was available, the

wrinkles ('What an ugly word!'), 'no *cosmétique* of any kind is equal' to raw veal kept on the skin at night, which 'gives the skin a most lovely soft and velvety appearance'.[88] Some cold creams were given more elevated names: Shaw's New York catalogue of beauty products in 1883 offered 'crème impératrice' named after the French Empress's 'beautiful complexion and youthful appearance', and also 'Eugenie's Secret of Beauty', which made the 'skin white, soft and smooth'. On the same page appeared a recommendation that cosmetics should be tested with a 'few drops of ammonia' which would turn poisonous products 'black or muddy',[89] for some women still preferred the effect created by the enamelled look of paint. After cleansing the skin with a cream or with a popular tonic such as Rowland's *Kalydor*,[90] then powder would be applied; from the late 1860s a harmless and effective face powder made from zinc oxide was introduced. To emphasise the transparency of the skin, especially on formal occasions, women might paint their veins (including the eyelids) with a blue paste of chalk tinted with indigo or Prussian blue, one of the earliest synthetic dyes. As for reddening the cheeks, Browning's 'Practical Hints on Personal Beauty' proposed 'a merest *soupçon* of rouge', the colour carefully chosen 'with due consideration for the colour Nature intended you to have';[91] finally, the eyebrows were darkened and the eyelids painted with a black line, which might still be made of kohl but increasingly by the 1870s was made from safer substances such as 'a little Indian ink and rose-water'.[92]

Manet's portrait of the Viennese beauty Irma Brunner (fig. 184), with her perfect and even creamy skin, eyes enhanced by mascara and a touch of eyeliner, and her red lips, might almost be an advertisement for an expensive brand of cosmetics; as artists in the mid-eighteenth century equated pastels with cosmetics, so Manet also thought that pastel was the most flattering medium for portraying beautiful women. Almost merging into her black feathered hat, Brunner's hair is loosely gathered into a coil at the back and forms a fringe over her forehead, a characteristic feature of the 1880s. This is a daytime hair-style, relatively simple for out-of-doors, but more elaborate styles were *de rigueur* for evening, often amplified with false hair, which, according to the author of *Beauty and how to keep it* (1889), had so improved in quality that it was 'difficult to detect which is false and which is real'.[93] Most colours of hair were fashionable, even red, deplored for so long; Haweis remarked: 'once, to say a woman had red hair was social assassination' but from the late 1860s it had become the 'rage', a fact she attributed to the Pre-Raphaelite artists.[94] It was still fashionable in the 1880s, as *Sylvia's Book of the Toilet* remarked: 'There is a warm and lovely tinge of red, that the old masters loved to paint, and which the pre-Raphaelite faction of our own time adore. There are gold lights in it, bronze *reflets* . . . and hints of brown in the shade. Such hair should always ripple and wave . . . It should catch the light at many different angles, so that, like a diamond or an opal, it may display

is almost, at times, a parody of Thomas Carlyle's ornate and ponderous prose, Beerbohm declared: 'Loveliness' shall sit . . . 'watching her oval face in the oval mirror. Her smooth fingers shall flit among the paints and powder, to tip and mingle them, catch up a pencil, clasp a phial'; on the toilet table itself would be powder puffs of eider down, cosmetic brushes of camel hair and chalk from the 'white cliffs of Albion shall be ground to powder for Loveliness, and perfumed by the ghosts of many a little violet'.[85] As in the eighteenth century (there was a revival of interest in the arts of this period from the 1850s), the toilet table was the focus for the creation of female beauty; there a woman 'studies fashion and adorns herself . . . by every artificial appliance at her command'. The aim of Marie Bayard's book *The Art of Beauty* (1876) was to instruct her reader in 'the art of harmonising colours to her complexion – of blending sweet perfumes, washes and pomades; to add lustre to her skin, and remedies for all blemishes; to give exquisite tints to her hair, and suitable styles for dressing it; to guide her in the delicate use of powders, stains and paints'.[86] It is with the Rococo in mind that Berthe Morisot painted a *Woman Powdering her Face* in 1877 (fig. 183); dressed in a white shift, a white muslin peignoir with pleated collar and cuffs falling off one shoulder, she puts the penultimate touch to her complexion – the rouge lies by her left hand. Of course, compared to the eroticism of a (male) artist depicting a female sitter in this way in the eighteenth century, the artistic encounter here is unheated; Morisot was familiar with such beauty routines and observed her subject with a coolly dispassionate gaze. The powder that Morisot's sitter uses is probably rice powder, which could be real or mineral, the latter 'vraiment reine dans l'arsenal de la coquetterie féminine', according to Ernest Monin's *Hygiène de la Beauté* (1886), as it adhered better to the skin.[87] A veritable flurry of beauty books from the 1870s, some by professional beauties and aristocratic women whose titles suggested familiarity with the customs of high society, advised women on make-up products and the techniques of applying them – *Beauty: What it is, and how to retain it* (1873), *The Art of Beauty, or Lady's Companion to the Boudoir* (1876), *Personal Appearance and the Culture of Beauty* (1877), *Beauty and how to keep it* (1889), *Livre de Beauté* (1892), *Les Secrets de Beauté d'une Parisienne* (1894), *Beauty Culture* (1898), *The Woman Beautiful* (1899) and many more. As the range of cosmetics commercially available increased enormously during the latter part of the century, make-up naturally became an area of feminine expertise, and the great majority of books on the subject were written by women, who were, on the whole, realistic about what cosmetics could and could not achieve.

Since the complexion was seen as the focal point of beauty, various lotions and creams (cold cream was still a favourite) were suggested by these authors to keep the skin soft and white; the author of *Beauty and how to keep it* recommended various kinds of cold cream but stated that in order to prevent

183 Berthe Morisot, *Woman Powdering her Face*, 1877. Musée d'Orsay, Paris

In contrast, some writers considered cosmetics an art and revelled in its theatricality and artifice, as well as delighting in inventing names for beauty products. At times they inhabited the role of fashion and beauty journalists: the poet Stéphane Mallarmé, for example, edited the magazine *La Dernière Mode* in 1874; he seems to have written every word himself, under various pseudonyms, and as 'Miss Satin' he became a beauty expert; in the number for 20 December Miss Satin extolled the virtues of complexion creams, such as *Lait d'Hébé* (Hebe's Milk), 'which might well be the nectar which that goddess poured on Olympus; for the bottle containing the marvellous liquid has within it strength and suppleness'. Miss Satin continued: 'To those of you, dear Ladies, who would not be attracted by a mythological label, I propose *Opoponax*, *Exora*, *Ylang-Ylang*, or *Nard Celtique*: strange but delicious fragrances which, when once breathed, send the mind dreaming, as does the mere pronouncing of their names.'[82] It is difficult to know what to make of *La Dernière Mode*, to know if it was intended to be a serious fashion journal or a parody of one, or even meant as a long prose poem. Mallarmé is a mystifying and original poet; some ten years after *La Dernière Mode*, he wrote a long poem called *Prose pour des Esseintes* (des Esseintes is the 'aesthete-hero' of Huysmans's *A Rebours*), which, defying 'countless efforts of explication [has] a mysteriousness still quite intact which is actually its principal beauty'.[83] From 1887 to 1889 Oscar Wilde edited the journal *The Woman's World*; it is not clear how much writing he did but some of the descriptions of cosmetics have a poetic touch which might signal at least a peripheral influence. In September 1888, for example, it reported that 'in the present day a woman of the world enhances her charms not only with clothes, but with washes and pigments . . . Crême Simon, and powder made of Russian or San Rémo violets. Her cheeks blush with rouge made only of Provence roses, and her rosy lips owe their colour to Baume de Thé; while a cleverly applied pencil renders her eyebrows shapely, and "puts fire in each eye"'.[84]

It was the Wildean 'woman of the world' whom Beerbohm celebrated in his famous *Defence of Cosmetics* (1894), and occasionally in Wildean quips – 'the use of pigments is becoming general, and most women are not so young as they are painted'. Beerbohm's view was that a woman's face should be judged on purely aesthetic grounds rather than as a 'vulgar index of character': 'We shall gaze at a woman merely because she is beautiful, not stare into her face anxiously, as into the face of a barometer'. More seriously (or perhaps, less tongue-in-cheek), he saw make-up as a way to empower women: 'artifice is the strength of the world, and in that same mask of paint and powder, shadowed with vermeil tinct and most trimly pencilled, is woman's strength'. By the end of the century, there was far less censure attached to wearing make-up, provided it was not used to excess but in a nuanced way as an art form; 'no longer are many faces set against . . . the love for cosmetics. No longer is a lady of fashion blamed if, to escape the outrageous persecution of time, she fly for sanctuary to the toilet table'. In what

also suggested that they adopt 'quaintness of action and garb', by which she meant that a more natural deportment could be achieved by replacing complicated body-deforming high fashion with 'artistic', historically inspired clothes in the 'prae-Raphaelite style'.[78] Her comments, although operational only within a relatively small and mainly metropolitan group of women moving in artistic circles, nevertheless opened doors to the idea that dress and beauty need no longer be totally dictated by fashion, and that other possibilities were available.

Beauty culture

From Haweis's *Art of Beauty* of 1878 to the end of the century with Beerbohm's *Defence of Cosmetics* (1896) and beyond, the culture of beauty was as much, if not more, to do with cosmetics as with abstract ideas based on harmony and proportions. This is not to say that critics no longer attempted to define beauty; according to the American Henry Finck (1887), the positive tests for beauty were 'symmetry, curvature, gradation, smoothness, delicacy, colour, lustre, expression', and the last was the most important – which is why, he claimed, the portrait painter was superior to the photographer, who could create only a transient image and a fixed form.[79] Many female writers, even while – like Haweis – paying lip service to a more abstract ideal of beauty, as in the past, nevertheless promoted the practical application of beauty towards empowering women. In an era when women were beginning to enter higher education, to break into the professions and to agitate for the vote, cosmetics could be seen as an aid to female visibility and self-confidence, as well as to social success. It was acknowledged that women were morally superior to men, but it did not follow that social reformers and early feminists had to abdicate from an interest in dress and cosmetics (this did not happen until the second half of the twentieth century). The *Art of Beauty* noted that the 'culture of beauty is everywhere a legitimate art . . . the natural right of every woman'; after all, the face is exposed, 'and it does demand at least as much attention as the rest of the person'. A woman wishing to look her best was 'another name for self-respect' and using cosmetics was not only no worse than 'padding the dress, piercing the ears, or replacing a lost tooth', but a duty if she had 'a complexion so bad that the sight of it gives one a turn'.[80] In *Beauty and how to keep it*, by 'A Professional Beauty' (1889), one reads that 'no woman has a right to be ugly, and ought to do everything in reason to make herself beautiful'; again, from Ellen Browning's *Beauty Culture* (1898): 'It is every woman's duty, in my opinion, to be as beautiful as she can, for as long as she can.'[81] Thus, dress reformer, woman of fashion and writer on beauty were all united in believing in the importance of cosmetics as an imperative both for the wearer and for society in general; cosmetics were seen as essentially worthy, and beauty as a component of self-expression rather than as an intrinsic quality.

181 George du Maurier, illustration to *A Legend of Camelot*, Part 1, *Punch*, 3 March, 1866

182 George du Maurier, illustration to *A Legend of Camelot*, Part 3, *Punch*, 17 March, 1866.

Punch in 1866. The heroine Braunighrindas, wearing nothing but a shift and warmed only by 'the red heat of her blazing hair', which she 'shook . . . about her form / In waves of colour bright and warm', leaves her tower in search of a quest; the first scene shows her wandering in the high street to the amazement and ridicule of passers-by (fig. 181). She meets Sir Galahad and Sir Lancelot walking hand in hand and the latter gets a weaver to make her hair into a 'wind and waterproof' garment. This forms the third scene (fig. 182) where Braunighrindas, on the right, encounters a 'stately maid/ Like her in radiant locks arrayed'; both women sink in a stream on their way to Camelot and their 'red-gold' hair is cut off by a Jewish old-clothes merchant who knows he can get a high price for it, so fashionable has it become. His comments on the appearance of the two maidens would strike a chord among the majority of *Punch*'s readers: 'How much their upper lipsh do pout! / How very much their chins shtick out! / How dreadful shtrange they shtare! they seem / Half to be dead, and half to dream!'; du Maurier may suggest here the use of belladonna which dilates the pupil and 'gives the eye a very singular staring look'.[74] In the final part of *A Legend of Camelot* du Maurier underlines the almost narcoleptic appearance of the Pre-Raphaelite models and those adopting their style:

> They speak not, but their weary eyes
> And wan white eyelids droop and rise
> > 𝕺 miserie !
> With dim dead gaze of mystic woe!
> They always take their pleasure so
> > 𝕺 miserie !
> In Camelot[75]

The work of the Pre-Raphaelite artists made critics re-think beauty. Symonds, dismissing the conventional ideas of beauty in much contemporary art as insipid, and equally caustic about Pre-Raphaelite artists' 'ugly contours, disproportioned figures, and ill-assorted colours', nevertheless declared that they painted 'faces which express life, passion and sentiment – though devoid of all beauty of configuration'.[76] In this new mindset, even the ugly could be beautiful; 'beauty may be strange, quaint, terrible, may play with pain as with pleasure, handle a horror till she leave it a delight'[77] – Swinburne's words anticipate the credo of *fin-de-siècle* decadence in art and literature. Eliza Ann Haweis noted in her *Art of Beauty* how the Pre-Raphaelite artists 'have made certain types of face and figure, once literally hated, actually the fashion'; they have shown that 'ugly faces . . . have a certain crooked beauty of their own'. She informed her readers: 'A pallid face with a protruding upper lip is highly esteemed. Green eyes, a squint, square eyebrows, whitey-brown complexions are not left out in the cold. In fact, the pink-cheeked dolls are nowhere, they are said to have "no character" . . . Now is the time for plain women'. This rallying cry for women without conventional beauty

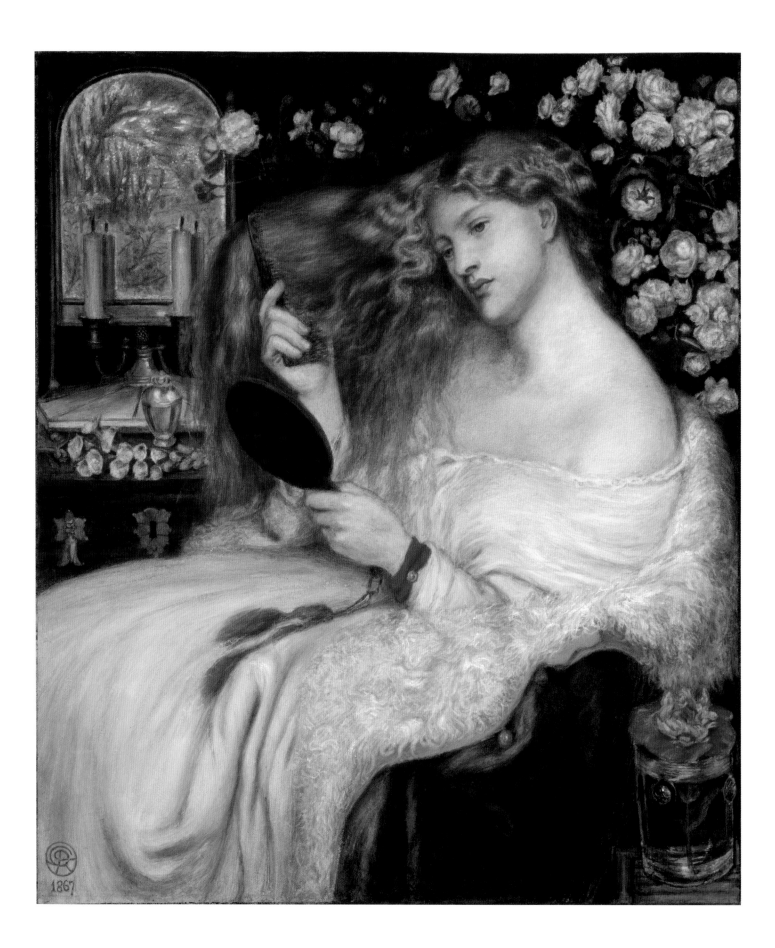

exemplifies the type with her large eyes, 'moonwhite' skin (the word is used in Thomas Woolner's poem *My Beautiful Lady* of 1863) and her flaming hair. Alexa Wilding, the model for *Monna Vanna* (the title, 'Vain Woman', comes from Dante's *Vita Nuova*), paradoxically wears a costume (described by the artist as 'Venetian') of white silk brocaded in gold, of the time of Raphael, not before or 'Pre-Raphaelite'. By the 1860s, some Pre-Raphaelite artists had begun to turn to the Renaissance for inspiration and to Raphael himself. Elizabeth Prettejohn notes: 'In the art theories of the European academies, Raphael's painting was valued above all, for having achieved the perfection of beauty, the goal and rationale of art itself'.[68] Although it was claimed by several critics that Pre-Raphaelite art rejected the very idea of beauty, Prettejohn comments that from the 1860s, notions of 'beauty' played an increasingly important part in art and life, perhaps as a way of countering 'the ugliness and squalor of Victorian industrial capitalism'.[69] In some Pre-Raphaelite art, beauty manifested itself in increasingly sumptuous and opulent 'Renaissance' costume, and the models' faces were strikingly painted (either by cosmetics or the artists' brush) to complete the *tout ensemble*.[70] A fellow member of the Pre-Raphaelite Brotherhood, Frederic George Stephens, in his monograph on Rossetti, remarked that *Monna Vanna* has 'something that is evanescent and fickle in her expression, a self-centred character revealed by every feature, lovely as these are . . . Her lips that have been often kissed are cherry-coloured, ripe and full, yet not warmed by inner passion, nor exalted by rapture of contemplation . . . still less are they chaste and untasted'.[71] Rossetti's *Lilith* (fig. 180), described by the artist as his 'Toilette picture', and modelled by Fanny Cornforth, has similar 'terrible, tender lips'; clothed in a loose white dress which reveals the slope of her shoulder, a dark green fur-lined gown cushioning her chair, she is a 'serene and sublime sorceress', absorbed in herself, her head 'superb and satiate with its own beauty'. These comments are from Swinburne's *Notes on the Royal Academy Exhibition* in 1868, where he describes the beauty of Rossetti's *Lilith*; the 'sleepy splendour of the picture is a fit raiment for the idea incarnate of faultless fleshly beauty and peril of pleasure unavoidable'. The frame of the painting (1868) is inscribed with a poem by Rossetti; Lilith, 'Adam's first wife . . . (The witch he loved before the gift of Eve)', whose 'enchanted hair was the first gold', sits still, 'young while the earth is old', and 'Draws men to watch the bright net she can weave, / Till heart and body and life are in its hold'.[72] Swinburne describes how she 'draws out through a comb the heavy mass of hair like thick spun gold to fullest length',[73] for long hair had a special resonance for those in the Pre-Raphaelite circle; in an age when women's hair was bound up on the head, long and untamed hair represented sexual freedom.

This is the focal point for du Maurier's spoof-medieval *A Legend of Camelot*, a parody of Pre-Raphaelite art and its love of Arthurian myth (after every two lines there is the refrain 'O Miserie!' in Gothic script), which was published in

180 (*facing page*) Dante Gabriel Rossetti, *Lilith*, 1867.
The Metropolitan Museum of Art, New York, Rogers Fund, 1908

Facing Beauty

reigns over the bow'rs, /So does thy beauty over the heart') is squeezed into a fashionably tight-waisted dress which emphasises her bust and hips; the rose was regarded as especially English ('Maid of Albion, sweetest of flow'rs') and also feminine in scent and colour. The mention in *How to preserve good looks* of 'full red lips' ('those terrible red lips', said the poet Swinburne in admiration) relates to one of the characteristic features of the unconventional kind of beauty seen in paintings by the Pre-Raphaelite artists, notably by Dante Gabriel Rossetti, whom Swinburne particularly admired as the painter of 'types of sensual beauty and spiritual, the siren and the sibyl'.[67] Rossetti's *Monna Vanna*, of 1866 (fig. 179),

Notions of beauty from the middle of the century began to widen out; 'you
will be sadly puzzled as to the relative merits of blue eyes and black, brown and
hazel; hair of golden hue and raven blackness, of classic coils and coquettish
breeze-loved ringlets; of rose-bud mouths and full red lips', stated the author of
How to preserve good looks in 1871, declaring the impossibility of getting any
agreement on what constituted beauty.[66] The reference to the ringlets and the
rose-bud mouth is to the kind of decorative packaged femininity seen in
contemporary beauty books, such as *Rimmel's Almanack* for 1863 (fig. 178), where
the figure for the month of June, the personification of the rose ('As the rose

Facing Beauty

portrait of his young bride (she was sixteen and he was thirty years older; the marriage lasted less than a year) shows Terry caught between the bright lights of the theatre (the red camellias) and conventional married domesticity (the humbler but sweet-smelling violets she holds in her left hand); she chose the former, as the portrait foretells. Watts chose to paint his wife in her wedding dress, which was not the white demanded by Victorian convention but a coloured silk with bands of black velvet, designed by Holman Hunt and inspired by Italian Renaissance costume. It was, therefore, both a portrait and an allegory of the choices people have had to make over the centuries, a timeless dilemma underlined here by the 'historic' dress she wears; even Terry's hair-style makes her look like a young Renaissance page. Suitably for a woman who moved in aesthetic circles, she was an actress of the senses rather than the intellect; to her friend the gentleman artist and theatre designer Walford Graham Robertson, she was 'the Painter's Actress (who) appealed to the eye before the ear; her gesture and pose were eloquence itself . . . She had learnt to create Beauty, not the strange beauty of whitewash and lip salve, but the painter's beauty of line, harmony and rhythm'.[65] The slightly pointed nose and strong chin that gave Terry beauty of character as well as face can also be seen in the photograph by Julia Margaret Cameron (fig. 177) probably taken when on honeymoon in the Isle of Wight; Terry, in her shift and with her hair down, has a slightly melancholy beauty. Is she acting out such a pose, or is the sadness of discovering the mistake of her marriage genuine?

177 Julia Margaret Cameron, *Ellen Terry at Age Sixteen*, 1864. The J. Paul Getty Museum, Los Angeles

[were] a combination of loveliness';[64] Scott's dark heroine is the first of the great Jewish beauties who feature in the century's literature and on the stage.

The theatre provided many of the famous beauties of the mid-nineteenth century and later; among them was Ellen Terry, from an acting family, who married the artist George Frederic Watts in 1864. His *Choosing* (fig. 176), the

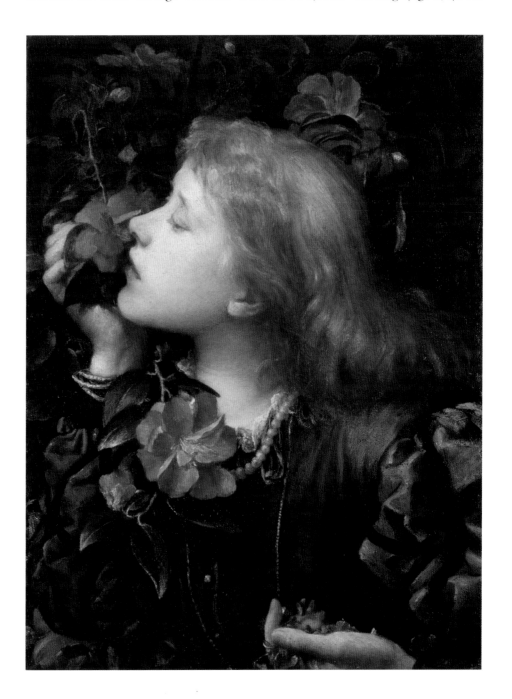

176 George Frederic Watts,
Choosing (Ellen Terry), 1864.
National Portrait Gallery, London

Facing Beauty

a blonde with the colouring of a brunette, and a rosy, sparkling smile. She will have a rather wide bottom lip, eyes that are limpid pools, a small rounded bosom, thin wrists, long dimpled hands, and she will sway when she walks like a snake walking on its tail . . . the kind of fine, firm beauty which is both strong and elegant, real and poetic at the same time. A Giorgione painted in the manner of Rubens . . .

Gautier is equally precise about what she will wear, a dress of scarlet or black velvet slashed with white satin or silver brocade, a Medici ruff and a 'saucy felt hat' with white feathers, *à la Rubens*;[61] his preference (in spite of the real Mlle Maupin's dates, 1670–1707) is for the 1620s and 1630s, the period of Rubens, whose portraits of women (see fig. 27) celebrate lavish rounded forms in beauty, figure and dress; this Baroque aesthetic was certainly in tune with Gautier's own tastes and those of his time. Leigh Hunt, for example, wondered why contemporary artists could not depict beauty like the Old Masters: 'The reds and whites look as if we could eat them. Look at that pearly tip at the end of the ear. The very shade of it has a glow. What a light on the forehead! What a moisture on the lip! What a soul, twenty fathom deep, in the eyes!'[62]

One of the cultural tenets of the nineteenth century, from Romanticism onwards, was a harking back to the past for literary and artistic inspiration. This can be seen as a reaction against the unsettling changes in society caused by the new industrial age which often resulted in scarred landscapes, brutal urbanisation and the disappearance of many traditional ways of life. Nancy Minty in *The Victorian Cult of Beauty* notes the Victorians' 'fear of losing their aesthetic sensibility', and how this explained their belief that certain historic periods were 'deemed nobler and more beautiful' than their own age.[63] The feeling that somehow there is more nobility and beauty in the past is, of course, the reason for the success of historical novels which first appeared as a popular and commercial genre with Sir Walter Scott's works early in the century, such as *Ivanhoe* (1819). This novel, although set at the end of the twelfth century, mixes various historical periods with the exotic, all coloured by contemporary aesthetics. Scott excused his lack of 'complete accuracy' by stating that he was writing fiction – the title, after all, is *Ivanhoe: A Romance*. The novel's two heroines personalise the contrast between the conventional Anglo-Saxon conception of beauty (the 'exquisitely fair' Saxon princess Rowena, whose hairstyle is akin to the fashionable style of Scott's day) and that of the exotic other, the dark Jewish beauty Rebecca. Rebecca is described as wearing 'a sort of Eastern dress' and a yellow silk turban, which 'suited well with the darkness of her complexion. The brilliancy of her eyes, the superb arch of her eyebrows, her well-formed aquiline nose, her teeth as white as pearl, and the profusion of her sable tresses, which . . . fell down upon . . . a lovely neck and bosom . . .

Art for Art's Sake

> You can never tell how beautiful (or how ugly) a face may be till you have tried to draw it.
>
> George du Maurier, *Trilby*, 1895[57]

> For behold! The Victorian era comes to an end and the day of sancta simplicitas is quite ended . . . we are ripe for a new epoch of artifice.
>
> Max Beerbohm, *A Defence of Cosmetics*, 1894[58]

In the period from the 1870s to the early years of the twentieth century, ideas of beauty (and of plainness) both in art and in women's faces were subject to a variety of interpretations. Théophile Gautier was the earliest and most forceful proponent of the idea of art for art's sake, that art no longer needed to have morally or spiritually uplifting content; on women's beauty (which, like Baudelaire, he regarded as a kind of art), he remarked, 'I have never asked anything from women except beauty. I can very well make do without intelligence and soul. A woman with beauty is always intelligent as far as I am concerned. She has the intelligence to be beautiful and I do not know any equal to that.'[59] Thus, in terms of art and beauty, form was privileged over content, and this was the message passed on to such disciples of the concept of art for art's sake as Walter Pater. For Pater, beauty was no longer a generic abstract but linked to the individual critic's 'power of being deeply moved by the presence of beautiful objects', to search for 'pleasurable sensations, each of a more or less peculiar and unique kind'[60] – an idea taken to sensual excess in Joris Karl Huysmans's *A Rebours* (1884). Oscar Wilde was perhaps the most famous disciple of Gautier (he described him as 'artiste en poésie'), especially with regard to the uselessness of beauty; this is most famously expressed in *The Picture of Dorian Gray* (1891) where beauty is described as 'a form of Genius . . . higher, indeed, than Genius, as it needs no explanation. It is one of the great facts of the world, like sunlight, or spring-time, or the reflection in dark waters of that silver shell we call the moon'.

Gautier's *Mademoiselle de Maupin* is a novel that focuses on gender confusion (Madeleine de Maupin was the bisexual daughter of one of Louis XIV's courtiers), desire and sexuality; it is also about the importance of beauty for beauty's sake, a celebration of the physical. The hero, the Chevalier d'Albert, dreams of his ideal mistress in precise terms of her appearance: she must be 'plump rather than thin. I am rather Turkish in this respect. I should not care to encounter a bone where I was expecting to find a softly rounded curve. A woman's skin must be well padded, the flesh firm and hard like that of an unripe peach' (Canova's *Pauline Borghese* (see fig. 6) is mentioned later in the novel). She is to be

greatest restorer and preserver in the world of female grace and loveliness'. Her book, entitled, inevitably, *Beautiful for Ever!* (1863) – described in *The Times*'s report of her trial in 1868, as 'an extraordinary literary performance' – listed her beauty preparations, which she contended were 'composed of the purest, rarest and most fragrant productions of Arabia, Syria, Sahara, Central India, China and Japan, collected and imported regardless of expense'. One of her more infamous recipes was 'Magnetic Rock Dew Water of Sahara' (actually water and bran), which supposedly increased the 'vital energies' and gave 'the appearance of youth to persons of considerable antiquity';[55] interestingly, like today's advertisements for beauty creams, the word 'appearance' is used, suggesting the impermanence of the product. No stranger to controversy and lawsuits, Leverson featured unflatteringly in newspapers and journals during the 1860s, most notably in 1868, when she was tried for blackmail. A cartoon in *The Censor* (27 June 1868), 'Rachel – and her children!' (fig. 174), depicts the figures of Lust, Folly and Fashion standing before Madame Rachel (her Jewish features emphasised) at the reception counter, which is inscribed 'Beautiful for Ever'; an accompanying verse entitled 'La Sainte Rachel Raddle' states that 'She will whiten, and redden, and plump up your cheeks,/ And paint out the crowsfeet, and hide your grey streaks,/ Till a woman of sixty, so frisky and vain,/ Shall, when painted, persuade you she's forty again'. In 'A Stall at "Vanity Fair"' (fig. 175) from an unnamed journal of 29 July 1868, Madame Rachel offers such cosmetics as Bloom of Ninon (bloom is face powder, here named after Ninon de l'Enclos, a famous seventeenth-century French beauty and courtesan), pearl powder and rouge; a range of items such as 'Teeth', 'Skins', 'Lips', 'Eye Brows' and 'Eye-Lashes' are also available. On the right are tubs of plaster and paint, below three painted and patched masks, while all around women queue up for appointments; the related verse states that she promises paying clients the 'loveliness' they pray for, 'patches, paint . . . philtres, aromatic slushes'. 'If she finds you, in addition,/ Husbands, she will charge commission'; this is a reference to a client who paid vast sums for beauty treatments and for a titled husband.[56] For this Leverson was sent for trial, sentenced to penal servitude and, as the result of a later trial, died in prison in 1880; a not totally ignoble epitaph to her career was to have a shade of face powder, named after her ('rachel', a cream colour), still occasionally in use today.

❧ ❧ ❧

174 'Rachel – and her children!
Dedicated to the Old "Girls of the
Period"', *The Censor*, 27 June 1868.
Francis Gillham Collection, Victoria
and Albert Museum, London

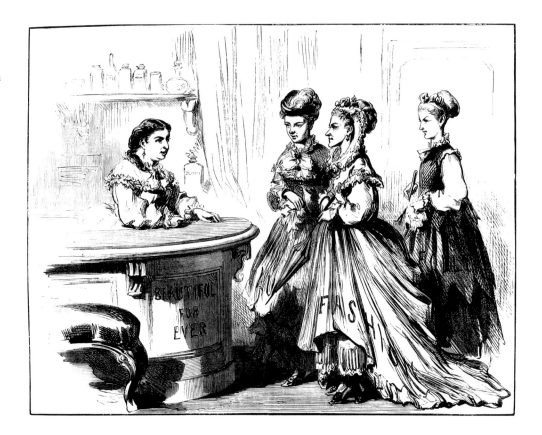

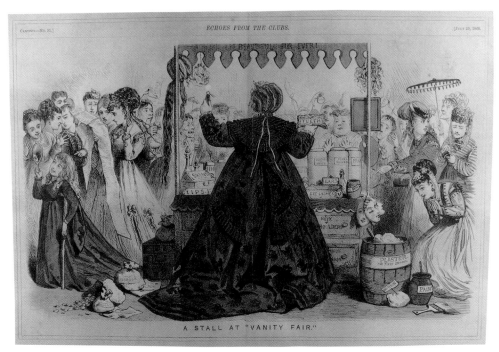

175 'A Stall at "Vanity Fair"',
anonymous cartoon, 29 July 1868.
Francis Gillham Collection, Victoria
and Albert Museum, London

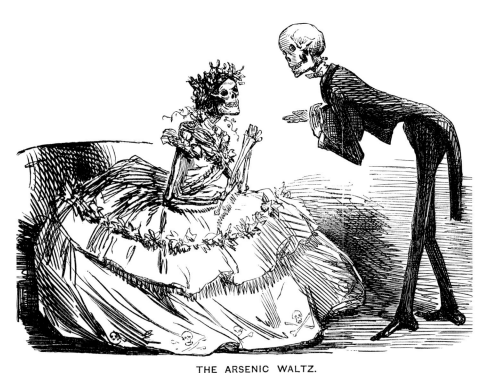

THE ARSENIC WALTZ.

THE NEW DANCE OF DEATH. (DEDICATED TO THE GREEN WREATH AND DRESS-MONGERS.)

wrinkles and marks on the skin were filled in with lead or arsenic paste, and then the face and neck were painted and powdered. The first references date from the 1770s and it became a popular beauty technique in the fashionable and stage world. Madame Rachel's own hyperbolic prose to promote enamelling – it removes 'every defect and blemish from the arms, neck and face, giving a brilliancy to the eyes, pearly whiteness to the teeth . . . natural colour to the lips, luxuriant flowing tresses', and confers 'the appearance of youth and beauty' – suggests some kind of skin treatment containing lead or arsenic.[53]

Rachel Leverson (her *curriculum vitae* included procuring – being literally a 'madam' – and blackmail) was perhaps the last of the great confidence tricksters who duped gullible women into buying completely spurious beauty treatments; in this respect, she was a 'descendant' of Giuseppe Balsamo (alias Alessandro Cagliostro), who in the 1770s promoted 'Count Alessandro's Beautifying Water, which claimed to smooth away all wrinkles, and rejuvenate faded faces'.[54] Leverson started selling cosmetics (her first husband was a chemist) late in the 1850s and in 1860 started a beauty salon in New Bond Street, with the legend above the door, 'Beautiful for Ever'; there she offered a wide range of expensive treatments and products, some of them named in honour of European royalty (such as the Empress Eugénie) who, she claimed, appreciated her skills 'as the

the Period' (1868), described a 'fast' woman as 'a creature who dyes her hair and paints her face';[48] a 'Canzonet on Cosmetics' in *Punch* (20 April 1867), a lament for lost beauty, itemises poisonous lotions for the skin and the 'dye of golden hue' (bleach) which caused the hair to fall out. Fair hair was revived as a popular colour in the 1860s, and when natural was linked with innocence; but when the hair was too obviously dyed, blonde hair assumed connotations of moral laxity and empty-headedness, features retained well into the twentieth century. That arbiter of middle-class manners and morals, *Punch*, carried on a crusade against painted women, both on health grounds and because they embodied deceit. One of the journal's targets was the use of arsenic, which was sometimes prescribed to improve the skin; Dr Robert Dick, in *The Connexion of Health and Beauty* (1857), noted that arsenic was used by pale and thin young women to become plumper and to gain 'glowing cheeks and sparkling eyes'.[49] As well as taken internally, arsenic was used externally in skin preparations; as late as 1899 Ella Fletcher gave a recipe for an 'arsenical cosmetic lotion . . . *Aqua Cypria* or *Eau de rose minerale*', urging her readers, however, not to drink it.[50] Arsenic was also incorporated into some dyes, such as 'Scheele's green' (invented in 1775) which – according to *Punch* (5 October 1861) – 'preserves its freshness and beauty under all trials of artificial light'; Scheele's green was widely used to dye cotton and linen, as well as artificial flowers. According to *Punch* (as above) a many-flounced evening dress of tarlatan (stiffened muslin) might contain as much as thirteen ounces of arsenic, which could leak out in sweat and be absorbed by the body. A cartoon in *Punch* (8 February 1862) entitled 'The Arsenic Waltz' (fig. 173) uses the traditional idea of the Dance of Death to make the point about the mortal peril of arsenic; fashionable men, too, were in danger by using the substance in skin and hair preparations, as well as internally. As for paint as deceit – another traditional topos – *Punch* (3 October 1863) spoke out against 'crinoline and cosmetics', posing the rhetorical question: 'who would care to marry a beautiful complexion if he knew it had been purchased in the Burlington Arcade . . . and how can one admire a snowy brow or swanlike neck when one believes it to be whitewashed, say, at six pence the square inch?'.[51] The reference to 'whitewash' may suggest concealment of the truth to preserve a perhaps spurious reputation, or it may be a specific allusion to the vogue for enamelling, by which, according to *Punch*, the beauty of 'painted Jezebels' was 'precisely matched by the loveliness of a whited sepulchre'. Quoting from an article in the *Morning Post* which reported that enamelling was very fashionable 'amongst the ladies of the *élite* who frequent fashionable and crowded assemblies, it being the only method ladies have of displaying their matchless beauty, and the only possessor in the world of that great art is Madame Rachel', *Punch* strongly disapproved of what it called a 'disgusting process'.[52] The word 'enamelling' was used both in the sense of thick white paint and more specifically a process whereby the

women never exaggerated their appearance, for 'elles ne ressemblent en rien aux dames du demi-monde'; courtesans were noted, he claimed, for their provocative scents ('parfums excitants'), their white and red paint and their eye make-up.[45] Bourgeau made his point by exaggerating, for not all women of the *demi-monde* appeared as vulgar and brash in their appearance as he suggested, and many were cultivated enough to mingle in high society; also, many respectable women could dress without taste. In any case, another argument suggested that with the unstoppable fashion force of haute couture available to all who could afford it, and high-quality cosmetic preparations widely on sale, who could tell the aristocrat from the courtesan? Thus with Paris as the fashion capital of the world, the luxury debate which had exercised the eighteenth century was revived during the Second Empire, with much discussion of how far fashion and cosmetics had penetrated beyond the upper echelons of society and if, or how far, it threatened the hierarchy of class. As with the eighteenth-century *Encyclopédie*, which came down in support of luxury as essential to the French economy, a similar conclusion was reached in the works of such critics as Ernest Feydeau, whose *Du Luxe des femmes* (1866) argued for the civilising influence of luxury, which – in moderation – was democratic because aspirational among most classes.

What is difficult to ascertain at this point in the nineteenth century is the extent to which dangerous lead-based or other metallic paints were in use; French physicians increasingly attacked face paints, not on moral grounds but on considerations of health, and they may have overstated their case by exaggerating the number of women who wore toxic make-up. Constantin James, for example, in 1865 suggested that contemporary cosmetics were more injurious than those of ancient Rome, that Virgin's Milk was still sometimes made with lead, as were some kinds of *blancs d'argent*, and that not only was vermilion used in rouge but also in rose soaps; so-called rice powder, he claimed, was not made of rice but of magnesium or chalk, and real rice powder required ceruse to make it more stable and to adhere to the skin.[46] In order to make women more aware of the poisonous nature of some of their paints, an article under the title of 'Les Cosmétiques' was published in the fashion magazine *La Mode Illustrée* in January 1865, reprinted from the *Moniteur* (the official French government newspaper) of 15 November 1864. One of the main points made in this article was the way in which face paints were given unthreatening names in order to entice women to buy them, such as 'blanc d'argent, de perle, de Vénus'; what could sound as attractive as 'silver white', 'pearl white' and 'Venus white'? Yet these names covered the harmful reality that they were made of metallic substances; even the black paint women used on their eyelids, and the blue on their veins, was made of lead.[47]

In England also, a painted woman was defined as no better than she should be; Eliza Lynn Linton in a famous series of anti-feminist essays on the 'Girl of

Pour Rire, one illustration (fig. 172) shows an overly made-up woman, with a large chignon and black beauty spots (another eighteenth-century fashion revived) in a box at the theatre. Two men in the background assess her, the 'possessor' of the woman asking his friend what he thinks of 'my little woman', to which the reply is: 'Well, I don't know, I'm not a connoisseur of painting'. Conduct manuals, like T. Bourgeau's *Les Usages du monde* (1864), stated that elite

really to be the most tasteful method of dressing the hair'.[39] Skill was needed to cope with complex hair-styles, especially formal *coiffures*, to curl, to dress the hair and to powder it (an eighteenth-century fashion revived for evening in the 1860s). Isabella Beeton's famous *Book of Household Management* (much more than a cookery book) details the duties of a ladies' maid who had to be 'a tolerably expert milliner and dressmaker', to have 'some chemical knowledge of the cosmetics with which the toilet table is supplied'; most importantly, she needed to 'be a good hairdresser . . . as the fashion and mode of dressing the hair is so continually changing'.[40] By the end of the 1850s, 950 hairdressers were listed in London, along with 27 wig makers and 17 hair manufacturers, and between 150,000 and 200,000 pounds of hair, valued at nearly a million dollars, were imported into the US.[41] Hair was big business, the trade monopolised by the French, with Paris 'Hair Merchants' who 'harvested' hair mainly from France, Germany and Spain, which was then treated and sold in the major capitals of Europe and in New York.[42] This hair was used remedially to counter the harmful effects of being what one writer calls 'twisted, frizzled, dyed, curled, greased, powdered, or otherwise tortured to please the styles of the day'[43] but also to provide the fashionable large chignons which were all the rage from the mid-1860s. No other style, perhaps because the artifice was so obvious, attracted as much comment in the period; the novelist Anthony Trollope in *He Knew He Was Right* (1869) used phrases like 'excrescence', 'monstrous', 'absurd', 'abominable' about the chignon, which was worn by his unsympathetic characters and not, of course, by his heroines. *Punch* (12 January 1866) suggested that as the style was so popular, women might dye their chignons to match their clothes and complexions ('a different chignon and a different complexion at different times of day'). Under the title 'The Chignon Question', the middle-class *Englishwoman's Domestic Magazine* (1867) urged its readers to beware of buying unclean hair which might contain 'minute insect life of a disgusting nature'.[44] Compared, however, to the savagery of eighteenth-century satire on false hair, this was fairly gentle; adding what Trollope called 'the supplemental mass behind', was so palpable that there was no real intent to deceive, unlike dyed hair which did mislead and suggested a woman of doubtful morals. George Cruikshank's drawing entitled *The Chignon* of 1870 (fig. 171) shows a small figure of Cupid perched on the chignon, attracting lovers, a suggestion of the love interest the wearer hopes for; the accompanying verse describes the chignon as 'a sort of cupid's nest', and 'it seems to be the Ladies delight,/ To keep him firing away, from morn till night'.

By this time, cosmetics had come to be largely accepted provided they were used in moderation; a woman who laid them on to excess was regarded as an inhabitant of the *demi-monde*, or – lower down the class structure – a woman of easy virtue. Among the 'Croquis Parisiens' by Alfred Grévin for the *Petit Journal*

beauty manuals indicate. In *Toilet Table Talk* (1856), published by a London chemist, women were advised to wash their hair in tepid soft water with alkaline soap, and when it was dry 'a little marrow pomatum, bear's grease, or fragrant oil, should be sparingly used'; two brushes were needed (one a 'polishing brush') and they were dipped in eau-de-cologne before being used. As for hair-styles, 'curls and ringlets generally harmonize with the female face, and seem

The Chignon.

The Chignon is a sort of Cupid's nest,
But where the little fellow has little rest,
For it seems to be, the Ladies delight,
To keep him firing away from Mor. till night
But the brave Chaps who are hit, Know 'tis their lot,
And if the truth must be told, they like to be shot.

J. Ck. 1870.

171 George Cruikshank, *The Chignon*, 1870. Courtauld Gallery, London

Facing Beauty

and it was only let down in the bedroom or boudoir, so seeing the hair unbound was a sign of abandonment, a sexual signal; only in the nineteenth century are there so many images of women with their hair loosened, for long hair was thought to be synonymous with femininity and had an erotic charge. Gustave Courbet's *Portrait of Jo* (*La Belle Irlandaise*) of 1866 (fig. 170) shows James McNeill Whistler's beautiful Irish mistress, Jo Hiffernan, looking in a hand mirror, her right hand enlaced in her auburn curls. Swinburne's poem 'Before the Mirror' (from his *Poems and Ballads*, 1866), apropos Whistler's 1864 portrait of Hiffernan, *Symphony in White, No. 2: The Little White Girl* (Tate Britain), begins with the lines 'I watch my face, and wonder/ At my bright hair', which are more appropriate for Courbet's portait; Hiffernan's delicate beauty as represented by Whistler is lacking in Courbet's earthier image.

'Without a fine head of hair no woman can be truly beautiful' was the diktat of Lola Montez[38] (and countless other writers on beauty) but long hair was difficult to keep clean, especially before the advent of shampoos (not in general use until mid-century); so hair was often cleaned with bran powder rather than wet washing. Cleansing the hair was a complex and time-consuming business, as

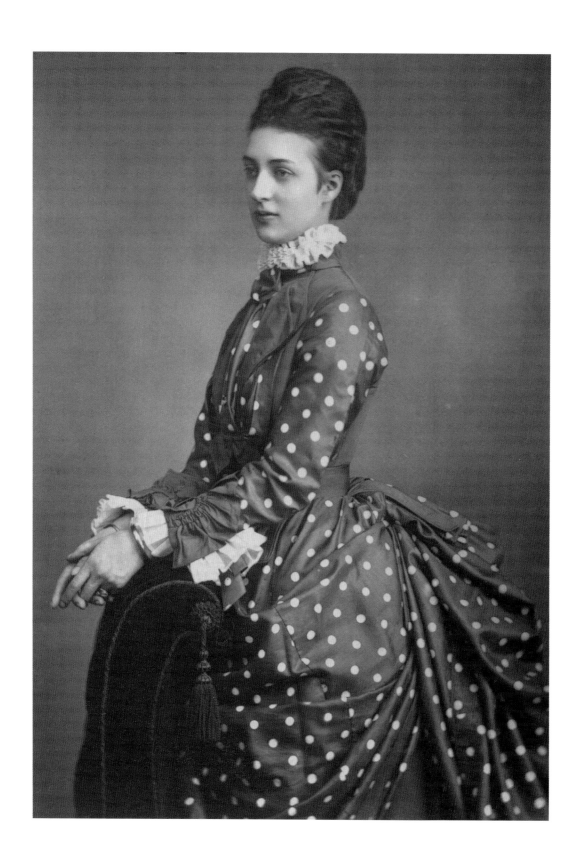

Moulton referred to as the 'Venetian type', that is, as in paintings by Titian) is arranged *à l'impératrice*, with a central parting and gathered in at the nape of the neck. As well as hair-styles named after her, and fashions as well (Florence Nightingale scornfully called her 'the Empress who was born to be a dress-maker'), Eugénie's make-up was also imitated, for her beauty was widely acknowledged by those who met her, especially in comparison with Pauline Metternich, who, according to Moulton, was not handsome. Carette claimed that her mouth was 'too extended' and her lips 'too pronounced', but that she 'dresses better than any woman in Paris, and has more *chic*';[35] to the modern viewer, the liveliness and presence of Metternich in her portrait by Winterhalter (see fig. 22) appeals more. Social beauty, of the kind seen in society portraiture, was often regarded as little more than fashionability; this was the critic Henri Delaborde's view apropos portraits of the Empress in his remarks on the Salon of 1853, a problem he attributed to a too faithful depiction of reality.[36] Yet this – with a dash of flattery, not too grovelling – was what society artists like Winterhalter were commissioned to depict; sadly, there is no image of Eugénie by one of Winterhalter's great French Impressionist contemporaries.

Of the three royal beauties, Princess Alexandra was – to use a contemporary term – the least 'showy'; coming from the small and modest Danish court, she arrived in England in 1863 as a bride for the wayward Prince of Wales, to find Queen Victoria in mourning for her husband and a court not renowned for stylishness or elegance even while the Prince Consort was alive. However, she had a sense of style (she became the first member of the British royal family to have fashions named after her or in her honour) and the camera loved her, as can be seen in the photograph (fig. 168) where she poses in a day dress of spotted silk, her hands on the back of a velvet chair. Undoubtedly beautiful and charming, there is a slight irregularity in her nose (not being completely straight), which only serves to give character and what writers on beauty would call 'expression' to her face. Like many beauties, Alexandra was able to turn minor disadvantages in appearance to good use; she had a scar on her neck which she covered by wearing various forms of stylish neckwear, such as the ruff seen here, and the wide 'choker' necklace which was popular from the 1880s into the Edwardian period. In terms of the fashionable female silhouette, the line of the 1870s was slender and elongated, with hair-styles much higher and more complicated than had previously been seen; the Princess of Wales has her hair built up over a pad to give the fashionable extra height to her figure.

Hair seems to have had a kind of fetish attraction for the nineteenth century (see fig. 180); a beauty manual declared in 1839: 'It is the Hair that adds the principal feature to a beautiful female – it is the luxuriant tresses that frequently arrest the attention and excite the admiration of the opposite sex'.[37] Women after adolescence had their hair pinned up (it was a rite of passage to put the hair up)

168 (*facing page*) *Princess Alexandra*, from a carte-de-visite of 1873, Maull & Co. National Portrait Gallery, London

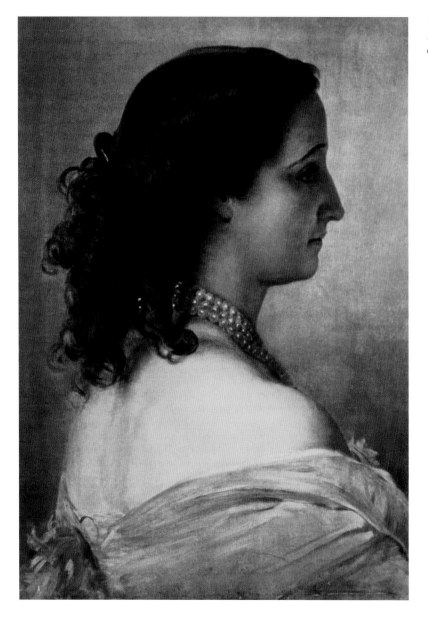

167 Franz Xaver Winterhalter, *Empress Eugénie, c.*1855. Arenenberg Collection, Switzerland

tion of her countenance, the best was one by Winterhalter where Eugénie is depicted in a 'white burnous, with pearls on her neck, and her hair carelessly curled behind'.[34] This is the portrait of 1855 (fig. 167), where the white burnous (a fashionable mantle, north African in origin) is pushed down to reveal the elegant line of her shoulders and back; her face is expertly made up, the eyebrows pencilled in, eyelashes darkened and a thin line of black paint (probably kohl) drawn along the edge of the upper eyelid. Eugénie's auburn hair (what

166 (*facing page*) Franz Xaver Winterhalter, *Empress Elizabeth of Austria*, 1865. Kunsthistorisches-museum, Vienna

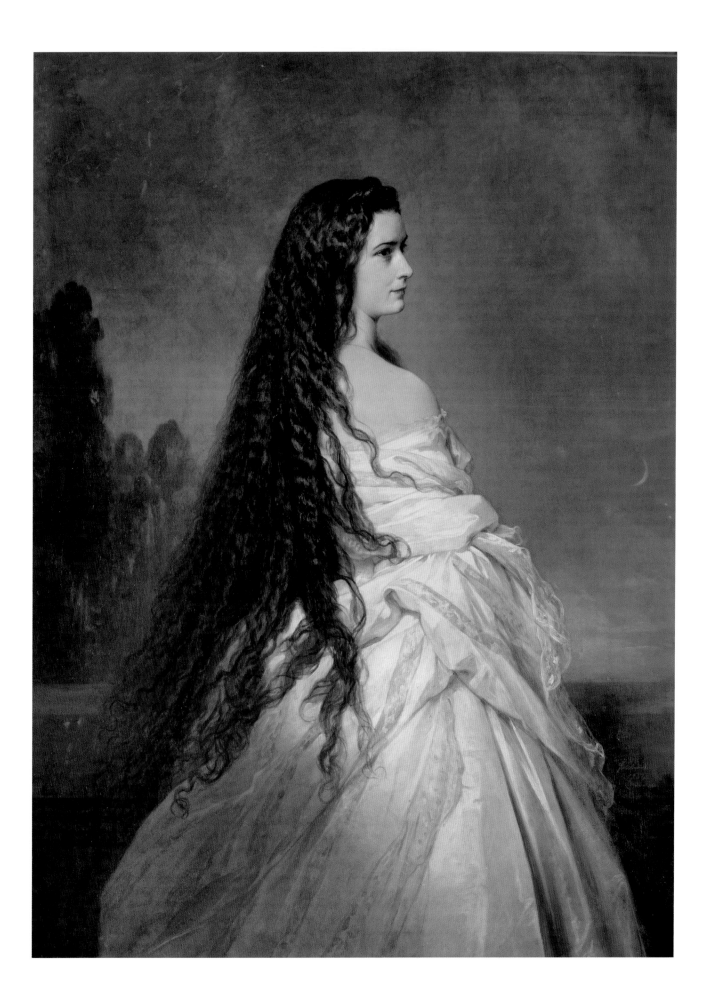

but only the beautiful, and therefore cannot lie. Baudelaire's idea of a beauty was a woman who knows how to dress, a kind of idol, perhaps stupid, but dazzling, enchanting, and her appearance was completed by a face finished and created by art.[30] Far less known is Gautier's short essay entitled *De la mode* (1858): 'Just as clever painters establish a harmony between flesh and drapery in their portraits, by applying light glazes to the canvas, so fashionable women whiten their skin, which would otherwise look too brownish when set beside the silks and laces of their costume'. Thus, women become like sculpture and the whiteness of the powder they wear on the face (and on the neck, bust and arms, with an evening toilette) softens the nudity of the skin by removing from it the warm, provocative colours of life; the black lines which lengthen the eyelids and the pencilling of the eyebrows are like the culminating touches of genius with which great artists complete their masterpieces.[31] What today we call eyeliner was described by the author of *How to preserve good looks* as an essential aid to beauty, 'laying a streak of some dark cosmetic along the edge of the eyelid, a very old Oriental custom [which] . . . has the effect of making the eyes appear larger and more brilliant than they actually are'.[32]

Many female 'masterpieces' in the middle decades of the nineteenth century took advantage of the greater number of cosmetics available from the firms specialising in beauty products. Guerlain in Paris (founded in 1828) was patronised by the Empress Eugénie and the Empress Elizabeth of Austria, whose favourite skin cream was their 'crème à la fraise pour le teint' (a more practical way of using strawberries than the use of the real fruit given in *Abdeker* in the previous century); Rimmel in London (1820) was 'Perfumer by Appointment' to Princess Alexandra, who also used Pears soap. The beauty of these three royal women, enhanced by their skill in wearing cosmetics, was a constant point of reference in fashion journals, recorded in contemporary memoirs and celebrated in art, most notably by Winterhalter, who conferred glamour on his sitters like a great Hollywood photographer. Of the three beauties, the most beautiful was the Empress Elizabeth, for her slim figure (created by a diet of oranges and veal juice), perfect features and lustrous hair; Winterhalter depicted her in a number of portraits – in a white and silver ball dress by Worth, her hair studded with diamond stars (Hofburg, Vienna), and in a white *robe de chambre*, with her hair streaming down over her back (fig. 166). The Empress Eugénie, according to the rather breathless prose of an American banker's wife, Lillie Moulton, who became her friend, was 'the most exquisite creature . . . Her smile is bewitching beyond description; her complexion perfect; her hair is of the Venetian type, and her profile classical. Her head is so beautifully put on her shoulders; her neck and shoulders are absolutely faultless. None of the many portraits of her, not even Winterhalter's, do her the least justice'.[33] In fact, Madame Carette, the 'second Reader' to the Empress, said that although portraits did not capture the anima-

165 (*facing page*) Josef Stieler (after), *Lola Montez*, 1847. Schloss Nymphenburg, Munich

From the 1850s, a growing number of beauty books were published, many of them as plagiaristic as in earlier centuries and sometimes 'written' by celebrities. The courtesan and dancer Lola Montez stated that the recipes she published in *The Arts of Beauty* (1858) were given to her 'by celebrated beauties who used them themselves' but there is no proof of this, and earlier beauty and conduct manuals were mined for her book, notably the American Anne Smith's *Etiquette for Ladies*, easily available to Montez when she was in the United States late in the 1850s. Born Eliza Gilbert, Lola Montez (the name she gave herself as a 'Spanish dancer' in London) had a delicate complexion, blue eyes and black hair, a type of Irish beauty sympathetic to the aesthetic ideals of the 1840s, as can be seen in her portrait by Stieler (fig. 165), painted when she was the mistress of King Ludwig of Bavaria. The portrait seems to embody both beauty and gentility, the personification of her words in *The Arts of Beauty* that a woman had to be cultivated and refined: 'without the sweetness of a happy mind, not all the mysteries of art can ever make her face beautiful'. Yet, the 'mysteries of art' were revealed in her book which contains various skin-beautifying ideas (from Paris, thin slices of raw beef placed on the face to remove wrinkles; from Spain, 'Pommade de Seville' of lemon juice and egg whites to remove blemishes) and skin 'brighteners' such as Virgin's Milk and pimpernel water ('a sovereign wash with the ladies all over the continent of Europe'). Bright skin, 'the finishing touch and final polish of a beautiful "lady"' could also be achieved by 'temperance, exercise, and cleanliness' – fashionable catchwords of the time. Her readers were warned against paints which made the face 'as expressionless as that of a painted mummy' and were advised that only a little vegetable rouge should be worn and never when women 'have passed the age of life when roses are natural to the cheek'.[28] Montez aimed to please an Anglo-Saxon readership with her comments on the deleterious effects of paint and the advisability of a moderate use of cosmetics, but practitioners of the cosmetic arts were understandably keen to promote their goods and services. A London hairdresser, Edwin Cher, said in 1865: 'Face powders . . . are prepared from rice, French chalk, Pistacchio, Brazil, Barcelona and Almond Nuts, blended with bismuth, talc, oxide of zinc, or other chemicals, all more or less dangerous', but still he claimed to find face paint 'artistic'.[29]

Most famously, the poet and critic Charles Baudelaire, within his essay *The Painter of Modern Life* (1863), included an 'Eloge du Maquillage', in praise of cosmetics, for a beautiful woman, he believed, was indivisible from her clothes and her make-up. He liked rice powder which helped to create a smooth complexion, rouge which brightened the eyes, eyes which were emphasised by kohl and mascara; like fashion, cosmetics were modernity – 'le rouge et le noir représentent la vie'. Deceit was not embodied in the use of make-up but merely an enhancement of a woman's beauty; artifice, he said, does not help the ugly

164 Title-page illustration to
*The Toilet: A Dressing-table
Companion*, 1839. British Library,
London

coming inevitably to a sad end; Alexander Walker declared coquetry to be the opposite of beauty, as it relied on artifice and spread its 'charms over even ugly forms'.[22] In France, however, coquetry was regarded as an auxiliary to beauty and often seen as a way to stay young: 'la coquetterie arrête le temps pour les femmes, prolonge leur jeunesse', claimed Horace Raisson, and it was a woman's duty to preserve her beauty by cosmetics.[23] The frontispiece illustration to an 1839 beauty manual, *The Toilet: A Dressing-table Companion* (fig. 164), shows a fashionable ringletted young woman within a mirror, which is surrounded by implements for the toilette such as brushes, scissors and curling tongs ('luxuriant tresses' are essential to 'a beautiful female'), and on the dressing table itself are flacons of toilet water, powder and rouge, and a pincushion.[24]

The basis of beauty, however, was increasingly linked to health; the word 'hygiene' (from Hygeia, the Greek goddess of health) was used frequently from the mid-nineteenth century, as gradually there was more access to bathing, and cleanliness (next to godliness, according to John Wesley) also had a clear moral message which appealed to middle-class Victorians. In 1853 Gladstone abolished the soap tax which had first been introduced in 1712 and this stimulated the manufacture of soap in small bars which were easy to use. From the 1860s soap was increasingly promoted as a cosmetic, especially for sensitive skins; 'Personal Beauty depends so much on the appearance and texture of the skin, that whatever contributes to protect it from injury or improve it, must be worthy of consideration', stated an advertisement for Pears soap in 1861.[25] Pears, founded in 1789, made the first transparent soap (from glycerine, an ingredient of natural oils and fats, discovered by the Swedish chemist Karl Wilhelm Scheele in 1779) and a range of cosmetics such as powder, rouge and skin creams; the firm was in the forefront of mass advertising campaigns, using, from the 1880s, fashionable beauties and celebrities such as Lillie Langtry and Adelina Patti to endorse their products. The word 'cosmetics' expanded to include everything which aimed to beautify; Arnold Cooley's important and comprehensive work *The Toilet and Cosmetic Arts in Ancient and Modern Times* (1866) discussed diet and exercise, along with cosmetics for the skin, hair and teeth. Cosmetics included what he called 'skin-blanches', such as cold cream, and lemon-based lotions, which 'impart either an artificial bloom, or whiteness and apparent delicacy to the skin'; more dangerously, 'a favourite cosmetic wash' was made with arsenic steeped in water. Cooley claimed that the 'unnatural and injurious practice of painting the skin', which in the past had been confined to 'courtisans and ladies of the demimonde', had now spread to the 'fashionable world'. By 'paint' he referred to 'metallic compounds which possess greater whiteness and brilliancy', made from bismuth, such as 'pearl powder, pearl-white, and Spanish-white';[26] such paints, and those based on lead, were condemned by many writers on beauty, although – paradoxically – recipes for them continued to be published.[27]

cheek'. Nevertheless, a woman's features, he averred, were not so much beautiful in themselves but in proportion to the face, and how they were presented. In a somewhat startling description, which Freud might have considered a sign of a deep-seated fear of women, Woolnoth conjured up an image akin to a sinister Gothic fairytale:

> bright eyes are considered beautiful; they are so: but bright eyes may be intrusive and staring: arched eyebrows are considered open and expressive, but they may be owlish and eccentric; white teeth are considered very ornamental, perhaps more so than agreeable, as they may be planted as though they were going to seize upon you; ruby lips and rosy cheeks are considered essential to the perfecting of the complexion, but they may be as overcharged and sudden as the enamel on a child's doll . . .[18]

Critics increasingly commented on the dichotomy between the abstract and the real in terms of beauty. In spite of the general veneration for Greek ideals of beauty ('beauty deified, in which art surpasses nature'), it was acknowledged that these were no longer relevant to modernity, except in art; for Arnold Cooley in his history of cosmetics (1866), ideal or absolute beauty could only exist 'in the works of the sculptor or painter'.[19] The anonymous author of *How to preserve good looks: Beauty and Cosmetics* (1871), remarks, 'The Greek idea of the beautiful head was modelled on a conception partly ideal, partly realistic. The ideal conception was the archetype – the *idea* of beauty in the abstract, endowed with all possible attributes which abstract ideas of beauty confer'. Yet, with such an idea, the writer suggested, there was no element of the 'useful, the convenient, or the merely ornamental', that is, 'the ideas of social beauty now possessed by mankind'.[20] The ways in which 'social' beauty was the creation of modernity, in Baudelaire's sense of the importance of fashionable appearance (including cosmetics), are what will be explored next.

Beautiful for Ever

it is the fashion of the present day to decry cosmetics, which were never in such perfection, and never so prevalent as now as women try to become 'beautiful for ever'

<div align="right">

How to preserve good looks: Beauty and Cosmetics, 1871[21]

</div>

As women's fashions became more complex from the 1820s, and youth was slightly dethroned from being the paradigm of beauty, the notion of the toilette and its attendant element, coquetry, returned. In England the coquette, too conscious of her charms, featured as a warning to young women in keepsake albums,

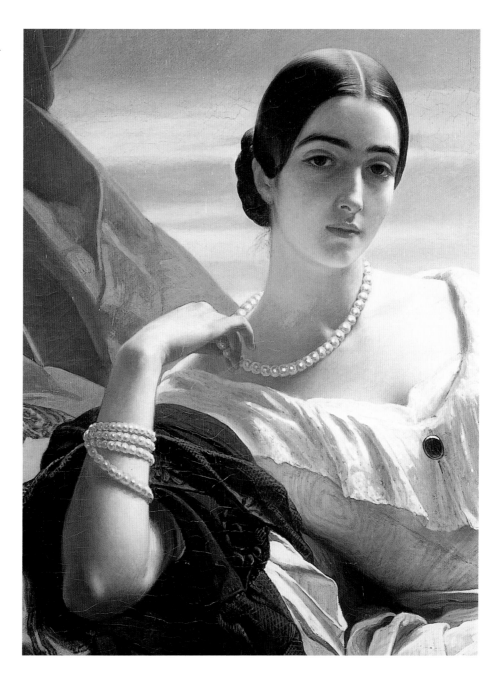

163 Franz Xaver Winterhalter, *Princess Leonilla zu Sayn-Wittgenstein-Sayn* (detail of fig. 162)

Woolnoth thought that if there were a rule for beauty, it was 'the absence of peculiarities', a somewhat negative definition, a kind of null symmetry perhaps; elsewhere he seems to have admired what he called comparative beauty, where individual features 'contrive to break upon you in fragments . . . raven hair, alabaster neck, ivory forehead, grecian nose, bow-and-arrow mouth, or dimpled

but 'still we unconsciously refer to a standard of beauty involving the idea of symmetry or harmonious colour'.[16] A glowing testimonial to beauty as symmetry and harmony is that of George Ramsay in 1848; for him a beautiful woman had:

> perfect Regularity of form, the exact correspondence of one side with the other, of eye with eye, and cheek with cheek . . . the oval form of the head and countenance, the smooth unwrinkled marble forehead, the plump downy cheek, the finely rounded chin, the full clear oval eye, the arched eyebrows, and the striking contrast between the dark hair and the white skin and the lively red of the lips. Mark also . . . the circular neck, the graceful curve of the falling shoulders, the alabaster back and breast, the swelling bosom . . . and you must exclaim, here, indeed is BEAUTY . . .[17]

Such an ideal woman was faultless of feature, with a perfect symmetrical countenance, but also with a hint of sexuality. The description evokes *Princess Leonilla zu Sayn-Wittgenstein-Sayn* by the German artist Franz Xaver Winterhalter (fig. 162); the exotic beauty is depicted lying on an oriental carpet placed on the terrace of her palace in the Crimea. The artist sees her as an odalisque, with creamy skin, sleek and shining black hair parted in the centre and swept over her ears, and her dark eyebrows almost meeting *à la Turque*.

162 Franz Xaver Winterhalter, *Princess Leonilla zu Sayn-Wittgenstein-Sayn*, 1843. The J. Paul Getty Museum, Los Angeles

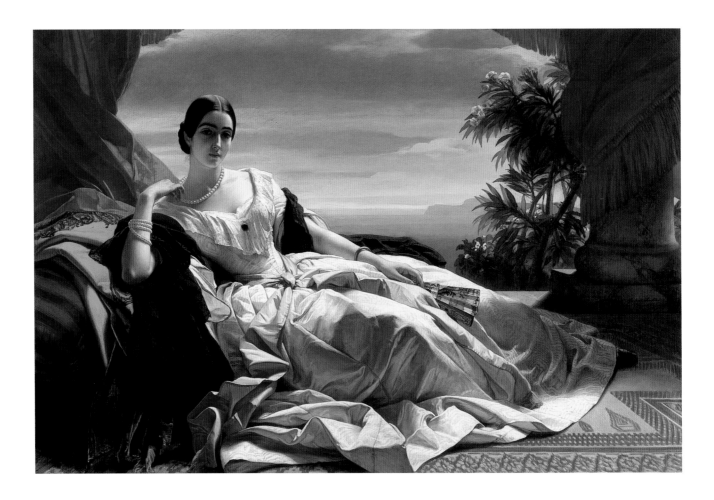

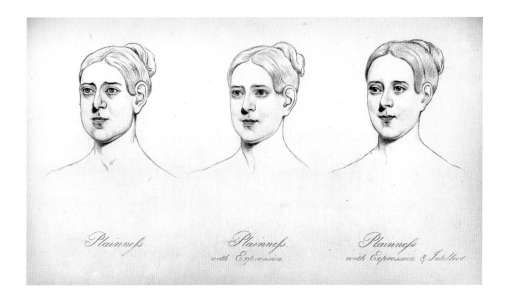

plainness as Woolnoth sees them, are not substantial; plainness occurs 'where the economy of the face and features are disturbed' and thus 'they no longer come within the range of beauty'.[15]

What occupied many writers by the middle of the century, as well as the moral aspects of beauty, was how far it consisted either in what John Addington Symonds in his *Principles of Beauty* (1857) called the 'fine configuration of feature' or in the 'beauty of expression', which he defined as 'the Intellectual, the Moral, and the Emotional'; we may, he said, in theory prefer the latter,

Facing Beauty

he divides them into '*Plainness*', '*Plainness, with Expression*' and '*Plainness, with Expression & Intellect*' (fig. 161); the first is the plainest, with a heavy jaw and 'irregular' nose, the second 'approaching somewhat nearer to beauty' and the third, being more 'proportionably refined', is 'the connecting link between Plainness with Expression and Intellect, and Beauty without either'. Although the hair-styles here are plainer and less 'Grecian' and the features of the first and second types more irregular and less refined, the differences between beauty and

were rarely portrayed in very dark colours, such colours were much seen in the nineteenth century, especially black – because it makes the body look slimmer and the skin whiter. As Gautier noted, when women wore black, their 'white skin turns into ivory, snow, milk, alabaster, everything white under the sun which is wont to be used by the writers of love songs'.[13]

One of the most influential writers on beauty in the 1830s was the Scottish physiologist Alexander Walker; his book *Beauty* (1836), based on Bell's physical classifications of female beauty (in *Kalogynomia*, 1821), moved Bell's discussion from the body to the 'Beauty of the face in particular'; his plate XVI (fig. 159) depicts the 'three species of beauty as they affect the head and face'. Number 1 (on the right) shows a woman with an 'oblong' face, fairly broad shoulders and darkish skin and hair; she is equated with Bell's 'mechanical or locomotive' beauty. Number 2 (on the left), Bell's 'vital and voluptuous' beauty, has a round face, blue eyes, a complexion where 'the rose and lily [are] exquisitely blended', and 'a luxuriant profusion of soft and fine flaxen or auburn hair'. Number 3 (in the centre) has an oval face with expressive eyes, and a high, pale forehead which 'announces the intellectuality of her character', and she is based on Bell's 'intellectual' beauty. Of the three types of beauty, Walker preferred the second, claiming to follow the ancients in declaring a white skin 'as the distinctive character of beauty' (he actually uses Gautier's words which I quote above), but acknowledged that 'individual beauty, the most perfect, differs always greatly from the ideal'; to a modern viewer, perhaps his choice is the most insipid of the three. In general terms, Walker's views on beauty were more akin to contemporary notions than to the ideals of ancient Greece; he admired a face which is 'a beautiful and rather opaque white', with a 'slight tint of rose colour' on the cheeks and the finely rounded chin, and a small mouth ('a large mouth and thick lips are contrary to beauty').[14]

The idea of three types of beauty seems to have obsessed writers during the first half of the nineteenth century and the portrait painter and engraver Thomas Woolnoth joined the number with his *Facts and Faces* in 1852. Woolnoth thought that beauty was 'subject to the most definite and unerring rules', which he defines as a happy mean between the 'Grecian forms . . . [of] excellence', and 'those of our handsome countrywomen'; his three kinds of beauty were '*Beauty*', described as 'a pleasing void' lacking 'Intellect or Expression', '*Beauty with Expression*', that is, 'more determined forms', and '*Beauty, with Expression & Intellect*', that is with 'more fixedness and decision of character' (fig. 160). To the untutored eye, the three types of beauty have similar features in oval faces; it is difficult to see, for example, what the author means when he says of *Beauty* that there is 'a weakness in the neighbourhood of each feature', that *Beauty with Expression* has eyelids 'more distinctly marked, to keep the eye in balance', and that *Beauty, with Expression & Intellect* has eyelids 'inclined to droop, as though more thoughtful and contemplative'. As for the comparative opposites to beauty,

which symbolises pride; 'La beauté morale' (an angel behind her) is neatly dressed, without ostentation, with her children who give money to a ragged beggar. Finally, a shipwreck scene, where the physical beauty (equated with selfishness and coquetry), miraculously unscathed, checks her appearance in a mirror, while the moral beauty (the personification of devotion and charity) tends a man saved from the sea.

In short, the ideal woman should be 'womanly'; the writer and journalist Leigh Hunt, in the essay 'Criticism on Female Beauty' from his book *Men, Women and Books*, added that 'beauty itself [is] a very poor thing unless beautified by sentiment', and that he could not 'think the most beautiful creature beautiful . . . unless she has a heart as well as a face'.[10] For Hunt, a beautiful woman had dark hair, arranged in ringlets, a face oval to round in shape, with cheeks of 'passive and habitual softness' (he notes 'an exquisite delicacy . . . in the transition from the cheek to the chin, just under the ear') and large eyes of 'sense and sweetness'. Hunt might be describing the kind of women depicted in the popular keepsake albums of the 1830s and 1840s – annual scrapbooks with sentimental verses and stories ('floods of elegant twaddle', in the words of Sheridan Lefanu) and with engravings of languishing beauties looking wistful in ringlets – but for him the saving grace of beauty was expression, without which a beautiful woman 'is nothing at any time but a doll'.[11] The conventional idea of female beauty during this period was indeed often of a doll-like figure, with, as the American Ella Adelia Fletcher scornfully wrote, a 'sylph-like fragility . . . a milk-white pallor and a proneness to faint on every and any occasion';[12] fainting was an occupational hazard when women wore tight corsets to emphasise the waist (from the late 1820s, metal eyelets in corsets enabled tighter lacing) and consumed substances like chalk, vinegar and Epsom salts to gain a whiter skin and a slimmer figure. Fletcher exaggerated the style of the fragile and simpering beauties of the English keepsake albums (akin to images of the demure and submissive middle-class Biedermeier girls in contemporary Austrian and German journals), as a deliberate contrast to the healthy and vigorous American beauties of the late 1890s, the time of her book. Yet there are many examples of spirited beauties in this period, such as Nanette Heine (fig. 158), the seventeen-year-old daughter of the head of the Jewish community in Munich, who had married the nephew of the Romantic poet Heinrich Heine. She was one of a series of beauties whose portraits by Karl Josef Stieler were commissioned between 1827 and 1850 by Ludwig I of Bavaria for his gallery at Nymphenburg, the Schönheitengalerie (they also included the king's mistress Lola Montez; see fig. 165). A girl of character, the simplicity of Nanette Heine's dark velvet dress sets off her elegant long neck, sloping shoulders (like a champagne bottle) and the grave beauty of her face, a perfect oval; a diamond and gold hair ornament in the shape of an arrow decorates her dark glossy curls. In contrast with earlier centuries, when women

158 (*facing page*) Josef Stieler, *Nanette Heine*, 1829. Bayerische Schlösserverwaltung, Munich

Facing Beauty

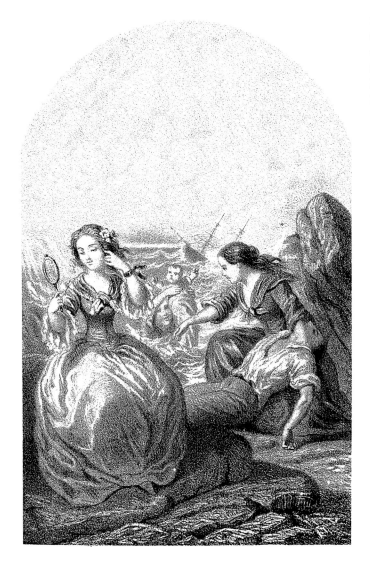

157 P. Faure, 'Beauté physique – égoïsme et coquetterie' and 'Beauté morale – dévouement et charité', from Joseph Duffeyte-Dilhan, *De la Beauté Physique et Morale*, 1857. Private collection

physique et morale (1857), was clear that this conjunction of beauty with moral- ity and virtue is extremely rare. Writing in the context of worries about luxury and laxness of morals which many critics saw as characteristic of society in the Second Empire, he claimed that moral beauty was rare 'parce que le luxe, la coquetterie, l'orgueil et l'amour des plaisirs prennent la place du travail, de l'ordre et des joies sereines de la famille' (because luxury, coquetry, pride and love of pleasure take the place of work, order and the serene joys of the family).[9] Duffeyte-Dilhan's work is illustrated by a series of lithographs (figs 155–7) which serve to underline the message of his text. Opposite the title-page, 'La beauté physique' is represented by a fashionably crinolined and bejewelled woman looking at herself in a mirror, behind which peers the Devil, and a peacock

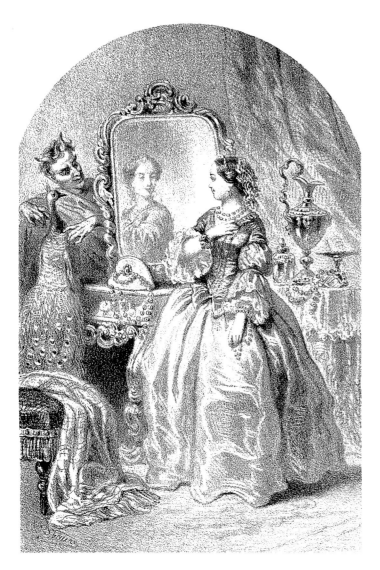

155 (*above left*) P. Faure, 'La beauté physique', from Joseph Duffeyte-Dilhan, *De la Beauté Physique et Morale*, 1857. Private collection

156 (*above right*) P. Faure, 'La beauté morale', from Joseph Duffeyte-Dilhan, *De la Beauté Physique et Morale*, 1857. Private collection

Cousin, beauty was spiritual and devoid of sensation – one should recognise 'the judgement of the beautiful as an absolute judgement' – for other writers there was a clear distinction between physical and moral beauty. As an aspect of the theory of art for art's sake, writers like Gautier pronounced beauty a thing in itself, without any moral content; it is, he said, 'a magnificent dress which hides the soul's imperfections'.[8] Less provocatively, more conventional critics insisted that, although the notion of beauty as goodness had little foundation, it was not impossible for a beautiful woman to aspire to be a moral one also, but this would depend on a genuine feeling that her beauty was a gift from God, and not to be cultivated at the expense of morality and the concerns of family and society. The novelist Joseph Duffeyte-Dilhan, in his work *Aux Femmes: De la beauté*

154 Jean Pierre Sudre (engraving after Ingres), *Odalisque*, 1827. British Museum, London

by an exquisite and delicate sentiment, and is sometimes even replaced by a disinterested worship'.[6] This adoration of Raphael echoed the views of Ingres, after whose *Grande Odalisque* of 1814 Jean Pierre Sudre made a lithograph in 1827 entitled *Odalisque* (fig. 154). The medium of this work heightens what the poet and critic Théophile Gautier in his novel *Mademoiselle de Maupin* (1835–6) called 'the beauty of form'; the plump, seductive and mysterious beauty of the *Odalisque* (more akin to a portrait by Raphael than to an image of a favourite of the Ottoman sultan) is perhaps more in tune with the fashionable ideals of the time of Gautier's novel than to the date of Ingres's original painting. Listen to Gautier again, how he adores the 'lovely Turkish eyelids, the deep and melting look . . . the proud nose so finely chiselled . . . the delicate curves, the pure oval shape which imparts such elegance and distinction to a face'.[7] Whereas for

the First World War, was widely accepted as part of the new empowerment of women resulting from political and social reform. The last section of this chapter, 'Beauty and the Modern Woman', deals with the ways in which 'freedom, democracy and modernity were signified by an image of artificially enhanced female beauty'.[3] Technological developments such as the creation of safe cosmetics and the invention of the permanent wave for hair, along with the wide availability of beauty products in department stores, large-scale advertising and the huge expansion of hairdressers and beauty salons, revolutionised the way women saw themselves. Make-up became almost a kind of theatre, as women experimented with bright colours in the 1920s, and from the 1930s followed the glamorous, sophisticated beauties seen in Hollywood movies. Cosmetics then catered for a mass market, at all price levels, even during wartime, in order to boost morale; the cult of sunbathing, and a more diverse range of fashionable role models for beauty, created new ideas of appearance. What almost completely disappeared was the notion of ideal beauty, too elitist an idea to survive in the modern world.

Beauty and Morality

Physical beauty is . . . the sign of an internal beauty, which is spiritual and moral beauty, and this is the foundation, the principle, the unity of the beautiful.

Victor Cousin *Lectures on the True, the Beautiful, and the Good*, 1854[4]

Perhaps the painted creature may be admired by an artist as a well executed picture; but no man will seriously consider her as a handsome woman.

Anne Smith *Etiquette for Ladies*, 1838[5]

A constant theme in mid-nineteenth-century treatises on beauty concerned morality. Given the admiration of the period for the art and culture of ancient Greece, it is not surprising that several writers suggested a return to the Platonic concept of virtue as intrinsic to beauty. 'Moral beauty is the foundation of all true beauty', remarked the French philosopher Victor Cousin in his *Lectures on the True, the Beautiful, and the Good*; for Cousin 'the end of art is the expression of moral beauty, by the aid of physical beauty'. Like the majority of contemporary writers on aesthetics, his preference was less for contemporary beauty than for the purity of classical beauty: 'The more beautiful a woman is, – and I do not mean that common and gross beauty which Reubens animates with his brilliant colouring, but that ideal beauty which antiquity and Raphael understood so well, – the more, at the sight of this noble creature is desire tempered

*T*HIS CHAPTER COVERS APPROXIMATELY A HUNDRED YEARS FROM THE 1830S TO THE START OF THE SECOND WORLD WAR; IT IS AN IMMENSELY complex and fragmented period, with little in the way of direct and uncomplicated narratives of beauty and appearance. So I have selected a number of major themes, which seem to me to chart the progress of modernity in attitudes to women's appearance: from a relatively uniform idea of beauty at the beginning of the period, to a growing sense of divergence linked to the first serious concepts of contra-fashion, especially within artistic circles; from moral concerns surrounding beauty and its enhancement, to the acceptance of cosmetics both as an art form and as a democratic right. The first section of this chapter begins with a discussion of innate beauty, the last gasp of a traditional concept linked to morality, but increasingly in decline, although not completely abandoned. For, especially in the middle decades of the nineteenth century, cosmetics continued to present moral problems about dissimulation, excessive luxury and overt sexuality; there was also the exploitation of the gullible by fraudsters such as Rachel Leverson who – under the banner of 'Beautiful for Ever' – tricked women into useless and expensive beauty treatments. Leverson's career sounded the death-knell of the quackery long associated with the beauty industry, which began to put its house – gradually – in order. Serious attacks on the use of cosmetics declined, recognition of the fact that make-up was an indisputable part of women's appearance, even – especially – at elite level, and promoted in the many fashion magazines of the period.

The second section of this chapter is devoted to two main themes which are linked together under the title 'Art for Art's Sake', the impact of new artistic ideas on beauty, and the celebration of art, that is artifice, with regard to cosmetics. In England the input of dress reformers and the aesthetic movement (often one and the same) encouraged what I refer to as 'contra-fashion', new notions of dress and appearance which diverged considerably from accepted conventional standards. Women in the Pre-Raphaelite circle were noted for their simplicity in dress, their prominent features and masses of wild, undisciplined hair; they offered up a *beauté du diable*, a striking contrast to the 'pink-cheeked dolls' deplored by the dress reformer Eliza Ann Haweis in *The Art of Beauty* (1878).[1] The idea of beauty as the creation of cosmetics was fostered by the beauty industry, by 'professional beauties' such as Lillie Langtry and famous actresses such as Sarah Bernhardt; such high-profile women from the 1870s set the standards in beauty which earlier in the century had been the preserve, mainly, of royalty and the aristocracy. Max Beerbohm's humorous *A Defence of Cosmetics* (1894) declared 'we are ripe for a new epoch of artifice' and that make-up was an art form and not 'a mere prosaic remedy for age or plainness'.[2]

Improvements in health and hygiene early in the twentieth century helped to ensure that cosmetics were no longer mainly remedial. Make-up, especially after

152 (*previous pages*) Berthe Morisot, *Woman Powdering her Face* (detail of fig. 183)

153 (*facing page*) Alfred Stevens, *Sarah Bernhardt* (detail of fig. 189)

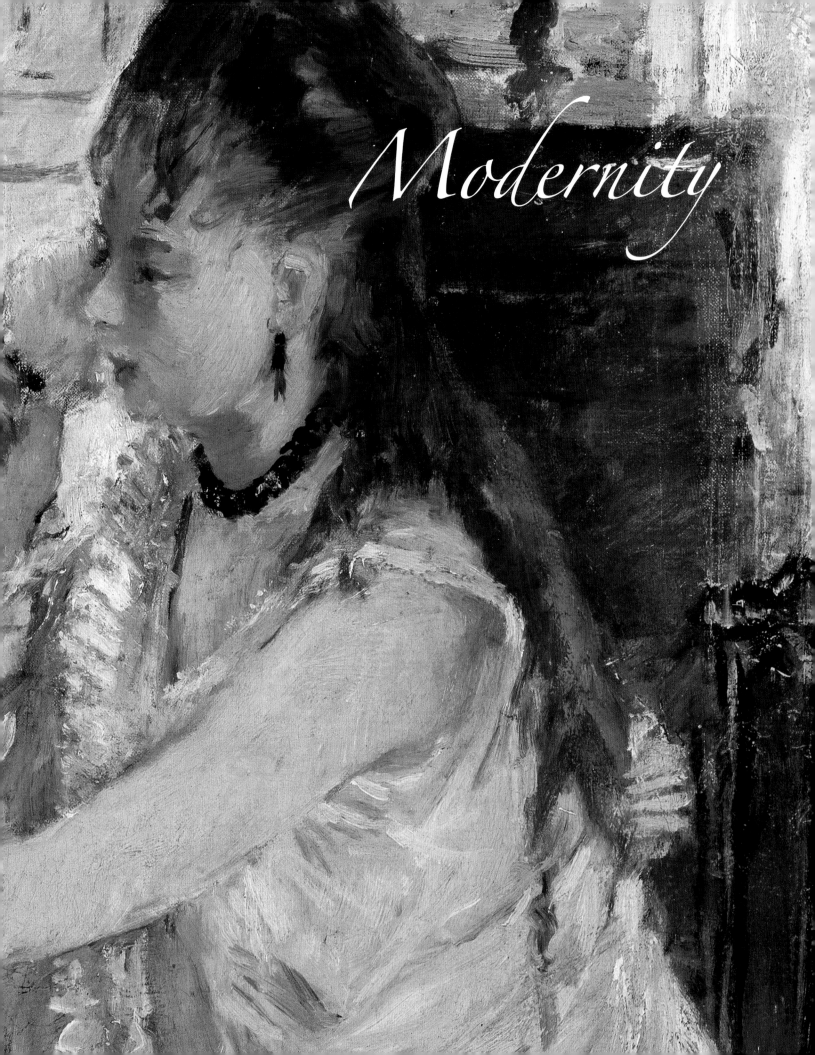

Modernity

was achieved by styles of dress thought suitable for their years and an avoidance of cosmetics. A little booklet entitled *The Toilet* of 1821, is typical of the anti-cosmetic publications of the period; the illustrations (figs 147–51) have flaps which when opened reveal a moral meaning – 'The Enchanting Mirror' has the text 'Humility', 'A Wash to smooth Wrinkles' is 'Contentment', 'Best white Paint' is 'Innocence', 'Rouge Superieur ne se vend à Paris' (not on sale in Paris), is 'Modesty' or blushing, and 'A fine lip salve' is 'Cheerfulness'. Each illustration is accompanied by a verse with an appropriate homily; that for rouge tells that modesty is 'Beauty's chief ornament, and Beauty's self / For Beauty must with Virtue ever dwell; / And thou art Virtue, and without thy charms, / Beauty is insolent, and wit profane'. The images of such beauty products, which would have been available on the dressing table of a fashionable woman are so attractive that one wonders how far the purchasers of *The Toilet* could resist buying them.

A Wash to smooth Wrinkles

Best white Paint

Rouge Superieur
ne se vend pas
a Paris

A fine lip Salve

alkanet, sandalwood, brazilwood or safflower) and to redden the lips with poppy or geranium petals. Caron told his readers that although paint was 'extracted from minerals more or less pernicious, but always corrosive' and was useless at 'preventing or repairing the ravages of time', it was acceptable for an old woman: 'when an antique and venerable dowager covers her brown and shrivelled skin with a thick layer of white paint heightened with a tint of vermilion, I am sincerely thankful to her; for then I can at least look at her without disgust';[163] the paradox is that such a woman became, with paint, uglier than she was in order that she might appear less so.

By the 1820s, when the taste for the antique had virtually disappeared, a more made-up face was in vogue, complementing the fashions which had become more structured and complex, with richer fabrics like silk replacing to some extent the plain muslins worn at the height of Neo-classical taste. According to *The Art of Beauty* (1825), red and white returned to the face and the most beautiful complexion was a happy medium between 'barn-door beauties with great ruddy and rosy cheeks' and 'hot-bed beauties, ghost-like and fleshless, with neither roses nor lilies to boast of on their pale and unsunned faces'.[164] The 'Modern Fine Lady', in John Corry's *The English Metropolis; or, London in the Year 1820*, once again returns to the 'splendour of artificial loveliness': the 'hairdresser supplies her with artificial locks; the corset-maker manufactures a *false bosom*; and the vendor of cosmetics prepares his beautifying wash. . . . the lovely dupe of vanity obscures her charms with artificial decorations. She eyes herself at the mirror, and steps into the public walk, courting observation'. Such women are 'a constant exhibition of animated painting'.[165] Corry's work is a satirical account of London life late in the Regency, a period when caricatures of all kinds flourished and men's dress was – in the figure of the dandy – as exaggerated (if not more so) than women's. Even when the vogue for the classical flourished at the turn of the century, not every woman abandoned face paint or cosmetics; make-up, like certain favoured styles of dress, is so much a part of a sense of self that it is often retained beyond youth, when no longer fashionable. Many women, especially those of a certain age, must have felt more comfortable when dress resumed a natural waist level, when the arms were covered and when, by using cosmetics, they could 'baffle time in his invidious warfare against comeliness'.[166] Nevertheless, compared to the previous century when paint and cosmetics were widely worn by women of all ages, the cult of youth fostered by the French Revolution established a permanent gap between the appearance of young and old, which lasted well into the twentieth century. A new moral climate based on middle-class manners and attitudes, which gathered momentum from the 1820s, sought to return young women away from the social freedoms of the immediate post-revolutionary period, towards a more conventional and subservient role, where their youth, modesty and inexperience of life had to be protected; this

146 Label for 'Pommade', sold from no. 263, Rue du Roule, Paris, 1800–20. Waddesdon Manor, Aylesbury, Bucks., The Rothschild Collection (The National Trust)

be created by good health practices, such as diet and exercise. Walking 'at a quick pace' or 'active amusement' out of doors was recommended by the author of *The Art of Beauty* (1825) and, after such exercise, a woman might rub her limbs with 'Madame Récamier's Pommade', made from the fat of a red stag mixed with olive oil and wax.[156] Dr William Buchan stated firmly in 1811 that 'beauty, both of shape and countenance, is nothing more than visible health'; he complained that in order to achieve the slim but rounded figure of the classical ideal, women had adopted 'injurious' notions, such as drinking vinegar 'to produce what is called a genteel or slender form' (and which also gave a fashionable pallor to the face).[157] Water, observed Buchan, was 'a foundation of health' and, for Caron, cleanliness in the form of 'frequent ablutions' was 'that precious quality which nearly transforms a woman into a divinity';[158] the authors of beauty manuals and the editors of fashion magazines increasingly advised women that regular bathing was as essential for beauty as a woman's looking glass. It was easier to see truth and beauty in a face when it was clean and healthy, no longer subject to skin disease and thus no longer made-up to the extent it had been in the past; skin had not just to look healthy but to be healthy.

By the late eighteenth century, Edward Jenner had developed a smallpox vaccination from cowpox (from *vacca*, Latin for cow); the *Lady's Monthly Museum* (1811) declared that there was thus no longer any need for women to paint themselves.[159] The foundation for a healthy and glowing face was unblemished skin, which was softened with a scented oil or a wax-based pomade (figs 144–6); Horace Raisson's *Code de la Toilette* suggested cucumber for the face and rosewater coloured with alkanet for the cheeks, and almond pomade for the lips.[160] At the start of the nineteenth century, the ideal skin had a pallor which was thought to be fashionably antique and cosmetic containers were sometimes correspondingly ornamented. A label for a French pomade (see fig. 146) imitates the decoration of a Greek vase, with smoke issuing from a classical altar; on either side of a vase of flowers are Flora and Zephyr – according to Ovid, Zephyr, the god of wind, fell in love with the nymph Chloris, who became the goddess Flora and ruled over flowers. For Caron (who devoted a chapter 'On the Beauty of the Skin' in his *Toilette des dames*), 'Whiteness is one of the qualities which it is requisite for the skin to possess, before it can be called beautiful', and it should be 'slightly tinged with carnation, soft and smooth to the touch'. He recommended Balm of Mecca, 'one of the most highly esteemed cosmetics', to make the skin 'incomparably white', or Virgin's Milk ('a tincture of benzoin precipitated by water'); alum dissolved in water gives a lustre to the skin but as it was too astringent he suggested that it be boiled with egg white and then scented with rose-water.[161] Paint, in the traditional sense, continued to be worn although increasingly advised against; women were urged instead to powder the face[162] and – if they felt the need – to add just a touch of vegetable rouge (made from

144 Pomade label, *Cowslip Pomatum* 1799. British Museum, London

145 Pomade label, *Mignonette Pomade* 1807. British Museum, London

but invented by a German doctor. Cosmetics, as he admitted, are distinct from 'medicinal preparations' but, nevertheless, his hope was that 'the art of *beautifying* may be considered an auxiliary of the art of *healing*'. After this impressive start, the reader soon realises that the work is intended to advertise a 'miracle' cure for old age; the 'Bath Lotion' (based on water from the famous Roman baths) is 'the only *real* cosmetic ever prepared in this kingdom; it communicates to the skin a brilliance of tint, a delicate fineness of texture and juvenile freshness, that cannot be described . . . and which render a countenance of moderate pretensions unaccountably and irresistibly attractive'.[155] This sales pitch is a familiar one, even today, but – as well as inventing a new word, which hints at a scientific basis – *Cosmeology* tapped into the contemporary beauty ethos which made a perfect skin the foundation (literally) of beauty, and which could best

143 Robert Dighton, *Fashionable Lady in Dress & Undress*, 1807. British Museum, London

motive or mechanical' beauty, admired by young men, the 'vital or voluptuous' beauty who between the ages of thirty and forty reaches 'highest perfection' and is particularly attractive to middle-aged men, and finally the intellectual beauty who appeals to older men. Bell's book is mainly concerned with the physical attributes of beauty and is illustrated by images of different body shapes; relative beauty was dismissed by the comment that 'throughout the universe a young and beautiful woman of the European race commands the admiration and receives the homage of men'.[153]

Cosmeology

Youthfulness was a crucial component of beauty – that is, a slim figure enhanced by light and simple dress, and a youthful complexion that remained well beyond the juvenile age. Chapter thirty-seven of Caron's *La Toilette des dames* is entitled 'Of the Possibility of growing young again'. Robert Dighton's *Fashionable Lady in Dress & Undress* of 1807 (fig. 143) shows the woman on the left in her chemise and with a frilled white cap in her hand, as she gazes into the mirror of her dressing table; on the right she is fully dressed in the same attitude, fan in hand, ready for a visit to the opera, wearing her wig, which is dressed *à l'antique* with a bunch of curls on the crown. As many fashionable women had cut their hair short in classical style, they needed to vary their appearance with a wardrobe of wigs, as can be seen from contemporary advertisements, such as one in 1806 for 'Bowman's Patent Perruques' (patented in 1800); made of the 'finest hair chiefly collected at Fairs from the Female Peasants on the Continent', these wigs were described as 'Correct Imitations of Nature' and held in place with 'Steel Springs or Wires' by which the 'Perruque adheres closely to the Head, without too much pressure'.[154] On the left of Dighton's caricature, the wig replaces the lost hair of youth and the bottle of anti-wrinkle lotion by the fan suggests a use of cosmetics to turn back the clock, but in fact the 'Fashionable Lady' in both guises looks quite youthful; there is none of the savagery of Rowlandson's *Six Stages of Mending A Face* of 1791 (see fig. 121), where an ancient hag is transformed by a sequence of horrifying 'beauty' processes into a fashionable 'young' woman. With more natural standards of beauty in body and face, there was no longer such a gulf between young and old in terms of dress and cosmetics.

An anonymous work of 1816 has as its title *Cosmeology; or The Art of Preserving and Improving Beauty, demonstrating the facility with which the Charms of Youth may be rendered more attractive and retained undiminished to a very advanced period, or restored to their original lustre . . .* The 'Charms of Youth' had, of course, been praised in earlier centuries as an aspect of female beauty but here the author claimed to call on science to aid women, via 'Cosmeology'; 'the elegant Art of Cosmeology', he averred, was 'a distinct science', inspired by the ancient Greeks

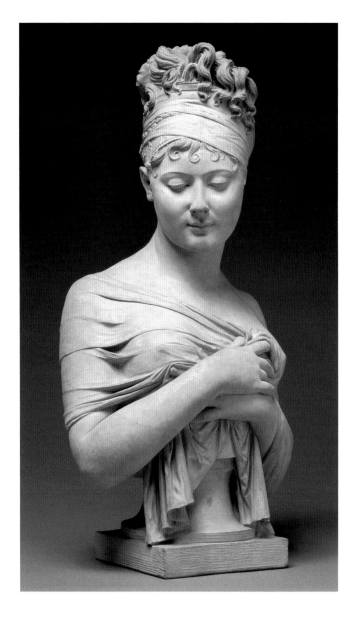

142 Joseph Chinard, *Juliette Récamier*, c.1801–2. The J. Paul Getty Museum, Los Angeles

about the psychology of attraction. Caron stated that a sensitive man 'of a delicate and tender soul' would be drawn towards a 'fair-haired beauty with blue eyes and lily complexion', a lively man would think that 'beauty consists in sparkling eyes, rosy cheeks and roundness of form' and the 'ardent man will prefer that brunette whose large black eye seems to flash fire'.[152] Taking a different but related view, John Roberton, a Scottish sexologist and social reformer, writing under the pseudonym Thomas Bell, in *Kalogynomia, or the Laws of Female Beauty* (1821), tried a more 'scientific' classification of beauty into three kinds: the 'loco-

Bonaparte wrote to his brother Joseph: 'Women are everywhere, in the theatres, the promenades, the bookshops . . . A woman needs to live in Paris for six months to know her due, to know what her empire is'.[146] The new feminine elite were known as the *élégantes*, women of the world with sometimes chequered careers, who set the latest fashions, extreme versions of the Neoclassical style; they were led by Josephine Beauharnais (who married the young General Bonaparte in 1796), Thérèse Tallien and Juliette Récamier – they reigned over the rather raffish society of the Directorate. Of these Three Graces, Récamier was by common consent the most beautiful; 'I would give half of the wit with which I am credited for half of the beauty you possess', the very plain Mme de Staël is supposed to have said to her,[147] for she was celebrated not only for her beauty but also for her charm. Joseph Chinard's terracotta bust (fig. 142) gives some idea of Récamier's slightly childlike beauty, with her roundish face and perfect repose; her hair, dressed *à la Psyché*, has a bandeau in classical style but this is her only adornment. As Caron remarked: 'The greater the beauty of a woman, the less occasion she has for ornament'.[148] Récamier was, according to Balzac in his novel *Cousin Bette*, one of those 'perfect, dazzling beauties, whom Nature fashions with peculiar care, bestowing on them her most precious gifts, distinction, dignity, grace, refinement, elegance; an incomparable complexion, its colour compounded in the mysterious workshops of chance. All such beautiful women resemble one another . . .'; writing in the 1840s, he argued that 'in spite of . . . their passions, and their lives of excess', such women 'remained lovely in spite of the years'. The slightly moral note is typical of the mid-nineteenth century but the idea that the great beauties of the Directorate and Consulate showed 'similarities in their build and proportions, and in the character of their beauty'[149] may be due to the powerful cultural and visual impact of Neoclassicism on appearance, which dominated the period.

The Dutch anatomist Petrus Camper tried to quantify beauty by inventing a device to measure facial profiles and 'took for granted that the statues of Greek antiquity represented the ideal of beauty'; Richard Payne Knight, while generally deploring 'the gloss of novelty or stamp of fashion', thought the figure-revealing dress of his time had at least begun to approach the ideals of classical Greece, which for him was the pinnacle of beauty in all the arts.[150] Yet other writers thought that women's beauty could not be assessed in the light of ideals in art, that it was *sui generis*; Caron, while stating the Platonic case that beauty was allied to virtue, thought that there were 'beautiful women who have neither the proportions nor the forms of the Grecian mould' and concluded somewhat lamely that 'Beauty . . . is nothing but the excellence of objects rendered visible'.[151] In defining beauty, the argument began to shift towards a quasi-Kantian idea of 'reception', that there was no one standard of beauty, but different types which attracted men according to their characters; beauty was

youthfulness, contemporary styles of dress which revealed much of the body were not appropriate for the older woman.[140] Men, on the whole, were generally in favour of dress and appearance related to the classical ideal; James Peller Malcolm in his *Anecdotes of the Manners and Customs of London* (1808) welcomed women's new look, for 'the Hair, cleansed from all extraneous matter, shines in beautiful lustre carelessly turned round the head in the manner adopted by the most eminent Grecian sculptors; and the Form appears through their snow-white draperies in that fascinating manner which excludes the least thought of impropriety'.[141] Hair-styles named after classical divinities, dressed with *huile antique* (Macassar oil, from the nut of the Ceylon oak) and bound with diadems in 'classical' taste, and high-waisted white muslin dresses – these were the new manifestations of female beauty. Josef Grassi's portrait of Queen Louise of Prussia (fig. 141), admired by her people for her spirit and energy in the wars against Napoleon, is a tribute to one of the extremely beautiful women of the time – 'she completely dazzled me when she came up to me', said Madame de Staël in 1804.[142] Queen Louise's beauty was natural and unaffected; the portrait depicts her perfect complexion, large and widely set-apart dark-blue eyes, expressive lips, a long, graceful neck and her hair bound round, antique-style, with gold bandeaux set with turquoise and aquamarine (like the armlet on her sleeve); her simple white dress is decorated on the shoulders with a cameo and girdled with ribbon under the bust, which is supported by lightly boned stays. Body, flesh and face were unified in whiter shades of pale but, although dress was essential to complete beauty, it had to be subservient to it and not to be 'Fashion', which 'is frequently the exterminating angel of beauty'. These are the words of Auguste Caron, whose *Toilette des dames* (1806), the most important beauty manual of its time, stated: 'Dress is to beauty what harmony is to melody; it ought to set it off to advantage, to enhance its lustre; never to cover or disguise it'.[143] As can be seen in the portrait of Queen Louise, the fashionable high-waisted dress placed great emphasis on the bosom which, according to Caron, should be 'white and soft, gracefully swelling, perfectly regular, firm', and with 'a sufficient interval between the two hemispheres'.[144] This is a reference to the new 'divorce' corset which separated the breasts like the modern bra and pushed them up, thereby creating in a woman what one critic called 'a sort of fleshy shelf, disgusting to beholders and, . . . incommodious to the bearer'; the ultra-fashionable Englishwoman was sometimes called a 'pigeon' because of her panting and exposed bosom.[145]

Once France had become more stable after the violence of the Terror of the mid-1790s, and a new form of government, the bourgeois republic of the Directory, had been established, society gradually emerged from the shadows and in a period of political change with shifting class and gender roles, women assumed even more importance than had been the case earlier in the century. Napoleon

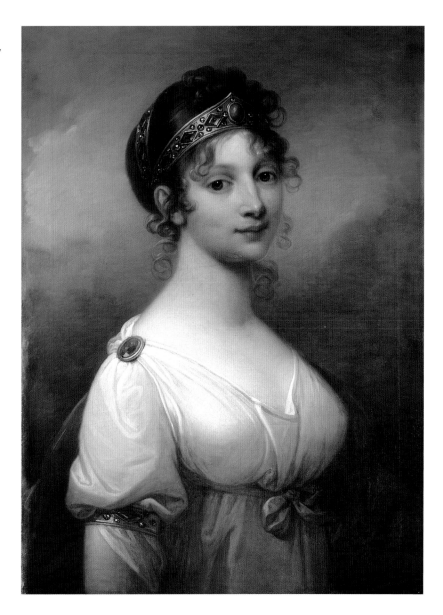

Revolution – lamented what she saw as the decline in etiquette and the disappearance of a way of life (Talleyrand's *douceur de vivre*) which it had brought about, had mixed views about the impact of the events of 1789. In her *Dictionnaire Critique et Raisonné des Etiquettes de la Cour* (1818), intended as guidance for the restored monarchy in France, she did not lament the decline of face paint ('un artifice honteux', a shameful artifice), or the disappearance of patches, hair powder, high-heeled shoes and hooped petticoats, all of which had enslaved women. Instead, she regretted the fact that, because the new ideal was that of

from the mask created by paint and the skin became, in Philippe Perrot's words, a mirror which reflected the internal being ('une espèce de miroir où viennent se réfléchir toutes les impressions intérieures'[139]). The dramatic changes in what women wore, how their hair was styled and their faces were presented, caused much comment; this was unsurprising, because no one could remember a time when women were not creatures of obvious artifice, with their layers of complicated dress and stiff under-structures of stays and hoops, their powder and their paint. Those, like Madame de Genlis, who – although supporting the French

which is draped a cashmere shawl. Her hair is cut short on the top and sides, carelessly curled over her neck and shoulders, and whatever make-up she wears is discreet and natural in appearance. Isabey's beautiful wife, Jeanne Laurice de Salienne (fig. 140), drawn around the same time, has her hair cut very short and curled, almost masculine in style, but her femininity is underlined by her perfect profile and by her ruffled collar.

Enlightenment thought finally laid bare the real truth and beauty of the appearance; the aim, in a Keatsian sense, is beauty as truth, for the face was freed

For the ideal increasingly promoted by artists and critics was, as the *European Magazine* (1785) stated, 'dress which Nature and a happy unrefinement of taste dictate . . . loose, simple, unconfining' and inspired by the 'freedom and ease' of the costume of ancient Greece and Rome;[134] the reference is to the *chemise à la reine*, the T-shaped dress made from voluminous folds of soft white muslin and held in at the waist with a sash, which was made fashionable by Marie-Antoinette in the 1780s. Even in a cold climate, claimed the author of *Woman* (1790), such 'classical' dress could be worn, with the addition of 'furred cloaks', and as for the hair, simpler styles were now in fashion, for women 'consult nature and good artists'.[135] Lawrence's portrait, exhibited at the Royal Academy in 1790, of the Irish-born actress Eliza Farren (fig. 137) shows her in a white muslin dress, which – with the vagaries of the English climate in mind and the artist's relish for materiality – she wears under a hooded satin pelisse cloak trimmed with fox fur. First appearing in London in 1777 as Miss Hardcastle in *She Stoops to Conquer*, one of her most successful parts was Lady Teazle in *The School for Scandal*; she possessed superb comic timing, along with a refinement of manners and 'great taste and elegance in her appearance'.[136] These attributes made her particularly successful in high-society roles and in 1797 she was able to perform the part in real life by her marriage to the Earl of Derby, who had commissioned Lawrence's portrait. Farren is painted with heightened colour (and a slightly red nose) and a windswept, casually arranged and lightly powdered hair-style; some artists wondered why women would wish to adopt, as Cochin put it, 'les marques caractéristiques de la vieillesse'[137] but, although hair powder might seem to mimic the grey hair of old age, in a young and beautiful face it serves to act as a foil to a youthful complexion. In order for this to work, the face needs colour and Lawrence's skill was to focus on what appears to be the 'natural' and lively beauty of his sitter, although it would have been aided by cosmetics, notably the cheeks crimsoned by rouge (and the brisk weather) and the glistening red lips; her fingernails are buffed with lightly coloured wax to make them shine. As David Piper comments, this image has a double aim, 'to portray the public, superficial creature of fashion and society in poise and dress, and, primarily in the face, to indicate the more private sensibilities of the heart, in the parted lips, the dilated brilliant eyes'.[138]

The French Revolution, although it did not initiate new styles of dress for women, none the less had a great impact on their appearance; inspired by notions of classical simplicity, which progressive thought in France equated with the replacement of a monarchy by a republic, women by the late 1790s had adopted the 'freedom and ease' of costume *à l'antique*, as admired by the *European Magazine* in 1785. This new ideal for women was based on youthfulness and naturalism, as in Andrea Appiani's portrait, *Fortunée Hamelin* (fig. 139). Painted in Milan in 1798, it shows a modern beauty in a white muslin chemise dress, over

138 Thomas Lawrence, *Eliza Farren* (detail of fig. 137)

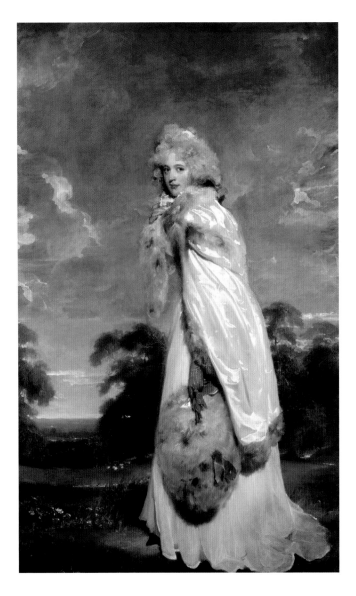

society. As Madame de Pompadour was to some extent the creation of Boucher, so Emma Hart was Romney's muse and the product of his obsession; he painted her as Miranda, Cassandra, Circe, Iphigenia, Circe, as a bacchante and at prayer, 'glamorized . . . [her] endlessly in terms of a flawless, almost synthetic beauty'.[133] As a spinstress, Hart seems to perform the quintessential feminine ideal but the demureness of her dress and occupation is subverted by her vivacious beauty with its direct sexual appeal. Romney's portrait is a curious mixture of synthetic sentimentality and the influence of Neo-classical simplicity, which the artist urged his female sitters to adopt in their dress and general appearance.

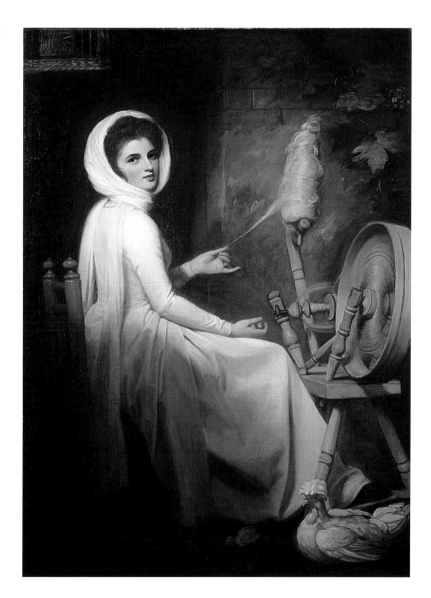

Not every woman wished to be represented in art imprisoned in an elaborate *tête*, especially by the mid-1780s, when styles of dress had become quite simple for everyday, with the growing popularity of cotton and linen. The fashion for sentiment and *sensibilité*, it was considered, could better be demonstrated by the wearing of plain dress, with which complex hair-styles and a face veneered in paint would look inappropriate. Romney's painting *The Spinstress (Portrait of Emma Hart)* (fig. 136) typifies this new approach; the future Lady Hamilton in a simple long-sleeved white dress, a muslin scarf wrapped round her head, has a healthy and glowing appearance far removed from the powdered artifice of high

ened the hair but women needed to add false hair to their own to achieve the height of the 1770s and the width of the 1780s. When Fanny Burney's heroine Evelina had her hair formally dressed, she complained how 'oddly' her head felt, 'full of powder and black pins, and a great *cushion* on the top of it . . . my face looks quite different to what it did before my hair was dressed. When I shall be able to make use of a comb for myself I cannot tell, for my hair is so much entangled, frizzled they call it, that I fear it will be very difficult'; the 'cushion' was a large pad, roughly triangular in shape, filled with false hair, wool or silk ('Silk Cushions from 1s to 2s' are advertised by Packwood; see fig. 135). Hair-styles were padded out with various materials such as animal hair or wool; Lydia Melford in Smollett's *Humphry Clinker* writes about spending six hours 'under the hands of the hair dresser, who stuffed my head with as much black wool as would have made a quilted petticoat'.[131] The penultimate touch to the hair-style was to powder it; 'Powder Machines' (a kind of bellows, or a flexible tube) ensured the even dispersal of the powder but, as it was a messy process, a separate powder room was the ideal. Charles Lillie, a famous London perfumer, relates that although rice powder could be used on the hair, the best powder was made from wheat meal (which was why it was heavily taxed in England from 1795, as wheat was needed to feed the army fighting the French); the finest powder was scented and came in a range of colours.[132] The final edifice was then decorated with feathers, jewellery or other ornaments; so complex and time-consuming was such a *tete* that it had to last as long as two weeks before it could be demolished and re-created anew.

on his ladder completes her coiffure. Mercier asserted in the *Tableau de Paris* that the art of coiffure in France was close to perfection[128] and, according to William Barker in a treatise dedicated to Georgiana, Duchess of Devonshire in 1780, the hairdresser (Barker dressed the hair of Sarah Siddons and other actresses) was more of an artist than the painter or sculptor:

> The painter, though an Apelles, leaves you only a figure without motion; nor can all his tints, his dyes, and touches, make that picture move. But when life and motion are added to the painter's beauty and the sculptor's grace, surely then the artist is invited to make the most splendid display of his taste and judgement; and though his work will decay like the most compact posey culled with judgement and arranged with taste, yet he will have the satisfaction of a temporary fame . . .[129]

In a sense, Barker might be said to have anticipated Schiller's idea that the creator of 'living feminine beauty' was more important than painted beauty; fashionable hair-styles were works of art. Hair has a peculiar function in relation to the body, for it is joined to it and separate from it as 'dead' matter; it is intimately related to the head, the most distinctive part of our appearance, and has perhaps transformative abilities equal to make-up. In the later eighteenth century, hair-styles (and women's wigs) were known as *têtes* (heads); they were widely advertised in newspapers, almanacs and women's magazines (fig. 135) for those who presumably had no regular access to the expensive services of a hairdresser. In *She Stoops to Conquer* the fashionable Londoner Hastings pretends to admire Mrs Hardcastle's 'head', wondering, tongue-in-cheek, if her *friseur* was a Frenchman; the reply is that she dressed it herself 'from a print in the Ladies Memorandum Book' (II). 'Hairdressing' implies that hair is treated like a dress and is to be seen as part of the *tout ensemble* when the head is 'dressed' with false hair – especially the case in the 1770s and 1780s. The hair-style was created by curling irons (or gummed water was applied to the hair, which was then put in curl papers), pomatum and powder, and this occupied as much time in the toilette as did dress itself. Of the list of toiletries offered by James Love (see fig. 115), half are items concerned with hairdressing; these include hair powders, scented pomatums, the 'Royal Auburn Liquid for thickening the Hair', 'Genuine Bears Grease', 'Black Hair Pins and Rollers', curling irons, 'Frizzing Combs', 'Powder Machines' and others. Fashionable hair-styles were not kind to the hair, so bear's grease was widely promoted as 'the only Thing possible to make the hair grow thick and long'; 'Ross's ornamental Hair and Perfumery Warehouse' in the city of London advertised (1792) that it had an 'Extraordinary Fine Fat Russian Bear', from which the fat could be cut off in the purchaser's presence so that he or she could see that it was real and not a fake.[130] Hair that was 'thick and long' was desirable for the complicated hair-styles of the 1770s and 1780s; to some extent pomade thick-

model, and specialist manuals were published. The figure of the French hair-dresser putting the final touches to his masterpiece was a feature of fashion plates and of caricatures; regarded on the one hand as effeminate, on the other hand he was likened to the staymaker as a man with too intimate a knowledge of his clients' bodies – the same accusation was levelled at the 'man-milliner' (couturier) of the mid-nineteenth century. This is perhaps the implication in a fashion plate from the *Gallerie des modes* (fig. 133), where the woman is clearly wearing no stays under her powdering mantle and reads a book called *L'Art d'aimer*, which cannot be identified – many books of poetry and prose were published with this title – or it could be a French translation of Ovid's *Art of Love*. A frequent theme of contemporary satire was to focus on exaggerated aspects of appearance, both male and female, and high hair-styles were popular subjects; the hairdresser on a ladder to dress a woman's hair seems to have literally been a standing joke, appearing in printed caricatures, porcelain figures and painted fans. The central vignette from a fan of the mid-1770s (entitled 'La Folie des Dames' (fig. 134)) shows such a scene, a woman seated at a table on which are the implements of the coiffeur – the curling irons, combs, brushes and long hairpins; the husband gazes at his wife's towering hair through a spyglass, while the juvenile hairdresser

134 French fan, gouache on vellum, with central vignette 'La Folie des Dames de Paris', mid-1770s. The Fan Museum, London, Hélène Alexander Collection

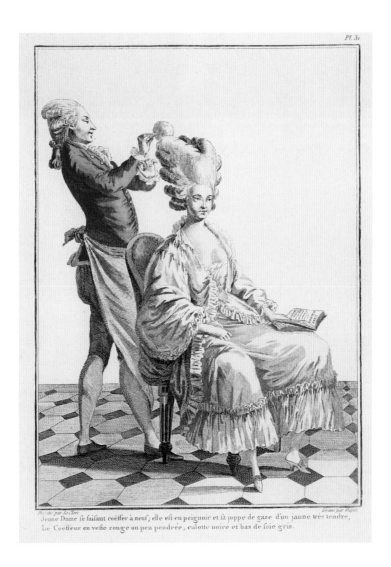

Pl. 31

Jeune Dame se faisant coëffer à neuf, elle est en peignoir et la juppe de gaze d'un jaune tres tendre, Le Coëffeur en veste rouge un peu poudrée, culotte noire et bas de soie gris.

late 1780s, many arbiters of female appearance declared that rouge should be used with economy, 'and only to animate the delicate whiteness of a beautiful skin',[127] for the wearing of too much was regarded as vulgar at best and the sign of a prostitute at worst. In any case, by the 1790s, rouge was inimical to the new influence of restrained classical taste and vanished (at least for a time), along with patches which disappeared for ever, apart from a brief revival in the mid-nineteenth century. Hair powder, too, declined in use in the 1790s, being regarded – like men's wigs – as too much part of *ancien régime* artifice, but during the late 1770s and throughout the 1780s, it was an essential part of the toilette.

As hair-styles became more complicated, professional hairdressing flourished, 'hair academies' were set up in the major capitals of Europe, after the French

painted faces and the large frizzed and powdered hair-styles in vogue through-out the decade – 'a fine head of hair is generally considered . . . as an essential part of beauty', pronounced *Hebe*.

Health alone, according to this beauty manual, gives 'fragrance to the lip, bloom to the countenance, and lustre to the eye',[125] but it can be mimicked by make-up. By the late eighteenth century, the word 'paint' no longer referred exclusively to lead-based products, though they continued to be used; traditional paint was popular, both on and off the stage, with actresses such as Robinson, due to its bright colours, opacity and superior adhesive qualities. Slightly less toxic cosmetics like Spanish White, and face powders (instead of liquid paint which 'affords a more shining varnish but totally stops the perspiration') were widely in use. So also were skin emulsions, that is, variants of the Virgin's Milk used in the Renaissance, but, instead of lead, a tincture of benzoin (a sweet-smelling balsamic resin) was precipitated with water; such 'milk cosmetics', *Hebe* noted, made 'the skin smooth, delicate . . . giving it a polished gloss'.[126] By the

131 (*above left*) Sir Joshua Reynolds, *Georgiana, Duchess of Devonshire*, 1780. Devonshire Collection, Chatsworth

132 (*above right*) Thomas Gainsborough, *Mary 'Perdita' Robinson*, 1783–4. Wallace Collection, London

she appeared to him as a woman with only 'promises of beauty in her' and he noted how her pale blonde hair was 'badly arranged'.[119] Four years later she was the new Queen of France, completely transformed into a sophisticated beauty; Horace Walpole was smitten by her appearance at a court ball: 'Hebes and Floras, and Helens and Graces, are streetwalkers to her. She is a statue of beauty'.[120] Henrietta Louisa, Baroness d'Oberkirch (also a client of Bertin), recalled Marie-Antoinette's appearance, her long face, aquiline nose and a mouth with 'a slight expression of disdain'; she had 'the Austrian lip in a higher degree than any member of her illustrious house' but a superb complexion, 'literally the mingling of the lily and the rose'.[121] The calligraphic portrait of Marie-Antoinette (fig. 130), engraved in 1787 after a drawing of 1780, shows a mature, slightly plump woman, with a high and elaborately arranged hair-style, decorated with a diadem, heron feather and floating gauze. In profile, her nose is definitely aquiline but Leigh Hunt remarked that she 'was not the worse for an aquiline nose; at least in her triumphant days, when she swam through an antechamber like a vision, and swept away the understanding of Mr. Burke';[122] in Edmund Burke's *Reflections on the Revolution in France* (1790), Marie-Antoinette was acclaimed as a tragic and beautiful heroine. In her 'triumphant days' she set fashions, most notably the simple white muslin chemise dress (popularised in England by Georgiana, Duchess of Devonshire and Perdita Robinson), which later became indelibly associated with the Neo-classical style; clothes, hair-styles and cosmetics were named after her. Ironically, the French Revolution created a diaspora of the fashion arts as aristocratic *émigrés*, along with dressmakers, hairdressers, purveyors of luxury goods and body servants flocked to European cities. Henri Meister, a Swiss who had lived many years in Paris before the Revolution, came to London early in the 1790s and noted how the appearance of Englishwomen had improved, owing to 'the united talents of Monsieur Léonard and Mademoiselle Bertin, not to mention a number of French *femmes de chambre* who have had the benefit of their skilful instructions'.[123]

Although *Hebe* declared that rules or proportions for beauty no longer existed, the author – in thrall to the conventions of writing on this subject, whether by philosophers or journalists – listed the features to be admired: the face should be longer than broad, a fairly high forehead, large and well-set eyes, a longish nose, 'full, firm and roundish cheeks' and a small mouth with 'lips moderately pouting'. The neck ought to be 'disengaged from the shoulders' and the bosom 'large, full and rising'; as for the complexion, the white and red signified the 'health and animal perfection' of beauty.[124] These characteristics are what one sees in portraits of the great beauties of the 1780s, such as Marie-Antoinette's friend the Duchess of Devonshire (fig. 131) and the actress Mary 'Perdita' Robinson (fig. 132; her nickname was derived from the part she played in Garrick's adaptation of *A Winter's Tale* in 1779); both these leaders of fashion of course have

Fashions in dress are linked to fashions in beauty, said Archibald Alison in his *Essays on the Nature and Principles of Taste* (1790) and these are due to 'the caprice or the inconstancy of the great'.[118] The 'great' may not have been naturally beautiful – possibly Alison had Marie-Antoinette in mind – but such women had the ability of self-presentation, to think themselves into beauty, aided by clever dressmakers and *visagistes*; the Queen of France, not conventionally beautiful with her Habsburg jaw and aquiline nose, was partly the creation of her modiste Rose Bertin and her most famous hairdresser Léonard (Léonard Autié). He first saw her when she arrived at Versailles as the new Dauphine in the spring of 1770;

Richard Payne Knight in his *Analytical Inquiry into the Principles of Taste* (1805), Greek sculpture offered 'standards of real beauty, grace and elegance in the human form and the modes of adorning it'.[114]

The years following the French Revolution were years of profound political, social and cultural change, reflected in widely differing opinions on all aspects of life, love and existence, including beauty and what value should be placed on it. The dramatist Friedrich Schiller, for example, in a series of letters *On the Aesthetic Education of Man* (1795), thought that an understanding of aesthetics was essential before humanity could become rational and moral. Schiller's views on beauty, as he admitted, are contradictory, for, having stated that beauty in the flesh should be privileged over beauty in art – 'Living feminine beauty will certainly please us just as well as, even somewhat better than, what is equally beautiful but only painted' – he then suggests that although the former is more pleasing, 'it pleases us no longer as absolute appearance, it pleases no longer the pure aesthetic feeling'; beauty is both the 'ideally Beautiful' of the imagination and the 'Beautiful of actual experience'.[115] With regard to 'living feminine beauty' Schiller does not elaborate; possibly, with the ideas of Lavaterian physiognomy as an aid to getting closer to God in mind, he thought that 'beauty' and 'truth' could best be discerned in the living, moving being, rather than in a static work of art. After all, as L'Isle André had noted in 1767, in a painting only one moment in time is seen, often the least part of an action or movement, which the artist wishes to recall to memory,[116] whereas with the real person, of whom the portrait is merely a simulacrum, we see a rounded human being in the flesh.

In the context of the brave new political world contemplated by the *philosophes*, and put into practice (to some extent, at least) by the French Revolution, there was a desire to forge a correspondingly new society, not just in France but all over Europe. This was reflected in clothing, the most obvious form of communication, in two ways: at a political level in France through the creation of national and official costume (for men only), and at a personal level in wider Europe by a search for greater truth in appearance after the perceived artifice of the *ancien régime*, a theme that was applied to both genders, although my concern here is with women. Fashion is a particularly sensitive barometer of the cultural climate and, as Walter Benjamin noted, 'the most interesting thing about [it] is its extraordinary anticipations': 'Each season brings, in its newest creations, various secret signals of things to come. Whoever understands how to read these semaphores would know in advance not only about new currents in the arts, but also about new legal codes, wars and revolutions'.[117] This is not, of course, to suggest that if one examines the fashions of the 1780s, the events of 1789 might be foreseen, but it is true to say that the greater simplicity in dress and appearance which characterised the end of the century began in a modest way in the decade before the French Revolution.

Facing Beauty

until the early nineteenth century, both for medical use (to hide sores or scars and as relief for migraines and toothache) and as beauty spots. Goya's portrait of the Duchess of Alba of 1797 (fig. 128) shows her with a large black patch by her right eye, worn probably to emphasise the startling contrasts of her beauty, with its high colour, black arched eyebrows and mass of black hair (fig. 129); to complete her theatrical appearance, Alba wears *maja* costume, Andalusian in origin, which had become 'national' Spanish dress, worn here possibly to suggest nationalist and anti-French sympathies resulting from the events of 1789. She was famous for her striking beauty, a French visitor noting in the 1780s: 'The Duchess of Alba possesses not a single hair that does not awaken desire. Nothing in the world is as beautiful as she . . . When she walks by, all the world stands at the window'.[111] Almost certainly she awakened desire in Goya, who had a special relationship with her and on one occasion actually painted her face when she came to his studio; 'I definitely prefer this to painting on the canvas', he wrote to his friend Martin Zapater.[112]

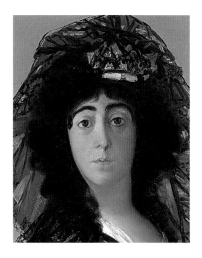

129 Francisco Goya, *Duchess of Alba* (detail of fig. 128)

Beauty and Truth

> Female beauty, so far as it respects the face, can have no influence founded in truth and nature but . . . as the complexion or symmetry of features denotes health . . . and [reflects] mind or soul. [There is no] general characteristic of beauty; for the ideas and sensations of different persons vary according to their different turns of mind . . . and the effect of objects upon these ideas and sensations vary in the same manner; and thus arise the different opinions respecting, not only personal beauty, but painting, statuary, and literary composition . . .
>
> *Hebe; or The Art of Preserving Beauty*, 1786

Beauty, according to the author of *Hebe*, is 'that pleasing effect which arises from the harmony and justness of the whole composition' but no longer were there any rules, for 'the most charming faces, and elegant forms frequently, nay generally, deviate from these established proportions'.[113] This 'definition' is indebted to Burke's notion of beauty as no longer requiring symmetry but able to be varied in its appearance, and to Kantian ideas of beauty as the judgement of personal taste. However, by the 1780s the implication was that variety and divergence from conventional ideas of beauty was the rule rather than the exception; moreover, one should judge female beauty as one might assess literature and the arts of painting and sculpture. Indeed, critics urged women to wear the 'classical' dress and adopt the simpler (relatively speaking) hair-styles seen in the works of artists such as Reynolds and David, an idea which came to fruition in the 1790s, along with the inspiration of antique sculpture on female appearance: for

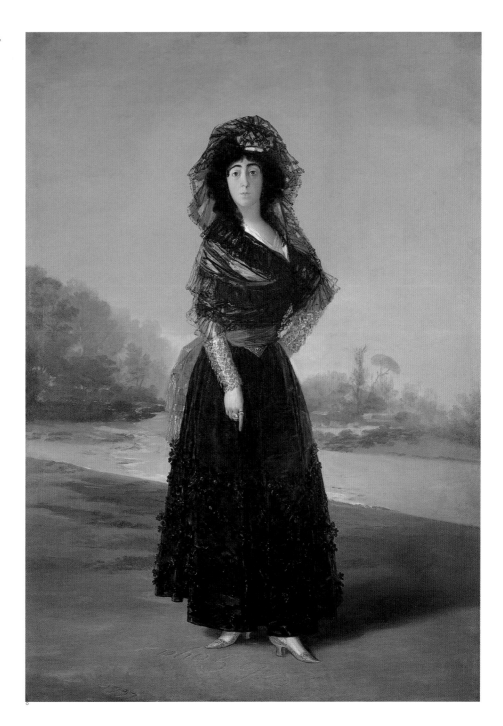

mole or a small patch,[110] referred to in *Abdeker* as 'gallant'; the original French word 'galant' better expresses notions of gaiety, flirtation and love intrigues. Patches in most of Europe had disappeared by the 1790s but remained in Spain

where a woman wears a patch. Only one English example comes to mind, and this is Gainsborough's half-length painting of Grace Dalrymple Elliott (fig. 127), who was famous for her beauty, her height (she was known as Dally the Tall) and her lovers, who included the Prince of Wales; the portrait was exhibited at the Royal Academy soon after Elliott had given birth in the spring of 1782 to a daughter, whose father she claimed was the Prince. Gainsborough depicts the frizzed and powdered hair and the obvious artifice of the complexion, of a fashionable woman of the world, a *demi rep*; in the middle of her cheek is either a

wearing of patches by associating each one with a silent romance; telling stories creates intrigue and arouses interest in the reader. When Abdeker, as professor of *maquillage*, painted Fatima's cheeks with rouge, a fly came and sat on her face at 'the exterior Angle of [her] Eye'; both admired the way that the fly made her eye 'look more lively and amorous', so Abdeker cut 'a Patch of black Taffety, which was cover'd with Gum Arabic, and cut it in the Form of a Lozenge, and applied it to the Spot where the Fly had been placed'. Then Fatima cut out a patch in the shape of a half-moon and applied it to her temple, followed by Abdeker who placed a star-shaped patch on her cheek; Fatima gave names to the patches, such as: on the forehead 'majestic', in the middle of the cheek 'gallant', by the lips 'coquet' and so on.[107] Patches were made of silk, usually taffeta or velvet, and gummed with an adhesive such as isinglass (a form of gelatine), and came in various shapes, as a selection of extant examples indicates (fig. 126).[108] As they were worn at court, 'Court Plaister' was a contemporary term, and as such they are listed among the goods for sale by James Love at his premises in the fashionable Haymarket in London (see fig. 115). Magazines gave advice on the wearing of patches, the *Lady's Magazine* for 1759 declaring that it was vulgar to put patches near the eye and the mouth and that only one or two patches should be worn (Morland's *Fair Nun* (see fig. 120) has six on her mask); women of taste 'place one large patch upon the temple, with a very little one near its edge, and no more'.[109]

Wearing patches, therefore, was a minefield through which the wearer had to tread carefully, avoiding accusations of sexual invitation (patches were 'stratagems of lust', according to the *Grand Magazine* in 1760) and – perhaps worse – of vulgarity; this is the only reason I can think of for the lack of identified portraits

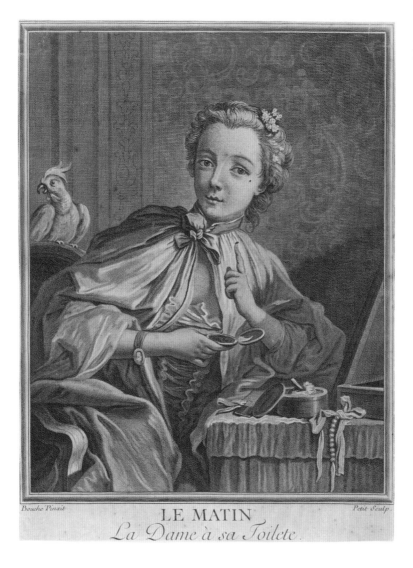

125 François Boucher (engraved by Gilles Edmé Petit), *Le Matin*, *c.*1745. British Museum, London

LE MATIN

La Dame à sa Toilete.

its mildly titillating subtext (the glimpse of nipple revealed by the décolletage of her dress beneath the white linen peignoir), might have been commissioned by her lover, or intended for him. The painting must surely be related to an engraving after Boucher, entitled *Le Matin* (fig. 125), from a series of four paintings of the Four Times of Day commissioned in 1745 by the collector Count Tessin, the Swedish ambassador to France from 1739 to 1742. Patches were a kind of face jewellery which drew attention to the good points of the face and supposedly had their own language; a patch by the eye, as in both these images, was known as 'killing'. At least, this is what *Abdeker* says, where each patch 'had a name answerable to the Effect it produced', a clever device to encourage the

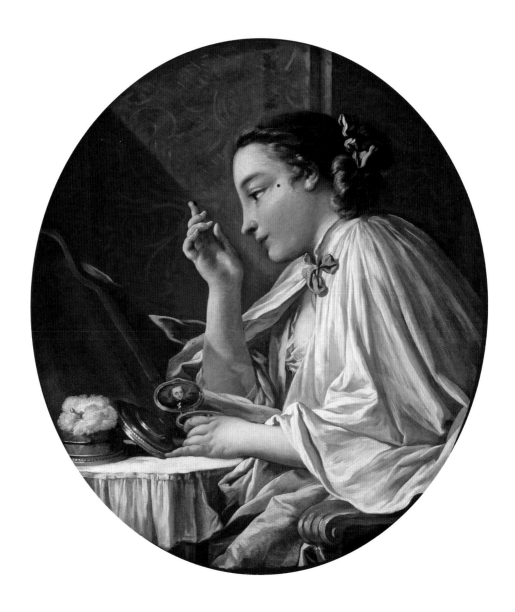

François Boucher, *Une Dame à sa Toilette*, *c*.1745. Private collection

Traditionally, Venus was supposed to have had a mole which inspired the patch but, according to this beauty manual, Helen wore a patch which heightened her beauty, made Paris fall in love with her and caused the Trojan War.[106] Patch boxes – of gold or silver, porcelain, ivory, enamel, hardwood or *papier mâché* – were on every fashionable woman's dressing table, and sometimes carried in their pockets, in case patches needed to be replaced or repositioned. Patch-boxes were sometimes gifts from a lover and contained his miniature, as can be seen in Boucher's painting *Une Dame à sa Toilette* (fig. 124), where the final touch is being added to the painted complexion. The theme of the painting – a woman made up with professional skill, holding a patch on the index finger of her right hand – with

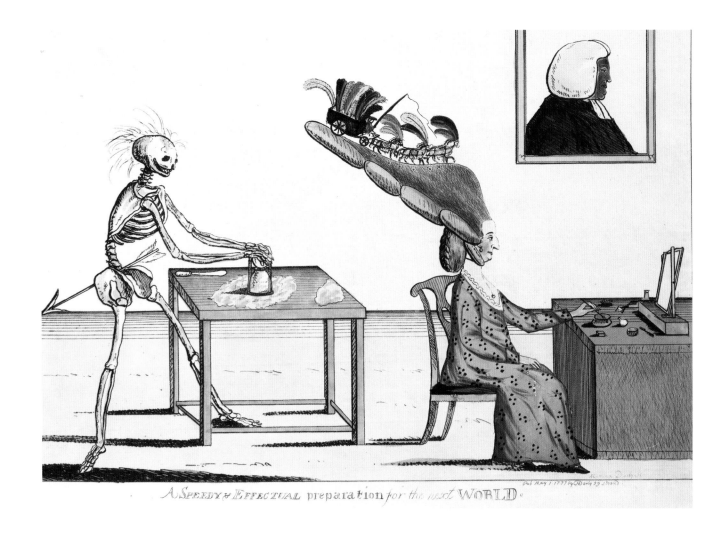

A SPEEDY & EFFECTUAL preparation for the next WORLD.

false eye-brows, false plumpness, and false colour, merely to have it said, she is a very good looking woman of her age'.[105] Those who rebelled against this accepted wisdom, especially prominent women, might find themselves caricatured, like the republican historian Catherine Macaulay in *A Speedy & Effectual preparation for the next World* of 1777 (fig. 123), where she is depicted as an old woman (she was forty-six) adding rouge to her complexion, oblivious of death due – the image suggests – to poisonous face paint (although in fact she lived until 1791). The high feathered hair-styles of the later 1770s were a gift to the caricaturist; here the brightly coloured feathers worn by the horses pulling a funeral cortege are used to symbolise her folly.

A number of images in this chapter show women wearing patches, and these were regarded as essential to the beauty of the made-up face. According to the *Manuel de la Toilette* (1771) some large patches had tiny brilliants (diamonds).

123 *A Speedy & Effectual preparation for the next World*, 1777. British Museum, London

This advertisement for what was probably a version of the well-known Liquid Bloom of Circassia, was cleverly contrived to appeal to those interested in the antique and to those who liked a story hinting at the sale of secret formulae, not unknown in beauty advertising in today's magazines.

Yet while outright fakery in such advertisements was probably recognised by all but the highly gullible, the notion of deceit in dress and in appearance was a general concern in the century. When it was accepted that women of fashion wore make-up, how could one always tell if this was *not* the case? In Daniel Defoe's last novel *Roxana* (1724), when the heroine's princely lover hesitates before wiping away her tears, thinking he will spoil her make-up, she pretends to take offence by swearing 'I have not deceived you with false colours'; she makes the prince wipe her face vigorously to prove it, causing him to declare that 'he could not have believed there was any such skin, without paint, in the world'. This may have been hyperbole but skilled courtesans like Roxana would have been expert in painting the face so that it looked unpainted, guaranteed to appeal to men who thought they preferred a 'natural' face in a woman. The more obvious question was: how could one tell if a woman was really beautiful if she wore too much paint? A writer in the *Gentleman's Magazine* for 1736 referred to the obligation placed on even beautiful women to paint themselves: 'Those who are indebted to Nature for a fair Skin find themselves obliged to lay on red. Those to whom Nature hath not been so liberal, make no Difficulty of daubing their Skin all over; and if White is not sufficient, they add Blue, and streak their Veins with it. So that nothing is left for real Beauty to distinguish itself to Advantage'.[102] The poet William Cowper pursued the idea of deceit in make-up, by asking how far the eye was really deceived if the face was overly made up. In France, according to his argument, women's use of paint was not intended to mislead because the artifice was too obvious; Englishwomen, however, tried to mislead by more subtle make-up, for they wanted 'to be thought beautifull, and much more beautifull than nature has made them', and so they were 'guilty of a design to deceive'.[103] So, whether women painted obviously or with restraint, they might be blamed for a 'design to deceive'. Another paradox affecting women of all ages was that cosmetics when worn by young women created a more sophisticated, experienced and, by implication, an older image; really older women, of course, imitated a youthful appearance in their use of paint. In England, certainly, older women were often criticised for continuing to wear cosmetics; Bishop Berkeley (1714) wrote: 'What a Curse it is to Ladies, to have this Pride of Beauty last when they are old. How ridiculous is it in them to confound Age and Youth, to fill up and hide the Breaches of Time with Patches and Paint'.[104] The *Lady's Magazine* suggested that women over the age of forty ought to be grateful that 'the everlasting labours of the toilette are over'; a sensible woman, the editor claimed, will no longer subject herself to 'false teeth,

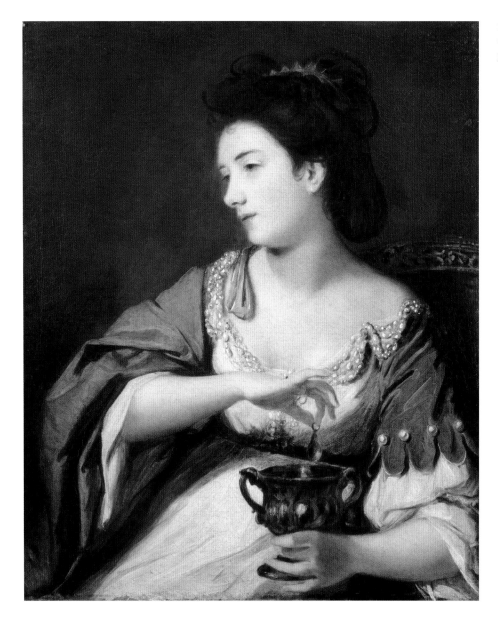

Cleopatra, was the most beautiful Female that flourished in Ancient Times; but Attractive as her Charms might be, yet they were in a great Degree improved by Art'; her doctors 'composed a Cream from the most innocent Vegetables which grow on the fertile Banks of the Nile; by the use of which, her Complexion exceeded the lovely Tint of the Lily, and the beautiful Tinge of the Rose', and this recipe, 'found in the Ruins of Herculaneum', has now been purchased from 'an English Gentleman, whose Name we are not at liberty to divulge'.[101]

gests the damage done by the continual application of lead-based paints which ate into the skin, caused teeth and hair to fall out and eventually led to death; there was no testing of such products on health grounds, but by this time the risks were well known. Moving from the top left, the woman (Lady Archer, a member of the Prince of Wales's coterie, famous for her gambling and for her 'cosmetic powers'[99]) places a wig on her bald head, inserts a glass eye, then a set of false teeth and paints her face. This *lever* will turn into the *coucher* at night, when – as Swift cruelly describes it – she will remove 'her artificial Hair', then 'picking out a Crystal Eye,/ She wipes it clean, and lays it by', pulls off her 'Eye-Brows from a Mouse's Hyde', takes out the plumpers from her cheeks and 'Untwists a Wire; and from her Gums/ A Set of Teeth completely comes' (*A Beautiful Young Nymph Going to Bed*, 1734, from ll. 10–20). False teeth could be made of bone (ivory was too prone to discolour) attached to wire but the best were 'live' teeth bought from the poor (a caricature by Rowlandson, *Transplanting of Teeth* of 1787, shows this process); from the 1790s, porcelain teeth, invented by a French dentist, were available but only to the wealthy.

'Let her paint an inch thick, to this favour she will come' is Hamlet's famous comment to Horatio when contemplating Yorick's skull, and Rowlandson's subject is almost a skull before her transformation makes her believe that fakery can make time stand on its head. Yet the problems posed by face paint were not merely about deception but about the dangers which could result in death, a fate which was the lot especially of fashionable beauties and beautiful courtesans. Maria Gunning, Countess of Coventry, died of lead poisoning and so, according to the contemporary press, did the beautiful courtesan Kitty Fisher, although consumption has also been suggested. Fisher's early career as a milliner gave her good dress sense to add to her beauty and she had a number of love affairs, including a liaison with Gunning's husband, the Earl of Coventry. Marwick argued that Fisher's career 'demonstrates both the potency of beauty, and . . . the "celebrity effect"; it is also suffused with that sense of tragedy insisted upon in so much of the folklore about beauty being no real blessing for a woman'.[100] Reynolds's portrait of Kitty Fisher as Cleopatra (fig. 122), dissolving in wine a large pearl taken from her ear in order to impress Mark Antony, shows her in a high-waisted dress *à l'antique* (to suggest the past), under a blue garment with scalloped sleeves, which hints at English coronation costume (to indicate royalty). There is a sense of theatre about the image, particularly the stage jewellery, a paste pearl decoration to the neckline of the dress, a fake gold diadem in her looped-up hair; the artist (one of her many admirers) presents her as though she is on the stage, heightening the matte white of her face to give her a ghostly beauty. Cleopatra's name was sometimes invoked to recommend beauty products; in a late eighteenth-century advertisement for 'Cleopatra's Beautifying Lotion', the reader is informed: 'It is well known that the Egyptian Queen,

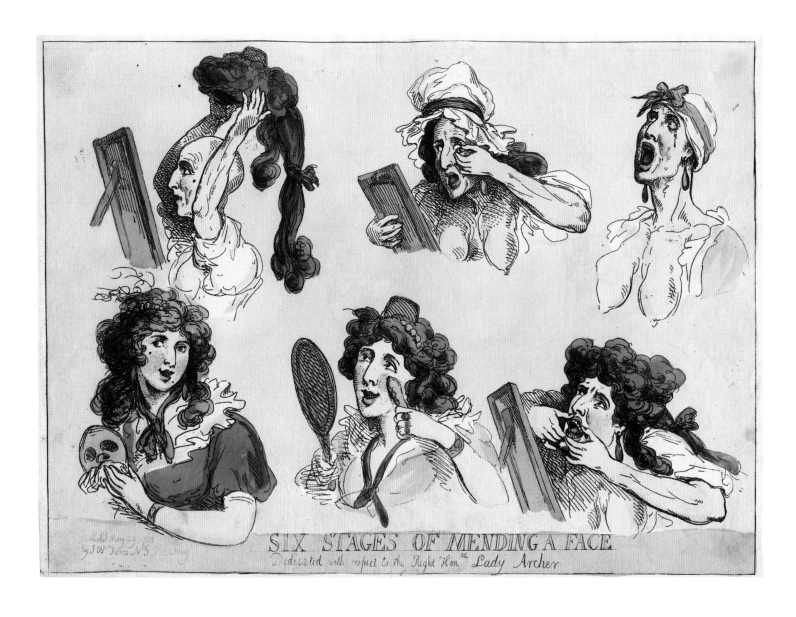

121 Thomas Rowlandson, *Six Stages of Mending A Face*, 1791. Lewis Walpole Library, Yale University, New Haven, Conn.

eighteenth-century slang for a prostitute) and that of the deceit created by face paint; this is not an actual mask worn as part of fancy dress but a 'real' face, expertly made up and profligately patched. Mikhail Bakhtin noted how the concept of masking had changed in the eighteenth century from 'the oneness of the folk carnival' to the ways in which 'the mask hides something, keeps a secret, deceives'.[98] It is therefore appropriate that in Rowlandson's *Six Stages of Mending A Face* of 1791 (fig. 121), the re-created 'beauty' is shown, in the final stage of her metamorphosis, holding a mask, so as to underline for the viewer, as if it were needed, that the whole edifice is built on deceit. The caricature sug-

likened women's use of paint to that worn by the Native Americans; such a
masque de fard was, admittedly, more truthful in terms of the colours of the face
than the paint worn by the Indians, he claimed, but none the less it was still a
mask and would appear ridiculous to us if we were not accustomed to seeing
more masks than faces around us ('si nous n'étions accoutumés dans le monde
à voir plus de masques que de visages').[97] Henry Morland's beautiful and enig-
matic painting *The Fair Nun Unmask'd* (fig. 120) may be a critique on make-up
as mask, for the beautiful 'Nun' suggests the idea of disguise on two levels, that
of a popular masquerade character with implications of immorality (a 'nun' was

tude of features.[92] This can present a problem for the historian of visual culture, for – given the dislike of many (perhaps the majority) of artists for make-up, especially later in the century – how can one always determine the artist's contribution to the likeness of the face, especially if the sitter was a fashionable woman wishing to be immortalised in beauty of dress and face? How much face painting was there meant to be in a painting of a face?

Mechtild Fend states the obvious in observing that from the Renaissance to 'the emergence of bourgeois modernity', there developed 'a new attention to the visual appearance of the body', especially in the period of the Enlightenment, but she rightly comments on how 'skin and face become metaphorically associated with painting, canvas or paper'; she quotes from Diderot's *Notes on Painting*, where he likens the 'human visage' to a 'canvas that becomes excited'.[93] In an article in the *Mercure de France* (1755) Cochin suggested, not altogether tongue-in-cheek, that women might like to have themselves made up by artists painting in pastels.[94] Pastel paints were crayons of powdered pigment mixed with weak gum water and similar to some cosmetics; certainly, pastellists could create the pearlised look seen in Coypel's portrait of the Marquise de Lamure (see fig. 101). The theme of women's paint being akin to the plaster on houses or in works of art such as frescoes, or sculpture, can be traced right through the Renaissance and into the Enlightenment. Satirical comments abounded, especially in mid-eighteenth-century English journals, of women who 'make use of a superfine stucco or plaister of Paris highly glazed, which does not require a daily renewal', and whose pearl powder is fixed with varnish, just like a painting (*The World*, 1755). Another writer criticised women whose faces were so 'crusted over with plaister of Paris . . . that when I am in a group of beauties, I consider them as so many pretty pictures: looking about me with as little emotion, as I do at Hudson's' (*The Connoisseur*, 1754);[95] Thomas Hudson was known for his formulaic portraits, more uniform than individual.

Paint and cosmetics, especially the former, when heavily applied, could create a mask which made it difficult to move the face, which – as in a portrait – remained frozen; Richard Steele refered to 'Picts', that is, painted women who were beautiful but with 'dead, uniformed Countenances' and 'fixed Insensibility' (*The Spectator*, no. 41, 17 April 1711). In *The Chinese Spy*, Goudar noted how 'the face, which represents the soul, has only one decoration; the passions are mute, and there is an end of all expression of surprise, as well as of the other emotions of the mind'. At a time when masquerade was a powerful cultural impulse, the word 'mask' was employed frequently in connection with face paint; Goudar in his character of the 'Chinese' outsider, declared that women wore masks of white and red (created 'in a little pot . . . the lilly complexion comes from Spain, and the rosy from Italy'), 'so ingeniously made, as to imitate faces, and strangers continually mistake them'.[96] Yves Marie de l'Isle André's *Essai sur le beau* (1767)

119 (*facing page*) François Boucher, *Madame de Pompadour at her Toilette* (detail of fig. 111)

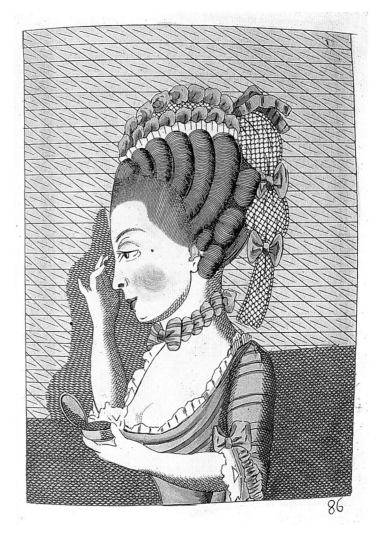

Not all artists and writers on art agreed. Gérard de Lairesse's *Art of Painting* declared that modern painting could not 'be accounted Art, where Nature is simply followed'; nature has be 'corrected and improved', just as women did with make-up.[90] How did an artist, then, 'improve' on nature? When painting a Helen, or a Venus, the aim was universality based on the antique, according to Allan Ramsay's *Dialogue on Taste* (1755); the result was often a blandness which, 'although it might charm few, would disgust nobody'.[91] Portraitists, however, had to steer a *via media* between the canons of ideal beauty and what at times must have seemed a caricature created by cosmetics; sitters, averred Cochin, placed a high value on verisimilitude but artists had different ideas as to what constituted 'likeness', which sometimes they interpreted more as character than as exacti-

117 and 118 Plates 72 and 86 from Jean Legros de Rumigny, *L'Art de la Coëffure,* 1768–70. Private collection

ing training to ladies' maids and to those wishing to become professional hair-dressers; in the late 1760s, his five-volume *L'Art de la Coëffure* was published and sent by him to all the courts of Europe. Appropriately, perhaps, he died by being crushed to death in the Place Louis XV during the celebrations in Paris in the summer of 1770 for the wedding of the future Louis XVI and Marie-Antoinette. The plates from his *magnum opus* (figs 117 and 118) show the complexity of the fashionable hair-styles at this period and the necessity for equal artifice in the appearance of the face, especially rouge.

In the mid-1760s, *The Chinese Spy* likened Parisian women to 'so many furies', their faces 'red as scarlet' from their use of rouge (applied to the lips as well as to the cheeks), whereas Englishwomen have 'a studied paleness . . . a premeditated negligence'; 'in company with English women I seem to be in an apartment of pictures of beauties, to each of which the painter has given a different attitude, and nothing but speech is wanting'.[84] Such pale and negligent beauties (as in the portrait of Anne Horton) were less in fashion by the 1770s, for Englishwomen – along with a greater use of hair-powder – began to wear rouge and not just on formal occasions. For English critics, too obvious an application of paint, especially rouge, suggested the *demi-rep* (literally, a woman with only half a good reputation, the equivalent of *demi-mondaine* in the nineteenth century) or at least the coquette. Female modesty, it was suggested, suffered as a result, for under the mask of 'conscious crimson' (Gay's definition of rouge in *The Fan*), women had no need to blush. In his *New Lecture upon Heads* (1772), Stevens believed that for women to 'vermillion themselves . . . looks as if they would fish for lovers, as men do for mackerel, by hanging something red upon the hook'.[85] The *Morning Chronicle* in 1778 claimed that Gainsborough gave his female portraits 'that sort of complexion laughingly called in the *School for Scandal* as "coming in the morning, and going away at night", than to blend properly speaking, Nature's own red and white';[86] the reference is to the comment made by Lady Teazle in a famous scene in Sheridan's play.[87] Rouge served to enliven the complexion and, according to Casanova, animated the face by giving it an 'amorous fury'; all shades from bright red to pale pink were available, and by 1781, two million pots were used each year in France, the most exclusive made by a Mlle Martin in Paris and supplied, according to the Baroness d'Oberkirch in 1786, in Sèvres porcelain to 'all the female sovereigns of Europe'.[88] The advertisement for the cosmetics and toiletries sold by James Love (see fig. 115) offers the 'Finest French Rouge', 'Carmine' (mixed with starch powder, it produced various shades of pink) and 'India' and 'Spanish' wools (loose 'cakes' of rouge 'like carded wool'); 'Chinese Powder' came from boxes of coloured powders, white and red, and black for the eyebrows.[89]

It all sounds like an artist's palette and it was in portraiture that women wished to see reflected their status and beauty, as the best face they might see in a mirror.

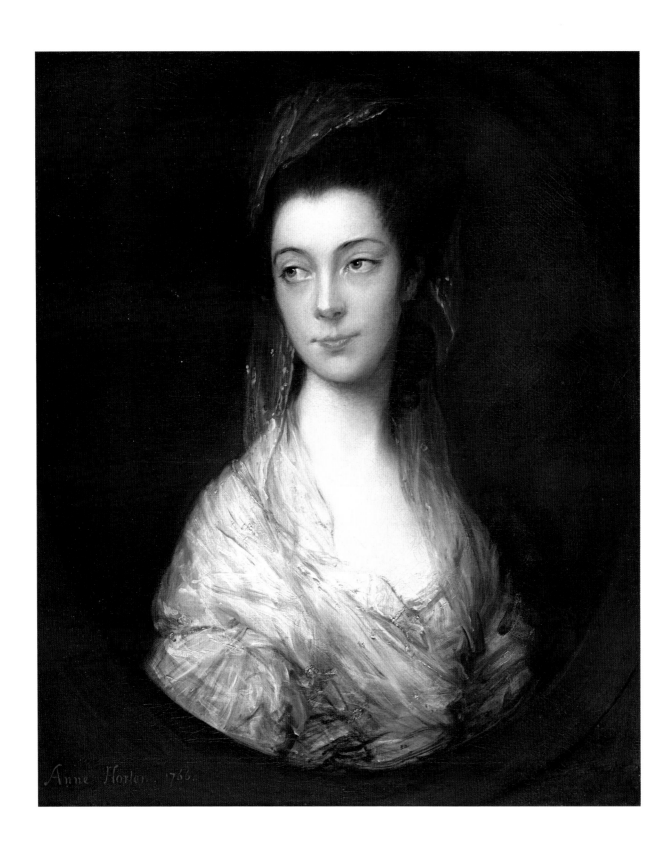

comprehensive list of cosmetics published in the *Statutes of the Realm* in 1786. With the costly war against the American colonies, the British government need for increased revenue led to a tax on all toiletries, including 'Sweet Scents . . . Perfumes and Cosmeticks' and every kind of 'Preparation or Composition for the Hair'. All sorts of 'Powders, Pastes, Balls, Balsams, Ointments, Oils, Waters, Washes, Tinctures, Essences, Liquors' for making up the face are listed; of the many face powders, some are named after leaders of fashion and beauty, such as Georgiana, Duchess of Devonshire and Queen Marie-Antoinette (see figs 130 and 131). French taste in cosmetics dominated Europe by mid-century, apart from Britain where an anti-French agenda occasionally promoted native 'simplicity' versus foreign artifice, by which was meant a too obvious use of paint on the face, and hair tightly curled and powdered. Joseph Spence in *Crito* declared that Frenchwomen were too fond of 'covering each Cheek all over with a burning Sort of red Color' so that they looked like 'a long Bed of high-colored Pionies in a Garden'; English beauties, on the other hand, were 'like a Bed of Lilies; or . . . like a Border of light-color'd Pinks'.[79] In *Beauty: A Poetical Essay* (1766) the author praised Englishwomen for the white lustre of their skins and 'unaffected grace' of their hair, which he compared favourably with the 'too refin'd taste' of 'proud Versailles', where women adopted 'the false varnish of a crimson dust'.[80] In the same year, a Scottish clergyman, James Fordyce, published *Sermons to Young Women*, in which he equated French art with the 'Gothic style', where artists 'load their women with jewels, trappings, and other embellishments, magnificent indeed, but tawdry';[81] this recalls Cochin's preference, as stated earlier in this chapter, for the simplicities of dress that he saw in English portraiture. If one compares Boucher's portrait of Mme de Pompadour with Gainsborough's *Anne Luttrell, Mrs Horton* (fig. 116), it is clear what critics of French artifice in appearance meant, for Horton is presented in simple gauzy draperies, vaguely Greco-Turkish in style, an 'antique' veil over her head, and is lightly made up, her lips just touched with pink. She was not regarded as conventionally beautiful but when in 1771 she married the royal Duke of Cumberland, Horace Walpole reported that she had 'the most amorous eyes in the world, and eyelashes a yard long. Coquette beyond measure, artful as Cleopatra, and completely mistress of all her passions and projects'.[82] Pye's *Poetical Essay* of 1766, critical of the over-refined taste in female appearance at court in Versailles, mentions the increasingly elaborate hair-styles in vogue; the *Chinese Spy* pokes fun at the pomatum, scented wax or fat ('five or six ounces of ointment'), which was added to the hair to thicken it and make the powder ('two or three pounds of a white dust') adhere and which was then decorated with head ornaments such as 'pompoons'.[83] 'Pompoons' is a reference to the style set by Pompadour (*pompons* were small hair ornaments such as flowers, feathers, ribbons or jewels). Her hairdresser, Jean Legros de Rumigny, opened the first hairdressing school in France, offer-

116 (*facing page*) Thomas Gainsborough, *Anne Luttrell, Mrs Horton*, 1766. National Gallery of Ireland, Dublin

115 Advertisement for James Love's *Italian, French, and English Perfumes and Powders, With a Variety of Choice and Curious Articles*, late eighteenth century. Bodleian Libraries, University of Oxford, John Johnson Collection

utensils for curling and dressing the hair and, later in the century, pads of false hair, and so on, for this list is by no means exhaustive. What appears on contemplating Boucher's *Mme de Pompadour at her Toilette* is how unnatural she looks, but these vivid contrasts of white and red signified an elite indolence; Cochin referred to this as the 'manière noble', with 'sharply contrasting areas of white powder and spots of rouge', as distinct from the 'manière bourgeoise', which looked more natural.[76]

False colours

In the middle decades of the eighteenth century, the artifice of beauty reached its height, with a continued use of lead-based products; in *Abdeker* (as in similar works by Le Camus's contemporaries) recipes for white and red paint continued to be published, although usually with warnings as to their dangers. For everyday use, pearl powders, either made of real pearls which were costly but gave a creamy-white glow to the skin, or made of bismuth with chalk or starch (Spanish White), were less harmful than paint, but were not as effective, being not as opaque.

Although smallpox continued to blight women's beauty (but far less than had been the case in the Renaissance), women's skin generally improved as a result of variolation; 'I vow', says Mrs Hardcastle in Goldsmith's play *She Stoops to Conquer* (1773), 'since inoculation began, there is no such thing to be seen as a plain woman; so one must dress a little particular or one may escape in the crowd' (III). With the improvement in women's complexions, more attention was given to the skin and advertisements began to use the word 'nourish' to suggest the need for skin care rather than skin coverage; *Abdeker* suggested veal slices as good 'for keeping the Skin supple, and preserving a fresh Complexion', and also a night face-mask of crushed strawberries, washed off the following morning with 'Chervil Water', after which 'the Skin becomes fresh and fair, and acquires a beautiful Lustre'.[77]

As for the cosmetics themselves, domestic production continued well into the eighteenth century but an increasing number of professional preparations were available and brand names began to appear with some regularity in advertisements. By 1786 a beauty manual entitled *Hebe* (named after the goddess of youth) recommended women not to follow recipes which were 'often dangerous, often absurd in their composition, and generally useless'[78] (yet lotions with ceruse and quicksilver were recommended for 'difficult' skins unresponsive to safer remedies). Instead, women were urged to buy cosmetics from the chemists or druggists who had formerly supplied apothecaries but were now opening shops and trading on their own account; the increasingly wide range of cosmetics and toiletries available is evidenced in contemporary advertisements (fig. 115) and in the

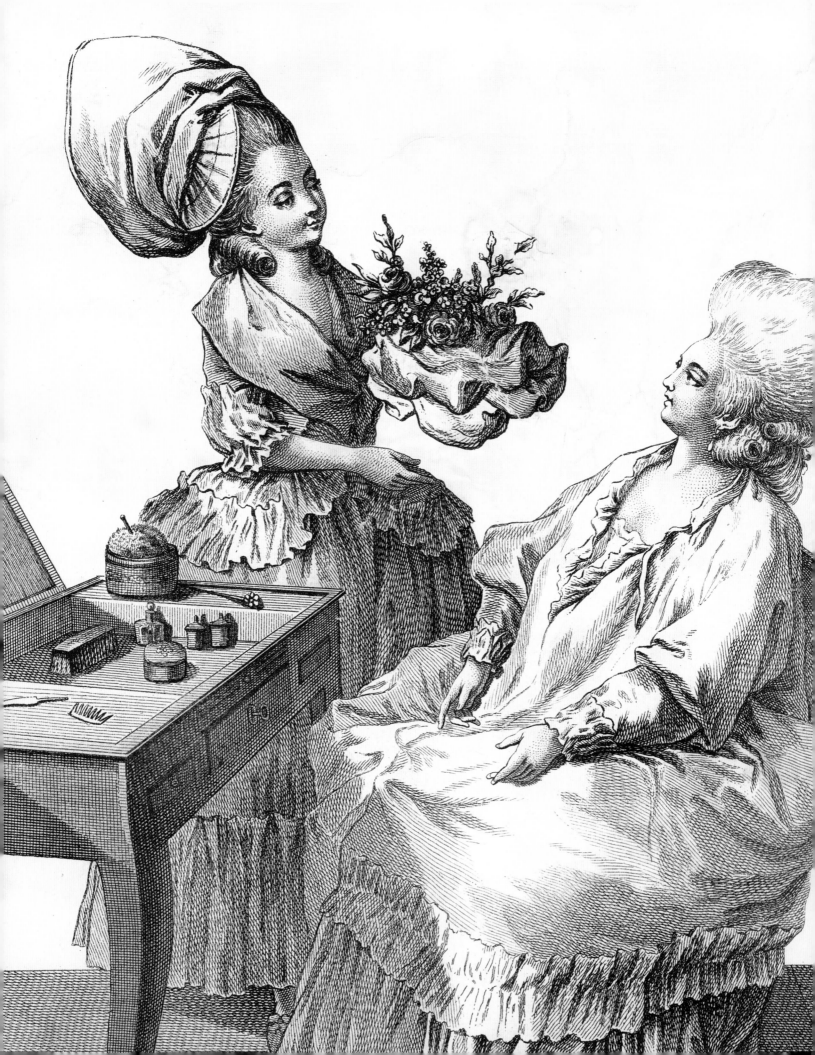

113 Sèvres porcelain toilet service, 1763. Wallace Collection, London

in 1764 (fig. 113); the complete set consists of two powder boxes, two pomade pots, two patch boxes, a clothes brush and a powder brush. A pomade pot (either for the face or the hair) is at the top right; next to it a powder box, and the patch box is bottom right; in the centre is a clothes brush, and the other item is a *vergette* for cleaning combs and brushing away any hair powder on the clothes. A complete toilette set would include many items for beautifying the face and body, such as glass bottles for bath unguents, floral waters and scents, porcelain containers for skin lotions and paints, boxes for hair and face powder, for powdered rouge, pots for liquid rouge and lip salves, for scented pomatums for the hair, and for kohl which was used on eyelashes and as eye-liner. (Alternatives to kohl as mascara (from the Italian *maschera*, mask) included non-toxic substances such as lampblack, soot, burnt matchsticks, oak galls and castor oil.) A woman of fashion would also need eyebrow pencils, lead combs to darken the eyebrows,

114 (*facing page*) Claude-Louis Desrais, 'Jolie Femme en Peignoire à sa Toilette' (detail of fig. 103)

112 Charles Germain de Saint-Aubin, 'Pomade pour les levres' *c.*1740–*c.*1775. Waddesdon Manor, Aylesbury, Bucks., The Rothschild Collection (The National Trust)

Pomade pour les levres inventée par Madame La Marquise de Cr....

pronounced; the bidet behind the chair suggests that this is the *première toilette*, before company was admitted, and the monkey collects its excrement to add to the pot it holds. As noted, cosmetics sometimes included what to us now might seem disgusting and improbable ingredients, so the monkey excreta suggested here should not surprise us; after all, the anal gland of the African civet cat produced, until fairly recently, an essential ingredient for scent.

If this is intended to represent Pompadour's toilette, the items on the dressing table would be of the most expensive and luxurious kind, such as the Sèvres porcelain set probably intended for the marquise but left incomplete on her death

appears merely 'personable'; this is the word used by Arthur Marwick in his *Beauty in History*, where he saw her as just 'an attractive woman with an agreeably oval face, but slightly undistinguished features'.[71] Boucher's achievement, however, is to fix her for all time as the ideal Rococo beauty, whether specifically in his portraits or as the inspiration for a favourite subject, the *Toilette of Venus*, where the goddess has the delicately powdered hair, the pearly white skin and the lightly but definitely made-up face of an earthly deity. Whether Boucher's portrait of Pompadour is to be seen as a power strategy or just as an image of elite making-up, it is certainly the apogee of the Rococo toilette. As we see the marquise at her toilette, a lace-edged white peignoir over her shoulders, the elaborate process of self-creation is over; white paint and powder has been applied, red added to the cheeks and lips, eyebrows pencilled, and the hair has been lightly powdered and a *pompon* (a hair ornament named after her) of blue flowers placed at one side. The artist shows her holding a box of rouge (almost empty) and the brush which has applied it, for this was the finishing touch to the complexion, the final act of theatre. It was necessary to add colour to the face which might otherwise look too pallid, especially when the hair was powdered; but it also symbolised the supremacy of French taste and refinement in the cosmetic arts. Rouge was picked on also as a sign of Pompadour's importance in politics – 'l'art de se mettre le rouge, qui est devenu une chose si importante dans l'état', was the artist Cochin's comment.[72] The red of rouge signalled power, authority and – bizarrely, given the dangers of the lead-based product – health; to Thomas Carlyle, Pompadour was famously a 'high-rouged unfortunate female' and on her deathbed her 'final act, after receiving the last rites from her priest, was to rouge her face'.[73] In the *Chinese Spy*, published safely outside France, Goudar had the eponymous hero remark: 'It is an established custom in France that the monarch's bed and the management of public affairs go together'; as an important royal favourite, fashion items such as ribbons and fans and 'every rag on a woman's toilet is now in the pompadour taste', and he wondered 'whether a pompadour bed be not fixed in such a manner as to give more delight to the senses than any other'.[74] Inevitably, there was considerable critical comment on the influence of the royal mistress; seduction, notes Lynn Festa, has 'political consequences in France, since beauty allows non-aristocratic women like Louis XV's mistress, Madame de Pompadour, to gain dominion over the King'.[75] Pompadour's very cosmetics were ridiculed, as in the illustration entitled 'Pomade pour les levres' from the *Livre de Caricatures tant Bonnes que mauvaises* (fig. 112), where the pink 'Rococo' costume worn by the monkey – frilly *pompon* with pendant ribbons, ribbon bow round the neck and small shoulder mantle – refers to the marquise's taste and favourite colour; the monkey is traditionally linked to frivolity, to lechery, to the mimicry of humanity. The very prettiness of the furnishings makes the savagery of the caricature more

of all – it would not 'come off by perspiration, or the use of a handkerchief', but it could safely be removed by a face cleanser, such as the 'Blossom Milk of Circassia'.[64]

The idea of the harem, in a period when the Ottoman world was a closed book to most Europeans (except for merchants, diplomats and a relatively small number of intrepid travellers), was intriguing to the western imagination; it fitted in well with the Rococo love of pleasure, of softness and accessibility. In *Woman* (1790) a male fantasy of 'Eastern Women' is described; they 'spend a great part of their time in lolling on silken sophas; while a train of female slaves, scarcely less voluptuous, attend. . . . to them, to fan them, and to rub their bodies, an exercise which the easterners enjoy with a sort of placid ecstasy'.[65] The freedom, in comparison with European dress, of oriental costume, which made physical relaxation easy, especially when loose trousers were worn, and the sexual appeal of such clothing, ensured that dressing *à la turque* was popular for fancy dress in life and in art; as well as at masquerades (see fig. 109), Turkish dress was fashionable as a conceit in portraiture. At Madame de Pompadour's chateau of Bellevue, built in 1748–51, her bedroom, known as the *chambre à la turque*, was furnished in oriental style and displayed three paintings by Carle van Loo of harem scenes, exhibited at the Salon of 1755. One of the paintings, *A Sultana taking Coffee* (Hermitage Museum, St Petersburg), is an image of Pompadour herself, *en sultane*; the implication behind the series is that although the Sultan (Louis XV) had many mistresses, they were only temporary sexual partners, and real power resided with the Sultana, Pompadour.[66] Elise Goodman-Soellner sees a similar theme of 'tribute to her role as *maîtresse en titre*' in Boucher's famous portrait *Madame de Pompadour at her Toilette* (fig. 111), a reading challenged by Alden Gordon, who states that the painting is not 'a political device made for a declining and ravaged beauty to reassert her hold on a King'.[67] Although Gordon claims that ' "making-up" was never the motive nor the motif behind the painting' (for the original portrait showed Pompadour placing flowers in her hair,[68] her 'signature' style), the present image as a dressing table scene, as Colin Jones notes 'allegorises the make-up process by which Jeanne-Antoinette Poisson had made herself up as an individual of quasi-regal proportions'.[69]

Jean-Nicolas Dufort de Cheverny remembered her in his *Mémoires* as a woman any man would have desired as a mistress: 'she had regular features, a magnificent complexion, superb hands and arms, eyes which were pretty but not large, but with a fire, an intelligence, and a brilliance that I have never seen in any other woman'.[70] Looking at the Boucher portrait, where the eyes are large, *pace* Dufort de Cheverny, one is reminded that the artist was not known for catching the likeness of his sitters, as Pompadour admitted, and she is shown with the fashionable oval face rather than 'le visage rond' of the courtier's description. To modern eyes, if one is to judge from Boucher's portraits of her, Pompadour

110 Thomas Hudson, (?)*Frances Anne Hawes, Viscountess Vane* (detail of fig. 109)

111 (*facing page*) François Boucher, *Madame de Pompadour at her Toilette*, 1750–*c*.1760. Harvard Art Museums, Cambridge, Mass., Fogg Art Museum, Bequest of Charles E. Dunlap. 1966.47

Facing Beauty

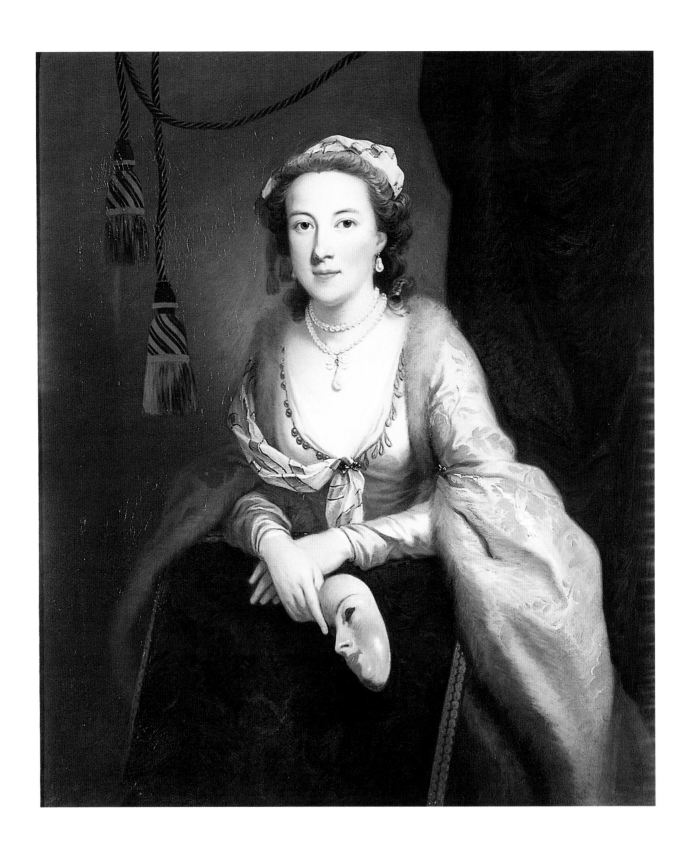

the idea of the seraglio, for example, comes to Mercier when he sees men looking at the pretty girls working among the ribbonry on offer in the boutiques of the *marchandes de modes*, for such women were traditionally thought to be as available as the items they sold.[59] Oriental, and particularly Turkish, dress was popular in female portraiture, perhaps a reflection of the vogue for such a costume in masquerades; the connotations of the harem gave an extra *frisson* to the supposed impropriety and libertinage of the *bal masqué*. The portrait of a beautiful woman, delicately made up with a touch of pink on her cheeks, who may be the famous (and notorious) beauty Frances Anne Hawes, Lady Vane (fig. 109), is heightened by her fur-trimmed Turkish masquerade costume. She leans over the back of a chair revealing a bosom not as tightly corseted as convention demanded – but, according to *Abdeker*, Ottoman women did not wear the 'Stays and Boddice . . . stiffen'd with Whalebone' essential to the appearance of European women.[60] Vane (if it is she) was famed for her extravagance, with a taste for love affairs and gambling; she persuaded Tobias Smollett to insert the scandalous 'Memoirs of a Lady of Quality' (which may have been based on her own life and written either by her and/or by Smollett) in his novel *Peregrine Pickle* (1751) – the only exciting bit of a rather dreary work.

As far as cosmetics were concerned, exotic names were particularly popular; as Sarah Berry notes in her discussion of 1930s Hollywood, 'European Orientalist fantasy was integral to the marketing of cosmetics and self-adornment from the eighteenth-century onward'.[61] *Abdeker* is set at the Ottoman court (see fig. 97) but the cosmetics mentioned – apart from one called 'The Secret of a Turk for making an excellent Carmine' (a recipe made from brazil-wood, white wine vinegar and alum) – are those to be found in a fashionable woman's beauty box. One of the most famous oriental cosmetics was Balm (balsam) of Mecca, an exfoliating lotion made from a resinous gum native to Southern Arabia. In 1717 Lady Mary Wortley Montagu tried it in Adrianople on her way to Constantinople, in order to improve her bad complexion resulting from smallpox, but she suffered a violent adverse reaction, and her face swelled up and turned red.[62] By the late 1770s, versions of Balm of Mecca were manufactured in Europe and more 'oriental' names appear in cosmetic manuals and in advertisements; examples include a 'fine Turkish Pomatum' (1778), 'Sultana Pomatum' and 'Seraglio Wash-balls'(1787), an 'Oriental dentifrice' and 'Circassian Wash Balls'(1785) and 'Bloom of Circassia' (1786).[63] The women of Circassia (northern Caucasus) were supposed to be the most beautiful in the Ottoman Empire, particular favourites of the Sultan, and it was not surprising that cosmetics were named as inspired by their fame to 'sell' beauty to Europeans. The most famous was a 'Liquid Bloom', which contemporary advertisements claimed was extracted, rather prosaically, 'from a vegetable' but 'instantly gives a rosy hue to the cheeks, not to be distinguished from the lively and animated bloom of rural beauty', and – best

109 Thomas Hudson, *(?)Frances Anne Hawes, Viscountess Vane, c.*1750. Private collection

concern with their appearance, to protracted cosmetic routines in order to give pleasure to men; this idea, as I have suggested, was a part of but not the whole story of the toilette, which involved creative rituals which greatly appealed to women. Certainly, oriental themes had infused European culture from Molière's *Bourgeois Gentilhomme* (1670), through Montesquieu's *Lettres Persanes* (1721) and Defoe's *Roxana* (1724), to Mozart's *Entführung aus dem Serail* (1782) and into the nineteenth century. Orientalism was a most potent force in the eighteenth century, when women became the focus of the erotic and playful imagination;

paint scrapers, a brush and comb, and writing implements in two drawers; the casket would have been a special commission, possibly a royal one. It must have been a pleasure to open such a casket in preparation for the ceremonies of the toilette; as Louis Sébastien Mercier noted: 'Les cérémonies commencent. On ouvre le dépôt des trésors cachés . . . Du fond de mille petits coffres élégans, sortent mille graces particulières' – such caskets house hidden treasures from which a thousand graces can be conjured. It is Mercier who in Chapter 496 in the sixth volume (1783) of his famous *Tableau de Paris* under the title 'Toilette' detailed the less decorative side of the toilette, the 'toilette secrète', where the woman, on her own, engaged in intimate ablutions (an illustration to a later edition of the *Tableau* shows her in a dressing gown on a bidet), after which she cleansed her skin and possibly added a whitening foundation. At the second toilette, a public event, she completed her make-up, so that, Mercier says tongue-in-cheek, she looked twenty-one years old for ever; it is here, he declared, that the careful manipulation of clothing – a peignoir in disarray, a glimpse of a half-naked leg, and a pretty mule falling off the foot – served to enhance a woman's sexuality, to create 'un déshabillé voluptueux'.[56] It is at this 'seconde toilette' that cosmetics were also used as part of the seduction process; according to Morag Martin, 'coquettes transformed themselves from bedroom beauties to society ladies. The public act of remaking the face performed for male admirers, functioned as titillating foreplay, promising to later uncover what was being cleverly masked'.[57] Mercier suggested, however, that removing the mask of artifice to reveal the 'natural' woman beneath was not an unmitigated pleasure. One suspects that at times the ritual of preparation must have been more enjoyable than the consummation of the sexual encounter that cosmetics supposedly promised. That there was a link between the act of making up the face and sexual activity is undeniable; caskets of the kind described here included writing materials, especially useful for love letters, and on a typical toilette table Mercier found *billets doux*, among the cosmetics, ribbons of all colours, '& une armée d'épingles'.[58] Pins were needed for fastening the various components of dress and attaching accessories such as headdresses, flowers and so on. In an English mezzotint of 1776 entitled *The Lady's Maid, or Toilet Head-Dress* (fig. 107), a caricature both of the huge and elaborate hair-styles of the mid-1770s, as well as a satire on the cosmetic toilette, a large pincushion appears in the centre, under a mirror. The 'table', draped with muslin and lit by two tapers, displays a scent bottle, small cosmetic boxes, scissors, a comb and jewellery – a necklace, rings and buckles; on the right is a pen and half-finished letter, almost certainly a *billet doux*.

The toilette was a female universe (men were there by invitation only) and envisaged by some western commentators as 'oriental' as a concept, a version of the harem where women devoted all their time to an intense and voluptuous

THE LADY'S MAID, OR TOILET HEAD-DRESS

107 and 108 (*above and facing page*) *The Lady's Maid, or Toilet Head-Dress*, 1776. British Museum, London

Facing Beauty

Fine Vermillion for the Cheek,
Velvet Patches *a la Grecque*

(Part I, Letter III, ll. 66–9, 88–9)[55]

Far grander receptacles than a band-box (which was mainly for items of millinery) were available for the wealthy; small coffers or boxes of portable beauty could stand on dressing tables and some of these were truly *objets de luxe*, incorporating items not just for making up the face and arranging hair-styles but manicure sets, card cases, sewing and writing implements and compartments for jewellery. One of the more luxurious English caskets (figs 104–6), and very much in Rococo style, dates from the mid-1750s; made of silver inset with plaques of porcelain – the floral designs include roses, sacred to Venus – the lid when opened reveals mirrored panels, and at the top a small clock attended by Cupid. The contents (fig. 106) include glass and china scent and lotion bottles, Chelsea porcelain boxes for powder, patches and a *carnet* for notes, a manicure set, powder and

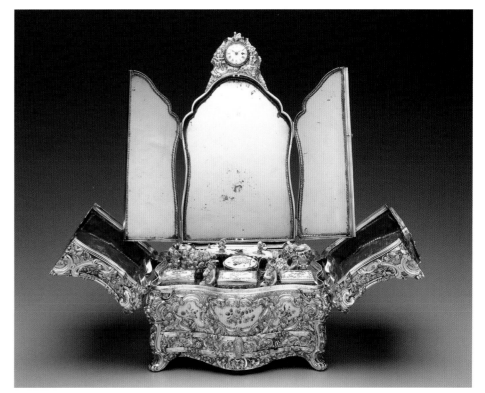

104, 105 and 106 (*above and facing page*) Casket of cosmetics, *c*.1755. Dallas Museum of Art, Texas

to it a curved knife to scrape excess paint from the face. The *modiste* hands her a headdress composed of a bunch of flowers set on a bed of silk; such confections (which, in an age of vast hair-styles, sometimes included false hair) were known as *poufs*, some of the more witty and elaborate being the creations of Marie-Antoinette's favourite *marchande de modes*, Rose Bertin.

Although the dressing table in this fashion plate looks fairly simple, in the eighteenth century, as Vincent Cochet notes, more elaborate pieces of dressing-room furniture appeared with compartments for the items of the toilette, such as containers of silver, glass or porcelain for powders, pastes, scents, patches (patches could also be found in drawers in wig stands).[54] In addition, when travelling, women needed containers for their beauty needs; Christopher Anstey's *New Bath Guide* (1766) urged women going to the fashionable spa to take their cosmetics with them 'in a band-box':

> Bring, O bring thy Essence Pot,
> Amber, Musk and Bergamot,
> Eau de Chipre, Eau de Luce,
> Sans Pareil, and Citron Juice
> . . .

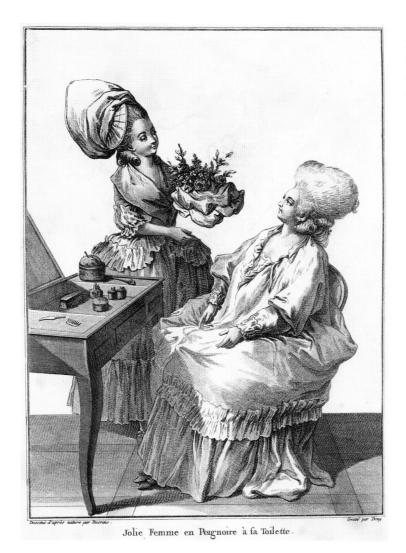

Jolie Femme en Peignoire à sa Toilette.

103 Claude-Louis Desrais, 'Jolie Femme en Peignoire à sa Toilette', from *Collection d'Habillements Modernes et Galants*, 1780, plate 89. Museum of London

beauty, in imitation of European taste and luxury: she covers a table in her room with a 'Cloth of Tyrian Purple', over which she drapes a veil. On this is a looking glass 'which a Venetian Ambassador gave as a present to Mahomet', and on either side of the mirror she places 'two round Boxes, which contained the most excellent Powder that could be found in the island of Cyprus', and china pots of 'the most fragrant pomatum that Italy could afford'; in preparation for the rites of make-up, Fatima puts on a short white gown with large sleeves ('Cimarre') and becomes 'the first Priestess of her Altar'.[53] This sounds like the capacious white garment which can be seen in a fashion plate by Claude-Louis Desrais, *Jolie Femme en Peignoire à sa Toilette* (fig. 103). A fashionable bourgeoise sits in front of her dressing table on which can be seen cosmetic pots, a swansdown puff on its powder box, a brush to remove spilt powder from the dress, a comb and next

102 (*facing page*) Charles-Antoine Coypel, *Charlotte Philippine de Châtre de Cangé, Marquise de Lamure* (detail of fig. 101)

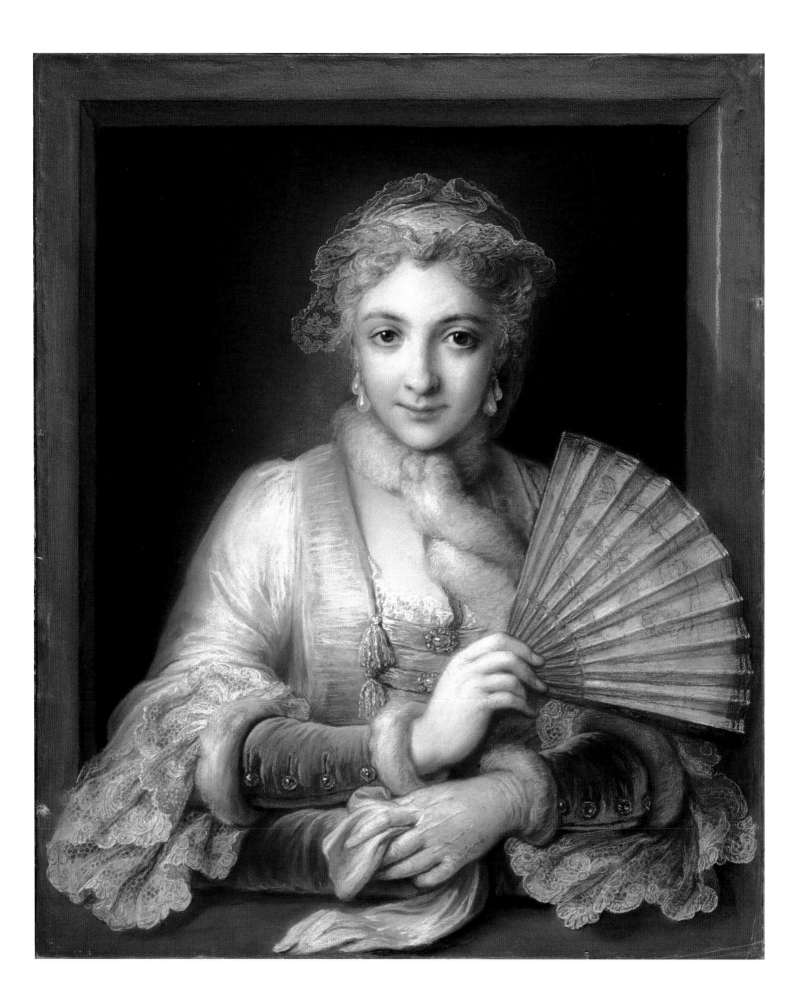

famed for the 'ease and sprightliness [of] their deportment'.[51] Andrews especially admired the brilliant eyes of many Frenchwomen, an essential element of their 'sprightliness', or what might be termed 'esprit', a wit and vivacity which could be independent of conventional beauty. Charles-Antoine Coypel's *Charlotte Philippine de Chatre de Cangé, Marquise de Lamure* (fig. 101), of about 1745, might typify the ideal French beauty, where charm is indissolubly linked to beauty. The dress (pale pink shot silk, trimmed with silver tassels) and the accessories (twisted fur tippet, fur-edged blue velvet muffettes which protected the arm from elbow to wrist, long kid gloves, the scallop shapes of the French needle-lace and the painted fan, and the pretty jewellery) conform to the Rococo taste for luxury, delicacy, serpentine lines and artifice; the face had to live up to this costume. The perfect oval of the face is dominated by huge eyes and the pallor of the skin was created by white face paint, touched slightly with pale pink on the cheeks and on the lips; the curls of her lightly powdered hair echo the curves of the fine lace of her cap with its streamers pinned on the top. Both dress and face result from an expert toilette, make-up chosen to match the clothes appropriate to the occasions on which they were worn. The more formal the event, when glittering jewellery was *de rigueur*, the more stylised the appearance of the face; George Alexander Stevens in his *New Lecture upon Heads* (1772) refers to 'an artificial evening candlelight face, of white and red'.[52]

A woman's toilette was both a ritual performance of dressing and making up the face and hair, and also the actual object(s) from which beauty was created. In the latter sense, in *Abdeker*, the toilette is constructed by Fatima as an altar to

100 (*right*) Jean-Baptiste Greuze, *The Broken Mirror* (detail of fig. 93)

101 (*facing page*) Charles-Antoine Coypel, *Charlotte Philippine de Châtre de Cangé, Marquise de Lamure*, *c.*1745. Worcester Art Museum, Worcester, Massachusetts. Bequest of Theodore T. Ellis

Facing Beauty

referring to the more tedious aspects of the eighteenth-century toilette (and ignoring any possibilities for a 'creative flow') than of the mid-twentieth century; today the very idea of the toilette has disappeared from the lives of all but a few women.

A theme to be seen in much of the discourse on the 'woman question' of the eighteenth century in the works of social philosophers who (in theory) were in favour of greater freedoms for the second sex, was how women – beautiful women especially – were obsessed by their own appearance, and too taken in by flattery. Such concerns were also articulated by the more thoughtful beauty manuals; the *Manuel de la Toilette et de la Mode* (1771) was annoyed by feminine egotism: 'sans cesse occupée d'elle-meme', a beautiful woman constantly draws attention to herself by such gestures as, for example, opening and closing a bracelet and fiddling with a necklace to show off her white arm and neck, refixing the patches on her face and so on.[48] More favourably, John Andrews remarked that the 'rage of being noticed in the world is more prevalent in the females of [France] than in those of any other country'; the 'allurements which women attain by art are in many cases more prevalent than those which flow from nature. Simplicity may be a strong charm for some, but people who live much in the world require something congenial to the disposition they have contracted by mixing a great deal in society'.[49]

The title of this section of this chapter is from Antoine-Léonard Thomas's essay on women (*Essai sur le Caractère, les moeurs et l'esprit des femmes dans les différens siècles*) published in 1772, in which he deplored (apropos both genders) 'la fureur de paroitre, l'art de tout mettre en surface'; specifically with regard to women, he criticised the time they spent on their appearance, which he could only conceive of in terms of mere surface adornment. In fact, Thomas was fairly sympathetic towards women, regretting the waste in their lives from being adored but oppressed, yet his writing reinforces Rousseau-like notions of the ideal woman as wife and mother, and the traditional female stereotypes of weakness and frivolity.[50] The toilette symbolised, for writers like Thomas, the feminine rage for surface decoration; it evoked considerable comment because it had become almost an official part of elite civilisation, a popular export from Paris to the wider world. Tourists, in particular, seemed to find it an essential aspect of the *douceur de vivre* of French life. For Andrews, the toilette was the Frenchwoman's 'sanctuary of art and refinement' where she 'prepares those charms and graces which she proposes to display in proper time and place'. Frenchwomen, it was often stated, were not as naturally beautiful as the women of other countries, but were able to make the most of what advantages they had, as 'a skilful economist, that knows how to make a little go a great way', in the words of Andrews in his *Remarks on the French and English Ladies*. He thought Englishwomen more beautiful than the French, but that the latter were more cultivated and witty, and

The patch, the powder-box, pulville, perfumes,
Pins, paint, a flattering glass, and black-lead combs
(I: ll. 127–30; 'pulville' was hair powder, often perfumed,
and a black-lead comb was used to darken the eyebrows).

In *The Lady's Dressing-Room* (1732), Swift describes the untidiness of Celia's dressing room, the 'Pettycoats in frowzy Heaps', and on the table the squalid detritus of the cosmetic routine, such as 'Gally-pots and Vials plac'd/ Some fill'd with Washes, some with Paste,/ Some with Pomatums, Paints and Slops' (ll. 33–5), combs filled with 'Sweat, Dandruff, Powder, Lead and Hair' (l. 24), and tweezers 'To pluck her brows in Arches round,/ Or Hairs that sink the Forehead low,/ Or on her Chin like Bristles grow'(ll. 55–7). He claims to find the whole process disgusting, but disgust, as Flügel noted in 1930, is a 'reaction against desire', and possibly here is a reaction against being taken in by surface beauty, by the deceits of the dressing-table.[44] For, when a woman sits before her mirror, according to Richard Steele in the character of Isaac Bickerstaffe, she 'endeavours to be as much another Creature as she possibly can' (*The Tatler*, no. 151, 25–8 March 1710): the toilette creates a new person. (In an earlier issue of *The Tatler* [no. 34, 25–8 June, 1709], Bickerstaffe/Steele 'invents' a 'Circumspection-Water . . . the only true Cosmetick or Beauty-Wash in the World', which, when a woman applies it and then looks in the mirror, immediately changes the face 'into downright Deformity'.) Ange Goudar in *The Chinese Spy* (1765) followed a well-worn path (most famously Oliver Goldsmith's *Citizen of the World* of 1762) with his satirical account of the manners and customs of a western nation supposedly observed by an oriental writer. 'Translated from the Chinese', it presents the familiar trope of beauty as complete artifice, the product of the toilette. In Goudar's work, the complexion was something to be 'made': 'the whole face must be taken to pieces, and then made as new as if it had never been'; after various 'ablutions, aspersions, immersions, washings and rubbings', the woman uses a seemingly endless parade of 'spunges, brushes . . . waters, essences, perfumes, &c' to create herself anew.[45] He may have been familiar with *Abdeker*, which contains a lengthy 'Library of the Toilet', a list of the many items a fashionable woman needed to have on her dressing table, such as floral waters, essences, pastes and pomatums, aromatic vinegars, 'spunges' for body and teeth, white paints, rouge (in paint and powder form), powders for face and hair, 'Patches of Velvet, of Sattin, of Taffety', and such items as 'Head-bands for the Wrinkles of the Forehead';[46] all these were necessary for the prolonged ritual of the fashionable toilette. Simone de Beauvoir in *The Second Sex* described the toilette as a 'social situation', dictated by an unvarying performance of acts of adornment: 'It is easy to see why woman clings to routine; time has for her no element of novelty, it is not a creative flow; because she is doomed to repetition, she sees in the future only a duplication of the past'.[47] Writing in 1949, she might be

translated), developed the idea, first discussed earlier in the century by writers such as Buffon, that faces could be 'read' and character assessed from their appearance.[42] This concept had an impact both on ideas of beauty and on portraiture as well; like physiognomy, portraiture, as Melissa Percival says, 'attempts to reproduce a unique individual through the emphasis of characteristic traits, and to align the spiritual qualities with the physical ones'.[43] In the Renaissance, artists and humanist writers had also 'read' faces, but their concerns were more with generalised concepts of nobility, virtue and beauty as types; late eighteenth-century art, especially portraiture, preferred to deal with emotional and moral states specific to the individual portrayed.

The Passion for Appearance

And thou, my toilette! Where I oft have sat,
While hours unheeded pass'd in deep debate,
How curls should fall, or where a patch to place:
If blue or scarlet best become my face

Lady Mary Wortley Montagu,
Six Town Eclogues: Saturday, 1716 (ll. 47–50)

The *Six Town Eclogues* were composed by Lady Mary Wortley Montagu early in 1716 while she was recovering from an attack of smallpox that left her face scarred. Later that year she accompanied her husband, the newly created ambassador to the Ottoman Porte (Empire), to Turkey, from where she brought back to England the practice of variolation – too late, of course, to save her own skin: 'No art can give me back my beauty lost' (l. 68). The lines in the epigraph above recall time spent at her toilette, the reference to 'blue' being related either to the colour of her dress, or possibly to the painting of blue veins at the temples, and the reference to 'scarlet' being related also to clothing or to the use of rouge. The 'deep debate' was not just about how she created her face for the day but perhaps to conversation and discussion with friends and family – the toilette could be an enjoyable and constructive period of leisure time. In England, writers who described the toilette varied in opinion from one extreme to the other: from the admiration of John Gay to the savage satire of Jonathan Swift. While Gay approved of the transformative capabilities of the toilette, Swift emphasised what must often have been the sordid reality. Gay's poem *The Fan* (1714), happily enumerates the items which make up the toilette (here used as an item of furniture or a beauty box):

There stands the toilette, nursery of charms
Completely furnish'd with bright beauty's arms;

99 Frontispiece illustration by
Samuel Wale (engraved by
Charles Grignion) to John Cozens,
The Economy of Beauty, London
1777. British Library, London

globe, implying her domination of the world; and Affectation looks at her
patched face in a mirror.[41] This is a familiar tale of artifice versus the supposed
simplicity of nature, but it is nature with an added element of sentiment, and
what the *Lady's Magazine* defined as the 'affections of the soul'. *Sensibilité* (feeling
and sentiment) was a key concept late in the century when, as Roy Porter noted,
'a new physiognomy was needed to tell the honest face and the heartfelt look',
to penetrate the outward mask of facial expression. The Swiss pastor Johann
Caspar Lavater in his *Physiognomische Fragmente* of 1775–8 (quickly and widely

tice of variolation, introduced into England early in the century, which lessened the effects of what *Beauties Treasury* (1705) called 'feature-fretting Small-pox'.[37]

Of the two kinds of beauty discussed in *Crito*, the second – 'the tender and kind Passions' – are also external, like the first, but incorporate ideas of morality and character. Spence gives them as modesty ('the prevailing Passion') and grace ('the noblest Part of Beauty' and 'Pleasingness itself'), which together create 'an Air of Divinity'. Beauty alone is insufficient and requires animation; 'all graceful Heads, even in the Portraits of the best Painters, are in Motion'. The features of a beautiful woman should express character and emotion, as can best be seen in the works of the Old Masters; with the mouth, for example, they depict 'a certain Deliciousness that almost always lives about the Mouth . . . not quite enough to be called a Smile, but rather an Approach toward one'[38] – Maria Gunning's portrait, I think, hints at this. Increasingly, the sentimental aspects of beauty became as important as the proportions of the features or the disposition of the colour in the face; as the Reverend John Andrews noted in his *Remarks on the French and English Ladies* (1783): 'a meer beauty is a meer picture, which we may admire for the tint and colouring; but at which we feel no more emotion than at the sight of the finest portrait that ever was taken from nature, or formed by imagination'.[39] In the works on beauty published in growing numbers later in the century, one notes the decline in medical and culinary recipes, in favour of a more structured and sustained discussion of cosmetics *per se* and the importance of mind and soul in the appearance. An essay on 'The Properties of a Perfect Beauty' in the *Lady's Magazine* (1772), having gone through the conventional details of features and colour in the face, spends some space describing how it should reveal the 'affections of the soul', for 'nothing is more seducing than looks animated by tenderness or pain; by hope or desire; by candour or ingenuousness'; 'modesty, sensibility, sweetness and innocence gives the greatest heightening to beauty'.[40] John Cozens in *The Economy of Beauty* (1777) proposed the notion that beauty is destroyed by an obsession with fashion and cosmetics, for it should be 'in a high Degree, dependent on Sentiment and Manners'. He explained the meaning of the frontispiece illustration to his moral poems (fig. 99): 'Pride, Affectation and Folly, the great Enemies of Beauty, with their proper Symbols and Attributes, offering a young Lady admission to their Coterie, are opposed by the author; who, in the character of Polyhymnia, the persuasive Muse, conducts her to the Temple of the Graces'. So, Polyhymnia, in classical draperies, a chaplet of laurel leaves in her hair, holds the hand of the 'young Lady' who wears a modest version of fashionable dress (although still with a train and high-heeled shoes); presumably, she wears little, if any, make-up and no 'supplemental Hair'. On the right, in the foreground, are characters symbolic of finery and appearance: a reclining half-naked Folly, with a jester's bauble in her hand; Pride, fashionably dressed and bejewelled, with attendant peacock rests her foot on a

The author of *Crito* divided his 'Dialogue on Beauty' into two kinds, the first being the colour and form of beauty, and the second dealing with 'all the tender and kind Passions [which] add to Beauty'. Of the first kind is the 'Delicacy and Softness' of the female body, which Spence considered should be more attractive than proportion and harmony; the body, he claimed, should be as beautiful (perhaps even more so) as the face, although of a different kind, for beauty too regular could pall and variety was crucial. He cited the Medici Venus as an example of what he meant: 'If you observe the Face only, it appears extremely beautiful; but if you consider all the other Elegancies of her Make, the Beauty of her Face becomes less striking, and is almost lost in such a Multiplicity of Charms'. With regard to the face, the colour of the complexion took pride of place, as 'the most striking and the most observed': 'a fine Red, beautifully inter-mixt and incorporated with White', but also praised was 'a complete brown Beauty' for 'the best Landschape-painters have been generally observed to chuse the autumnal Part of the Year'.[34] By 'brown', Spence does not intend a tanned skin browned by the sun[35] which would suggest manual labour, but a complexion somewhat darker than the bright white and red hallowed by cosmetic and literary tradition. Alexander Pope, for example, referred to elite Englishwomen as 'like variegated Tulips' (*Of the Characters of Women*, 1735, l. 41), perhaps a reference to the 'gaudy Tulips rais'd from Dung', the last line of Swift's poem *The Lady's Dressing Room* (1732), which describes Celia's appearance after using her 'Ointments, Daubs, and Paints and Creams' (l. 138) (see p. 160). To European eyes, conventional standards of beauty could not admit a really brown or black skin; so that in *Abdeker*, Fatima comes from Georgia, which 'produces the handsomest women in the world', as fair-skinned as any western beauty. Abdeker invents a lotion for Zuizima, a Turkish slave, whose owner had promised to marry her if she changed her 'tawny Colour' to a skin 'as white as Milk and as bright as Snow', and therefore he supposedly created the famous Spanish White, a face paint which replaced lead with bismuth (a mineral, but less dangerous than lead or mercury), which gave a pearly colour and smooth texture to the skin.[36] Zuizima's face, and that of Fatima as well, conforms to Le Camus's belief in a 'finished' complexion which expertly mingled white and red; it reflects the taste for explicit artifice in cosmetics at the French court. In England, as the heroines of mid-century British novels increasingly reflected bourgeois taste, their complexions were described as healthy, more natural and without the rouge which would have been worn by elite women at court. Sophia Western in Fielding's *Tom Jones* (1749) has a complexion with 'rather more of the lily than the rose', and Emily Gauntlet in Smollett's *Peregrine Pickle* (1751) a 'complexion incredibly delicate and glowing with health'; *Crito* says that good health was essential to beauty ('that Lustre of Health, which shines forth upon the Features'). The surface and smoothness of the face improved because of the prac-

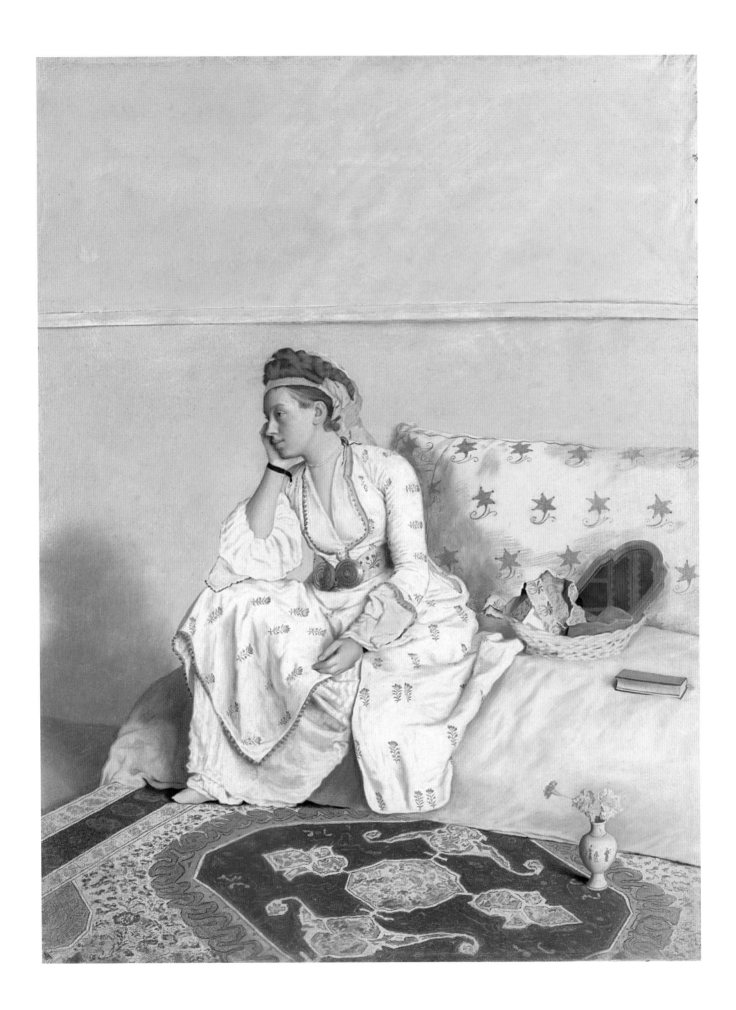

Liotard's portrait of a famous Irish beauty, *Maria Gunning, Countess of Coventry*,
of about 1753–4 (fig. 98), could be the perfect illustration to *Abdeker*, especially
as she is dressed *à la Turque*. Her face is the desirably perfect oval, her features
well formed and given vivacity by the nose which is rather more pointed than
conventional beauty demanded; the enhanced colouring of her complexion hints
at her fondness for paint, which eventually caused her death. Her unpowdered
hair is styled in a way Hogarth approved of, 'braided like intertwined serpents',
the kind of 'interlacing' he admired in his *Analysis of Beauty*.[33]

Enquiry 9. What are those *Features* and *Accomplishments* of Body, which in your Opinion make a *perfect Beauty?*

AN *Ingenious Gentleman thus answers this Enquiry*: There are *Twenty Six* Things remarked to constitute a perfect *Female-Beauty*. 1. Youth. 2. A Stature neither too big nor too little. 3. To be neither too fat nor too lean. 4. Symmetry and Proportion of all the Parts. 5. Long, Light, and Fine Hair. 6. A Delicate and Smooth Skin. 7. A Lively White and Red. 8. An Even Fore-head. 9. The Temples not Hollow. 10. The Eye-brows as two Lines. 11. Blew Eyes, close to the Head, having an amorous Look. 12. A Nose somewhat long. 13. Cheeks roundish, making a little Dimple. 14. A graceful Laughter. 15. Two Coral Lips. 16. A little Mouth. 17. Teeth White as Pearls, and well set. 18. A Chin roundish and fleshy, with a little Cherry-pit at the End of it. 19. The Ears Small, Red, and well-joined to the Head. 20. An Ivory Neck. 21. An Alabaster Breast. 22. Snow-white Balls. 23. A white Hand somewhat long and Plump. 24. Fingers ending Pyramid-wise. 25. Nails of Mother of Pearl turned Oval-wise. 26. To which is added a sweet Breath, an agreeable Voice, a free, and not an affected Gesture, a fine Presence and a modest Gate ——— But all these Points

96 'What are those *Features* . . . which . . . make a *perfect* Beauty?', from *Delights for the Ingenious; or, a monthly entertainment for the curious of both sexes*, London 1711. British Library, London

round, a nose somewhat longish but of a fine turn and, like the antiques, her eyes large, and not so sparkling as melting; her mouth graceful, without a smile, but rather of a pouting turn, which gives it at once both grace and dignity; her hair clean and without powder'; this, he says, 'is what the English painters have often occasion to represent',[31] and this is the kind of beauty to be found in contemporary portraiture by artists such as Thomas Hudson and his pupil Joshua Reynolds (see figs 109 and 122), and in English novels of the period.

In *Abdeker*, Le Camus dwelt on the beauty of the face above all: 'The Face is the chief Seat of Beauty: It there displays all its Force and all its Majesty; it is there it places those powerful Charms that command and captivate the Spectator's Heart, and excite his Admiration'. The paradigm of the beautiful face is, of course, Fatima's and the title-page illustration of *Abdeker* (fig. 97) shows her looking into a mirror to gaze at her own perfection:

Her Face form'd a perfect Oval; her Eyes were blue, and full of sweet and pleasing Smiles; her Eye-brows were brown, and represented two corresponding Segments of two equal Circles. The Height and Breadth of her Forehead were in due Proportion . . . Her Nose, which sprung insensibly from her Forehead, separated her rosy Cheeks; her Mouth was small and well form'd; her Vermilion Lips were border'd with two Rows of Teeth, that represented so many Pearls; and the lowest Part of her Face was adorn'd by a Chin that form'd a perfect Arch . . .[32]

Abdeker purports to be a treatise written in the midde of the fifteenth century by the eponymous author, a doctor to the seraglio of the Sultan Mahomet II, where he meets the heroine Fatima, a favourite (odalisque) of the Sultan. The book is partly the love story of Abdeker and Fatima (who finally flee from the Ottoman court to Italy), but it is mainly a collection of recipes to cultivate and enhance Fatima's beauty; her body, it relates, is as much an incitement to wantonness as her face, especially her 'alabaster neck and her heaving Bosom'. Although Le Camus sets his story in Constantinople, the perfect female figure is seen as completely western, being slim, without 'too much Fatness' which 'spoils Beauty'. European women, according to Abdeker, 'seem to have more Means at hand to hinder their Bellies from growing big, than those of Asia or other Eastern Countries', by which he means 'Stays and Boddice that are stiff-en'd with Whalebone'; such stays slim the stomach and oblige 'a Woman to stand upright, to keep out her Breast and draw in her Shoulders, and gives her Stature and her Shape a particular Grace'.[29] Elegant deportment and a good 'Shape' (figure) were important in the construction of social beauty, as women played more visible roles in society; increasingly, as the century progressed, beauty manuals paid more attention to diet and exercise in promoting a slender, more active female body.

What features make a perfect beauty

In *Delights for the Ingenious* (1711), among a heterogeneous collection of epigrams, brief essays, queries and answers, is the question and reply to 'What are those *Features* . . . which . . . make a *perfect* Beauty?' (fig. 96). The first of twenty-six requirements is 'Youth', followed by the details of the perfect face and body, 'a sweet Breath, an agreeable Voice' and correct deportment ('a modest Gate'); but the author admits at the end of his list that 'all these Points are never to be found in one Person'. As a description of ideal beauty, this accords with the rel-ative homogeneity of such standards in western Europe throughout the eigh-teenth century – an oval face (although here this is omitted, or perhaps taken for granted), a smooth complexion with 'Lively White and Red', regularity of fea-tures with a longish nose, small mouth and a round chin, and blue eyes. Blue eyes have, according to Buffon, 'the most powerful effect in beauty', for 'they reflect a greater variety of rays from the tints of which they are composed'; to Auguste Caron at the beginning of the following century, more emotions could be seen in blue eyes, such as 'the open look of innocence, the sparkling look of pleasure . . . the eager look of desire . . . the stolen look of the enamoured nymph, the languishing look of love'.[30]

Jean-André Rouquet, describing the ideal Englishwoman in 1755, reported that she 'must have a fine white skin, a light complexion, a face rather oval than

Facing Beauty

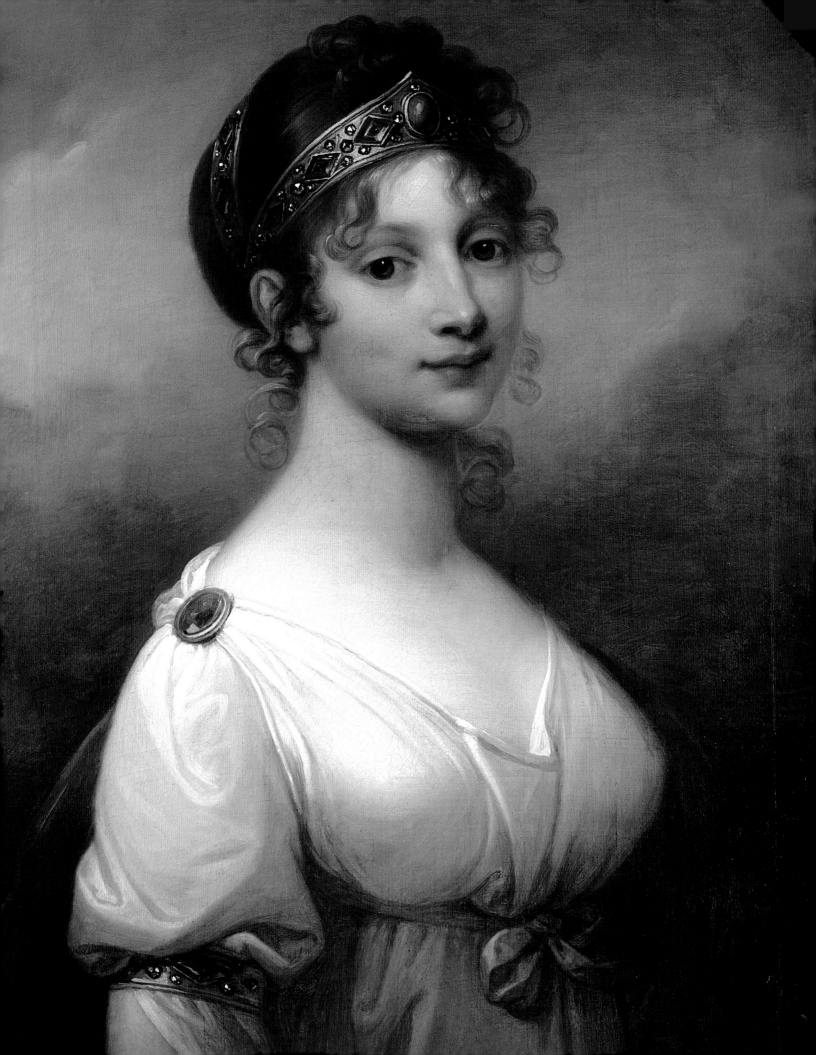

behind the scenes. Buffon claimed that 'it is only among nations highly polished that women are raised to that equality of condition which is naturally their due, and so necessary to the true enjoyment of society';[24] in 1790, an English writer remarked how women in France 'dictate almost everything that is said, and direct everything that is done' – an exaggeration influenced perhaps by the events leading up to the 1789 Revolution, when women were poised to play a major political role (which never materialised).[25] It was accepted that fashion and appearance played an essential part in women's lives, but many writers wondered if this was at the expense of other, deeper aspects of existence; the moral dangers of fashion, its problems of consumption and of vanity, were acknowledged but what was increasingly recognised was its power and presence. A chapter entitled 'De la Parure des Femmes' in Pierre-Joseph Boudier de Villemert's *L'Ami des femmes* (1758) discussed the importance to women of their clothes and their cosmetics. On the one hand, he disapproved of the amount of fabrics and ornaments to dress (*colifichets*) which disguised the female figure (this period, the Rococo, saw complicated and highly decorated fashions); on the other hand, he correctly discerned how the novelty of fashion was able to renew a woman – 'c'est un stratagème du sexe pour renouveller la meme personne, & la repro-duire, avec avantage, sous diverses formes'.[26] Fashion, in short, could be inter-preted as a language for women's lives, a self-conscious signalling of personal events and rites of passage. In addition, the whole French economy depended on dress and appearance; the *Encyclopédie* has hundreds of entries on fashion and cosmetics, an encouragement of 'a way of life in which sociability required acceptance of the culture of appearances'. Moreover, the regular appearance, from the 1770s, of fashion magazines provided a vast amount of information not just on the details of dress, accessories, hair-styles and so on, but on the precise social situations in which they were appropriate, and the nuances of appearance – a new 'civilisation of the visual'.[27]

Compared with the Renaissance, the eighteenth century was a period of personal comfort, of improved hygiene and of bodily intimacy, all of which turned the toilette into a high art, in which the theatre of dressing and undress-ing was as much an enjoyable entertainment as making up the face. The century regarded beauty as a whole, the body as well as the face; Dr Johnson's defini-tion of 'Beauty' in his *Dictionary* (1755) is 'that assemblage of graces or propor-tion of parts, which pleases the eye'; more specifically, the first line of *The Art of Beauty* (1760) states, 'Beauty is that form of an entire body, which pleases every one of our senses'. This was copied directly from the most celebrated cosmetic treatise of the century, *Abdeker: or, The Art of Preserving Beauty* (1754) by Antoine Le Camus, which continued: 'This entire Body pleases our Eyes by the Extent, Colour, Number, Disposition, and proportion of its Parts: It pleases our Sense of Feeling by its Texture, our Nose by its Smell, and our Hearing by its Sound'.[28]

95 (*facing page*) Josef Grassi, *Queen Louise of Prussia* (detail of fig. 141)

Facing Beauty

size, and their defects not to be seen, but through a magnifying glass' (my italics). The Comte de Buffon, the French naturalist and author of the monumental *Histoire Naturelle* (1749–67), of which his 'Description de l'homme' is a part, stated that 'every nation, and every individual, has a peculiar prejudice or taste with respect to beauty', which he thought might derive from 'some pleasing impression received in infancy', and 'therefore depends more perhaps on habit and chance than the disposition of our organs'.[20] Regarding standards of beauty in the past, Spence wondered why, for example, Rubens 'delights so much in Plumpness', for he represents beautiful women with 'a good Share of Corpulence . . . His very Graces are all fat'. As for today, 'Every Object that is pleasing to the Eye when looked upon, or delightful to the Mind on Recollection, may be called beautiful; so that Beauty in general may stretch as wide as the visible Creation, or even as far as the Imagination can go'. In short, 'every body may be beautiful in the Imagination of some one or other', and 'the most opposite Things imaginable may each be looked upon as Beautiful in whole different Countries, or by different People, in the same Country'.[21] Such concerns were the result of growing interest in a world expanded by trade and travel, by the beginnings of colonialism and by intellectual curiosity encouraged by Enlightenment thought and the publications of *philosophes* and scientists, who aimed to codify all knowledge. During the Renaissance, poets had used the trope of otherness to contemplate the range of possible beauty, as had Abraham Cowley in his poem 'Beauty':

> Beauty, thou wild fantastic Ape
> Who dost in ev'ry country change thy Shape,
> Here black, there brown, here tawny and there white (*Poems*, 1656).

For some satirical writers it had become a game to compare the supposed absurdities of non-western notions of beauty with European ideals; thus, a template for beauty may vary 'according to the Diversity of Times and Countries; for the Africans esteem the Eye-brows in Triangles. In France they carry them Arched-wise. In China little Eyes are most esteemed. The Libians love a great Mouth. The Japanese blacken their Teeth. In Ethiopia the blackest are the greatest Beauties'.[22] More seriously, philosophers such as David Hume addressed his readers' fear of difference: 'we are apt to call *barbarous* whatever departs widely from our own taste and apprehension', so it was important to remember how 'the continual revolutions of manners and customs' affect ideas of beauty.[23]

The place of women in society was a key talking point in cultivated circles in the eighteenth century; what roles could they play other than the traditional domestic and decorative ones? In some countries, especially France where salons encouraged intellectual discourse between both sexes, women's views on all aspects of society were welcomed and they even took part in politics, albeit

picture in 2004 suggested that this was 'a serious and rare attempt by the artist to represent ideal feminine beauty', and it is true that Hogarth has given her the long neck, elegant turn of the head, regular and well-proportioned features and the perfect pink and white complexion of a conventional beauty like Catherine Hyde. Yet, so accustomed are we to Hogarth's vigorous and lively women, that this sketch, beautiful as it is, appears insubstantial and rather ghostly in comparison.

Hogarth was among the many writers of the era who commented on the relativity of appearance, how beauty varied in time and in type, and what this might mean in terms of defining what it was. But even though lip service might be paid to variety in faces from different times and cultures, familiarity was the key to perceptions of beauty. In Swift's *Gulliver's Travels* (1726), the tiny inhabitants of Lilliput find large faces nauseous; 'this made me reflect upon the fair skins of our English ladies who appear so beautiful to us, *only because they are of our own*

S-line of beauty may apply'.[19] From this description by David Piper, one can understand why it is that there is a certain fleshy similarity in Hogarth's portraits of women, who all look far too healthy to be judged beautiful by Burke's canons of fragility and delicacy. The one image by Hogarth which suggests that he might have had similar ideas to Burke, is a fairly recently rediscovered *Head of a Woman* (fig. 94), traditionally said to be Mary Fitzwilliam, Countess of Pembroke; apparently, her beauty and grace impressed the artist so much that he sketched her from memory. The museum display caption accompanying the

quise de Merteuil records how grief enhances the beauty of the convent girl Cécile de Volanges, seduced by Valmont; she 'had not yet performed her *toilette*, and soon her dishevelled hair had escaped over her shoulders and naked bosom . . . Lord! how beautiful she was! If the Magdalene was at all like this, her penitence must have been much more dangerous than her sin'. Greuze, the artist of mood and sentiment, catches perfectly the sexual aura of grief-stricken beauty in such works as *The Broken Mirror*, of 1762–3 (fig. 93); a young woman in lustrous satin morning dress, bodice unlaced, hair undone, surrounded by agents of her destruction in the form of her finery and cosmetics (the powder puff), gazes in misery at the broken mirror at her feet, symbolic of her lost virginity. Burke reminds one that the face was not the only area where beauty could be seen: 'Observe that part of a beautiful woman where she is perhaps the most beautiful, about the neck and breasts; the smoothness; the softness; the easy and insensible swell; the variety of the surface, which is never for the smallest space the same; the deceitful maze, through which the eye slides giddily, without knowing where to fix, or whither it is carried'.[14] As for the face itself, Burke's concept of beauty was consistent with the variety, 'mild' colours and the gently curving lines of the Rococo ideal which regulated contemporary fashion;[15] any angularity was to be avoided, the parts 'melted as it were into each other', to create 'that agreeable relaxation which is the characteristic effect of Beauty'.[16] Although the sentiment and moral content of *The Broken Mirror* is inimical to the true Rococo, Greuze could not help but be influenced by contemporary aesthetics in his love of curves and *objets de luxe* – the gleaming silks, and the pearls, ribbons and pink velvet reticule on the table.

So prevailing was the Rococo as an art form that even William Hogarth, that most English of artists, incorporated his own version of the style, his famous Line of Beauty (a curving and shallow serpentine line) in portraits and genre scenes; women of the 'best taste', claimed the artist, 'choose the irregular as the more engaging' – 'picturesque' hair-styles, where 'the many waving and contrasted turns of naturally intermingling locks ravish the eye', and asymmetry in the placing of patches – 'no two patches are ever chosen of the same size, or placed at the same height, nor a single one in the middle of a feature'.[17] Like Burke, Hogarth believed that beauty should 'please and entertain the eye' and, unlike Shaftesbury, he thought that beauty should be real and not ideal; present-day women, he claimed, had 'faces and necks, hands and arms . . . that even the Grecian Venus doth but coarsely imitate'.[18] However, while his portraits are certainly 'real', they have little conventional claim to beauty; his female faces offer to our modern eyes 'an interplay of plump convexities, cheek and chin, and chin again, and popping eye; his mouths are full and fleshy, yet vigorous with a wiry flick of humour in the corners, and in a somewhat schematized drawing of a mouth one can see, for once, precisely how, in the shading of the upper lip, the

would not see anything as beautiful but merely 'convenient'. Hutcheson found a superior or 'absolute' beauty in objects, such as painting, which had no 'comparison to any thing external'; an inferior or relative beauty was to be found in more mundane objects, such as dress, gardens, houses and so on, which we can judge on comparative grounds, and 'in Faces I see nothing which could please us, but Liveliness of Colour, and Smoothness of Surface'.[6] Hutcheson's idea of beauty in a woman's face related to the given notion of regularity of features and a smooth complexion, but also with a distinctive personal charm and 'Liveliness of Colour'. Such a beauty might take the form of *Catherine Hyde, Duchess of Queensberry*, who in person added wit and intelligence to her charms; Robert Dodsley's *Beauty: – or, The Art of Charming* (1735) praised 'the Charms of Feature when combin'd,/ With Virtue, Sense, and Beauties of the Mind'.[7] The portrait attributed to Charles Jervas (fig. 92), of about 1725–30, depicts the perfect oval of her face with its high, polished forehead, long nose, a light rosy colour on the cheeks and plump pink lips. In her dress of pale brown silk, plain linen cap and apron, she affects rustic simplicity; this guise serves to emphasise her beauty – a 'fine Lady is never more agreeable than in her Undress'[8] – and was adopted later in the century by other famous beauties such as Emma Hamilton (see fig. 136).[9] The French artist Charles-Nicolas Cochin admired the English taste for simplicity in their portraits, claiming that art did not show to advantage when there was an over-scrupulous rendering of dress; why, he wondered, should a painting be subject to such servile exactitude when poetry was not.[10]

For Hutcheson, pleasure was an essential part of beauty, as it was for many writers; in a long article on 'Beauté' in volume II of the *Encyclopédie*, the Chevalier Louis de Jaucourt defined it as 'la puissance ou faculté d'exciter en nous la perception de rapports agréables'. Agreeable sensations for Jaucourt, 'a sense of joy and pleasure' for Edmund Burke in contemplating beauty, in his famous *Philosophical Inquiry into the Origin of our Ideas of the Sublime and Beautiful* (1757). The key word for Burke in thinking about beauty was 'affecting'; a sense of feeling, of emotion was necessary and thus an 'appearance of *delicacy*, and even of fragility, is almost essential to it'.[11] This was not a new idea, for – as Etherege had said in *The Man of Mode* (1676) – 'a melancholy beauty has her charms. I love a pretty sadness in a face which varies now and then, like changeable colours, into a smile' (II: i). Yet Burke's idea was that the most beautiful women contrive 'an air of weakness and imperfection';[12] Joseph Spence (under the pseudonym of Sir Harry Beaumont), in his *Crito; or, a Dialogue on Beauty* (1752) had similar thoughts, noting that grief can create an 'appearing Softness or Silkiness of some Skins; that Magdalen-look in some fine Faces after weeping'.[13]

The notion of female fragility as an aspect of beauty is linked to the appearance of sentiment to be seen in literature and in art during the second half of the eighteenth century. In Laclos's novel *Les Liaisons dangereuses* (1782), the Mar-

92 (*facing page*) Charles Jervas, *Catherine Hyde, Duchess of Queensberry*, c.1725–30. National Portrait Gallery, London

Facing Beauty

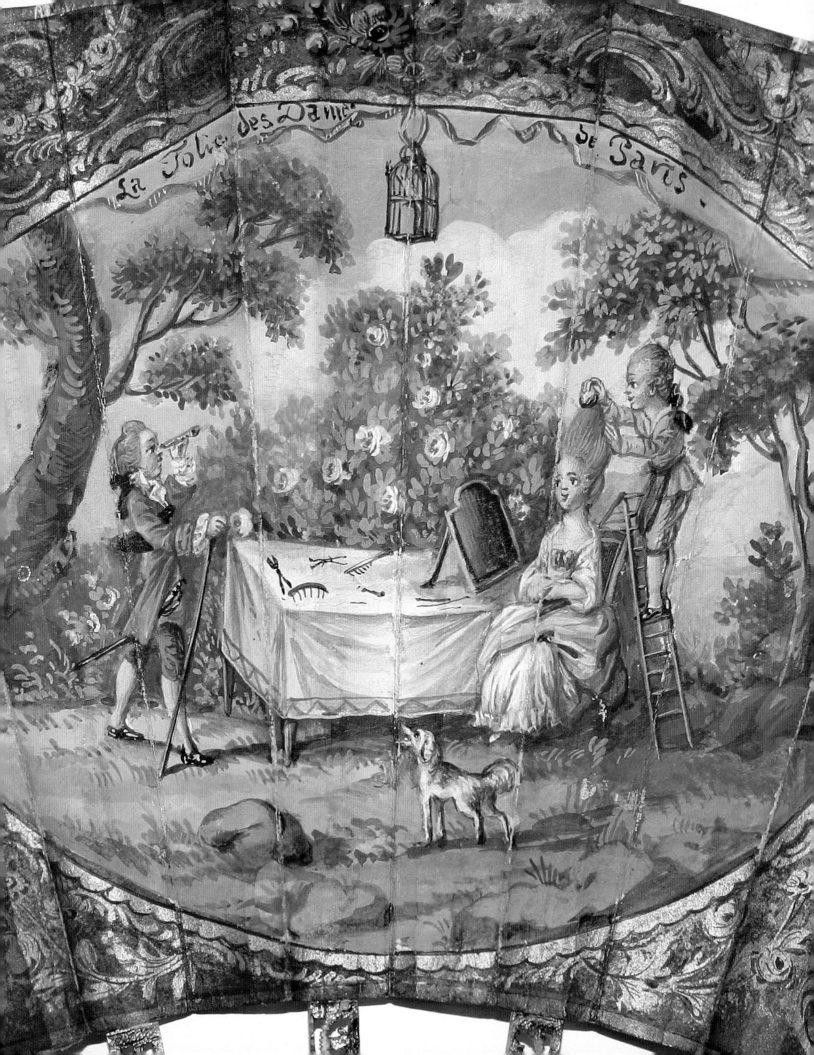

La Jolie des Dames de Paris.

artistic theory in the form of Neo-classical ideals being applied to the practicalities of women's dress and appearance, and new ideas of beauty based on *sensibilité*, extending from the late eighteenth into the early nineteenth century.

Ideas of the Sublime and Beautiful

> Beauty is taken for the Idea rais'd in us, and a Sense of Beauty for our Power of receiving this Idea . . .
>
> Francis Hutcheson *An Inquiry into the Origins of our Ideas of Beauty and Virtue*, 1726[2]

By the early eighteenth century, beauty was a *fait accompli* in much philosophical reasoning, even if definitions of it assumed differing forms. For the moral philosopher Anthony Ashley Cooper, 3rd Earl of Shaftesbury, beauty was dependent on symmetry and order, on decorum and on taste; taste, in particular, became an essential element in the culture of politeness which was taken up by the newly wealthy bourgeoisie. Taste was all important, for beauty was a part of taste, and taste part of beauty; 'all Beauty is Truth' – not truth in the sense of nature as a role model but truth formed by rules and proportions. For Shaftesbury, 'Virtue, Knowledge and Beauty formed a club of the good' and, as true 'proportions [make] the Beauty of Architecture', so 'True Features make the Beauty of a Face'.[3] What did he mean by 'true'? Regularity of features and colour harmonies in the face, perhaps? Yet he also referred to the importance of design, what he called 'the Form or Forming Power', which is more difficult to explain with regard to the face, unless it means the use of cosmetics as beauty aids (as well as God's hand) and the opinions of cultivated humanity – ''Tis Opinion which makes Beauty, and unmakes it'.[4] In the dialogue on beauty created by art, he wrote: 'The Art then is the Beauty . . . And the Art is that which Beautifies . . . So that the Beautifying, not the Beautify'd, is the really Beautiful . . . For that which is beautify'd, is beautiful only by the accession of something beautifying: and by the recess or withdrawing of the same, it ceases to be beautiful'.[5] Clearly, he intended that with art, the *act* of painting is all important and it is that which makes a beautiful object; beauty, therefore, cannot be embodied in the person depicted. Can one also interpret this statement as support for the use of artifice by women, that paint and cosmetics can be beautifying acts? Not completely, for although Shaftesbury believed that 'Art and Design' are essential to beauty, a beautiful woman did not cease to be beautiful 'by the recess or withdrawing of the same'; but cosmetics or other enhancements to beauty must play a part in the genteel and tasteful order and harmony of the face.

According to Hutcheson's *Inquiry into the Origins of our Ideas of Beauty and Virtue*, humans have an innate 'Sense of Beauty and Harmony', otherwise we

91 (*facing page*) French fan, gouache on vellum, detail showing central vignette, 'La Folie des Dames de Paris' (detail of fig. 134)

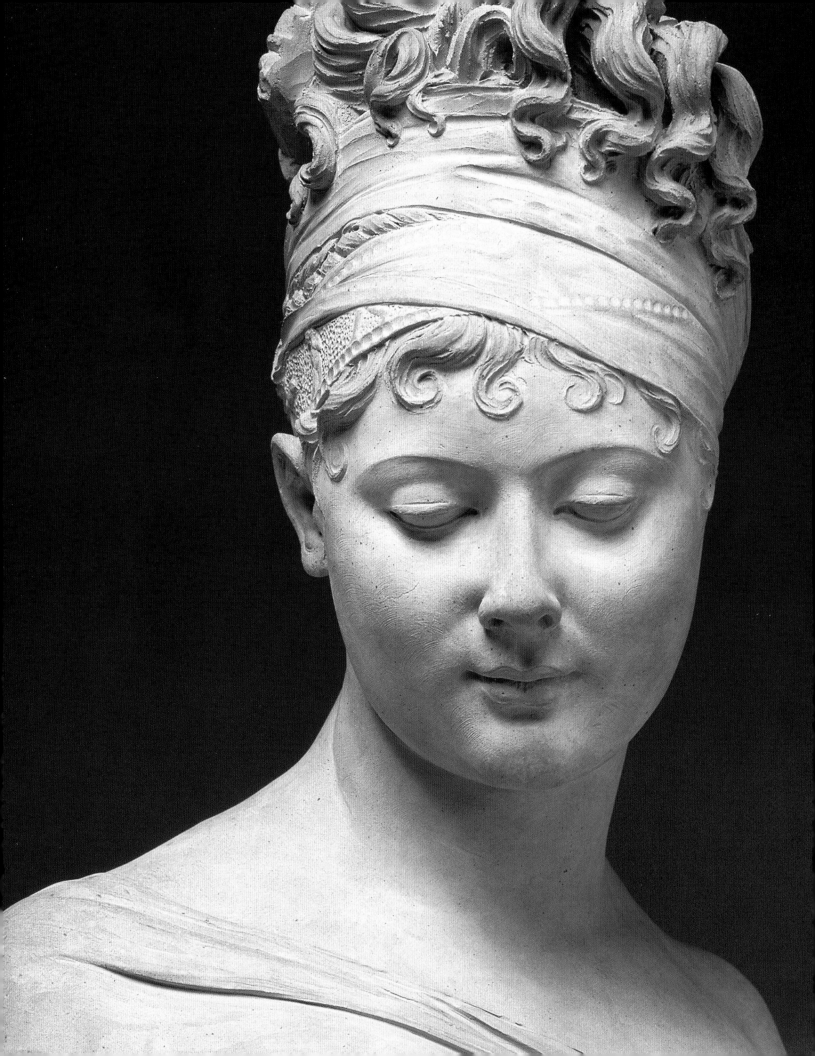

*F*ASHION, CLAIMS DANIEL ROCHE, WAS 'ONE OF THE MAJOR THEMES OF ENLIGHTENMENT THINKING AND ITS HERITAGE'.[1] AT FIRST GLANCE, it might be wondered how fashion – and its close companion, cosmetics – with its connotations of frivolity and superficiality, could be incorporated into the realm of reason and logic which the Enlightenment embodied. Yet if one pursues the idea that the Enlightenment questioned traditional customs and manners, and argued for an open discussion of social and public issues, among them the position of women, then Roche is surely correct in seeing the culture of appearances as an essential part of the movement. The extension of the concept of fashion (as distinct from dress), encouraged by new forms of communication such as fashion journalism and allied to the complementary art of cosmetics, is also a symbol of egalitarianism inherent in the Enlightenment.

The main stories of this chapter relate to the empowerment of women through fashion and appearance. In Roche's culture of appearances, fashion was a stratagem for women to constantly renew themselves, so I argue that the face also acted as a site for changing ideals of beauty. These ideals were partly constructed through philosophical debate in which concepts of 'social' beauty and the place of 'taste' were discussed – the eighteenth century is perhaps the period when philosophy was more central to cultural concerns than has ever been the case since classical antiquity. So in the first section of this chapter I deal briefly with some of the main ideas of beauty of face and body articulated by philosophers (including various critiques of relative beauty), and then I review 'What Features make a perfect Beauty', as an essay published in *Delights for the Ingenious* (1711) had it.

The central section of this chapter revolves round what the French writer Antoine-Léonard Thomas referred to in 1772 as 'la fureur de paroître', an obsession with appearance, of surface rather than substance, which might be said to characterise the middle decades of the eighteenth century. Under the aegis of French ideas of fashion and taste, the arts of cosmetics and the toilette which skilfully employed those ideas, reached new heights of refinement; fashion and cosmetics became, all over Europe, symbols of civilisation, and a part of the luxury debates of the century. Nevertheless, when, from the 1780s, simpler styles of dress appeared, the presentation of the female self also underwent a change, in a rejection of what was seen as the artifice of the *ancien régime* – a trend encouraged by political events such as the French Revolution of 1789 and its aftermath – towards a greater naturalism. This is the subject of the final section of the chapter. If the Enlightenment can be thought of in terms of the critical questioning of traditional customs, then the radical change in women's appearance can be identified as an important part of this movement, as can the opening up of fashion/appearance concepts to a wider public sphere, no longer limited to the elite. In addition, one sees for the first time a successful application of

89 (*previous pages*) Thomas Gainsborough, *Anne Luttrell, Mrs Horton* (detail of fig. 116)

90 (*facing page*) Joseph Chinard, *Juliette Récamier* (detail of fig. 142)

Facing Beauty